Being
Modern

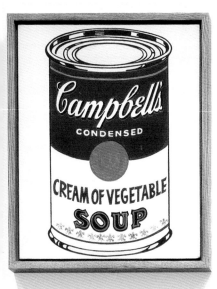
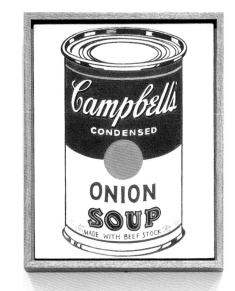
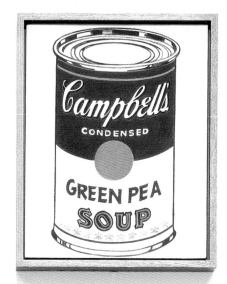
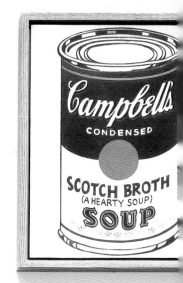
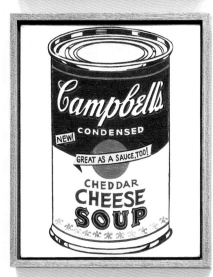
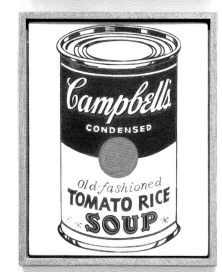
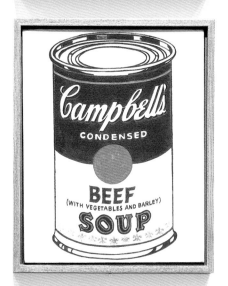
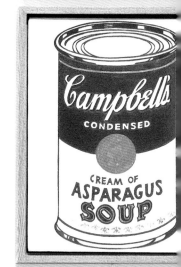
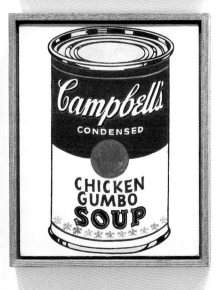
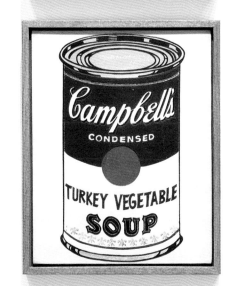
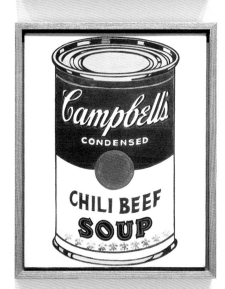
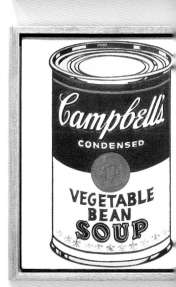
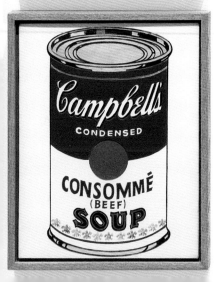
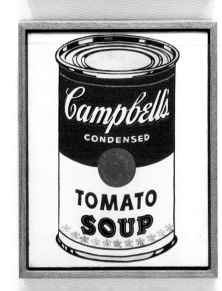
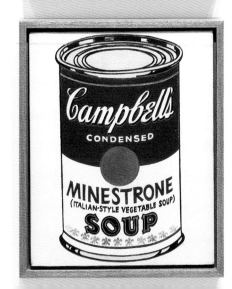
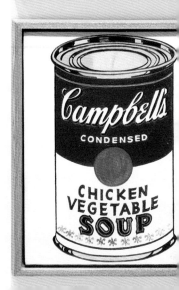

Being Modern
MoMA in Paris

Edited by **Quentin Bajac**

Preamble by **Glenn D. Lowry**
Preface by **Suzanne Pagé**

With contributions by
Quentin Bajac, **Michelle Elligott**,
Glenn D. Lowry, and **Olivier Michelon**

With 230 illustrations

Fondation Louis Vuitton, Paris The Museum of Modern Art, New York **Thames & Hudson**

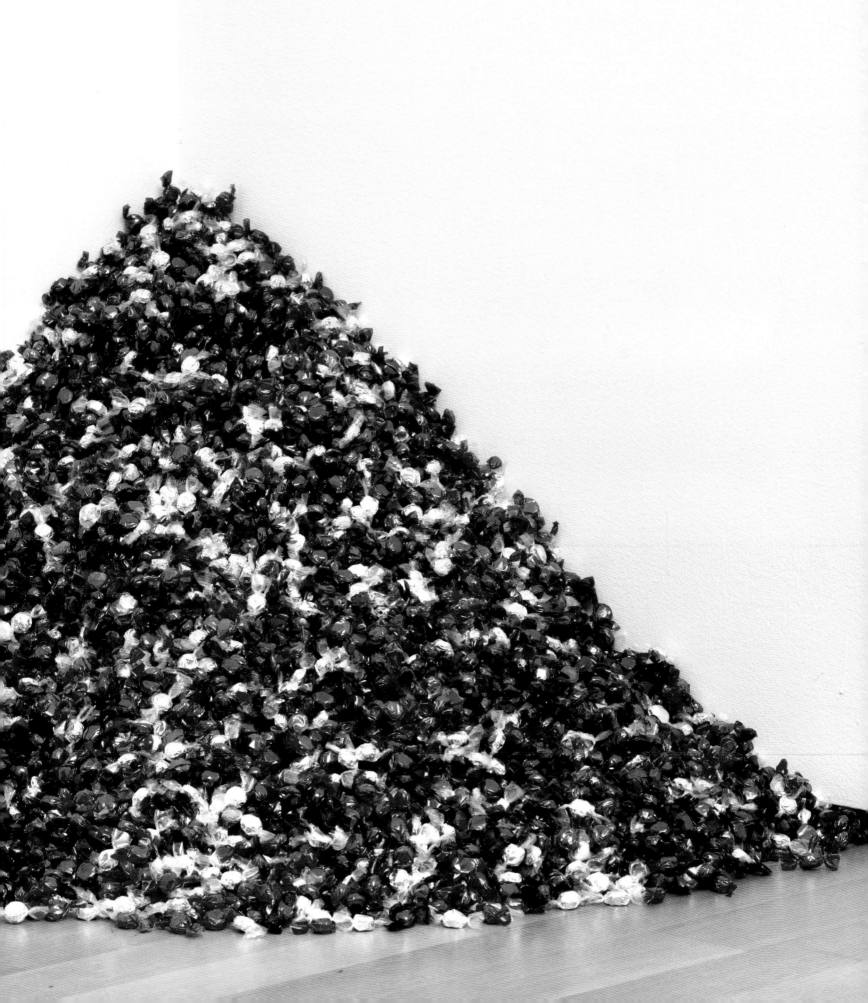

Contents

Foreword

Bernard Arnault
President, LVMH/Moët Hennessy. Louis Vuitton
President, Fondation Louis Vuitton, Paris

The exhibition *Being Modern: MoMA in Paris* at the Fondation Louis Vuitton resonates powerfully with *Icons of Modern Art: The Shchukin Collection,* the exhibition that opened at the Fondation a year earlier. Here the legendary collection of Sergei Shchukin, one of the greatest philanthropists of the twentieth century, is followed by the collection of The Museum of Modern Art, New York, whose mythic history is intimately interlinked with that of twentieth-century art. The masterworks on display all come from MoMA, a museum that has been both an extraordinary conduit of European modernity and a seminal supporter of American art as it became one of the leading institutions in the international art world. I am especially delighted that the French public will have a chance to see such works as Paul Cézanne's *The Bather* (c. 1885), Pablo Picasso's *Boy Leading a Horse* (1905–06), Gustav Klimt's *Hope, II* (1907–08), and Andy Warhol's *Double Elvis* (1963), as well as *Untitled (Club Scene)* (2013) by Kerry James Marshall and *Let's Walk to the Middle of the Ocean* (2015) by Mark Bradford, along with many other remarkable works that we have loved discovering or revisiting in New York. Like *Icons of Modern Art*, this exhibition is a story of personal passions—those of the philanthropists-collectors who, committed to the public good, rallied together in the early twentieth century to give New York a modern art museum worthy of the nation, which was then emerging as the world's leading power.

When the Fondation Louis Vuitton opened three years ago, the exhibition *Keys to a Passion* presented (thanks to generous loans of masterpieces by more than forty major institutions) the powerful themes that define the institution's artistic engagement: contemplation, expressionism, Pop-ism, and connections with music. Subsequently, our exhibition of Shchukin's collection demonstrated the degree to which a passion for art can be both provocative and visionary. This new exhibition presents the vision that has guided MoMA since its founding in 1929: it is intimate and collective, intuitive and reasoned, dedicated to exemplary citizenship, engaged, and generous. As friends of the United States, we see MoMA as exemplary because this desire to collect and conserve the most modern artworks of the time and make them available to New Yorkers—and indeed all Americans—was initiated by remarkable personalities who all belonged to a new community of philanthropists, a community that has grown steadily

from the 1920s until today. Lillie P. Bliss, Abby Aldrich Rockefeller, and Mary Quinn Sullivan—the three "founding ladies" at the origin of the MoMA story—devoted their energies not only to the creation of what would become one of the world's great museums but also to building the foundations that would guarantee its success for generations to come. The transition from Mrs. Rockefeller to two of her sons—Nelson and David, who both served to lead the Museum—is nothing short of exemplary. Today this torch is carried by our friend, MoMA President Marie-Josée Kravis. When the Museum first opened, in a rented space in November 1929, it had no building of its own, nor did it have its own collection. The pioneering spirit and courage of the trustees were equaled only by the erudition and vision of MoMA's first director, Alfred H. Barr Jr., a seminal figure in the history of art. Glenn D. Lowry holds this position today. At the Fondation, Suzanne Pagé, Artistic Director, and her team worked closely with him and with Quentin Bajac, The Joel and Anne Ehrenkranz Chief Curator of Photography at MoMA, to bring the *Being Modern* project to fruition, and I extend my warmest thanks to them.

MoMA has become a model for education and artistic enrichment that never stops growing. In two years it will inaugurate a remarkable new architectural expansion, increasing its gallery space. The opening in 2019 of this "new" MoMA will offer an occasion to reaffirm the fundamental values expressed in the title of the current exhibition, "being modern." The museum's cross-disciplinary approach, inaugurated in 1929, has led it to collect not only painting and sculpture but also photography, prints, performance art, drawings, architecture, design, media art, and film. Equally important is MoMA's engagement with the international dimension of art that, now more than ever, characterizes our global world.

"Being modern" is an ambition we all share. It is a rallying cry, a call to see artists play a decisive role in our perpetually changing world, a call for unending progress. It is an ambition to share freedom and passion with the widest possible public through forms of creativity and thought that are resolutely contemporary yet also draw inspiration from the entire twentieth century. With this ambition, we aspire for an art that achieves the transformative experience described by Picasso: "Art washes away from the soul the dust of everyday life."

Preamble

Glenn D. Lowry
Director, The Museum of Modern Art, New York

Being Modern: MoMA in Paris is the first comprehensive exhibition in France of the collection of The Museum of Modern Art. We are delighted to collaborate with the Fondation Louis Vuitton, Paris, to present the extraordinary works of modern and contemporary art the Museum has acquired between its founding, in 1929, and today. This cross-disciplinary selection of more than two hundred objects was conceived for the Fondation's Frank Gehry–designed building and arranged to create a compelling historical narrative across its four floors. *Being Modern* sets aside the traditional objective of the survey exhibition—comprehensive and cohesive coverage—to focus instead on the evolution of the collection over the past almost ninety years. Organized jointly by the two institutions, the display weaves together paintings, sculptures, drawings, prints, photographs, films, media art, performances, architecture, design objects, and archival material to tell a chronological story of the assembling of the Museum's unparalleled holdings. From iconic paintings such as Paul Signac's *Opus 217* (1890), to the curtain wall of the facade of the 1952 United Nations Secretariat Building, to the first iteration of the 176 digital emoji we use on our mobile phones every day (1998–99), the exhibition underscores the diversity and relevance of MoMA's collection while providing a fresh perspective on the modern canon.

In recent decades, MoMA has made a commitment to expand the geographic and ethnic range of the collection, making it clear that modern art is not limited (and has never been limited) to North America and Western Europe. While *Being Modern* is on view in Paris, MoMA is in the midst of a multiyear expansion project, scheduled to be completed in 2019. Fifty thousand square feet of new gallery space will enable us to realize a long-held aspiration: to present significantly more of the collection through a series of fluid, interconnected narratives across multiple mediums and with an expanded global perspective.

It has been a genuine pleasure to work with the Fondation Louis Vuitton on *Being Modern* and to see our multiyear discussions come to fruition in both exhibition and catalogue. The partnership between the Fondation and MoMA has deepened through our institutions' dedication to this colossal endeavor. On behalf of the trustees of MoMA, I extend my deepest gratitude to our colleagues in Paris:

Bernard Arnault, President; Jean-Paul Claverie, Advisor to the President, Administrator; Suzanne Pagé, Artistic Director; and Sophie Durrleman, Executive Director. I am indebted to the curatorial team that spearheaded this project: Quentin Bajac, The Joel and Anne Ehrenkranz Chief Curator of Photography, MoMA; Olivier Michelon, Curator, Fondation Louis Vuitton; Katerina Stathopoulou, Assistant Curator, MoMA; and Michelle Elligott, Chief of Archives, Library, and Research Collections, MoMA. I am grateful to the exhibition architect, Jean-François Bodin, for his visionary approach, and to Lana Hum, Director of Exhibition Design and Production, MoMA, for her instrumental guidance. This catalogue would not have been possible without the invaluable leadership of Christopher Hudson, Publisher, MoMA, and Raphaël Chamak, Head of Publishing, Fondation Louis Vuitton.

Preface

Suzanne Pagé
Artistic Director, Fondation Louis Vuitton, Paris

As early as our opening show, *Keys to a Passion*, in 2015, and in 2016 with *Icons of Modern Art: The Shchukin Collection*, the Fondation Louis Vuitton has been privileged to collaborate with the world's most important museums of modern and contemporary art. Why, now, this special focus on MoMA?

Quite simply because in this show, *Being Modern*, the iconic New York institution synonymous with a certain vision of modernity is presenting a kind of manifesto, laying out the principles behind the new incarnation of the Museum, embodied by the extension designed by Diller Scofidio + Renfro that is planned to open in 2019.

Created in 1929, MoMA has long been a mythical force, not only in the art world but also for the general public, and nowhere more so than in France, where visiting the Museum is part and parcel of the national fascination with New York. For everyone here, MoMA stands almost alone in meeting the challenge of "being modern." And if this museum of modern art is something of a fixation for the French, that is not least because it has, from the outset, been rooted in a familiar history of European painting and sculpture, with a notable predilection for the French avant-garde dating to the late nineteenth century, one that yielded in the postwar era to a distinctively American vision.

MoMA is a beacon for modern art in the West, and for decades its narrative of art-historical modernism was uncontested. It has also established itself for its discernment in regards to the art of today, an institution possessed of a clear-eyed vision of its future. Today, the *doxa* and legend are being reassessed.

To endure, myths must be capable of a certain flexibility. In the case of MoMA, that has involved tactics of opening up and adjusting its narrative of modernity and expanding its parameters in terms of geographies, cultures, identities, and technologies. This exhibition of MoMA *by* MoMA sets out to reveal this process of evolution and to explore its contemporary implications.

Unfolding chronologically to chart the history of the MoMA collection, the exhibition and its accompanying catalogue are structured by two principles fundamental to the Museum. The first concerns the multidisciplinary approach that was central to the original conception of the institution, which was a radical innovation at the time. Today, this approach is uppermost in MoMA's

emphasis on the mixing of disciplines—painting, sculpture, photography, cinema, graphic arts, architecture, industrial design—in its strategies of display and exhibition. The second centers on the specific history of the collection as one assembled by this private institution in concert with those who conceived its creation and guided its growth, a remarkable collaboration of donors, collectors, curators, and artists (see the presentations of material from the MoMA Archives).

The result, a reframing of the issues, may sometimes surprise viewers with unexpected juxtapositions, yet these are always enlightening with regard to art and its history, generated as they are by a major institution responding to the evolving demands of "being modern."

Thus, spanning the entire history of the Museum's collection, dating back almost ninety years—from the creation of MoMA in 1929 to its current development, and including the flamboyant growth of the 1950s and '60s, when it affirmed its commitment to the American art of the day—this exhibition is shaped by two aims: to show, in Paris, within a historical continuum, pivotal works from the history of modern art, and to reveal the new face of a MoMA engaged in the complex and important work of challenging orthodoxies and remapping the broad outlines.

Paradoxically, it is true, MoMA's success has often disguised its singularities. Its quasi-hegemonic status shaped the fable of a (possible) universal museum of modern art. Today, those at the helm are conscious of the obsolescence of such an idea.

The famous "canon" represented by that diagram drawn in 1936 by Alfred H. Barr Jr., MoMA's legendary first director, traces from their European precursors two schools, Fauvism and Cubism, and culminates in abstraction (p. 75). This became an almost uncontested point of reference, even though it was at odds with the principles of openness—laid down by Barr himself—to other geographical horizons, identities, and disciplines. These principles are articulated here from a new position, redefined and redeployed.

The exhibition unfolds across all of the Foundation's spaces. It opens with a room evoking the original MoMA, the museum of Barr in the early 1930s, and ends with a selection of the Museum's most recent acquisitions that exemplify the increasing porosity and resonant crossovers between them. The overarching conception of the exhibition and the selection of artworks, which alternate between widely recognized masterpieces and lesser-known yet seminal works, were defined by MoMA director Glenn D. Lowry and curator Quentin Bajac. They received vital input and collaboration from across all six curatorial departments at MoMA, in further evidence of the increasing openness to reciprocal engagement among these divisions, which still retain their autonomy.

The project was carried out in partnership with the Direction artistique at the Fondation, whose input resulted in a progression by successive levels in a dynamic engagement with the architecture of Frank Gehry, further articulating the specific strengths of the spaces he conceived. Witness the use of interstitial areas for works by Sol LeWitt and General Idea, and the distinct zones occupied by Cindy Sherman (Gallery 7), Roman Ondák (Gallery 8), and in a very different way, Janet Cardiff (Gallery 10).

At pool level—*Galleries 1* and *2*—the first room constitutes a kind of statement of the founding principles, reflecting the Museum's strong focus on European painting and sculpture from its beginnings, with works such as *The Bather* by Paul Cézanne, *Bird in Space* by Constantin Brancusi, and *The Studio* by Pablo Picasso, as well as its Bauhaus-inspired commitment to multidisciplinarity, exemplified by its early acquisitions of photography (Walker Evans), cinema (Edwin Middleton and T. Hayes Hunter), and industrial design. Elsewhere, Edward Hopper's now-iconic *House by the Railroad*, the first major painting acquired by the Museum, speaks of MoMA's desire, also from the start, to respond to contemporary American art.

The second sequence features a number of modern masterpieces from the MoMA collection. Here we find modernity in Europe, its roots and manifestations: Post-Impressionism (*Opus 217* by Paul Signac), Futurism (Umberto Boccioni's *States of Mind* triptych), towering figures of the early half of the twentieth century (*Boy Leading a Horse* by Picasso; *Goldfish and Palette* by Henri Matisse), plus Dada (Marcel Duchamp's *Bicycle Wheel*; Francis Picabia's *M'Amenez-y*), Surrealism (*Gare Montparnasse* [*The Melancholy of Departure*] by Giorgio de Chirico; *The Persistence of Memory* by Salvador Dalí; *The False Mirror* by René Magritte), and abstraction (Piet Mondrian's *Composition in White, Black, and Red*; Kazimir Malevich's *Suprematist Composition: White on White*). Central Europe also has its place here, with the iconic *Hope, II* by Gustav Klimt, as does photography (Eugène Atget).

The crises and conflicts of the 1930s are evoked via *Departure* by Max Beckmann, which constitutes a powerful symbol. Here, the cinema of Sergei Eisenstein, photographs of Lisette Model and of Alfred Stieglitz, and Soviet-era graphic design of Gustav Klutsis appear perfectly relaxed about the proximity of Walt Disney's Mickey Mouse.

The shifting emphasis from modes of European expression to the United States that followed in the wake of World War II and continued into the 1960s is evidenced next in the room dedicated to American Abstract Expressionists, featuring major paintings by Jackson Pollock (*Echo: Number 25, 1951* and *The She-Wolf*), Mark Rothko (*No. 10*), and groundbreaking works by Willem de Kooning (*Woman, I*) and Barnett Newman (*Onement III*).

On the ground level, *Gallery 4* is introduced by Sol LeWitt's *Wall Drawing #260* of 1975. The gallery presents in diptych form the new aesthetics that emerged in the 1960s, Minimal and Pop art, both characterized by series and repetition. On one side of the gallery appear important examples of Minimalism: Ellsworth Kelly's *Colors for a Large Wall*, Frank Stella's *The Marriage of Reason and Squalor, II*, and Carl Andre's *144 Lead Square*, presented in relation to the architecture of Mies van der Rohe. On the other side of the gallery, we see the advent of Pop epitomized in Jasper Johns's *Map*, Roy Lichtenstein's *Drowning Girl*, and two works by Andy Warhol—*Double Elvis* and *Campbell's Soup Cans*—in addition to samples from his filmic series *Screen Tests*. These works revisit and transpose popular culture; the same applies to *Patchwork Quilt* by Romare Bearden. This sequence also

explores photography, with work by Diane Arbus (*Identical Twins, Roselle, New Jersey*). In those years the collection was boldly extended to include anonymous prints, just as it was opening to objects like the legendary *Fender Stratocaster Electric Guitar*.

On the first level, *Galleries 5* and *6* are introduced by General Idea's *AIDS (Wallpaper)*, which opens onto the new forms of expression that developed starting in the 1960s surrounding questions of the body and identity, echoing the social revolutions occurring outside the museum, reflected here in Gilbert Baker's *Rainbow Flag*. Work in the classic medium of painting, such as that of Philip Guston or Christopher Wool, is now pollinated by action and performance art as exemplified by the work of Edward Krasiński, while Joseph Beuys, Felix Gonzalez-Torres, and Cady Noland further extend the traditional boundaries of sculpture into installation. Bruce Nauman's use of neon and Jeff Wall's use of the light box both offer powerful reformulations.

Anticipating the most radical propositions in video, dance (Yvonne Rainer) and performance (Laurie Anderson) now find their "place" in the space of the museum, each reflective of a certain dematerialization of art and media culture.

At the same time, collages and manipulations partake of a new treatment of the image, as can be seen here in the work of Barbara Kruger. Significantly affirmed is an engagement with the explicitly political, in Kruger's works and those of David Hammons, Juan Downey, and Lynn Hershman Leeson. Despite its relatively small format, Gerhard Richter's *September* powerfully evokes a new consciousness of the reality of our archipelago-world.

Very much out on its own, *Gallery 7* sees Cindy Sherman organize in her own space a multitude of identities, defined through Hollywood stereotypes of women, themselves conveyed by the media, whose grip these works affirm (see the *Film Stills* series).

On the second level, in *Gallery 8*, *Measuring the Universe* by Roman Ondák inscribes the personalized trace of individual visitors on the walls of the museum itself, thus marking as well art's new relationship to its public.

Galleries 9 and *11* reflect a decisive new broadening of cultural engagement at the Museum, an expanded horizon that takes into account both globalization and revolutions in technology. Forms of expression emerging from geographical areas hitherto sparsely represented in the collection now find their place, as in the work of Egyptian artist Iman Issa and Turkish artist Aslı Çavuşoğlu.

Alongside painting and drawing, which take on board new realities (Mark Bradford, Rirkrit Tiravanija), sculpture (Trisha Donnelly, Cameron Rowland) and photography (LaToya Ruby Frazier) both reflect problematics arising from a new complex of formal and identity issues. Now the street bursts into the museum with all its immediacy, its everyday realities, and its battles—*The Newsstand* by Lele Saveri.

DIAGRAM I

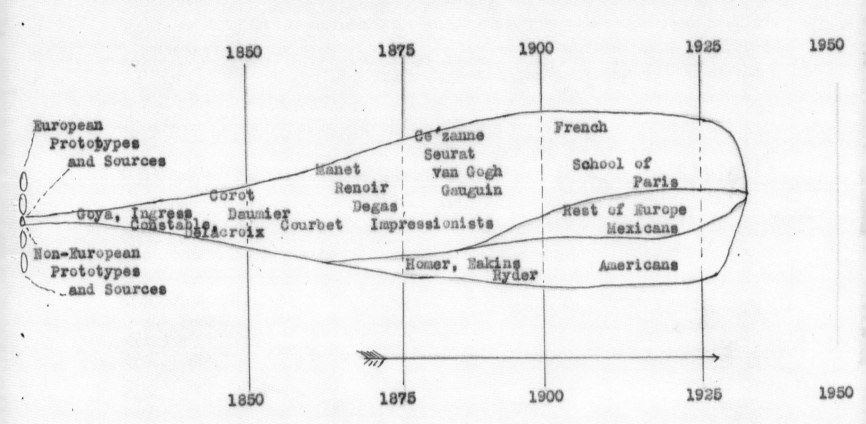

"TORPEDO" DIAGRAM OF IDEAL PERMANENT COLLECTION

Overarching all this are architect Rem Koolhaas's prescient visions of a New York City in architectural overdrive; produced in the analog era, these renderings nevertheless seem to presage the digital age.

Computers and the internet now come to the fore, having definitively gained access to the Museum, beginning with the revolutionary video game designs of Tomohiro Nishikado and Dave Theurer, and proceeding through to the original set of *Emoji* by Shigetaka Kurita and such now-ubiquitous digital icons as Jens Eilstrup Rasmussen's *Google Maps Pin*, the *Power Symbol*, and Ray Tomlinson's repurposing of the @ sign.

In *Gallery 11*, the immersive digital video installation by Ian Cheng endlessly self-invents by recycling its own data in a computer program that self-generates live.

Quite separate, in the distinctive space of *Gallery 10*, Janet Cardiff's *The Forty-Part Motet* transports the visitor to the space-time specific to art.

The exhibition offers a fascinating adventure that puts the viewer "on the spot," experiencing the fulfillment of the pioneering institution's original mission. *Being Modern* punctures the teleological fable to rediscover the laboratory spirit that has long been an animating force at MoMA.

Today, thanks to lucid corrections of the past and the intrepid explorations of new territories in a limitless world, a new youthfulness is manifest, embracing the risk of uncertainty, of misunderstandings and occasional imbalances. A tremendous energy emerges from the integration of new identities into the canon: women, African Americans, Latin Americans, artists from Eastern Europe, and new critical, social, economic, and political issues. Coming from the USA, such a strategy is particularly significant.

For MoMA, "being modern" means being aware that the "canon" developed at the Museum's creation was not closed but rather contained the parameters of a dynamic and paths leading to *other elsewheres*, like guarantors of a future and first germinations of a rhizomatic thinking for the present, inseparable from the world of networks. The risk of calling into question a canonic image then becomes, for the Museum, a clear protocol to consolidate it; MoMA is aware that its responsibility for making accessible an exceptional collection obliges it to act as a beacon. The new challenge, driven by artists and already instituted by a few museums close to them (Tate Modern, notably), now compels MoMA to accept and adopt the provisional and the unstable as an imperative dynamic for being modern.

The mission of the Fondation, grounded in the history of modern art while serving to reflect the creative expressions of the contemporary moment, makes the dialogue with this new MoMA particularly stimulating. The metaphorical dynamic of the "torpedo" envisioned by Barr for MoMA's early collection (p. 15) echoes the élan of the schooner, sails blown by the wind, conceived by the architect Frank Gehry.

•••

Being Modern: MoMA in Paris is a very new kind of project. Upon its inception, MoMA director Glenn D. Lowry immediately expressed his determination not to simply present the Museum's masterpieces but instead to exhibit the institution's history and, above all, to explore its new challenges. Quentin Bajac, The Joel and Anne Ehrenkranz Chief Curator of Photography at the Museum, worked with him and organized both the exhibition and the catalogue, assisted by Katerina Stathopoulou and, from the Museum Archives, Michelle Elligott. The contributions of the department heads at MoMA and their staffs were invaluable: Ramona Bronkar Bannayan (Exhibitions and Collections), Christophe Cherix (Drawings and Prints), Stuart Comer (Media and Performance Art), Kate Lewis (Conservation), Rajendra Roy (Film), Martino Stierli (Architecture and Design), and Ann Temkin (Painting and Sculpture). Lana Hum contributed her expertise in matters of exhibition design. We are deeply grateful to them all.

At the Fondation Louis Vuitton, curator Olivier Michelon has been an essential actor at my side in the realization of this project, in liaison with exhibition architect Jean-François Bodin. Many at the Fondation have contributed to the success of the exhibition, foremost among them Sophie Durrleman, executive director, as well as Elodie Berthelot for production, Raphaël Chamak for the publication, and Joachim Monegier du Sorbier for visitor programs. Our warmest thanks go to each one. –S.P.

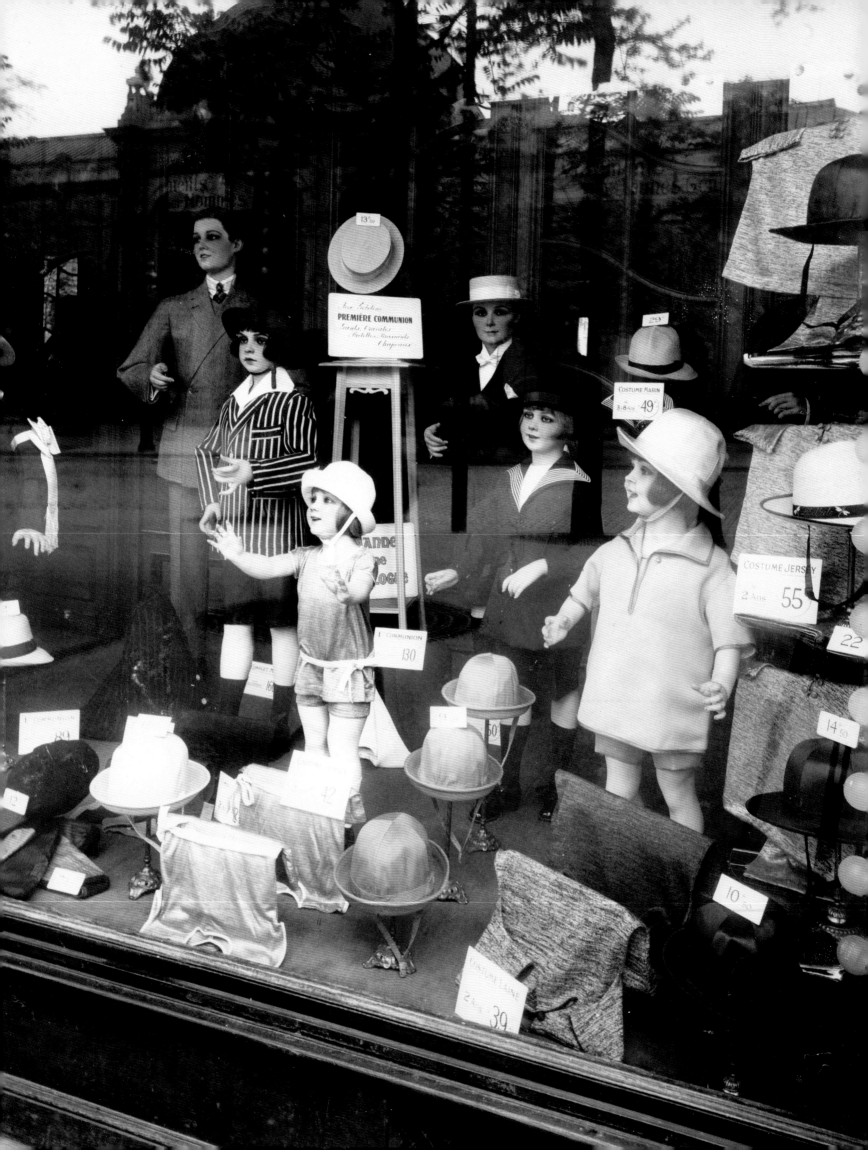

Building the Collection of The Museum of Modern Art

Quentin Bajac

In 2008, The Museum of Modern Art invited Brazilian artist Vik Muniz to curate a show of works in its collection as part of its long-standing Artist's Choice exhibition series. Muniz opted to organize his show around the visual motif of the rebus, choosing eighty works from throughout the Museum's areas of specialty—from painting to design, from drawing to sculpture, from moving image to photography—and installing them according to a chain of free associations, here visual (a similar color or shape), here intellectual (like topics or other affinities), and always playful and surprising.[1] The show transgressed traditional notions of style, school, chronology, and—an idea previously at MoMA's core as an institution—departmental logic: Joseph Beuys's felt suit of 1970 (p. 181) adjoined Eugène Atget's *Avenue des Gobelins* (p. 139), a photograph from 1925 of men's suits in a shop window, which in turn was followed by Roy Lichtenstein's painting *Mirror #10* (1970), a tondo evoking a reflection in a mirror, and so on. In the manner of Dada collage, the proposal exploded the seriousness of the principle of historical linearity traditionally and widely followed in collection exhibitions, highlighting the diversity of the MoMA collection more than any exhibition prior.

And how could it be otherwise? Born almost ninety years ago, enlarged over the decades by several curatorial generations with different profiles and sensibilities, and in good part informed by the input of the collectors outside the Museum who have made so many important and decisive gifts, MoMA's collection is polyphonic. It goes well beyond the somewhat reductive view of it still sometimes suggested, often on the basis of a quick assessment of the painting and sculpture collection alone: that of a group of masterpieces of Western modernism, European in its first period, then American. The collection is certainly that, but that *as well*, one might say, because it is certainly—equally—far more than that. Multidisciplinary and international almost from the beginning, diverse and in constant evolution through both accession and deacquisition, it has not flowed smooth but, on the contrary, has been since the 1930s a hotbed of debate—on its goals, its purpose, its limits (chronological, geographical), its areas of focus, and, finally, on the very nature of the works it should be considering.

1. *Artist's Choice: Vik Muniz, Rebus*, organized by Muniz with MoMA curator Eva Respini, was on view at the Museum from December 11, 2008, to February 23, 2009. Installation views, the press release, and the checklist are available online at www.moma.org/calendar/exhibitions/304.

When does the story of modern art begin? This was a crucial question for the Museum during its first twenty-five years. Should the story it told start at the beginning of the nineteenth century, with the Industrial Revolution? In the 1850s and '60s, with the birth of Impressionism? In the 1880s, with the Post-Impressionists and the emergence of the idea of the avant-garde? Or in the early twentieth century, with Cubism seen as a decisive rupture? The final decision to begin with the 1880s, at least as far as painting and sculpture were concerned, was the consequence as much of practical considerations as of intellectual ones: when MoMA opened its doors, in 1929, New York's Metropolitan Museum of Art, an encyclopedic museum founded in 1870, had already begun to collect the art of the nineteenth century, including Impressionism, and major works were already rare on the market.[2] On the other hand, as Alfred H. Barr Jr., the Museum's founding director, pointed out, the two following generations, that of Paul Gauguin, Georges-Pierre Seurat, Vincent van Gogh, and, of course, Henri Matisse and Pablo Picasso, were not represented at the Met.[3]

Meanwhile, in 1929, the date "1880" defined a period of fifty years of the modern spirit. This was the period that MoMA set out to present. Seeking to complement New York's other institutions, and particularly the Met, Barr developed the model of the torpedo (p. 15): the institution would always be in motion, always moving forward, its tip being the present moment, its body covering the art of fifty years back from that moment, and its wake constituted of older works, which it would deaccession. The idea that MoMA would regularly and systematically divest itself of works in its collection as they achieved the age of fifty was actually concretized in an agreement of 1947 with the Met, which was to be the recipient of these works, only to be rescinded by MoMA's board of trustees in 1953.[4] Although some twenty paintings and sculptures, including some by Paul Cézanne, were in fact deaccessioned, most of the Post-Impressionist works were kept and still greet visitors today on the Museum's fifth floor. It is these works that establish one end of the collection's chronological spectrum. It should be added, however, that the starting point of 1880, dictated by choices relating to the history of painting and imposed on the other aesthetic disciplines, did have exceptions, notably in the Department of Photography, which from its beginnings in the 1940s saw photography as a young art and felt that its entire history, beginning with its origins in the 1820s and '30s, should be included in the collection.[5]

Barr's years of study at Harvard with the medievalist Paul Sachs, and a visit he had made to the Bauhaus in Germany in 1927, had sensitized him to the value of a multidisciplinary approach, and he made MoMA open to many different artistic practices. Today we have trouble fully appreciating how radically innovative this aspect of the project was at the time. Almost all of the disciplines that the Museum still collects—architecture and design, prints and artists' books, painting and sculpture, film, drawing, and photography—began to enter the collection in MoMA's first decade. The Museum's administrative organization by curatorial department has changed little since then,

2. See William Rubin, in *The Museum of Modern Art, New York: The History and the Collection*, with an introduction by Sam Hunter (New York: Harry N. Abrams in association with The Museum of Modern Art, 1984), 44.

3. See Alfred H. Barr Jr., "A New Museum," *Vogue*, October 1929; reprinted in Irving Sandler and Amy Newman, eds., *Defining Modern Art: Selected Writings of Alfred H. Barr, Jr.* (New York: Harry N. Abrams, 1986), 73–76.

4. See Kirk Varnedoe, "The Evolving Torpedo: Changing Ideas of the Collection of Painting and Sculpture of The Museum of Modern Art," in *The Museum of Modern Art at Mid-Century: Continuity and Change*, Studies in Modern Art no. 5 (New York: The Museum of Modern Art, 1995), 12–73.

5. See Quentin Bajac, "'Background Material': Historical Photography at MoMA," in *Photography at MoMA 1840–1920* (New York: The Museum of Modern Art, 2017), 10–17.

and most often under the influence of art itself. In the late 1960s, for example, when drawing and printmaking were becoming central to the avant-gardes of the time, these disciplines, until then the precinct of the Department of Painting and Sculpture, were empowered to become a department of their own.[6] Similarly, in 2006, the Museum a little belatedly generated the Department of Media, amplified into the Department of Media and Performance Art in 2009, to address time-based works, recognizing the need for a more focused attention to art forms that until then had been collected somewhat incompletely by the Department of Film and the Department of Painting and Sculpture, which had acquired both video and multimedia installations as they saw the need.

6. On the Museum's administrative organization, see Glenn Lowry's essay in this volume, as well as the chronology by Michelle Elligott.
7. See John Elderfield, in *The Museum of Modern Art, New York: The History and the Collection*, 262.
8. See Mary Lea Bandy and Eileen Bowser, in ibid., 530.
9. See Arthur Drexler, in ibid., 385–88.

Although the administrative framework in which artworks are collected at MoMA has been relatively stable, the objects themselves are diverse and their definitions are in constant transformation, reflecting the evolution of practices and technologies, albeit sometimes with a little delay. The definition of drawing, for example, was limited to black-and-white works until the 1950s, when the Museum gradually began to call other practices by this name, from color to collage. The acquisition of prints was extended to multiples at the same time.[7] The Department of Architecture, long limiting itself to collecting drawings, plans, and models, soon turned energetically to photography and moving images. Similarly, the Department of Photography only really began to take into account forms of nonartistic photography, and in particular amateur photography, in the 1960s.

From this perspective, it is interesting to note that while MoMA is often seen as the stronghold of an elitist vision of modern art, it acknowledged popular culture early on. In the 1930s, for example, Iris Barry, the first curator of the Film Library, acquired works by both Sergei Eisenstein (p. 85) and Walt Disney (p. 73), treating exemplars of the *auteur* film and the mass-entertainment film with the same seriousness, and dissolving boundaries by showing Eisenstein at the Museum to the general public while screening Disney in an academic setting, at Columbia University.[8] No less barrier breaking was the Museum's early commitment to industrial design: starting with the *Machine Art* exhibition of 1934 (pp. 60–63), the industrial product was favored over the precious object, function over aesthetics, and a cultural, even anthropological approach over an artistic one.[9] Within this framework, the Department of Architecture and Design has constantly pushed the limits of the collection by questioning, probably more than any other department, the definition of the museum-ready object, acquiring in recent years popular forms such as video games (p. 231) and various kinds of universal symbols (pp. 233, 267).

While working within an overall general schema, each department developed its own culture, its own logics of acquisition. This evolution was reinforced in the mid-1960s by the replacement of a Museum-wide acquisition committee with departmental acquisition committees. Departing from the idea of a collection made up as far as possible by masterpieces, the departments of Architecture and to a lesser extent Photography built their collections in part around the acquisition of archives—in architecture, that of Ludwig Mies van der Rohe, in 1969 (p. 133), and more

recently that of Frank Lloyd Wright; and in photography that of Atget, in 1968 (pp. 136–139). The debate between the desire for a collection of masterpieces and the interest in a more diverse collection for educational purposes was a leitmotif of MoMA's first decades.

From its beginnings, MoMA was reproached for being too international—or specifically, too European—and as such insufficiently supportive of the American domestic scene, and particularly of the abstract art developing in the United States. In 1940, in fact, American abstract painters protested outside the Museum and distributed a manifesto, "How Modern Is The Museum of Modern Art?" While Barr's European tropism is indisputable in painting and sculpture, MoMA's exhibition and acquisition policies were more balanced than they appeared. The American presence was particularly strong in the fields of film, photography, and architecture and design, some of the Museum's goals here, in Barr's mind, being to ensure greater visibility for American art: "Another important factor," he wrote in 1936, "is the tendency on the part of the public to identify art with painting and sculpture—two fields in which America is not yet, I am afraid, quite the equal of France; but in other fields—film, architecture and photography, for instance, the United States would seem to be the equal or superior of any other country."[10] Significantly, these curatorial departments devoted their first monographic exhibitions to Americans: the architect Louis Sullivan and the Chicago school, in 1933; the photographer Walker Evans, in 1938 (p. 83); and the director D. W. Griffith, whose films were the subject of a retrospective in 1940. In 1942, in a sign of the will to maintain this balance, John Hay Whitney, then the Museum's president, was able to write in the preface of the first catalogue of the collection: "It is natural and proper that American artists should be included in greater numbers than those of any other. But it is equally important in a period when Hitler has made a lurid fetish of nationalism that no fewer than 24 nations other than our own should also be represented in the museum collection."[11]

If the accusation of favoring Europe was a feature of the early criticism of MoMA, the Museum would later be attacked—especially in the 1980s, when contemporary art was opening to non-Western art scenes—for being too deeply rooted in the domestic, for being the museum of the triumph of American art. In 2009, in a reflection of a global tendency among large European and American institutions, a cross-departmental research program was created at the Museum to focus on non-Western geographical regions.[12] That initiative has begun to bear fruit: in the last five years all departments have seen a significant increase in acquisitions of works by non-Western artists, particularly those from South America, thanks to the support of the Latin American and Caribbean Fund, founded in 2006 on the initiative of Patricia Phelps de Cisneros and others. Here, it should be noted, the Museum was to some extent reviving a policy from its beginnings: in its first fifteen years, the Department of Painting and Sculpture was an avid collector of Mexican (p. 97) and Latin American art, a policy sanctioned in 1942 by the establishment of the Inter-American Fund to support these acquisitions, and then by the publication of a book to catalogue them the following year.[13]

10. Alfred H. Barr Jr., "Bulletin on What the Museum has done in the Field of American Art," Memorandum to Miss Miller, October 10, 1940; quoted in Sandler and Newman, eds., *Defining Modern Art*, 16.

11. John Hay Whitney, foreword to *Painting and Sculpture in The Museum of Modern Art* (New York: The Museum of Modern Art, 1942).

12. The program, titled Contemporary and Modern Art Perspectives (C-MAP), is divided into three research groups, respectively addressing Asia; Eastern Europe; and South and Central America, Mexico, and the Caribbean basin.

13. Lincoln Kirstein, ed., *The Latin-American Collection of The Museum of Modern Art* (New York: The Museum of Modern Art, 1943).

But this geographical openness is coupled today with a much stronger and more determined acknowledgment than in the past of criteria of gender (the Modern Women's Fund, created with the support of Sarah Peter in 2005, fosters the acquisition of major works by women artists) and of ethnicity, particularly with regard to African American artists.

While the chronological field that the Museum covers must by definition grow steadily larger, the priority in all areas of collecting remains the contemporary. Beyond generations and departments, many of the works presented here—from Piet Mondrian (p. 77) to Jackson Pollock (pp. 101, 141), from Willem de Kooning (p. 115) to Frank Stella (p. 121), from Diane Arbus (p. 131) to Carl Andre (p. 143), and today from Ian Cheng (p. 259) to Cameron Rowland (p. 269)—were acquired within months of their completion, a proof if any were needed of the institution's responsiveness to art in its moment. The support of the Fund for the Twenty-First Century, founded in 2011, has been a major element of this acquisition policy. Where the Museum is always concerned to catch up in areas it considers neglected, its policy in such cases is focused on a few, carefully selected pieces; contemporary acquisitions follow a more open logic. As William Rubin, director of the Department of Painting and Sculpture in the 1970s and '80s, once explained: "The overwhelming majority of [the Museum's] acquisitions are of contemporary work. To this extent, its purchases of contemporary art must be considered somewhat reportorial; it is not expected that every work—indeed that the majority of them—will figure in the collection fifty years hence."[14]

The methods used may differ: the Department of Photography, for example, for years used its study collection as a sort of air lock in which photographs by young photographers could be deposited, leaving the next generation of curators with the task of either bringing them into the collection, or not. This flexibility is an essential dimension of the institution's practice. Refusing the notion of the immutability of the collection, MoMA, like many North American art museums, has operated in part by divesting itself of certain works in order to acquire new ones. When Lillie P. Bliss, one of the Museum's founders, bequeathed to it her extraordinary collection, in 1931, she explicitly stated that it could divest itself of certain pieces to buy others if need be—and indeed, Picasso's *Les Demoiselles d'Avignon* (1907) was acquired in 1939 thanks to the sale of a painting by Edgar Degas from her collection. The departments of Painting and Sculpture, Drawings and Prints, and Photography, when they move to catch up on historic works that they are acquiring late—Andy Warhol's *Campbell's Soup Cans* (1962; p. 189) is one example—can often only proceed thanks to deaccessioning. Tightly controlled and yet regular, the practice is sometimes subject to debate: in 1999, as his contribution to the MoMA exhibition *The Museum as Muse: Artists Reflect*, the Conceptual artist Michael Asher published a catalogue of the paintings and sculptures that the Museum had deaccessioned since its founding, an indirect questioning of the way in which the institution has shaped the writing of art history as well as of its relations with the market.[15] But deaccessioning goes beyond a simple sale. Exchanges with artists and other institutions are also practiced: in the 1960s, the Department of Prints conducted major exchanges with the

14. Rubin, in *The Museum of Modern Art, New York: The History and the Collection*, 43.
15. Michael Asher, *Painting and Sculpture from The Museum of Modern Art: Catalog of Deaccessions 1929 through 1998* (New York: Michael Asher and The Museum of Modern Art, 1999).

Bibliothèque Nationale in Paris, the Hermitage in what was then Leningrad, and the Tate Gallery in London to enrich its collections of European artists, and in the 1990s the Department of Film made similar exchanges with China's national film archives.[16]

The Museum's acquisition practices, while attentive primarily to the art of the moment, have had their failures: Warhol's work was little collected before the 1990s, for example, with the notable exception of *Gold Marilyn Monroe* of 1962, a major work purchased and donated by Philip Johnson in the year it was made. (A contributor to the Museum not only as a trustee but also as an architect and a curator, Johnson donated many works, particularly in the area of Pop art. He often purchased radical pieces from which the institution's own acquisition committees had backed away, then gave them to the Museum as gifts.)[17] Every curatorial department is aware of gaps and missed opportunities in its history of collecting, sometimes repaired by gifts from private collectors. From Bliss (p. 50) to James Thrall Soby, a champion of Surrealism (p. 146), from Abby Aldrich Rockefeller, another of the Museum's founders (p. 58), to her son David Rockefeller (p. 174), the Museum's trustees have been essential and vital figures in the constitution of the collection. That support has gone beyond the trustee circle; it was Olga Guggenheim, for example, who fostered the Museum's acquisition of some exceptional textiles, notably by European moderns from Marc Chagall to Matisse and Picasso, between 1935 and 1973.[18] The gift of part of Katherine Dreier's collection in 1952 added to the collection a number of important Dadaist works (pp. 110–113), a current that until then MoMA had somewhat neglected. And the Werner and Elaine Dannheisser collection, given in 1996, partly rectified the absence from the Museum's galleries of works by certain major artists of the 1980s and '90s, including Jeff Koons and Felix Gonzalez-Torres (p. 187). More recently, the acquisitions and gifts from the collections of Gilbert and Lila Silverman and Herman and Nicole Daled (pp. 210–213, 222–223) have spectacularly strengthened the presence of Fluxus and Conceptual art at the Museum almost four decades after the fact.

This rapid, far from exhaustive overview of ninety years of collecting can only outline a more complex and more diverse panorama than the mythology of MoMA would suggest. As is often the case, the factual history is revealed to be richer than the fiction. The reality is that of a collection always in flux; a collection that, although it has moved away from Barr's model of the torpedo, has nevertheless preserved its essential aerodynamic principle; a collection as subject to change as modern art itself. All preconceptions of Barr and of the Museum to the contrary, this was something he understood well. In 1934, after all, as if to disarm his critics, he wrote, "Modern art cannot be defined with any degree of finality either in time or in character, and any attempt to do so implies a blind faith, insufficient knowledge, or an academic lack of realism."[19]

16. See Riva Castleman, in *The Museum of Modern Art, New York: The History and the Collection*, 328; and Bandy and Bowser, in ibid., 530.
17. See Rubin, in ibid., 44.
18. See Ann Temkin, *Painting and Sculpture at The Museum of Modern Art* (New York: The Museum of Modern Art, 2015), 15.
19. Alfred H. Barr Jr., "Modern and 'Modern,'" *The Bulletin of the Museum of Modern Art*, May 1934; quoted in Sandler and Newman, eds., *Defining Modern Art*, 83.

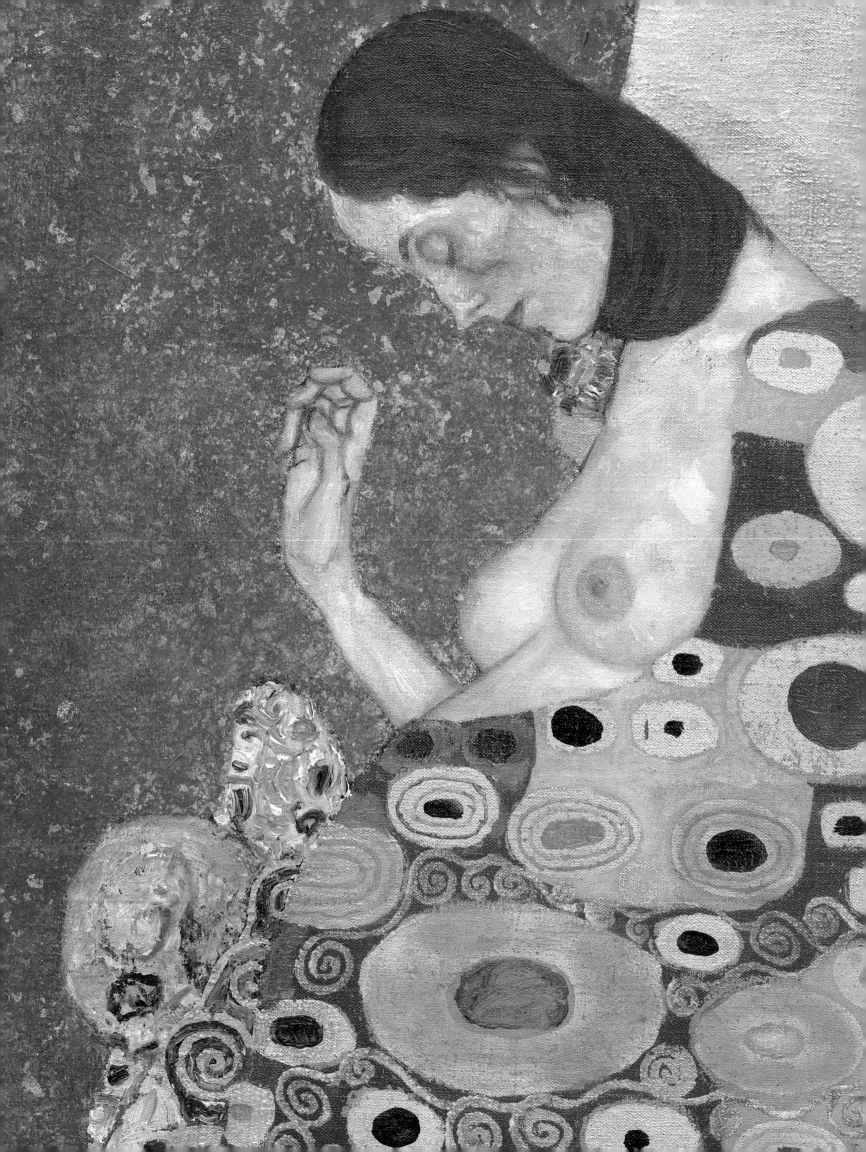

Being Modern: A Brief Meditation

Glenn D. Lowry

Almost every art museum is associated with at least one myth. In the case of The Museum of Modern Art, the most prevalent one is that it is the high temple of modernism, its collection of painting and sculpture the "sacred tablets" of a modernist faith built around European and North American avant-garde movements of the first half of the twentieth century. In this myth, the Museum operates with the certainty of the church, its opinions definitive. The reality, of course, is very different and more interesting. While there is little doubt that the Museum's collection of modern and contemporary art is among the finest, if not the finest, in the world, it did not become so easily or overnight, as even a cursory reading of Russell Lynes's rollicking tale of the Museum's early years, *Good Old Modern* (1973), makes clear.

From the outset there were many false starts, rash appointments and equally rash dismissals, internecine battles, chaotic decisions, and heated private and public debates over what the Museum should collect and how. The Museum of Modern Art was conceived in 1929 and born later that year, just after the great stock market crash; the turbulence of the period is woven into its DNA, and from the beginning, it has been in an almost perpetual state of change, at times explosive and disruptive, at others more measured. One of the reasons for this is that the Museum lives with two irreconcilable tensions. The first is that its aspiration to always be modern—that is, of the present—is at odds with the fact that this condition is never fully attainable because the present is always slipping into the past. The second is that the Museum's desire to present a coherent reading of modern and contemporary art conflicts with the fact that this is physically impossible to do given the breadth and complexity of the artistic practices this involves.

A brief survey of the Museum's history gives a sense of how rapidly and frequently the institution has evolved. From its founding until the completion of its first purpose-built home a decade later, in 1939, it went from being a tentative experiment, uncertain if it had an audience or a future, to boldly declaring on its roof that it was *The* Museum of Modern Art, a powerful statement about its presence in the rapidly developing center of New York. It was during this time that the Museum's exhibition and collecting programs were established. Seminal exhibitions such as *Machine Art* and

Cubism and Abstract Art defined the Museum as a progressive institution with a broad range of interests, from industrial arts to painting and sculpture. Exhibitions devoted to Charles Burchfield, Henri Matisse, and Diego Rivera, among others, established the Museum's commitment to living artists and to the monograph as a primary means of presenting the work of individual artists, while shows like *Prehistoric Rock Pictures in Europe and Africa*, *Persian Fresco Painting*, *American Folk Art: The Art of the Common Man in America, 1750–1900*, and *African Negro Art* demonstrated its interest in exploring the roots of modernism as well as traditions beyond the Western canon. The creation of the Departments of Painting and Sculpture (1929, though not formally named as such until the 1940s), Architecture (1932, with Industrial Art added three years later) and the Film Library (1935) reflected the young institution's debt to the notion of the interdisciplinarity of artistic practices developed at the Bauhaus, which Alfred H. Barr Jr., the Museum's founding director, had visited in 1927.

In the late 1930s, '40s, and '50s, the Museum became a laboratory open to the public, to paraphrase Barr. During this period it mounted a wide range of exhibitions, including highly experimental ones like *Useful Objects of American Design Under Ten Dollars*, *Are Clothes Modern?*, *Modern Interiors*, and *Original Costume Design*. Several of these were presented in the Young People's Gallery, an educational space, and reflected the Museum's desire to enable a public of all ages to share in its aesthetic values. Dramatic lighting and innovative display techniques, often accompanied by plants, curtains, and other props, turned these exhibitions into almost-theatrical events. The Museum continued to examine the origins of modern art, with installations of Native American, Oceanic, Pre-Columbian, and "outsider" art. And with exhibitions like *Matisse: His Art and His Public* and *Picasso: Forty Years of His Art*, it continued its commitment to monographic exhibitions and confirmed its ongoing support of artists who had been at the forefront of the modernist revolution. More departments were also created during this time: Photography (1940), Industrial Design (1940), and Dance and Theater Design (1944). Drawings and Prints was formed under the aegis of Museum Collections in 1960 (it would become an independent department in 1966).

By the late 1960s and '70s, many of the Museum's innovative approaches had given way to more standardized and less dramatic installation strategies, particularly in regard to the collection, as the Museum sought to codify its earlier experiments with clearly defined parameters of interest focused on independent departments anchored by painting and sculpture. The bold lighting and plants of the 1940s and '50s disappeared in favor of simplified overall lighting and what has come to be called a white-box approach. It was during this time that the intellectual structure and narrative that has come to be associated with the Museum—the myth of the Museum—was introduced, despite the fact that the Museum has challenged this structure almost from the moment it was proposed.

Throughout the Museum's history, departments were abandoned, like Dance and Theater Design (1948); consolidated into one department, like Architecture and Design (1949); or divided into multiple departments, as when Prints and Illustrated Books split off from Drawings (1969). The process of reconfiguration continues to this day with the formation of new departments,

such as Media and Performance Art (2009), and the reintegration of previously separate departments, such as Drawings and Prints (2013). These changes often follow new curatorial directions and interests, reflecting the fact that despite attempts in the 1970s and '80s to establish a definitive organizational structure and narrative for the Museum, it has proven impossible, if not undesirable, to do so.

Another indication of the degree to which the Museum remains a work in progress is that its architectural needs continue to change. After occupying rented office space on Fifth Avenue (1929), a town house at 11 West 53rd Street leased from the Rockefeller family (1932), and temporary quarters on the concourse level of Rockefeller Center (1937), the Museum oversaw the construction of its first purpose-built home, designed by Philip L. Goodwin and Edward Durell Stone (1939), additions by Philip Johnson (1951 and 1964), the redesign of The Abby Aldrich Rockefeller Sculpture Garden, also by Johnson (1953), an expansion by Cesar Pelli (1984), and a major renovation and an expansion by Yoshio Taniguchi (2004). It is now in the midst of a renovation and an expansion by Diller Scofidio + Renfro (to be completed in 2019). Each of these projects has provided the Museum with either more, or different, space, enabling it to respond to the demands of a growing collection, the changing nature of contemporary art, and the needs of an expanding public.

There are several ways to consider the frequency of these expansions. Seen through the lens of social history, they demonstrate the wealth and commitment of the Museum's trustees and patrons and their access to the capital required to build almost continuously while collecting at levels few other museums have been able to sustain. Seen through the prism of cultural history, they reflect evolving intellectual and curatorial practices and needs that often demand different kinds of spatial relationships. Considered in terms of demographics, the Museum's growth responds to the need to accommodate the ever-larger and increasingly diverse audiences for modern and contemporary art. In 1995, for example, 1.3 million people visited the Museum; by 2015 that number had grown to 3.2 million. During those twenty years, student attendance grew by 63 percent and attendance by children under sixteen by 775 percent. In recent surveys, a third of the Museum's first-time visitors have identified themselves as non-white. And finally—and perhaps most interestingly, from the perspective of artistic practice—these expansions affirm the Museum's commitment to the art of the present. While the Museum's collection spans more than 150 years, it thinks in the present. What I mean by this is that it looks at the past through the eyes of the present in an effort to avoid historicizing the works of art it displays and in order to position them in a dialogue with contemporary artistic practices. As those practices change, they require either differently scaled or designed spaces in which to be experienced. This is what led, for instance, to the construction of a film theater in the Goodwin-Stone parti, and additional ones in the Pelli and Taniguchi buildings; the creation of galleries dedicated to contemporary art as part of the 2004 project; and plans for a studio for performance art in the current expansion. These numerous changes to the Museum since its founding, and others, too, support different, even competing ways of understanding the institution. But taken

together they underscore the fact that the Museum remains very much an unfinished project, with neither a fixed campus nor fixed parameters of interest.

Perhaps the most important driver in the growth of the Museum's campus is the continued growth of its holdings, which now comprise more than 195,000 objects, with 43,000 added since 2010 alone.[1] The regular addition of major works of art in all mediums, often among the most significant of an artist's career, combined with the Museum's steadily increasing dedication, especially in the last couple of decades, to presenting a more global perspective and to expanding its representation of work by women, African Americans, and other historically under-recognized groups, has only made the questions of what to show and how to do so more complicated. While the Museum will have doubled its gallery space over a span of thirty years when the 2019 renovation is complete, from 80,000 square feet to 165,000, its collection has grown even faster. The gifts of art from the collection of Edward R. Broida (2005), The Judith Rothschild Foundation Contemporary Drawings Collection (2005), The Gilbert and Lila Silverman Fluxus Collection (2013), and the Colección Patricia Phelps de Cisneros Collection (2016) have alone added over 3,500 vitally important works.

There is, however, a fundamental paradox embedded in the Museum's constant efforts to accommodate its rapidly growing audiences and collections: it is committed to being a midtown Manhattan museum, firmly engaged with and rooted in its neighborhood, yet it can never satisfy its need for space in its current location as there is simply not enough of it available. The recognition of this led the Museum in the early 1990s to explore the possibility of creating a second building elsewhere in Manhattan where it could gain far more space than is available in midtown, but the trustees could not agree on whether this was a good idea, and the issue became moot when the Dorset Hotel, adjacent to the Museum on 54th Street, became available and was acquired for the expansion designed by Taniguchi. But even while the Museum undertook this project in the mid-1990s, it understood it would ultimately need more space than midtown could provide. The desire to extend and expand its commitment to contemporary art was one of the motivations behind the merger of MoMA and P.S. 1 Contemporary Art Center in Long Island City, a ten-minute subway ride away.

Almost from the time of the Museum's founding, the trustees recognized the inherent problem caused by the need to remain engaged with the present—to be modern—while developing an ever-larger collection with roots in the second half of the nineteenth century. This is the conundrum Gertrude Stein pointed out to Barr in 1939 when he called on her for tea in Paris: she told him that a museum could be either modern or a museum, but not both at the same time.[2] In an effort to explain to the trustees how the Museum could deal with this issue, Barr envisioned the Museum's collection as a torpedo moving through time, with the nose the ever-advancing future, and the tail the ever-receding past (p. 15). The torpedo's forward progress was propelled by successive avant-garde movements, its tail receding as the past was no longer needed to explain the present. Barr's

1. This includes 25,000 works in the Frank Lloyd Wright Foundation Archives, which the Museum jointly owns with the Avery Architectural & Fine Arts Library at Columbia University.

2. See the Margaret Scolari Barr Papers, III.F, MoMA Archives, NY, for a record of this conversation. I am grateful to Michelle Elligott, Chief of Archives at the Museum, for tracking down this reference.

use of a military analogy to describe artistic development may have been prompted by the aftereffects of World War I and the impending Second World War, but it was also apt. The tension between maintaining a commitment to the past while engaging with the present, not to mention the future, always carries with it the possibility of exploding, and it was bound to create a series of intellectual and organizational ruptures for the Museum, which it did, and continues to do. After exploring several options, the trustees determined that the appropriate span for the Museum's collecting was approximately fifty years, or two generations. This led to a decision in 1947 to transfer the Museum's older masterpieces to The Metropolitan Museum of Art in return for funds for collecting contemporary art. Twenty-six works were sold to the Metropolitan before the arrangement was terminated in 1953. It was, in principle, a reasonable idea, had both institutions been able to act in a coordinated way. But this was either never fully explored or, more likely, institutionally impossible, and thus the agreement failed.[3]

However, the problem of how to meaningfully display modern art in the limited space of the galleries while continuing to collect did not go away. In the 1970s and '80s, the Museum tried to solve this problem by severely editing what was on display in the galleries devoted to the collection. This led, inevitably, to a presentation, especially of the Museum's painting and sculpture holdings, that did not reflect the breadth and complexity of its collection, and that gave the impression that the Museum's interests were limited to a fixed canon of major European and North American artists, adding to, if not creating, the myth of the Museum's collection as the definitive account of modern art. The decision to maintain clearly defined galleries for each of the curatorial departments, continued until recently, also provided support for this myth. Because the largest and most extensive galleries were dedicated to Painting and Sculpture, it was possible to believe that the holdings in that department presented a reasonable overview of modern art through the 1970s. But this, of course, was deceptive, since painting and sculpture were by no means the only, and often not even the primary, mediums for many leading artists since at least the 1960s. Moreover, the Museum's collection, even of painting and sculpture, included from its inception in the early 1930s major works of art from other parts of the world, especially Latin America, whose absence in the galleries failed to convey the Museum's full range of interests.

One of the other consequences of maintaining departmentally specific galleries was that it compartmentalized the Museum's audience, with those interested in a specific medium able to avoid having to encounter works in other mediums by simply going directly to the gallery of their choice. While this may have had a certain convenience for partisans of a given medium, it promulgated a balkanized view of the Museum. In the early 1990s the Museum's curators began exploring ways to move beyond this compartmentalization, building on an idea first articulated by René d'Harnoncourt, director of the Museum from 1949 to 1967, of "fixed" galleries of painting and sculpture surrounded by galleries devoted to other mediums or organized thematically. In d'Harnoncourt's model the "fixed"

3. For a detailed discussion of this ill-fated relationship and the issues surrounding the Museum's collecting strategies of the time, see Kirk Varnedoe, "The Evolving Torpedo: Changing Ideas of the Collection of Painting and Sculpture of The Museum of Modern Art," in *The Museum of Modern Art at Mid-Century: Continuity and Change* (New York: The Museum of Modern Art, 1995), 13–73.

galleries would tell the core story of the Museum while the "variable" galleries would inflect and enrich this story. D'Harnoncourt's model can be seen, in part, as a response to Barr's (mythologized and misread) diagram of 1936 (p. 75) that maps the development of abstract art from its early influences, including Japanese prints, Near Eastern art, and African sculpture, through Cubism and ultimately on to geometric and non-geometric abstraction. Whereas Barr proposed a progression—albeit a complicated one, full of intersecting and parallel relationships, highlighting key styles and influential artists—d'Harnoncourt suggested a more nuanced way of articulating relationships and styles that recognizes multiple issues and concerns, though it is still based in the centrality of the tradition of painting and sculpture.[4]

4. Although often mischaracterized as only having focused on painting and sculpture, the exhibition *Cubism and Abstract Art*, for which Barr produced the famous chart that appears on the catalogue's dust jacket, also included constructions, photography, architecture, design, industrial arts, theater, film, posters, and typography.

The Taniguchi expansion of 2004 endeavored to make the essence of d'Harnoncourt's idea possible on the fourth and fifth floors of the Museum with an inner gallery loop that would contain "fixed" galleries for all mediums and an outer loop that would house "variable" galleries. However, after a series of initial experiments with this arrangement, including the three cycles of exhibitions that composed *MoMA2000*, the idea was not fully realized. There were many reasons for this, not the least of which was the sense that despite the newly increased size of the Museum, there was still insufficient space to show the core holdings for most mediums, and especially painting and sculpture, let alone integrate them into thematic or multidisciplinary installations. Consequently, distinct departmental galleries were retained with the understanding, nonetheless, that mediums from different departments could be displayed within these galleries at will, which has happened at a far greater rate since the Taniguchi expansion than it had before.

What, then, can the Museum do to reflect the breadth and quality of its collection while striving to present a more thoughtful and comprehensive story of modern and contemporary art? Because it is clear that no amount of space can resolve the tension between these two aims, we must continue to reconsider how best to use the space available. In this regard, two issues seem evident: that whatever stories the Museum tells must address a range of concerns in greater detail than before, and that the one-to-one relationship between its collecting departments and its galleries needs to be rethought. Or, put differently, the way the Museum collects does not need to be mirrored in the way it displays its collection, any more than artists should be confined to a set of concerns or a single medium or department at the Museum. Into its narratives, the institution needs to continue to incorporate, among other things, a consideration of the roles of women, African Americans, and artists from beyond Western Europe and North America; the impact of technology, critical discourse, and political events; and movements like Fluxus and Conceptual art, previously underrepresented in the collection and in its display. These are not new concerns, nor are they unique to MoMA, and the Museum increasingly has the works it needs to tell an expanded story that takes them into account.

A new generation of curators with a deep commitment to building on the history of the Museum and initiatives like *MoMA2000* have already changed the way the collection is presented. In the installation *Walker Evans: American Photographs* (2013–14), for example, sixty prints from this series of photographs were installed in the suite of painting-and-sculpture galleries devoted to the 1950s, connecting Evans to artists like Mark Rothko and Jackson Pollock and suggesting a parallel between the daring of the *American Photographs* and the radicalness of Abstract Expressionism. Similarly, early cinema now appears regularly in galleries with painting, sculpture, and other mediums, and exhibitions like *From the Collection: 1960–1969* (2016) and *A Revolutionary Impulse: The Rise of the Russian Avant-Garde* (2017) include works from all departments. None of these approaches provides "the answer," but each suggests that it is possible to create galleries that allow for surprising juxtapositions between works across mediums and expand our understanding of art history.

Building on these lessons, the Museum's dual strategy for the future is to have *both* integrated galleries *and* medium-specific galleries, as appropriate. This strategy is guided by several considerations. The first is that the disjunctive nature of modern and contemporary art can—and should—be reflected in the galleries. This means using a collage-like approach, with each gallery telling an independent story, enabling competing and even contradictory relationships to emerge instead of trying to present a linear progression of artistic movements or relationships that can never, in fact, be more than an arbitrary abstraction. And, with frequent rotations of most of the galleries, a multiplicity of stories can accumulate over any given year, destabilizing the notion of a "fixed" or already determined history and emphasizing that the histories of modern and contemporary art are still in the making.

The second consideration is that by including works by artists from a broad geographic range, with differing responses to modernism and modernity, we can develop more complicated narratives that are truer to the world we live in. In doing so we will continue to build on the knowledge gained from research programs like Contemporary and Modern Art Perspectives in a Global Age (C-MAP), which focuses on Asia, Central and Eastern Europe, and Latin America. Through its work with eminent scholars, critics, curators, and artists, C-MAP has substantially expanded the Museum's understanding and holdings of art from these regions and has led to multidisciplinary installations of the collection, like *Transmissions* (2015), which explored the relationships between artists in Eastern Europe and Latin America during the 1960s and '70s. By telling a more cosmopolitan story, we can create a more vibrant intellectual space for all of the works in our collection and make clear that modern art is not limited—and never has been limited—to North America and Western Europe. At a time when nationalism and xenophobia are on the rise in the United States, Britain, and elsewhere, and intellectual and cultural borders are being drawn like battle lines rather than expanded, this seems especially important to do.

The third consideration is that the Museum needs to further integrate its programs in contemporary art with those of MoMA PS1. While the two institutions have worked together since they

merged in 2000 on projects like the *Greater New York* quinquennial, the annual Young Architects Program, and exhibitions like the Mike Kelley retrospective (2013), they have maintained, until now, relatively independent programs. However, given the Museum's desire to develop a more robust contemporary presence, they need to work together in a fully coordinated way. This means taking advantage of MoMA PS1's ability to act quickly and The Museum of Modern Art's ability to develop projects over longer periods of time to create an overall program that spans the spectrum of possibilities at both places. The future of each institution—and the two together—depends on their ability to foreground contemporary art as vital to understanding the present.

The fourth consideration is that there is a dynamic relationship between what happens at the Museum and what happens online through the Museum's website, social media, and other digital platforms. Between 2010 and 2015 alone, visits to the website grew from nearly 16 million to 22 million, and the Museum currently has more than 10 million social-media followers. The Museum's growing digital presence allows it not only to engage audiences in a 24/7 loop of conversations but also to connect those who are on-site with those who are not. More importantly, the vast amount of information stored in the Museum's digital files means that almost all of the Museum's collection, and an array of supporting information, can be instantly accessed by visitors in the galleries, amplifying what is on view with what is not and resolving, at least in part, the dilemma of only being able to display a fraction of the collection at any one time.

The fifth consideration is that different mediums have differing needs and histories, and there is value in enabling these differences to surface and be explored. The goal, however, is to embed these medium-specific histories—whether for architecture and design, prints and drawings, media and performance art, painting and sculpture, or film and photography—in the larger narrative sweep of the galleries so that they can expand on each other's stories and engage in a broader conversation about modern art. In doing so, we return to one of the founding principles of the Museum: that its interests lie in the various manifestations of a modern aesthetic across multiple disciplines. This is the promise of the idea of a museum of modern art. And while this promise has been contested, revised, and reinterpreted over time—as it will continue to be in the future—it is fundamental to ensuring that The Museum of Modern Art stands for a generous and broad understanding of modern art.

Staying Modern

Olivier Michelon

Today, as in 1929, the year of MoMA's creation, museums of modern and contemporary art are not able to hide behind the barricade of time when making decisions. Such institutions must take a proactive stance with respect to heritage, assume responsibility not for christening objects of the past but for determining what we want to pass on and find a place for in the future. The term "modern" itself, chosen by MoMA for its very name, speaks to this responsibility: the Museum exists, as its first director, Alfred H. Barr Jr., once said, to promote the modern, or "the progressive, original and challenging rather than the safe and academic which would naturally be included in the supine neutrality of the term 'contemporary.'"[1]

Through this engagement, and the constancy and clarity of its implementation, MoMA, though not strictly speaking the first museum dedicated to "modern art," would in twenty years become the model of the genre.[2] At the end of World War II, its size and audience greatly exceeded those of other institutions of art.[3] This hegemony would lead to widespread acceptance of the modern canon the Museum had set in stone, wherein "cubism [was] firmly established as the nexus of early modernism, while abstraction [was seen] as the final stage in its evolution," and of a museological canon, in which MoMA was seen as the exemplar.[4] For the Museum combined historical depth and living creation; it struck a successful balance between its focus on the collection and its commitment to exhibitions; and it innovated in its communications as well as in its educational programs and public outreach. Carrying on, surpassing, or breaking with MoMA's standards is still the central preoccupation of most debates regarding the mission of museums devoted to the art of the twentieth and twenty-first centuries.

Museums of modern and contemporary art today seem to be faced with the challenge of responding to and collecting in a new and expanded geographic and cultural landscape. While accustomed to moving vertically in time, value, and hierarchy, these institutions are now faced with a horizontal world and criteria.[5] Does this place them on a new quest for balance? As an

1. Alfred H. Barr Jr., quoted in John Elderfield, *Modern Painting and Sculpture: 1880 to the Present* (New York: The Museum of Modern Art, 2004), 12.
2. The Musée du Luxembourg in Paris opened in 1818 with the mission of collecting living artists; from 1923 to 1948, the Museum of Modern Western Art in Moscow put together one of the great collections of early modernity with the Morozov and Shchukin collections; the Sztuki Museum in Łódź, opened in 1929, was dedicated to the abstract avant-gardes; and El Lissitzky's Kabinett der Abstrakten (Cabinet of Abstract Art), commissioned in 1927 by the Hannover Provincial Museum (now the Sprengel Museum) was a place of radical museological experimentation.
3. See Serge Guilbaut, *How New York Stole the Idea of Modern Art*, trans. Arthur Goldhammer (Chicago: University of Chicago Press, 1985). The theses developed in the book have since been tempered. See, for example, David Caute, *Dancer Defects: The Struggle for Cultural Supremacy during the Cold War* (Oxford, UK: Oxford University Press, 2003), 539–67. For a broader perspective, see also, Fred Turner, *The Democratic Surround: Multimedia and American Liberalism from World War II to the Psychedelic Sixties* (Chicago: University of Chicago Press, 2013), 129–49.
4. Elisabeth Lebovici, "The Canon and Stories of Modern Art," in *Keys to a Passion*, eds. Suzanne Pagé and Béatrice Parent, exh. cat. (Paris: Fondation Louis Vuitton/New Haven, CT: Yale University Press, 2015), 47.
5. See, for example, Pascal Gielen, "When Flatness Rules," in *Instituting Art in a Flat World* (Amsterdam: Valiz, 2013), 1–7.

institution, a museum of modern art has to err on the side of stability, permanence, and borders. But it cannot do this without embracing, in Baudelaire's words, "the ephemeral, the fugitive, the contingent, the half of art whose other half is the eternal and the immutable."[6] Contemporary to the avant-gardes, the idea of the museum of modern art shared a similar limitation and a similar ambition: that of *faire leur temps* ("enliven[ing] their time").[7] After defining their temporal and disciplinary boundaries and writing the chronology of "modern art," MoMA and other institutions of its kind had to accept the historical and stylistic shuttering of their subject of study and take on the challenge of the contemporary in the 1960s. These museums were international by nature; now they had to become global. Through the examples of MoMA, the Centre Pompidou in Paris, and Tate Modern in London—that is, three of the largest institutions to call for a global vision of this sort—this essay will outline in broad strokes modern and contemporary art museums' responses to this tectonic shift in the cultural field.

In the Torpedo

At its inception, MoMA translated the multidisciplinary and international spirit of the European avant-gardes of the 1920s into the American context, with Barr's vision of multiple curatorial departments informed by his admiration for the Bauhaus. Moreover, Barr imagined the museum's ever-evolving collection as "a torpedo moving through time" (p. 15).[8] This image, which Barr employed in the report he submitted to his trustees in 1933, put the museum in a most unprecedented relation to past and present: in the front, the tip of the projectile touches the present; in the back, the torpedo's wake gradually dissipates along with influences of the past, blurred in the passage through time. Barr's institution would balance the need for permanence, transmission, and authority essential to any museum's mission with an unusual commitment to the ephemeral. To pursue this path unimpeded, MoMA originally planned to sell off works once they had attained the age of fifty, to fund new acquisitions.

The Museum's earliest exhibitions revolved around the contours of a collection to come and oscillated between historical figures and recent works. The first, in November 1929, was *Cézanne, Gauguin, Seurat, van Gogh*; the second, *Paintings by 19 Living Americans* (1929–30); and the third, *Painting in Paris* (1930).[9] In the last two cases, the works shown were, for the most part, made after 1920, and some were completed only a few months before the exhibition. The alternation between the fundamentals (*Corot, Daumier* in 1930) and recent productions (*46 Painters and Sculptors under 35 Years of Age*, also in 1930) continued as Barr brought the collection closer to his great "genealogical" exhibition *Cubism and Abstract Art* (1936), with its notorious accompanying schema (p. 75). This was a turning point, as was the sale of a Degas bequeathed by Lillie P. Bliss to fund the acquisition of Picasso's *Les Demoiselles d'Avignon* in 1939. Ten years after its creation, the MoMA collection began to take on a shape of its own, "a collection of art made internationally

6. Charles Baudelaire, *The Painter of Modern Life and Other Essays*, trans. Jonathan Mayne (London: Phaidon, 1964), 13.

7. As Guy Debord said, "Avant-gardes have only one time; and the best thing that can happen to them is to have enlivened their time without *outliving* it." Debord, "*In girum imus nocte et consumimur igni*," in *Guy Debord: Complete Cinematic Works: Scripts, Documents*, trans. Ken Knabb (Oakland, CA: AK Press, 2003), 182.

8. Alfred H. Barr Jr., "Report on the Permanent Collection," November 1933. Alfred H. Barr Jr. Papers, II.C.16. MoMA Archives, NY; quoted in Harriet S. Bee and Michelle Elligott, eds., *Art in Our Time: A Chronicle of The Museum of Modern Art* (New York: The Museum of Modern Art, 2004), 39. Supplementing the torpedo diagrams he drew to accompany the report, Barr wrote: "The Permanent Collection may be thought of graphically as a torpedo moving through time, its nose the ever advancing present, its tail the ever receding past of fifty to a hundred years ago."

9. *Paintings by 19 Living Americans* featured Charles Burchfield, Charles Demuth, Preston Dickinson, Lyonel Feininger, George Overbury "Pop" Hart, Edward Hopper, Bernard Karfiol, Rockwell Kent, Walt Kuhn, Yasuo Kuniyoshi, Ernest Lawon, John Marin, Kenneth Hayes Miller, Georgia O'Keeffe, Jules Pascin, John Sloan, Eugene Speicher, Maurice Sterne, and Max Weber. *Painting in Paris* assembled Pierre Bonnard, Georges Braque, Marc Chagall, Giorgio de Chirico, Robert Delaunay, André Derain, Maurice Dufresne, Raoul Dufy, Jean Fautrier, Jean-Louis Forain, Othon Friesz, Marcel Gromaire, Moïse Kisling, Marie Laurencin, Fernand Léger, Jean Lurçat, Henri Matisse, Joan Miró, Pablo Picasso, Georges Rouault, André Dunoyer de Segonzac, Chaim Soutine, Léopold Survage, Maurice de Vlaminck, and Édouard Vuillard.

since Post-Impressionism, with an emphasis on Europe in the earlier years and a broader emphasis later," as former chief curator John Elderfield summed it up.[10] In 1953, MoMA abandoned the principle of a "temporary" collection, meant to be constantly refashioned, and committed itself to providing a permanent home for artworks made after 1880.

The torpedo metaphor, useful to Barr, also proves helpful in understanding the logic of MoMA's transformation from creator of the canon to vigilant custodian of its advancement: for the torpedo to continue moving forward, it had to be impermeable. With the exception of its surface, the torpedo allowed no interaction with the outside world. It could not cross paths with other narratives or genealogies or it might have foundered and failed to complete its trajectory. Artworks, curators, historians, and visitors were all situated inside the missile, passengers in a "modern" narrative they were persuaded was objective and must be maintained.

The late philosopher Arthur C. Danto recalls first moving to New York "at the end of the forties, when 'our art' was modern art, and the Museum of Modern Art belonged to us in that intimate way. To be sure, a lot of art was being made which did not as yet make an appearance in that museum, but . . . it seemed a wholly natural arrangement that some of this art would sooner or later find its way into 'The Modern,' and that this arrangement would continue indefinitely, modern art being here to stay, but not in any way forming a closed canon. It was not closed, certainly, in 1949, when *Life* magazine suggested that Jackson Pollock might just be the greatest American painter alive. That it is closed today, in the minds of many, myself included, means that somewhere between then and now a distinction emerged between the contemporary and the modern. . . . The modern seemed more and more to have been a style that flourished from about 1880 until sometime in the 1960s."[11]

In his reading—which has itself become canonic—Danto situates the break at Pop, or with the appearance in art of "the objects and icons of common cultural experience."[12] We could easily add to the list of markers of this rift the manipulation of ephemeral forms (events, performances, language) and the development of an aesthetic experience outside the places typically reserved for art. "This notion of a modernism that is to be found inscribed on the face of everyday life, in everyday fashion, in popular culture and in the popular media," Stuart Hall, one of the founders of cultural studies in Britain, observed, "does obviously jeopardise the whole concept of gathering together the best of all this in one place and calling it a museum."[13]

The Experience of the Present

In 1972, in France, President Georges Pompidou wanted to start construction of a "cultural center as they have tried to create in the United States with uneven results up until now."[14] He is talking then as much about art as about his era: "To sum up, I would say that contemporary art has two features: it is constantly in motion, and that's good; it's not comfortable, because it's not sure of itself. The legacy of the past is too heavy, and the future too diverse. Art, between the two, searches for its meaning . . .

10. Elderfield, *Modern Painting and Sculpture*, 17.
11. Arthur C. Danto, *After the End of Art: Contemporary Art and the Pale of History* (Princeton, NJ: Princeton University Press, 1997), 10–11.
12. Ibid., 130.
13. Stuart Hall, "Museums of Modern Art and the End of History," in Stuart Hall and Sarat Maharaj, *Annotations No. 6: Modernity and Difference* (London: London Institute of International Visual Arts, 1999), 22. A comparable thesis, based on different perspectives and with different conclusions, can be found in Yves Michaud, *L'art à l'état gazeux* (Paris: Stock, 2003), and Gilles Lipovetsky and Jean Serroy, *L'esthétisation du monde: Vivre à l'âge du capitalisme* (Paris: Gallimard, 2013).
14. Georges Pompidou, "Entretien avec Jacques Michel," *Le Monde*, October 17, 1972; reprinted in Nikola Jankovic, *De Beaubourg à Pompidou II* (Paris: Éditions B2, 2017), 106 (my translation).

Contemporary art is contradictory in its essence: as sober as mathematics or violently lyrical, sincere to the point of shamelessness or insolent in imposture, an explosion of color and joy or the negation of everything, including itself, it is always on the lookout for tomorrow. Isn't that the image of our world?"[15]

While the chronology of the Musée national d'art moderne, the core of the Centre Pompidou, is very similar to MoMA's—younger by a generation, it begins with the Fauves—the Parisian museum immediately stood out because of the exhibition policies of its first director, Pontus Hultén, who opened the Beaubourg with the solo show *Marcel Duchamp* (1977), and followed that symbolic inauguration with *Paris–New York: 1908–1968* (1977); *Paris–Berlin: 1900–1933* (1978); and *Paris–Moscow: 1900–1930* (1979), three shows that together revisited the birth of modern art from various geographical perspectives and cultural dialogues. The end of the modern period created a new position for museums of modern art; they are no longer the agents of modernism but instead its historians.

But by the same token, museums in this era act with new intensity. Characterized by its fluid architecture, the Centre Pompidou has, from its inception, been committed to multidisciplinary, temporary, event-based programming. It embodies the present. First the director of the Moderna Museet in Stockholm, Hultén was a familiar of and a collaborator with MoMA. But he was also marked by the Stedelijk Museum in Amsterdam under William Sandberg and the central place that this institution reserved for living artists within its program. For Hultén, "the memory of a visit to Beaubourg is not just an impression left by this or that work of art, painting, book, or exhibition but fashioned by the complex interplay of experiences." To his mind, the Pompidou was "not an anti-museum but a place where there is natural contact between artists and the public in developing the most contemporary elements of creativity. Such a museum is not simply a place to conserve works which have completely lost their individual, social, religious or public function but a place where artists meet their public and where the public themselves become creator."[16]

A Spatial Turn

For Nicholas Serota, director of the Tate from 1988 to 2017 and a guiding force behind Tate Modern, the Pompidou's program was located someplace between "experience and interpretation."[17] This slippage between museum as a reflection of art history and museum as a place to stage personal encounters with art is also visible in the early 1980s in the importance accorded monographic galleries in the permanent collections of many museums. For Serota, a critical apex was achieved in the inaugural exhibition of the Guggenheim SoHo in New York in 1992, which was organized around three pairs of artists (Robert Ryman and Constantin Brancusi, Carl Andre and Vasily Kandinsky, Louise Bourgeois and Joseph Beuys) and in which "the traditional disciplines, juxtaposition, analysis and interpretation were reduced to a minimum; experience was paramount."[18]

Starting in 1990, Rosalind Krauss pointed out the waywardness of a discourse "that switches from diachrony to synchrony." In her seminal essay "The Cultural Logic of the Late Capitalist Museum," Krauss argues, "The encyclopedic museum is intent on telling a story, by arraying before its visitor a particular version of the history of art. The synchronic museum—if we can call it that—would

15. Ibid., 107.
16. Pontus Hultén, *Le Centre national d'art et de culture Georges Pompidou* (Paris: CNAC-GP, 1977), 52; quoted in Nicholas Serota, *Experience or Interpretation: The Dilemma of Museums of Modern Art* (London: Thames & Hudson, 2000), 14.
17. Ibid.
18. Ibid., 17.

forego history in the name of a kind of intensity of experience, an aesthetic charge that is not so much temporal (historical) as it is now radically spatial."[19]

This shift—its seed contained in Frank Lloyd Wright's building for the Solomon R. Guggenheim Museum in New York and anticipated by the Centre Pompidou in Paris—is ultimately responsible for the so-called Bilbao effect. A museum's architecture—and the visitor's experience of its volumes and spaces—has taken on an importance comparable to or even exceeding that of the viewer's engagement with the institution's collections and exhibitions.

The undeniable success of Tate Modern since its opening in 2000 shows its designers' understanding of this last point.[20] This success has also given the museum the firm footing needed to stick with its program of thematic presentations even after the uproar over its inaugural show's abandonment of chronology as the sole organizing principle. As controversial as this move was, the strategy was provisionally adopted around the same time by MoMA (*MoMA2000*), and then by the Centre Pompidou (*Big Bang* [2005–06]; "*Le Mouvement des images*" [2006–07]).[21] Tempered since 2006 by theoretical categories that have reconnected with chronology, the position taken by Tate Modern spotlights the end of the modern narrative—which it could not implement in terms of its collections—and its replacement by ever-multiplying narrations.

With the opening of The Tanks and The Switch House in 2016, the newly expanded Tate has taken a resolutely geographical turn. Dedicated to "foreign art" at its inception and therefore not subject to a national narrative, Tate Modern now has a program of "highlighting original, singular, and influential moments that occur in places far removed from the centers of Western modernism" and considers its collections a "temporary stabilization."[22] This manifesto responds to a shared concern. The Centre Pompidou, following its show *Plural Modernities from 1905 to 1970* (2013–15), continues to pursue such connected histories with exhibitions along the lines of *Art et Liberté: Rupture, War, and Surrealism in Egypt (1938–1948)* (2016–17). In New York, in February 2017, in reaction to the anti-immigration travel ban issued by President Donald J. Trump, MoMA pointedly placed works by artists from the predominately Muslim countries targeted by his executive order alongside more familiar representatives of the museum's collection—a gesture of inclusion that feels of a piece with an exhibition program that has in recent years foregrounded the work of Lygia Clark, Yoko Ono, Joaquín Torres-García, and Walid Raad.

Universalism is no longer a requirement. Museums are now more focused on intersecting histories. L'Internationale—a consortium of arts institutions founded in 2010 and today comprising the Moderna galerija in Ljubljana, the Museo Nacional Centro de Arte Reina Sofía in Madrid, the Museu d'Art Contemporani Barcelona (MACBA), The Museum of Contemporary Art Antwerp (M HKA), SALT in Istanbul and Ankara, and the Van Abbemuseum in Eindhoven, The Netherlands—proposes a circulation of artworks, exhibitions, publications, and ideas based on "values of difference and horizontal exchange" (to quote the organization's mission statement) through a constellation of institutions that are locally rooted and globally connected.

19. Rosalind Krauss, "The Cultural Logic of the Late Capitalist Museum," *October* 54 (Fall 1990): 7; quoted in *Grasping the World, The Idea of the Museum*, eds. Donald Preziosi and Claire Farago (Aldershot, UK: Ashgate, 2004), 604.

20. In 2016, when it opened its extension, Tate Modern received 5.8 million visitors, creating an enormous gap with the Centre Pompidou (3.3 million visitors) and MoMA (2.8 million visitors). See *The Artnewspaper*, "Visitors Figures," March 29, 2017.

21. J. Pedro Lorente, *The Museums of Contemporary Art: Notion and Development* (Aldershot, UK: Ashgate, 2011), 270.

22. Frances Morris, "From Sugar Cube to White Cube and Beyond," *Tate Modern: The Handbook* (London: Tate, 2016), 22, 24. The latter term is borrowed from Stuart Hall.

The Museum of Modern Art

THE immediate purpose of the Museum of Modern Art is to hold, in its gallery at the Heckscher Building, 730 Fifth Avenue, New York, some twenty exhibitions during the next two and a half years.

These exhibitions will include as complete a representation as possible of the great modern painters—American and European—from Cézanne to the present day, but will be devoted primarily to living artists, with occasional homage to the masters of the Nineteenth Century.

With the co-operation of artists, collectors and dealers, the Trustees of the Museum hope to obtain for these twenty exhibitions, paintings, sculptures, drawings, lithographs and etchings of the first order.

The ultimate purpose of the Museum will be to acquire, from time to time, (either by gift or by purchase) a collection of the best modern works of art. The possibilities of The Museum of Modern Art are so varied that it has seemed unwise to the organizers to lay down too definite a program for it beyond the present one of a series of frequently recurring exhibitions during a period of two and a half years.

[handwritten: 1.]

ALL over the world the increasing interest in modern movements in art has found expression, not only in private collections but also in the formation of public galleries created for the specific purpose of exhibiting permanent as well as temporary collections of modern art.

Nowhere has this tide of interest been more manifest than in New York. But New York alone, among the great capitals of the world, lacks a public gallery where the works of the founders and masters of the modern schools can today be seen. That the American metropolis has no such gallery is an extraordinary anomaly.

The municipal museums of Oslo, Halle, Halsingfors, F r a n k f u r t, Utrecht, Lyons, Prague, Geneva, Cleveland, Chicago, Buffalo, Detroit, Providence, Worcester and a score of other cities provide students, amateurs and the interested public with more adequate permanent exhibits of modern art than do the similar institutions of our vast and conspicuously modern metropolis.

In these museums it is possible to gain some idea of the progressive phases of European painting and sculpture during the past fifty years. But far more important than these smaller exhibitions are the modern public collections in the great world-cities — London, Paris, Berlin, Munich, Moscow, Tokio, Amsterdam. It is to them that New York may look for suggestion, for they have each solved the problem with which New York is confronted. And this problem is as delicate as it is difficult.

IN the past few years New York's great museum—the Metropolitan—has sometimes been criticized because it did not add the works of the leading "modernists" to its collections. Nevertheless the Metropolitan's policy is reasonable and, probably, wise. The Metropolitan, as a great museum, may justly take the stand that it wishes to acquire only those works of art which seem certainly and permanently valuable. It can well afford to wait until the present shall become the past, until time, that nearly infallible critic, shall have eliminated the probability of error. But the public interested in modern art does not wish to wait. Nor can it depend upon the occasional generosity of collectors and dealers to give it more than a haphazard view of what has developed, in art, during the past fifty years.

Experience has shown that the best way of giving to modern art a fair presentation is to establish a gallery devoted frankly to the works of artists who most truly reflect the taste, feeling and tendencies of the day. The Louvre, the National Gallery of England and the Kaiser Friedrich Museum, to mention only three national museums, follow a policy similar to that of our Metropolitan. But they are comparatively free of criticism because there are in Paris, London and Berlin—in addition to and distinct from these great historical collections—museums devoted entirely to the exhibition of modern art. There can be no rivalry between these institutions because they *supplement* each other and are at times in close co-operation.

[handwritten: collection ⑤]

The Museum of Modern Art will in no way conflict with the Metropolitan Museum of Art but will seek rather to supplement the older institution. The younger Museum will have many functions. First of all it will attempt ultimately to establish a very fine collection of the immediate ancestors, American and European, of the modern movement; artists whose paintings are still too controversial for universal acceptance. This collection will be formed by gifts, bequests, purchase and perhaps by semi-permanent loans.

[handwritten margin: period ③]

THE Museum galleries will display carefully chosen permanent collections of the most important living masters, especially those of France and the United States, though there will eventually be representative groups from England, Germany, Italy, Mexico and other countries. Through such collections American students, artists and the more general public can gain a consistent idea of what is going on in America and the rest of the world—an important step in contemporary art education. Likewise, and this is also important, visiting foreigners can be shown a collection which would fairly represent our own accomplishment in art. This is quite impossible at the present time.

[handwritten margin: period / internat. / national]

In time the Museum will expand beyond the limits of painting and sculpture in order to include departments devoted to drawings, prints and other phases of modern art. In addition to the Museum's permanent collections, space will be set aside for great and, it is hoped, constantly recurring loan exhibitions, both national and international.

[handwritten margin: other dept. ⑥]

But even the beginnings of such a museum are not created overnight. A suitable building, a trained staff, as well as notable collections, will eventually be needed—and none of these can be had immediately. The present galleries will house as many as six or seven major and perhaps a dozen minor exhibitions during each year.

THE choice of artists for the first exhibition has been no easy matter. After careful consideration it was decided to open the galleries (on November 8th, 1929) with ninety-eight works by Cézanne, Gauguin, Seurat and Van Gogh. Although these masters were all European they are, none the less, more the ancestors of modern American painting than any four American painters of the past century. They are, indeed, the strong pillars upon which are builded the painting of the early twentieth century, the world over.

Edward Hopper (American, 1882–1967)

House by the Railroad. 1925
Oil on canvas, 24 x 29 in. (61 x 73.7 cm)
Given anonymously, 1930

In 1930, Edward Hopper's *House by the Railroad* became one of the first works to enter the MoMA collection. Depicting an isolated Victorian mansion bathed in slanted light, its base oddly truncated by train tracks, the painting brilliantly evokes the quiet yet charged atmosphere that would become a hallmark of the artist's work. Painted in 1925, when Hopper was just coming to prominence, it was sold the following year to Stephen C. Clark, heir to the Singer sewing machine fortune and an enthusiastic art collector.

In October 1929, Clark joined the board of the soon-to-open Museum of Modern Art and promptly agreed to loan his Hopper to the Museum's second exhibition, *Paintings by Nineteen Living Americans*. Ranging from rather "conservative" artists to the most "radical" and "advanced," the show aimed to present a variety of artists who were, in the words of Alfred Barr, "fairly representative of the principal tendencies in contemporary American painting."[1] The deliberately eclectic selection provoked immediate controversy, and Hopper was no exception: some critics went so far as to denounce the artist's very inclusion in a museum supposedly devoted to "modern" art, grousing that "[Hopper] ha[s] as much to do with modernism as has a Doric column."[2]

Soon after the exhibition closed, Clark expressed his desire to anonymously give *House by the Railroad* to MoMA. Such donations were critical to the fledgling Museum: with no dedicated fund for purchases, Barr had to rely upon the generosity of trustees and other supporters to start building a collection. While he was always grateful for new offerings, he itched to implement a coherent and "controlled" acquisition strategy. "Building up a permanent collection should not be left to chance," he exhorted.[3]

Yet Barr clearly considered Clark's gift a fortuitous one: the Museum's frequent promotion of *House by the Railroad* as among its first acquired artworks can be read as evidence of Barr's esteem both for Hopper and for this particular work, which he would rank as one of MoMA's "best American paintings."[4] It also speaks of the Museum's willingness to show its support for the American art scene, despite its director's personal penchant for European artists and his skepticism of collecting in a field in which The Metropolitan Museum of Art was already investing, soon to be joined by the new Whitney Museum. But nationalism was rising, and Clark, in giving the Hopper painting, expressed his concern to "[disarm] our critics who say that we are too exotic and foreign."[5] As he explained, "It is highly desirable for the Museum to start a collection which, in the beginning at any rate, will be predominantly American."[6]

In 1933, MoMA presented the first major retrospective of Hopper's work, and *House by the Railroad* was the show's earliest painting. Today the work remains a cornerstone of MoMA's collection, frequently hanging on the Museum's walls or traveling to countless other institutions, both within the United States and around the world. —Charlotte Barat

1. Alfred H. Barr Jr., foreword to in *Paintings by Nineteen Living Americans* (New York: The Museum of Modern Art, 1929), 14.
2. William B. M'Cormick, "Bone of Contention Is New Group at Modern Museum," unidentified New York newspaper, December 22, 1929 [PI, mf 1;119]. MoMA Archives, NY.
3. Alfred H. Barr Jr., "Report on the Permanent Collection," November 1933, p. 13. Alfred H. Barr Jr. Papers, II.C.16. MoMA Archives, NY.
4. Alfred H. Barr Jr., "Chronicle of the Collection of Painting and Sculpture," in *Painting and Sculpture in The Museum of Modern Art, 1929–1967* (New York: The Museum of Modern Art, 1977), 624.
5. Stephen C. Clark to A. Conger Goodyear, January 20, 1930. A. Conger Goodyear Scrapbooks, 31. MoMA Archives, NY.
6. Ibid.

Emancipated Horizons

The cultural consequences of globalization and the escalating impact of new technologies have placed museums of modern and contemporary art in an unprecedented situation.[23] They are powerless to establish the selection criteria necessary to formulate the genealogy their missions imply. The recognition of new relations between centers and peripheries, as well as the heterogeneity of artistic proposals and the cultural references of contemporary audiences, make it difficult to defend norms and values increasingly considered exclusive.[24]

23. For further discussion of the museum's contemporary dilemmas, see Catherine Grenier, *La fin des musées?* (Paris: Éditions du Regard, 2013), esp. 93–100.

24. See, for example, Arjun Appadurai, *Après le colonialisme: Les conséquences culturelles de la globalisation* (Paris: Payot, 2015), 63–90.

25. Jacques Rancière, *Le spectateur émancipé* (Paris: La Fabrique, 2008), 63.

26. Kathy Halbreich, interview in *Artforum*, Summer 2010, 277. She went on to say, "In other words, if the canon is about a kind of certainty, perhaps permission could usefully be about a kind of fluidity—a different way of constructing reality."

But weren't these already the challenges faced by MoMA from the moment of its founding? Were the intellectual and political crises of that period minor compared to those of the present? In regard to globalization, it should be remembered that museums of modern art, through their topic of study, were the first to go beyond the questions of schools and nations that had made museums successful in the nineteenth century. The exhibitions and initiatives mentioned above show the ongoing capacity of museums of modern and contemporary art to combine the writing of a history, the intensity of the present, and the questioning of preestablished schemas, without giving up on their patrimonial mission.

Could the spectacularization of the architecture of these institutions, often criticized, be perceived in a more nuanced way? Such architecture is the signal of a place that wishes to mark its extraordinary character with a particular spatial and temporal regime, that wants to preserve its power of separation and mark a discontinuity with the everyday, to allow the appreciation of the works it is exhibiting. Formerly, this had been accomplished via the suspension of a work's religious and practical functions; today, it is achieved via an attraction to forms that refuse to be drowned in the tumult of the ordinary. "Aesthetic distance," notes Jacques Rancière, "has in fact been assimilated by a certain sociology to the ecstatic contemplation of beauty, which [is said to] conceal the social foundations of artistic production and its reception and [to] thwart the critical consciousness of reality and the means to act on it. But this critique misses the very thing that constitutes the principal component of this distance and its effectiveness: the suspension of any determinable relationship between the intention of an artist, a sensible form presented in a place of art, the gaze of a viewer, and a state of community."[25]

It is to the maintenance of this place of art, inherited from Western modernity, that the museum must be devoted. Its patrimonial mission is central to this. But that mission can only be considered in light of each collection, its capacity to create a temporal density, a present history "in acts" that can be revisited, reappraised, amended, and refuted by all—historians, audiences, and artists alike. According to Kathy Halbreich, MoMA's associate director, in the twenty-first century the museum's role is to set "standards in terms of permission rather than in terms of canon."[26] To stay modern and convey what it does not yet know, the museum must agree to take on the role of the ignorant schoolmaster.

Plates

Central to this exhibition and its catalogue is the story of how, starting around 1930, The Museum of Modern Art assembled its collection. As such, the plates that follow are presented chronologically according to the year the Museum acquired each artwork. The accompanying texts seek to illuminate each work's significance both singly and in the context of its MoMA acquisition. The texts were written by the following authors:

Seth Anderson
Paola Antonelli
Quentin Bajac
Luke Baker
Charlotte Barat
Jessica Bell Brown
Stuart Comer
Kayla Dalle Molle
Christina Eliopoulos
Michelle Elligott
Margaret Ewing
Teresa Fankhänel
Starr Figura
Michelle Millar Fisher
Samantha Friedman
Paul Galloway
Lucy Gallun
Kristen Gaylord
Karen Grimson
Jenny Harris
Michelle Harvey
Heidi Hirschl
Ana Janevski
Martha Joseph
Anna Kats
Juliet Kinchin

Sofia Kofodimos
Talia Kwartler
Emily Liebert
Jonathan Lill
Tellina Liu
Ron Magliozzi
Cara Manes
Roxana Marcoci
Tamar Margalit
Sarah Hermanson Meister
Anne Morra
Annie Ochmanek
Erica Papernik-Shimizu
David Platzker
Paulina Pobocha
Christian Rattemeyer
Yasmil Raymond
Hillary Reder
Lynn Rother
Katharine Rovanpera
Kelly Sidley
Katerina Stathopoulou
Sarah Suzuki
Elisabeth Thomas
Akili Tommasino
Lilian Tone

From the Archives: **MoMA's first brochure**, 1929

Two copies of The Museum of Modern Art's first brochure, 1929, showing the cover (left) and interior spread (right), both with handwritten annotations added later by Alfred H. Barr Jr.

Alfred H. Barr Jr. Papers, II.C.3. MoMA Archives, NY

When The Museum of Modern Art opened its doors in 1929, it was the first New York institution devoted to exhibiting the work of contemporary artists. In the Museum's first brochure, founding director Alfred H. Barr Jr. asserts: "That the American metropolis has no such gallery is an extraordinary anomaly," a situation he contrasts with "the modern public collections in the great world-cities—London, Paris, Berlin, Munich, Moscow, Tokio [sic], Amsterdam. It is to them that New York may look for suggestion, for they have each solved the problem with which New York is confronted."[1] MoMA's earliest press announcements made it clear that there would be no conflict between the new museum and The Metropolitan Museum of Art, offering as an analogy the relationship between the Musée du Luxembourg and the Louvre in Paris, which together afforded the public the opportunity to see both the current art of the day and the masterworks of the past.

Barr further set out to define the program of the new Museum in the four-page bifold brochure that was the first published by MoMA. The trustees had selected Barr, who was only twenty-seven years old, as the Museum's first director because, as a professor at Wellesley College, he had designed and taught a course on modern art, the first in the country and forward-thinking in its scope. Influenced as well by his visit to the Bauhaus in Germany in 1927, Barr's original plan for MoMA was based largely on the headings of his Wellesley course to include "departments devoted to drawings, prints, and photography, typography, the arts of design in commerce and industry, architecture (a collection of *projets* and *maquettes*), stage designing, furniture and the decorative arts. Not the least important collection might be the *filmotek*, a library of films . . ."[2] Yet the trustees, concerned about the public's readiness to embrace new art forms, substantially pared down Barr's far-ranging list so that the final text simply reads: "In time the Museum will expand beyond the limits of painting and sculpture in order to include departments devoted to drawings, prints and other phases of modern art." As Barr later wrote in pencil on a copy of the brochure shown here: "Contains 2 indirect references to 'multidepartmental plan'—all that I could get away with at the time." Still, that plan remained front and center in his mind. Another copy of the brochure in the MoMA Archives, likewise shown here, includes Barr's handwritten listing of individual departments and the dates they were established, almost a scorecard of the fulfillment of his original vision.

MoMA was the first fine arts museum to establish curatorial departments devoted to architecture and design, film, and photography. The Museum still adheres to the multidepartmental plan today, adding new programs and departments when necessary. —Michelle Harvey

1. Alfred H. Barr Jr., "The Museum of Modern Art," brochure (New York: The Museum of Modern Art, 1929), 2. Alfred H. Barr Jr. Papers, II.C.3. MoMA Archives, NY.
2. Alfred H. Barr Jr., "Chronicle of the Collection of Painting and Sculpture," *Painting and Sculpture in The Museum of Modern Art 1929–1967* (New York: The Museum of Modern Art, 1977), 620.

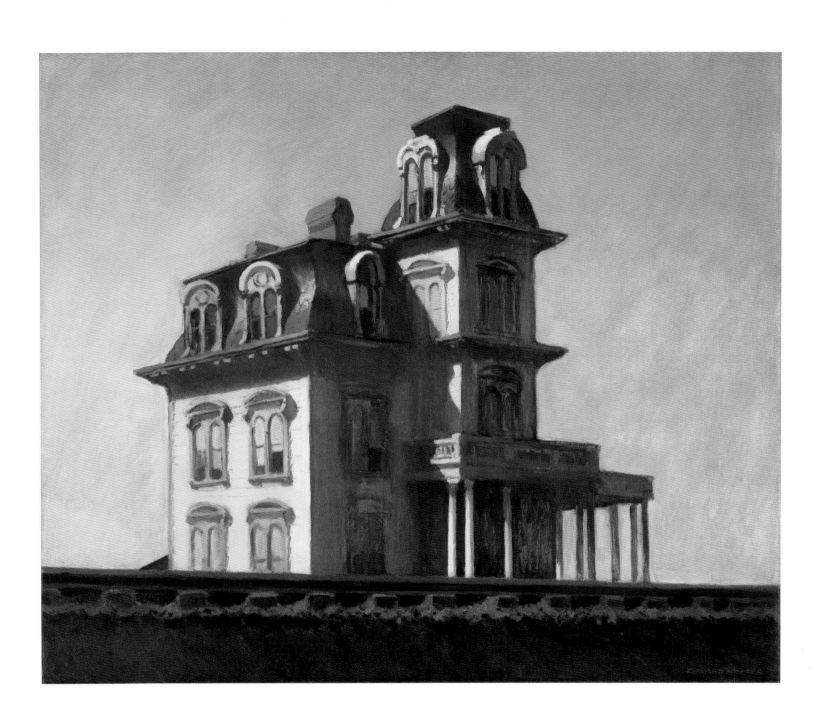

From the Archives: **Henri Matisse: Retrospective Exhibition**, 1931

a. Copy of the exhibition catalogue with a drawing
and inscription by the artist to Alfred Barr, 1931
Alfred H. Barr Jr. Papers, X.D.3. MoMA Archives, NY

b. Installation view, 1931
Photographic Archive. MoMA Archives, NY

c. Letter from Henri Matisse to Alfred Barr, December 14, 1931
Alfred H. Barr Jr. Papers, X.D.3. MoMA Archives, NY

On November 6, 1931, The Museum of Modern Art opened its third season with its first monographic exhibition of an artist, *Henri Matisse*. Displaying works from as early as Matisse's academic years to his most recent creations, Alfred Barr sought to illustrate the development of the artist's talent across his career. Featuring more than 130 works in a variety of mediums, including paintings, sculpture, watercolors, drawings, and prints, along with the publication of an equally extensive catalogue, the retrospective was the first comprehensive exhibition of the French artist to be held in the United States. With half the works on loan from Europe and the remaining either from private collections or from public collections outside New York, the show was likely the first encounter with Matisse's art for many of the more than 36,000 visitors to the exhibition during its five-week run.

In preparation for the show, Barr had traveled to Paris the summer before with his wife, art historian Margaret (Marga)Scolari Barr. There, the couple made repeated visits to Matisse's concurrent show at the Galeries Georges Petit, including several trips accompanied by the artist himself, whose nonchronological arrangement of his work would ultimately inspire Barr's own installation in New York. Unable to attend the MoMA retrospective in person, Matisse nevertheless responded enthusiastically to photographs Barr sent to him:

Dear Mr. Barr:
I just received the photographs of the exhibition at the Modern Museum you were kind enough to send me. They convey the idea of a perfect installation. Which is exactly what my son already wrote me. The catalogue is also very good, but I have not yet received mine, though my son also said that you had sent me one. I am very touched, dear sir, dear madame, by the great care and conscientiousness that you have taken to present this exhibition in a satisfying manner; it greatly contributed to its success. I hope to have the pleasure of expressing my gratitude to you in each of your personal copies of the catalogue, either when you send them to me or when you give them to me when you come to Paris. Please accept, dear Mr. and Mrs. Barr, my warmest thanks.
Yours truly, Henri Matisse.

True to his word, the artist would inscribe copies of the show's catalogue for both Barrs. Alfred Barr's copy, which includes a pencil sketch of two female nudes, also bears an inscription that reads: "In memory of an ensemble whose harmony is born of a common understanding." Matisse would be no less appreciative two decades later, when Barr published the first full-scale English-language monograph of the artist's work, *Matisse: His Art and His Public*, further cementing the connection between Barr, the artist, and the Museum, whose collection today is among the most comprehensive of the artist's groundbreaking production. —Christina Eliopoulos

MUSEUM OF MODERN ART

HENRI·MATISSE
RETROSPECTIVE EXHIBITION

NOVEMBER 3 1931 DECEMBER 6
730 FIFTH AVENUE · NEW YORK

a.

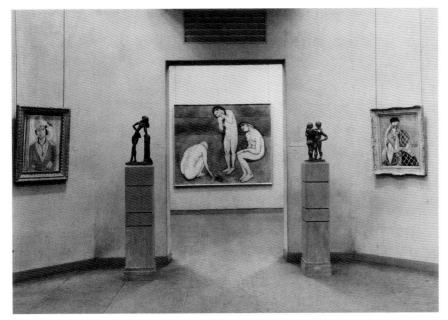

b.

c.

Paul Cézanne (French, 1839–1906)

The Bather. c. 1885
Oil on canvas, 50 x 38⅛ in. (127 x 96.8 cm)
Lillie P. Bliss Collection, 1934

By the time Paul Cézanne's *The Bather* formally entered the nascent collection of The Museum of Modern Art in 1934, the approximately fifty-year-old painting could hardly be called "modern" anymore, at least insofar as it no longer represented "the art of the present" that MoMA had defined as its primary focus. What had been at the forefront of "modern art" in the 1880s was no longer avant-gardist a half century later, yet Alfred Barr deemed it essential that the Museum provide historical lineage and include in its holdings certain fine works by the "immediate ancestors of contemporary painting."[1] Cézanne's paintings were thus to play a specific role within the chronological scope of the Museum's collection: as Barr argued, one could not understand Picasso without looking at Cézanne.

The Bather perfectly demonstrates why Barr thought of Cézanne as "the father of modern painting," a pioneer who broke with pictorial traditions and would go on to profoundly impact the direction of twentieth-century art.[2] In radical contrast to the elaborate posture, muscular body, and idealized proportions of academic painting, Cézanne's male figure appears awkward, both physically ungraceful and psychologically remote—an anonymous antihero. Likewise, the painting's unified palette and brushstrokes defeat the conventional hierarchy of the figure over its background: here they are interdependent, echoing if not dissolving into one another.

Cézanne was one of the four visionary European artists celebrated in MoMA's very first exhibition, which opened in a rented space on Fifth Avenue in November 1929 and paired the artist with Paul Gauguin, Georges-Pierre Seurat, and Vincent van Gogh. Comprised entirely of works on loan, the show featured nearly thirty canvases by Cézanne, including the large *Bather*, which was loaned by Lillie P. Bliss, vice president of the Museum's board of trustees and one of the three prominent women who, along with Abby Aldrich Rockefeller and Mary Quinn Sullivan, had founded the Museum not six months before. Praised as "an advocate for modern art when it had few admirers, a patron when it had almost no market," Bliss had begun collecting in the 1910s and gradually assembled a splendid assortment of Post-Impressionist paintings, including one of the finest collections of Cézanne's work privately held in the United States.[3] In the late 1920s, *The Bather* was featured prominently in her apartment's living room, hanging above the fireplace and surrounded by smaller-scale masterpieces. Upon her death in 1931, Bliss bequeathed the bulk of her collection—including *The Bather*—to the Museum, on the condition that the institution she had helped to found "become in fact what it is in name," that is, a *museum*, sufficiently endowed and financially stable, capable of maintaining a permanent collection.[4] Two years later, Barr could report that the Museum's "period of trial" was over; her conditions satisfied, Bliss's foundational bequest officially became part of MoMA's collection in 1934.[5] —Charlotte Barat

1. Alfred H. Barr Jr., "Report on the Permanent Collection," November 1933, p. 4. Alfred H. Barr Jr. Papers (AHB), II.C.16. MoMA Archives, NY.
2. Alfred H. Barr Jr., *A Brief Survey of Modern Painting* (New York: The Museum of Modern Art, 1934), 7.
3. "E. B." [Mrs. August Belmont Jr.], "Lizzie P. Bliss," in *Memorial Exhibition: The Collection of Miss Lizzie P. Bliss* (New York: The Museum of Modern Art, 1931), 7.
4. A. Conger Goodyear, "Memorial to Lizzie P. Bliss," in ibid., 5.
5. Alfred H. Barr Jr., "Report on the Permanent Collection," November 1933, p. 2. AHB, II.C.16. MoMA Archives, NY.

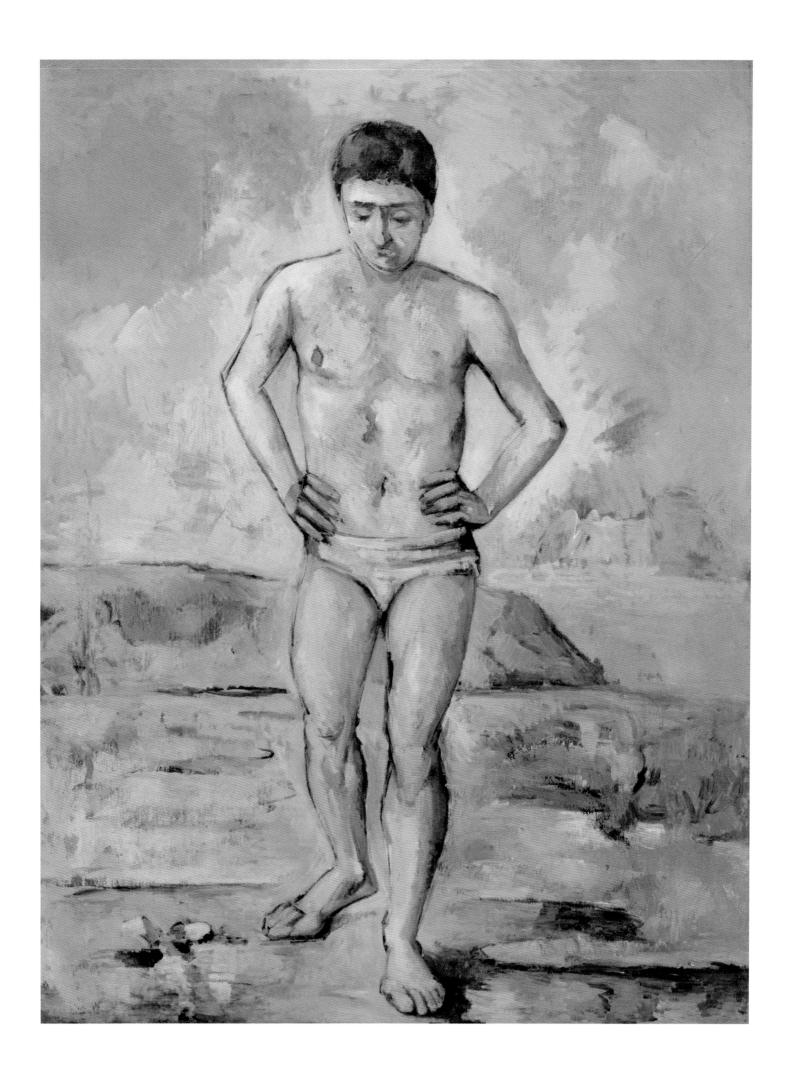

Paul Cézanne (French, 1839–1906)

Still Life with Apples. 1895–98
Oil on canvas, 27 x 36½ in. (68.6 x 92.7 cm)
Lillie P. Bliss Collection, 1934

Like Cézanne's *The Bather* (p. 51), *Still Life with Apples* entered the MoMA collection via the bequest of Lillie P. Bliss. Cézanne made the painting approximately a decade after he painted his solitary male figure, and the work shows the artist's continued fascination with optics and his refusal to aim for illusion, challenging the traditional rules of perspective, light, color, and space in ways that would profoundly influence future generations of artists. "As has happened with most great masters, followers of Cézanne's art, unable to master the whole, select some easier part which they develop as their own," Alfred Barr wrote in 1929. "All over Europe and America fragments of Cézanne's art reappear in a thousand disguises."[1] During the course of his career, Cézanne cultivated a distinctly abstract manner, as this painting demonstrates: the draped tablecloth appears unfinished, some areas are left bare, the lines of the table are askew, and the edges of the jug and some of the fruit are undefined. Cézanne painted more than 180 still lifes; eighty-two of them feature apples.[2] He used still life to test the limits of painting, legendarily announcing that he wanted to "astonish Paris with an apple."[3]

The jury of the official Paris Salon, however, was not impressed; they persistently rejected Cézanne, who increasingly chose to work in artistic isolation, primarily in the South of France. He received virtually no public recognition until very late in life, when the dealer Ambroise Vollard held the artist's first solo show, in Paris in 1895. A decade later, Cézanne was known across Europe, but it wasn't until the landmark Armory Show in New York in 1913, seven years after the artist's death, that his work began to become more widely known in the United States.

Around the same time, Bliss started her collection of Cézanne's work. *Still Life with Apples* was purchased as the top lot at the New York auction sale of the Dikran Khan Kélékian Collection in January 1922, before it hung in a large and perfectly lit gallery in Bliss's Park Avenue apartment. When she made her generous bequest, which came as a surprise to the Museum, she stipulated that works could be deaccessioned to acquire other artworks at the curators' discretion. But *Still Life with Apples*, one of her favorite paintings, was excluded from this clause: it was never to be sold.

—Lynn Rother

1. Alfred H. Barr Jr., foreword to in *Cézanne, Gauguin, Seurat, van Gogh* (New York: The Museum of Modern Art, 1929), 22.
2. Walter Feilchenfeldt, Jayne Warman, and David Nash, "The Paintings of Paul Cézanne: An Online Catalogue Raisonné," http://cezannecatalogue.com/catalogue/index.php.
3. See, for example, Alex Danchev, *Cézanne: A Life* (New York: Pantheon Books, 2012), 11.

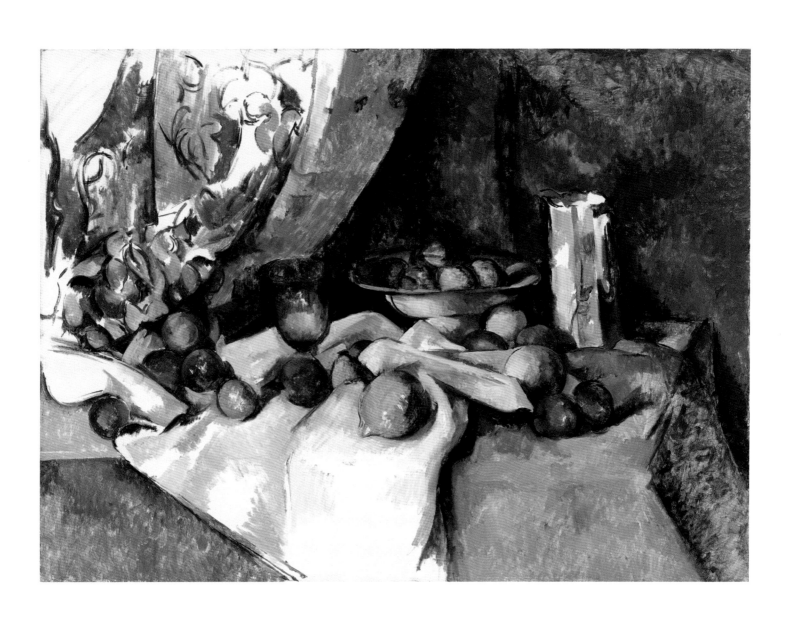

Constantin Brancusi (French, born Romania, 1876–1957)

Bird in Space. 1928
Bronze, 54 x 8 ½ x 6 ½ in. (137.2 x 21.6 x 16.5 cm)
Given anonymously, 1934

Four years after founding trustee Stephen C. Clark gave MoMA one of its first artworks for its collection, Edward Hopper's *House by the Railroad* (p. 47), he made an anonymous gift of this sculpture by Constantin Brancusi. Clark was an intrepid collector and early champion of modern painting; by the 1920s, he had developed a considerable interest in contemporary European sculpture as well, corresponding directly with the artist about the purchase of this work, an early variant on what would be a recurring subject for Brancusi. Though the artist frequently worked in series, he returned to the subject of the bird more than any other, reworking the idea again and again over the course of nearly forty years and ultimately creating fifteen variants, cast in highly polished bronze or sleek marble. "These must not be considered as reproductions," Brancusi wrote of his earliest variants, "for they have been differently conceived, and I did not repeat them merely to do them differently, but to go further."[1] In the case of *Bird in Space*, Brancusi's aim was not to represent a bird's external appearance but rather to convey its essence in abstract form.

MoMA's acquisition of this sculpture came seven years after a much-publicized trial related to the importation of an earlier variant. In 1926, Edward Steichen, the artist and later the director of the Museum's Department of Photography, returned to the United States from Paris with a version of *Bird in Space* made that same year, having recently purchased the sculpture from Brancusi's studio. Unconvinced that the object was a work of art, U.S. customs officials instead classified it among kitchen utensils and other utilitarian objects and imposed a hefty tax, from which an artwork would have been exempt. With the support of his growing network of American patrons, Brancusi launched a rebuttal, taking the case to trial in October 1927. After a yearlong battle that invoked an impressive list of art-world experts, the judge ruled in favor of the artist: "There has been developing a so-called new school of art, whose exponents attempt to portray abstract ideas rather than to imitate natural objects," he concluded. "The object is made of harmonious and symmetrical lines, and while some difficulty might be encountered in associating it with a bird, it is nevertheless pleasing to look at and highly ornamental, and as we hold under evidence that is the original production of a professional sculptor . . . we sustain the protest and find that it is entitled to free entry."[2]

Two years after MoMA acquired the variant of *Bird in Space* shown here, Alfred Barr included it along with five other works by Brancusi in his landmark exhibition *Cubism and Abstract Art*. In his now-famous catalogue text and diagram (p. 75), Barr singled out Brancusi as "the most original and most important of the near abstract sculptors."[3] MoMA's collection of the artist's work has since grown to twelve sculptures, including another bronze variant of *Bird in Space*, from 1941. —Jenny Harris

1. Constantin Brancusi, quoted in Anna C. Chave, *Constantin Brancusi: Shifting the Bases of Art* (New Haven, CT: Yale University Press, 1993), 207.
2. Ibid., 201.
3. Alfred H. Barr Jr., *Cubism and Abstract Art* (New York: The Museum of Modern Art, 1936), 116.

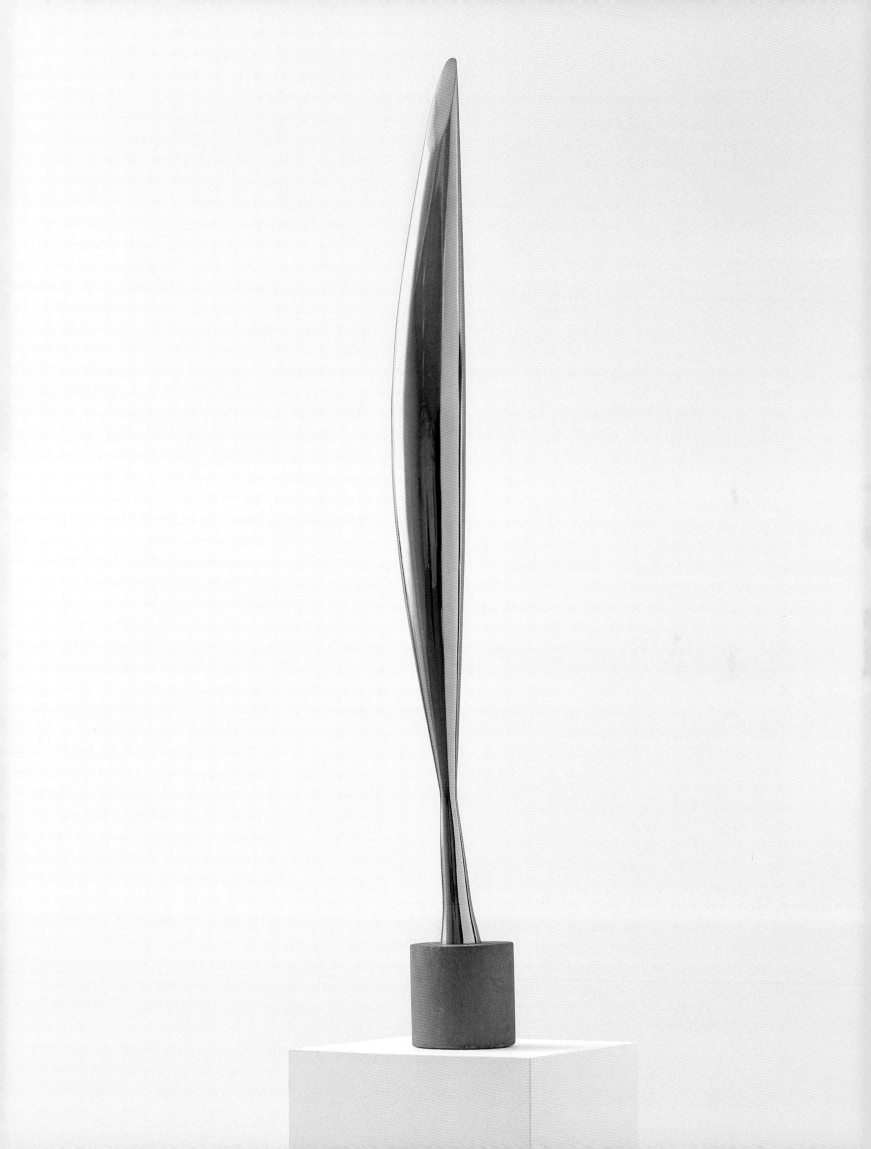

Salvador Dalí (Spanish, 1904–1989)

The Persistence of Memory. 1931
Oil on canvas, 9½ x 13 in. (24.1 x 33 cm)
Given anonymously, 1934

One of the most recognizable images of the twentieth century, *The Persistence of Memory* was painted under "exceptional circumstances," as Salvador Dalí would later recall, perhaps with a bit of characteristic mythologizing, in response to MoMA's standard artist questionnaire. During a "migraine attack," the then-twenty-seven-year-old artist revisited a canvas he had already painted: a barren coastline reminiscent of his native Catalonia. According to Dalí, the melting watches occurred to him around 10 p.m., and by midnight, the painting was finished.[1]

Dalí first showed *The Persistence of Memory* in June 1931 at Galerie Pierre Colle in Paris. The picture went unsold but was purchased shortly thereafter for $250 by dealer Julien Levy, who returned with it to New York. Levy first offered the painting to the Wadsworth Atheneum in Hartford, Connecticut, following the success of its groundbreaking Surrealist exhibition that November, *Newer Super-Realism*. The museum could not afford Levy's asking price and instead purchased another disquieting Dalí dreamscape, *Solitude* (1931). In 1934, after protracted negotiations over price, Levy finally agreed to sell *The Persistence of Memory* to MoMA for $350, which Alfred Barr secured from an anonymous donor. The acquisition was first presented in MoMA's fifth anniversary exhibition, which opened in November, and it immediately assumed landmark status in the Museum's galleries.

MoMA has been the beneficiary of a long and generous tradition of anonymous patronage: close to 1,400 works in the collection have been acquired to date from donors who asked that their gifts remain anonymous. In the case of Dalí's Surrealist masterpiece shown here, at the time of the painting's MoMA debut, *The New York Times* revealed the donor to be advertising executive and Museum trustee Helen Lansdowne Resor.

Described by colleagues as among the best copywriters of her generation, Resor is remembered as an erudite activist-patron: an early supporter of the Planned Parenthood Association, she was also active in the women's suffrage campaign, using her position as an executive at the J. Walter Thompson Company to hire unemployed suffragists after the ratification of the Nineteenth Amendment in 1920. Professionally, Resor's aesthetic legacy includes bringing Cecil Beaton, Norman Rockwell, and Edward Steichen into advertising. Privately, she amassed an impressive collection of modern art with her husband, Stanley, and in 1937, through Barr's introduction, commissioned a house by Mies van der Rohe for the family ranch in Jackson Hole, Wyoming, which was not realized.[2]

Resor's patronage of MoMA extended beyond the more than seventy gifts she gave during her lifetime. In the 1930s, she made an unconventional arrangement with Barr, providing him money to buy artworks for her during his frequent trips to Europe. These purchases were made with the understanding that MoMA could buy the works back within a year at the same price. Resor later extended this time limit; well into the 1950s, the Museum purchased from her works at their original 1930s prices, including Pablo Picasso's *Two Figures on a Beach* (1933) and the Balthus portrait *André Derain* (1936).

—Kayla Dalle Molle

1. Salvador Dalí, Artist Questionnaire in Object File, Department of Painting and Sculpture, MoMA, NY.
2. MoMA's Department of Architecture and Design holds more than fifty works related to Mies's unbuilt Resor House Project, including drawings and architectural models.

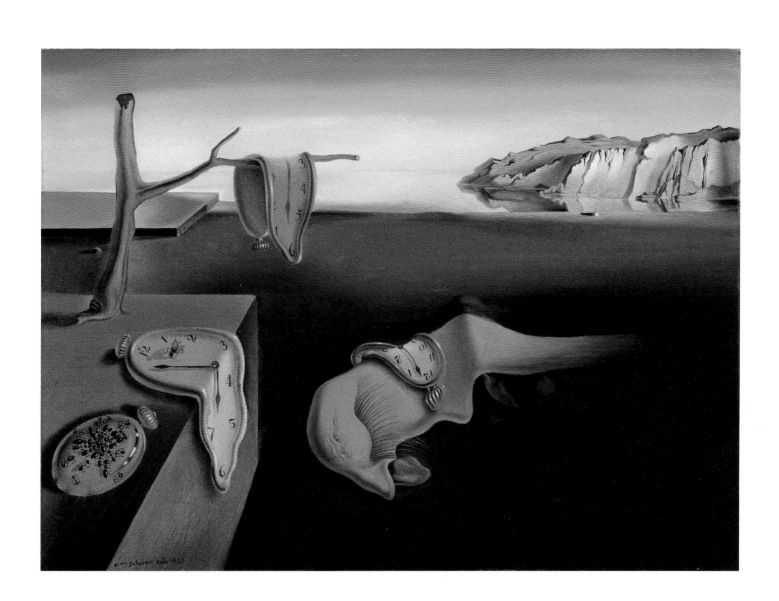

Alexander Calder (American, 1898–1976)

A Universe. 1934
Painted iron pipe, steel wire, motor, and wood with string,
overall: 40½ x 30 in. (102.9 x 76.2 cm)
Gift of Abby Aldrich Rockefeller (by exchange), 1934

In February 1934, the First Municipal Art Exhibition opened to the public at Rockefeller Center. This mayoral-sponsored "mile of art"—a massive display of nearly a thousand artworks for sale—aimed to assert the quality of contemporary American art and to establish New York as its commercial center. Proceeds from the twenty-five-cent admission fee were used to purchase works, which were selected by a small committee of museum directors and dispersed to various institutions citywide. Private purchases were also made, and one of the first sales went to MoMA cofounder Abby Aldrich Rockefeller: a "hoop-shaped" metal sculpture by Alexander Calder, which she specifically intended for MoMA's collection.[1] The thirty-five-year-old artist had received recognition for his sculptures propelled by small motors or manual cranks, which he had begun showing in Paris two years prior— a type of kinetic work dubbed "mobiles" by his friend Marcel Duchamp.[2]

When a group of recent acquisitions was installed at MoMA in May, however, the Calder piece from Rockefeller was not included. The artist felt that it was "not a very representative work," as Alfred Barr explained in a letter to Rockefeller, and he instead wanted for the Museum something "very much superior."[3] This accolade Calder bestowed on *A Universe*, from his first solo show at the Pierre Matisse Gallery in New York that year, a work Barr agreed showed the artist at his finest. The exchange was made in time for the director to include the piece in MoMA's fifth anniversary exhibition in November, where of the more than two hundred works on display, it was a particularly contemporary presence, as it was the most recent sculpture to be shown.

As exemplified in *A Universe*, Calder's early mobiles combine volumes, primary colors, and movement in compositional balances that recall the gravitational dance of celestial bodies. Here, a central Saturn-like form outlined in wire is orbited by two small painted wood spheres. An iron pipe bends through the center and is tied by clothesline to a motorized system concealed in a separate box. As the pipe moves, so the spheres travel along their pathways, with one full rotation taking forty minutes.

This initial purchase of Calder's work was to be followed by decades of continued support by MoMA, whose large collection of the artist's sculptures, works on paper, and design items represents the full extent of his career. Calder's objects have been long-standing fixtures of the institution—the hanging mobile *Lobster Trap and Fish Tail* was commissioned by the Museum for the stairwell of its new Goodwin-Stone building in 1939, and outdoor works such as *Black Widow* (1959) or *Sandy's Butterfly* (1964) can often be seen in the Abby Aldrich Rockefeller Sculpture Garden. In 1943, MoMA was the first museum to organize a Calder retrospective. Twenty-three years later, the artist offered a large selection of his work as a gift, writing to Barr, "I have long felt that whatever my success has been, has been greatly as a result of the show I had at the MoMA in 1943."[4]

—Annie Ochmanek

1. Alfred H. Barr Jr. to Mrs. John D. Rockefeller Jr., October 16, 1934. Museum Collection Files, Department of Painting and Sculpture, MoMA, NY.
2. Marcel Duchamp, as quoted in Alexander Calder, *Calder: An Autobiography with Pictures* (New York: Pantheon Books, 1966), 127.
3. Alfred H. Barr Jr. to Mrs. John D. Rockefeller Jr., May 15, 1934. Museum Collection Files, Department of Painting and Sculpture, MoMA, NY.
4. Alexander Calder to Alfred H. Barr Jr., May 18, 1966. Museum Collection Files, Department of Painting and Sculpture, MoMA, NY.

Sven Wingquist (Swedish, 1876–1953)

a. **Self-Aligning Ball Bearing**. 1907
Chrome-plated steel, 1¾ x 8½ in. (4.4 x 21.6 cm)
Gift of S. K. F. Industries, Inc., Hartford, CT, 1934

Aluminum Company of America, Pittsburgh, PA (American, established 1888)

b. **Outboard Propeller**. c. 1925
Aluminum, diam. 8 in. (20.3 cm)
Gift of the manufacturer, 1934

American Steel & Wire Company, Worcester, MA (American, established 1898)

c. **Bearing Spring**. Before 1934
Steel, 2½ x 1⁵⁄₁₆ in. (6.4 x 3.4 cm)
Gift of the manufacturer, 1934

Scovill Manufacturing Company, Plumbers Brass Goods Division, Waterbury, CT (American, established 1802)

d. **Flush Valve**. Before 1934
Chromium, 13⅜ x 12 in. (34 x 30.5 cm)
Gift of the manufacturer, 1934

The exhibition *Machine Art* ran for just seven weeks in 1934, yet it is of fundamental importance to MoMA's history as it counts as the genesis of the Museum's design collection. The show was not the first exhibition of architecture and design at MoMA—that distinction goes to 1932's *Modern Architecture: International Exhibition*, organized by Henry-Russell Hitchcock and Philip Johnson—but it was the first from which any design objects were acquired for the permanent collection. So significant was *Machine Art* that, in 1935, the Department of Architecture was renamed to become the Department of Architecture and Industrial Art (today is it the Department of Architecture and Design).

The springboard for *Machine Art* derived from conversations between Johnson, an architect and founding head of the department; Hitchcock, an architectural historian; Alan Blackburn, then executive director of the Museum; and Alfred Barr. Each was interested in exploring the territory of designs created by mass manufacture, divorced from an auratic creator and ripe for aesthetic appreciation based on formal qualities of geometry and material rather than practical use. Among the four hundred items exhibited in *Machine Art* were typewriter carriage springs, a toaster, cash register, pots and pans, a microscope, and petri dishes, exemplifying Barr's intention that the Museum collection and exhibition program "expand beyond the narrow limits of painting and sculpture."[1]

Included in the show, Sven Wingquist's *Self-Aligning Ball Bearing* was an important engineering advancement that allowed it to automatically correct for misalignment in factory machinery. Its hypnotic interlaced chrome-plated-steel circles and spheres, pitting delicacy of form against

1. Alfred H. Barr Jr., quoted in *Art in Our Time: A Chronicle of The Museum of Modern Art*, eds. Harriet S. Bee and Michelle Elligott (New York: The Museum of Modern Art, 2004), 29.

a.

b.

c.

d.

S. K. F. Industries, Inc., Hartford, CT

(Swedish, established 1907)

e. **Steel Balls**. Before 1934
Nickel-plated steel, dimensions range from a minimum
diameter of ⅜ in. (1 cm) to a maximum diameter of 1 in. (2.5 cm)
Gift of the manufacturer, 1934

American Steel & Wire Co., Worcester, MA

(American, established 1898)

f. **Spring**. Before 1934
Steel, 2¼ x 2¼ in. (5.7 x 5.7 cm)

g. **Textile Spring**. Before 1934
Steel, 9¼ x 2¼ in. (23.5 x 5.7 cm)

Gift of the manufacturer, 1934

extraordinary structural strength and speed, marked it as the perfect choice to grace the cover of the *Machine Art* catalogue. The works in the exhibition were arranged on pedestals, a deliberate co-option of the language of museum display. The message, derived from the Bauhaus principle of equal appreciation for art, architecture, and design, was clear: these works deserve the same consideration given to those often created in similar media but collected as art objects. *Machine Art* was "an anti-handcraft show," Johnson would recall in 1991. "The worship of the machine was an important part of it, kept over from the Futurists . . . Hitchcock and I were more interested in the style side of things—a word that everybody hated and still do—but we felt that a machine made an ideology, a theme that would be good to substitute for the handcrafts . . . The result, of course, was extraordinary. Everybody hated us deeply for being anti-art."[2]

 Machine Art marked the start of an important public conversation at MoMA about design as democratic, effective, and often inexpensive, and as a force with the potential to positively impact society at large. The Museum's program of circulating design exhibitions from the 1930s onward took this message to wide audiences both nationally and internationally, a conversation that continues today. —Michelle Millar Fisher

2. Oral History Program, interview with Philip Johnson, 1991. MoMA Archives, NY.

e.

f.

g.

Pablo Picasso (Spanish, 1881–1973)

The Studio. 1927–28
Oil on canvas, 59 in. x 7 ft. 7 in. (149.9 x 231.2 cm)
Gift of Walter P. Chrysler Jr., 1935

The work of Pablo Picasso was first exhibited at MoMA in *Painting in Paris from American Collections*, the fledgling institution's third exhibition, which opened in January 1930, just two months after the Museum itself opened to the public. MoMA's commitment to Picasso's work extends from the beginning to the end of his career and across all mediums; the Museum's holdings have grown to include more than 1,300 works by the artist, making it the second most comprehensive collection in the world, after that of the Musée Picasso in Paris.

In the winter of 1927, Picasso made a distinct turn from softer, curved figures to more spartan and attenuated forms, as seen in the monumental painting *The Studio* as well as *Painter and Model*, a closely related composition from 1928 also in the MoMA collection. In the case of *The Studio*, the painter (at left), his subject (a bowl of fruit, red tablecloth, and white plaster bust), and environs (door, table, and framed decor) are reduced to elementary networks of bisecting lines and overlapping geometries. The painter's implements are implied (the palette, a circular hole; the paintbrush, a line), his canvas blank. While *The Studio* has been linked to specific predecessors in the history of art, namely Diego Velázquez's *Las Meninas* (1656), here Picasso's formal simplifications of the painter and his atelier carry a strong aftertaste of Cubism, acknowledging earlier works from his own oeuvre, such as *Head of a Man with a Hat* (1912), as well as traditional masks from the Kwele and Igbo cultures of coastal West Africa.[1] In this way, *The Studio* expresses the encompassing power of Picasso's retrospective gaze.

In 1935, *The Studio* came to MoMA as a gift of automotive industry heir Walter Percy Chrysler Jr. The following year, Alfred Barr foregrounded Picasso's work in his sprawling, transformative exhibition *Cubism and Abstract Art*; twenty-eight works by the artist were shown, including *The Studio*. In 1939, Chrysler, who at the time owned the largest Picasso collection in the country, lent thirty-three works to *Picasso: Forty Years of His Art*, also organized by Barr and the most comprehensive retrospective of the artist's work to date. —Kayla Dalle Molle

1. This observation is indebted to William Rubin's discussion of Picasso's figures of the 1920s and '30s in *"Primitivism" in 20th Century Art: Affinity of the Tribal and the Modern* (New York: The Museum of Modern Art, 1985), 60.

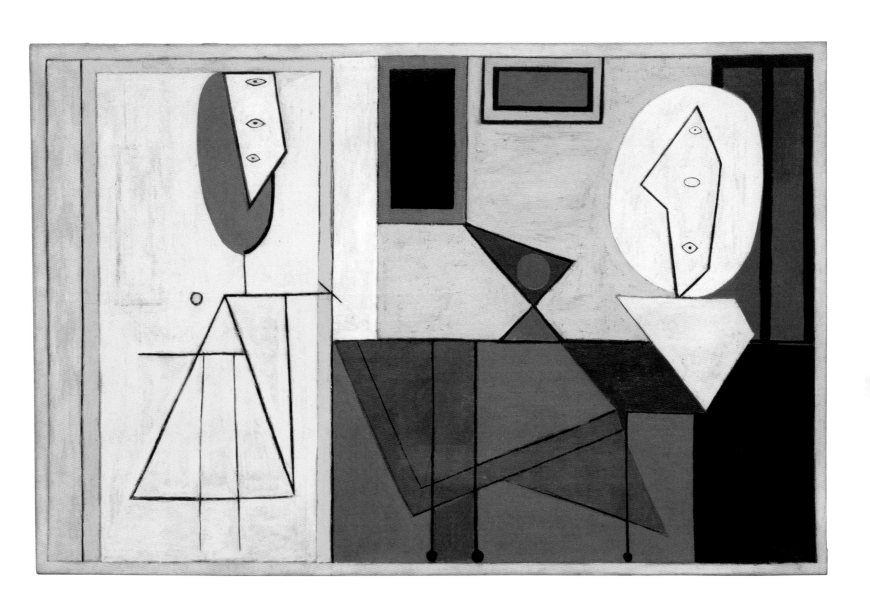

Edward Weston (American, 1886–1958)

Shell. 1927
Gelatin silver print, 9⅜ x 7⁵⁄₁₆ in. (23.8 x 18.6 cm)
Gift of Merle Armitage, 1935

Merle Armitage, a successful West Coast theater promoter and innovative book designer whose eclectic interests included collecting modern art, first encountered the work of Edward Weston in the early 1920s, an experience that, as Armitage later recalled, "resulted in a re-examination of my attitude toward photography."[1] His esteem was solidified several years later when he saw the artist's latest images: "Weston's crystal-clear photographs of shells, gourds, rocks, vegetables and plants were an introduction to a world of photographic tension, form and profound analysis of common-place objects . . ."[2] Armitage began buying Weston's prints, including *Shell*, which presents a nautilus that Weston had borrowed from the artist Henrietta Shore in 1927. Armitage's championing of the photographer eventually extended far beyond collecting to include writing and editing the first monograph devoted to Weston, published in 1932.

Three years later, Armitage gifted *Shell* and ten more Weston prints to MoMA. That a Los Angeles-based collector would donate these works to a museum on the East Coast perhaps indicates the conflicted status of photography during an era when the art world was undergoing its own "re-examination" of the medium. In 1935, no American museum was yet systematically collecting and displaying photography, although MoMA's program was evolving in that direction: the Museum acquired its first prints in 1930 and, in 1937, Beaumont Newhall organized MoMA's first comprehensive photographic exhibition, *Photography: 1839–1937*. When Weston learned the following year that the Museum was considering the establishment of a separate department for photography, he wrote to Newhall: "It is most fitting that the museum of modern art should be the first to do this. If anything is contemporary, it is photography; if anything is peculiarly American, it is photography. Count on me to cooperate in any way I can . . . Once it becomes known that the museum of modern art has a plan, and a section of important work, I can well imagine that offers, donations, and cooperation will flow in from unexpected sources. In time you should have a collection worthy of pilgrimage to see—the only one of its kind."[3]

In 1932, however, anxiety concerning photography's precarious status had compelled Weston himself to address the naysayers who argued that the medium should be disqualified as fine art because it relied on mechanical tools: "Results alone should be appraised; the way in which these are achieved is of importance only to the maker."[4] During the next decade, this defensive position was gradually replaced by more assured sentiments. MoMA formally established its Department of Photography in 1940, with Newhall as curator. Six years later, when the Museum mounted its first solo exhibition of Weston's work, Armitage marked the occasion by donating three more prints and producing a second monograph on Weston. In it, the poet Robinson Jeffers quipped: "Now I hear rumors of an old-fashioned controversy on the subject of art; can photography be considered an art? It seems to me that the question is rather verbal than vital."[5] —Kelly Sidley

1. Merle Armitage, untitled text in *Fifty Photographs by Edward Weston* (New York: Duell Sloan & Pearce Publishers, 1947), 1.
2. Ibid.
3. Edward Weston to Beaumont Newhall, March 1, 1938. Museum Collection Files, Department of Photography, MoMA, NY.
4. Edward Weston, "A Contemporary Means of Creative Expression," in *The Art of Edward Weston* (New York: E. Weyhe, 1932), 7.
5. Robinson Jeffers, untitled text in *Fifty Photographs by Edward Weston*, 8.

Kazimir Malevich (Russian, born Ukraine, 1878–1935)

Suprematist Composition: White on White. 1918
Oil on canvas, 31¼ x 31¼ in. (79.4 x 79.4 cm)
1935 Acquisition confirmed in 1999 by agreement with the
Estate of Kazimir Malevich and made possible with funds from
the Mrs. John Hay Whitney Bequest (by exchange), 1935

Kazimir Malevich made *Suprematist Composition: White on White* in Moscow the year following the Bolshevik Revolution, in the midst of the extreme privations that plagued Russia's cities. This spare work, a carefully brushed gray-white trapezoid set at an angle against a creamy white field, provides an unlikely banner of revolution. Yet in it, Malevich pushed the premises of the Suprematist philosophy he had defined in 1915 to a culmination. In his Suprematist pictures, Malevich had debuted a new abstract pictorial language of colored geometric shapes against a white background. These works, he announced, offered a "new painterly realism," jettisoning pictorial illusion and the realm of objects in order to leave the materialism of the world behind.[1] With *White on White*, even color was all but evacuated. Years later, Alfred Barr would describe the work as "the ultimate step in [Malevich's] effort to purify the art of painting—that is to eliminate every possible element of representational, decorative, or sensual order, leaving only what he called the 'pure experience of non-objectivity.'"[2]

Two decades later, it was more political upheaval—this time in Germany—that provided the context by which *White on White* entered MoMA's collection. In 1935, while doing research for his upcoming exhibition *Cubism and Abstract Art*, Barr visited legendary curator of experimental art Alexander Dorner in Hannover, where Dorner was serving as director of the Provinzialmuseum (today, the Landesmuseum).[3] Dorner explained his predicament. Malevich, he recounted, had spent time in Germany in 1927 preparing for an exhibition at the Große Berliner Ausstellung, but he was abruptly recalled to the Soviet Union, leaving some seventy works from the exhibition in the care of a friend, who had subsequently transferred them to Dorner. Malevich died in May 1935, just a few months before Barr's visit, without giving explicit directives regarding the artworks, and now Dorner was keeping them secreted in a hidden gallery at his museum, worried that they would be seized by Nazi officials in their campaign to rid Germany of what they had tarred "degenerate" art.

Resolving with Dorner that Malevich's works would be safer out of Germany, Barr arranged to purchase four, including *White on White*, with a discretionary fund provided by Abby Aldrich Rockefeller; he then smuggled them out of the country, the unstretched canvases wrapped around an umbrella and concealed in his briefcase. It was in the nick of time. Dorner's museum was "the last redoubt," as Barr recalled years later. "Within a year or so it was closed, its works of art dispersed, destroyed, or sold abroad" by the Nazis.[4] In 1999, the acquisition of these works by MoMA was confirmed through a settlement with Malevich's heirs. —Kayla Dalle Molle

1. Kazimir Malevich, *Ot kubizma k suprematizmu: novyi zhivopisnyi realizm (From Cubism to Suprematism: New Painterly Realism)* [1915], exh. brochure; reprinted in Aleksandra Shatskikh, ed., *Kazimir Malevich. Sobranie sochinenii v piati tomakh*, vol. 1 (Moscow: Gileia, 1995), 27–34.

2. Alfred H. Barr Jr. to Sarah Newmeyer, July 29, 1947. Museum Collection Files, Department of Painting and Sculpture, MoMA, NY.

3. Leah Dickerman, "Abstraction in 1936: Cubism and Abstract Art at The Museum of Modern Art," in *Inventing Abstraction, 1910–1925: How a Radical Idea Changed Modern Art* (New York: The Museum of Modern Art, 2012), 368.

4. Alfred H. Barr Jr., quoted in Samuel Cauman, *The Living Museum: Experiences of an Art Historian and Museum Director, Alexander Dorner* (New York: New York University Press, 1958), 108.

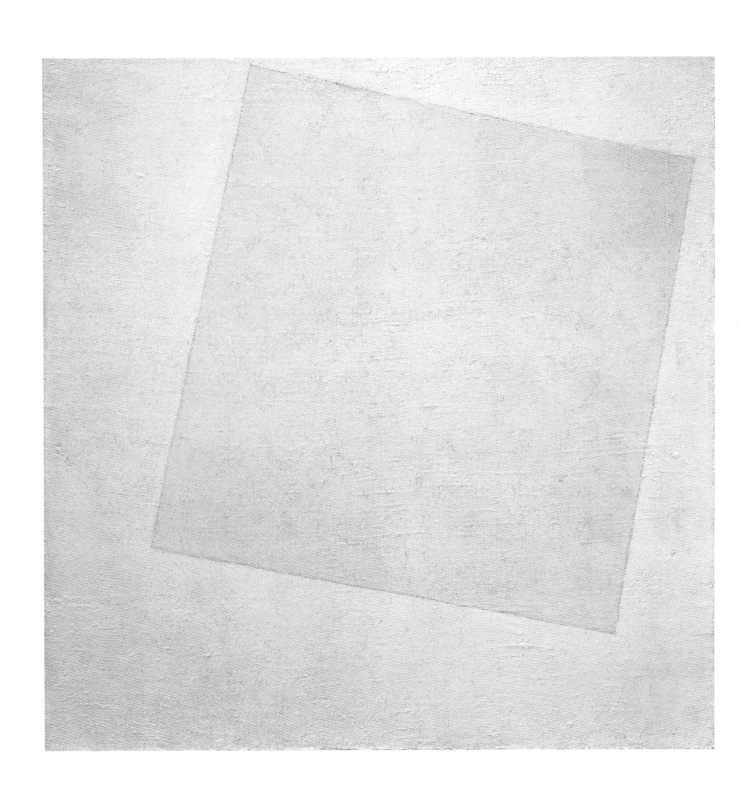

René Magritte (Belgian, 1898–1967)

The False Mirror. 1929
Oil on canvas, 21¼ x 31⅞ in. (54 x 80.9 cm)
Purchase, 1936

As with many other works in the MoMA collection, René Magritte's *The False Mirror* first came into the Museum as part of a loan for a temporary exhibition; specifically, it was one of seven Magritte paintings included in the landmark show *Fantastic Art, Dada, Surrealism*, which opened in December 1936. Like *The False Mirror*, most of the works on display were borrowed from Europe: to assemble such an ambitious exhibition, Alfred Barr had spent the previous summer based in Paris, visiting artists, galleries, and collectors in search of the best possible works to include in the show.

At that time, however, Magritte had long relocated to his native Belgium. The three years he had spent in Paris in the late 1920s—a prolific period during which he painted *The False Mirror*—had failed to fully integrate him within the Surrealist group of poets and artists gathered around André Breton. As for Barr, his agenda that summer was too hectic to allow him to make a special trip to Brussels to meet Magritte, but during a visit to London in July to see *The International Surrealist Exhibition*, Barr did cross paths with E. L. T. Mesens, leader of the Belgian Surrealists and an avid champion of his compatriot. "Magritte must be as well-represented in your show as Dali, Max Ernst or Miró," Mesens argued later to Barr. "Just because journals like *Minotaure* and *Cahiers d'Art* have always presented Magritte as the poor relation does not mean that his importance must always be underestimated."[1]

Another advocate of Magritte's work was the Dada and Surrealist artist Man Ray. In fact, it was in Man Ray's Paris apartment that Barr first encountered *The False Mirror*, which Man Ray had bought from Mesens a few years earlier, enthusiastically reporting that Magritte's "'eye of sky' is hanging in my apartment, and it sees a lot of things! For once a painting sees as much as it is seen itself."[2] While choosing among Man Ray's own works for the show, Barr hastily scribbled "Magritte eye" at the end of his list of pieces seen "chez Man Ray"; not long after, he requested the painting for the exhibition.[3]

Traveling aboard the SS *Lafayette* with dozens of other loans, the painting arrived in New York on October 22. As the show opened, MoMA cofounder Abby Aldrich Rockefeller offered $2,000 to acquire some of the works on view; among Barr's picks was *The False Mirror*. The work's noteworthy provenance added to its inherent desirability, demonstrating Man Ray's artistic patronage and placing the painting at the heart of the Surrealist network. As Barr wrote to Man Ray, "We are delighted to have it both for itself and because it comes from your collection."[4]

Depicting a lashless eye whose iris has been incongruously replaced by a cloud-swept blue sky, *The False Mirror* offers an inextricable visual puzzle: often hung high, the enormous eye seemingly watches Museum visitors below while simultaneously inviting them to look through its iris as through a window—or is it a mirror? —Charlotte Barat

1. E. L. T. Mesens to Alfred H. Barr Jr., October 25, 1936. Registrar Exhibition Files, Exh. #55. MoMA Archives, NY.
2. Man Ray to E. L. T. Mesens, July 12, 1933. E. L. T. Mesens Papers, box 9, folder 16. Getty Research Institute Special Collections, Los Angeles.
3. "AHB Notebook, Paris and Netherlands," Alfred H. Barr Jr. Papers [XIII.34, mf 3261: 674/675]. MoMA Archives, NY.
4. Alfred H. Barr Jr. to Man Ray, December 24, 1936. Registrar Exhibition Files, Exh. #55. MoMA Archives, NY.

Walt Disney (American, 1901–1966)
Ub Iwerks (American, 1901–1971)

Steamboat Willie. 1928
35mm film (black and white, sound), 8 minutes
Acquired from The Walt Disney Corp., 1936

In August 1935, a few months after the founding of the MoMA Film Library, Iris Barry, the Museum's first film curator, found herself in the lush garden at Pickfair, the Hollywood home of movie stars Mary Pickford and Douglas Fairbanks. To the assembled group of studio bosses, well-known directors, and celebrities, including Samuel Goldwyn, Walt Disney, Ernst Lubitsch, and Harold Lloyd, Barry pitched a radical idea: their films were more than simply commercial products; they were worthy of study and preservation, in a museum devoted to modern art. Barry knew that if she was going to fulfill her curatorial goal "to trace, secure and preserve the important films, both American and foreign, of each period since 1889," she needed to cultivate the support of Hollywood, and that meant deftly navigating the tensions between art and commerce.[1] MoMA's Film Library would not compete with the movie studios on a commercial basis, Barry assured the group; its purpose would be solely educational and to facilitate a more academic approach to the medium.

The goodwill Barry engendered that evening soon reaped the benefit of the donation of *Steamboat Willie* by The Walt Disney Corp. This pioneering animated short film created by Walt Disney and Ub Iwerks introduced the soon-to-be-iconic Mickey Mouse along with a synchronized soundtrack. Perhaps in response to the financial success of *The Jazz Singer* (1927), Disney recognized that audiences clamored for sound and technical innovation in their cinematic entertainment.

Steamboat Willie premiered on November 18, 1928, at New York's Colony Theater. What audiences experienced that day was an animated character imbued with humanistic traits, a sense of fair play, and a hale-and-hearty constitution. When the film opens, we see a chipper Willie—Mickey Mouse—steering a riverboat, leading us to believe he is the ship's captain. Yet in what would become an all-too-typical situation for Mickey, we quickly learn that he is, in fact, the vulnerable but kind underling to a cruel, domineering boss. Mickey eventually bests his intimidator and sails merrily along. He gleefully whistles, and in response, the ship's steam pipes chirp back in rhythm. This black-and-white film is charmingly syncopated with a nautical-themed score by Wilfred Jackson.

The combination of a synchronized soundtrack, an original animated character who would quickly become a ubiquitous figure in popular culture, and an enchanting narrative distinguished *Steamboat Willie* and solidified Disney as an eminent animator, a tribute that remains true nearly ninety years later. —Anne Morra

1. John E. Abbott and Iris Barry, "An Outline of a Project for Founding the Film Library of The Museum of Modern Art" [1935]; reprinted in *Film History* 7, no. 3 (Autumn 1995): 327.

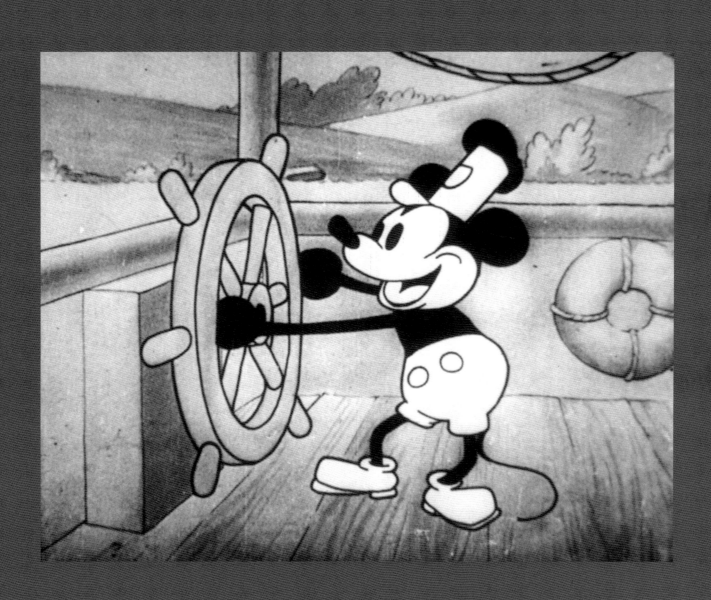

From the Archives: **Alfred Barr's Cubism and Abstract Art chart**, 1936

a. Alfred Barr's hand-drawn draft of the chart for the cover of the exhibtion catalogue, 1936
Alfred H. Barr Jr. Papers, VI.A.38. MoMA Archives, NY

b. Cover of the catalogue, 1936
Publications Archive. MoMA Archives, NY

In March 1936, Alfred Barr mounted the exhibition *Cubism and Abstract Art*, the first in a series of five exhibitions "planned to present in an objective and historical manner the principal movements of modern art" and one that has since been lionized as the Museum's foundational statement on the subject.[1] For the dust jacket of the exhibition catalogue, Barr set out to chart the evolution of modern art movements, beginning in 1890 and continuing through 1935, illustrating how cross-pollination and hybridization led to later art forms.

In Barr's schematic, painting from fin-de-siècle France, infused with non-Western influences such as "Japanese Prints," "Near Eastern Art," and "Negro Sculpture," led to Fauvism and Cubism, which then commingled with other sources like the "Machine Esthetic" to spawn such movements as (Abstract) Dadaism and Surrealism, Suprematism, Constructivism, and de Stijl. The result was the seemingly irrevocable march of modern art toward abstraction, be it biomorphic or geometric.

Barr was no stranger to the art of diagramming, and he traced these developments with the tools and scientific approach of a genealogist. First as a student and then as a college instructor, he produced scores of charts, delineating the evolution of the arts of antiquity, of Northern European painting, and of the Italian Renaissance. He initially attempted to categorize more recent art in 1927 with his "-ism dictionary" and to graph the development of modern artistic expression as a professor at Wellesley College, and again in 1932 on the occasion of his exhibition *A Brief Survey of Modern Painting* at MoMA.

But in 1936, Barr's thinking on the matter coalesced at a quick pace. During the mere six weeks in which the catalogue was written and produced, he made numerous drafts of the chart that reveal his shifts in thinking, such as his identification of artists whom he considered exemplars of each movement. The final chart, however, includes but seven names and situated Paul Cézanne, Paul Gauguin, Georges-Pierre Seurat, and Vincent van Gogh in positions of seminal importance at the top, perhaps of no coincidence, as it was these four artists to whom the Museum had devoted its inaugural exhibition in 1929.

Despite the finished chart's being imbued with the aura of an immutable, canonical text, Barr, on the occasion of a possible reissue of the book, declared that his original job had been too hastily done and emphasized that the chart contained errors that needed to be corrected. The bold design of the chart itself reveals Barr's long-standing interest in typography and design, art forms that he championed from the founding of the Museum. Today the chart has become an icon of the historical development of modern art. —Michelle Elligott

1. Alfred H. Barr Jr., *Fantastic Art, Dada, Surrealism* (New York: The Museum of Modern Art, 1936), 7.

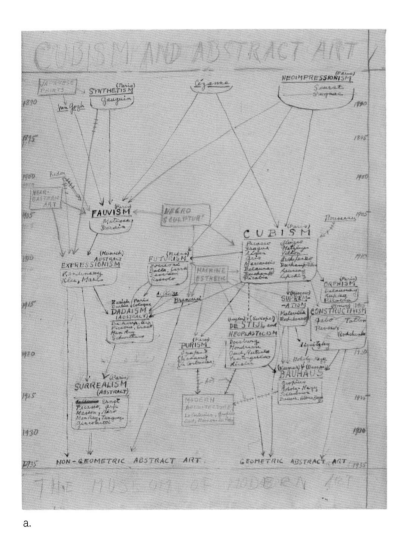

a.

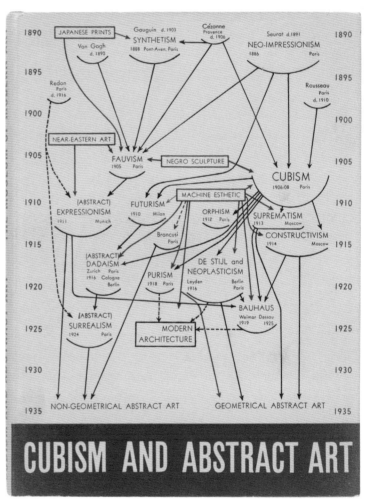

b.

Piet Mondrian (Dutch, 1872–1944)

Composition in White, Black, and Red. 1936
Oil on canvas, 40¼ x 41 in. (102.2 x 104.1 cm)
Gift of the Advisory Committee, 1937

This painting, composed solely of vertical and horizontal lines and rectangular forms in a palette of white, black, and red, was the first work by Piet Mondrian to enter the MoMA collection. Mondrian was a member of de Stijl, the renowned Dutch avant-garde movement led by Theo van Doesburg and comprised of artists, poets, architects, and designers who sought to move away from direct representations of nature and toward a more abstract ideal.

The style for which Mondrian is best known, Neo-Plasticism, evolved out of his collaborations with de Stijl. In 1920, Mondrian wrote that the "New Plastic . . . is [an] *entirely new painting* in which all painting is resolved, pictorial as well as decorative."[1] The artist continued to develop this approach for the rest of his career. In 1932, Mondrian invented what he called the "double line," a pictorial device that allowed him to minimize black and to achieve more luminosity in his paintings.[2] Made four years after this innovation, *Composition in White, Black, and Red* shows Mondrian's continued exploration of the double line: in the painting's lower right quadrant, the artist even doubled the double line so that the three lines can be read either as a single visual unit or as separate pairs of parallel lines.

Alfred Barr became increasingly involved with Mondrian's work while preparing for the exhibition *Cubism and Abstract Art* (1936), visiting the artist's studio in Paris with his wife, Margaret Scolari Barr, the June prior to select works for the show. Mondrian, in turn, was well represented in the landmark exhibition, with a group of nine paintings made between 1911 and 1935. In the catalogue, Barr lauded Mondrian as one of the "finest artists of [his] time."[3]

A few months after the exhibition took place, George L. K. Morris, an American abstract artist and artistic patron, visited Mondrian's studio, and he purchased the not-yet-completed *Composition in White, Black, and Red* on behalf of the Museum's Advisory Committee, a group of young collectors who served as junior trustees. Mondrian and Barr stayed in close contact about the painting throughout the remainder of the year. Indeed, the artist wrote to Barr in early December, "I am sorry I haven't been able to finish the painting earlier, but a large painting is quite difficult to do, isn't it?"[4] Nevertheless, Mondrian finished the work soon thereafter, and while the painting was en route to New York later in the month, Barr replied to the artist with excitement, "Believe me, we congratulate ourselves on having acquired what we believe to be one of your finest works."[5] The painting officially entered MoMA's collection in early 1937. —Talia Kwartler

1. Piet Mondrian, "Neo-Plasticism: The General Principle of Plastic Equivalence" [1920]; reproduced in *Art in Theory, 1900–2000: An Anthology of Changing Ideas*, ed. Charles Harrison and Paul Wood (Malden, MA: Blackwell Publishing, 2003), 290 (emphasis original).

2. See Joop Joosten with Angelica Zander Rudenstine, "Chronology," in Yve-Alain Bois, Joop Joosten, Angelica Zander Rudenstine, and Hans Janssen, *Piet Mondrian, 1872–1944* (Boston: Little, Brown & Company, 1994), 63.

3. Alfred H. Barr Jr., *Cubism and Abstract Art* (New York: The Museum of Modern Art, 1936), 141.

4. Piet Mondrian to Alfred H. Barr Jr., December 3, 1936. Museum Collection Files, Department of Painting and Sculpture, MoMA, NY. Translated by Charlotte Barat.

5. Alfred H. Barr Jr. to Piet Mondrian, December 18, 1936. Museum Collection Files, Department of Painting and Sculpture, MoMA, NY.

Gustav Klutsis (Latvian, 1895–1938)

a. **Under the Banner of Lenin—Socialist Construction**. 1930
Publisher: State Publishing House, Moscow and Leningrad
Print run: 30,000
Lithograph, 38⅜ x 28¼ in. (97.5 x 71.8 cm)

b. **Storming the Third Year**. 1930
Publisher: IZOGIZ (State Publishing House of Graphic Arts),
Moscow and Leningrad
Print run: 10,000
Lithograph, 40¾ x 29¼ in. (103.5 x 74.3 cm)

c. **We Will Pay Back Our Coal Debt to the Country**. 1930
Publisher: IZOGIZ (State Publishing House of Graphic Arts),
Moscow and Leningrad
Print run: 20,000
Lithograph, 41⅛ x 29⅛ in. (104.5 x 74 cm)

Gustav Klutsis (Latvian, 1895–1938)
Sergei Senkin (Russian, 1894–1963)

d. **May Day**. 1931
Publisher: OGIZ-IZOGIZ (Union of State Book and
Magazine Publishers), Moscow and Leningrad
Print run: 30,000
Lithograph, 40⅝ x 28¾ in. (103.2 x 73 cm)

Purchase Fund, Jan Tschichold Collection, 1937

As a demonstration of how modern art could filter into everyday life, posters fascinated Alfred Barr, whose program for the Museum embraced graphic design as an accessible and technologically progressive form of expression that merited as much attention as painting or sculpture. Barr included posters in both his landmark survey exhibitions *Cubism and Abstract Art* (1936) and *Fantastic Art, Dada, Surrealism* (1936–37), and the Museum devoted several exhibitions exclusively to posters during the early to mid-1930s. In 1936–37, the two groups of posters highlighted here were among the first examples of contemporary graphic design to enter the MoMA collection. The punchy slogans, limited redblack palette, dramatic contrasts in scale, and use of photomontage created an arresting impact, fusing radical art and ideology to communicate powerful political messages in support of, respectively, the Soviet Union's First Five-Year Plan and the Republican cause in the Spanish Civil War.

Gustav Klutsis, a pioneer of photomontage, often used photographs that he took himself, manipulating scale to create dramatic perspective effects. Seven of his posters celebrating the Soviet Union's industrial and social transformation were among a group of sixty-seven European avant-garde posters the Museum purchased from Jan Tschichold, a leading advocate of innovative machine-age graphic design. When MoMA bought the posters in 1937, Tschichold was a financially destitute refugee from Nazi Germany, where he had been branded a Bolshevik, not least for his open admiration of the Soviet revolutionary avant-garde (for several years he even used the name Iwan) and for his extensive correspondence with communists such as Klutsis in the preparation of his influential writing on the New Typography.

a.

b.

c.

d.

Jaume Solá Valleys (Catalan, c. 1915–1995)

e. **Mes Homes! Mes Armes! Mes Municions! (More Men! More Weapons! More Munitions!)**. 1936
Publisher: Union General de Trabajadores (General Workers' Union),
Barcelona; Partit Socialista Unificat (United Socialist Party), Barcelona;
Propaganda and Press Section, Catalan Ministry of Defense
Lithograph, 39 x 27½ in. (99.1 x 69.8 cm)
Gift of Christian Zervos, 1936

H. V. (Catalan)

f. **Alerta UGT Está Contra el Feixisme (The UGT Guards Against Fascism)**. 1936
Publisher: Union General de Trabajadores (General Workers' Union), Barcelona;
Sindicat de Dibuixants Professionals (Union of Professional Designers), Barcelona;
Propaganda and Press Section, Catalan Ministry of Defense
Lithograph, 39 x 27½ in. (99.1 x 69.8 cm)
Gift of Christian Zervos, 1936

Attributed to Augusto (Spanish)

g. **What Are You Doing to Prevent This?** 1937
Publisher: Ministerio de Propaganda (Ministry of Propaganda), Madrid
Lithograph, 31¾ x 22 in. (80.6 x 55.9 cm)
Special Purchase Fund, 1937

Antonio Cañavate Gómez (Spanish, 1902–1987)

h. **Evacuad Madrid (Evacuate Madrid)**. 1937
Publisher: Junta Delegada de Defensa de Madrid (Board for the Defense of Madrid)
Lithograph, 39½ x 28¼ in. (100.3 x 71.8 cm)
Purchase, 1937

The first set of Spanish Civil War posters, acquired in 1936, were initially published in Barcelona under the auspices of the Union General de Trabajadores (General Workers' Union) and the Catalan Ministry of Defense. One poster depicts a disciplined row of men pressing forward with bayonets to spear the red swastika of fascism, while another urges women to join the combat forces. The acquisition came as a gift of Christian Zervos, the founding editor of the Paris-based international art magazine *Cahiers d'Art* who had already embarked on a monumental study of the oeuvre of his friend Pablo Picasso. Zervos, a member of the Communist Party, was outspoken in his praise for Picasso's commitment to the Republican cause and of the artist's controversial mural in response to the indiscriminate aerial bombardment of a civilian population in Guernica in November 1936. Picasso's painting helped to create a groundswell of international support for the Republican struggle, including MoMA's purchase of eighteen more Spanish posters with support from the North American Committee to Aid Spanish Democracy. Drawing parallels with contemporary American design, the Spanish works were displayed in the exhibition *Spanish and U.S. Government Posters*, shown at MoMA at the end of 1938. Contemporary political posters were also exhibited during World War II. Yet such explicit political engagement was the exception at the Museum, where aesthetic and technical concerns would typically dominate MoMA's presentation of even the most politically radical propaganda art. —Juliet Kinchin

e.

f.

g.

h.

Walker Evans (American, 1903–1975)

a. **Posed Portraits, New York**. 1931
Gelatin silver print, 6 ¹⁵⁄₁₆ x 5½ in. (17.7 x 13.9 cm)

b. **Westchester, New York, Farmhouse**. 1931
Gelatin silver print, 6⅞ x 7⅜ in. (17.5 x 18.8 cm)

c. **Breakfast Room at Belle Grove Plantation, White Chapel, Louisiana**. 1935
Gelatin silver print, 6 ¹⁵⁄₁₆ x 8 ⁹⁄₁₆ in. (17.7 x 21.7 cm)

Anonymous Fund, 1938

d. **Bethlehem Houses and Steel Mill, Pennsylvania**. 1935
Gelatin silver print, 7 ⁷⁄₁₆ x 9 ⁷⁄₁₆ in. (18.9 x 24 cm)
Gift of the Farm Security Administration, 1938

No photographer is more closely tied to the early years of MoMA than Walker Evans. His *Lehmbruck: Head of a Man* (c. 1929) was the first photograph to enter the collection, in 1930, and he was featured in the first exhibition that included photography—*Murals by American Painters and Photographers* (1932), organized by Lincoln Kirstein—alongside contemporaries such as Berenice Abbott, Ben Shahn, Charles Sheeler, and Edward Steichen. The next year *Walker Evans: Photographs of Nineteenth-Century Houses*, also organized by Kirstein, was the first solo exhibition of a photographer at the Museum, and Kirstein made a major gift of that work to MoMA. Evans would be featured in five more exhibitions before the Department of Photography was formally established in 1940.

These four Evans prints all came to MoMA in 1938. *Bethlehem Houses and Steel Mill, Pennsylvania* was part of a large gift from the Farm Security Administration (F.S.A.), the New Deal agency whose influential photographic program documented the conditions of American farming communities during the Great Depression. The F.S.A.'s gift included images by almost all of its photographers: Evans, Shahn, Theodor Jung, Dorothea Lange, Russell Lee, Carl Mydans, Arthur Rothstein, and John Vachon.

The other three works were part of a portfolio created especially for the Museum. In 1935, George Parmly Day, founder of the Yale University Press, wrote to MoMA president A. Conger Goodyear about a postcard project he had recently undertaken with the artist Samuel Chamberlain called "The American Scene." He suggested MoMA might be interested in doing something similar, arguing, "If it is true that 'picture post cards constitute the poor man's art gallery[,]' it is obviously desirable that the post cards available for purchase throughout the United States should be of the highest possible standard in every way instead of being, as they now are only too often, quite atrocious from an artistic standpoint." [1]

The Museum's executive director, Thomas D. Mabry Jr., *was* interested, and suggested the collaboration of Evans, who had himself been a collector of postcards since childhood, amassing thousands over his lifetime. A contract was executed and a commission forwarded, but over the next two years the project never really got off the ground, at least in part due to Evans's notoriously unhurried pace. (Mabry once wrote to him, complaining, "You are so slow that we will all be dead before anything gets started." [2]) In 1938, Mabry suggested that twenty-five of Evans's prints—including these three—join the collection in place of his fulfilling the postcard commission. It was an important acquisition, and almost overnight, Evans's work became nearly half of the Museum's nascent collection of photography. Six months later, eleven of the images in the portfolio were included in the exhibition and book *Walker Evans: American Photographs*, which went on to become one of the defining bodies of work of twentieth-century art in any medium. —Kristen Gaylord

1. George Parmly Day to A. Conger Goodyear, May 25, 1935. Department of Photography Files, MoMA, NY.
2. Thomas D. Mabry Jr. to Walker Evans, November 27, 1936. MoMA Exhs., 78.3. MoMA Archives, NY.

a.

b.

c.

d.

Sergei Eisenstein (Russian, 1898–1948)

Battleship Potemkin. 1925
35mm film (black and white and hand-colored, silent), 75 minutes
Acquired from Reichsfilmarchiv, 1938

Even before the founding of MoMA, key figures who would soon become central to the establishment of the Museum were enthusiastically engaged with Russian cinema, whose filmmakers were attracting international attention for their technical innovation, fearless experiments with editing, and unabashed antiestablishment criticism. Before being appointed the first curator of the Film Library, Iris Barry had founded the London Film Society, which during its inaugural year in 1925, hosted Russian director Sergei Eisenstein as a guest speaker. Late that same year, Alfred Barr, then still a college instructor, traveled to Russia; on the day he arrived he attended a *kino-party* (private screening) where Vsevolod Pudovkin and Mikhail Doller's homage to the October Revolution, *The End of St. Petersburg*, was shown. When Barry and John Abbott, director of the Film Library, toured Europe in 1936 to acquire new work for the Museum, Russian-made films were high on their *want* list.

Battleship Potemkin, Eisenstein's cinematic homage to the 1905 rebellion against Czarist troops, is frequently considered one of the most distinguished films of the twentieth century. First shown at Moscow's Bolshoi Theatre on December 21, 1925, the film is comprised of five distinct sections that chronicle the mutiny on the battleship and its aftermath, including the slaughter of civilians on the Odessa steps and culminating in the ship's victorious departure. Eisenstein's ingenious style of editing manipulates time and physical action in order to heighten dramatic tension, escalate rhythm, and engender sympathy for the civilians and hostility toward the soldiers. Perhaps the best-known image from the film occurs during the battle on the Odessa steps, in which an elderly woman is wounded in the eye in close-up and screams in horror after having been shot by the Czarist troops. The editing in this montage is metrical and deliberately repetitive, allowing for the near-simultaneous compression and elongation of time to create a disorienting effect that emphasizes the confusion of battle. Contemporary filmmakers such as Francis Ford Coppola, Brian De Palma, and George Lucas, to name a few, have incorporated similarly structured scenes in their own films.

In 1938, MoMA acquired a German-titled 35mm print of *Battleship Potemkin* from the Reichsfilmarchiv that showed evidence of censorship. The following year, another incomplete print was acquired from the Soviet film export company Soyuzintorgkino, which included scenes that were missing from the German copy and subsequently combined by MoMA into the production of a new negative. In 2005, eighty years after *Battleship Potemkin* premiered, a European restoration of the film that included many previously censored scenes and correct translations of the Russian intertitles was shown at the Berlin Film Festival. —Anne Morra

From the Archives: **The Goodwin-Stone Building**, 1939

Philip L. Goodwin (American, 1885–1958)
Edward Durell Stone (American, 1902–1978)

a. **Model of The Museum of Modern Art, New York City, New York**. 1939
Wood, plastic, and linoleum, 15¾ x 23¾ x 39⅝ in. (40 x 60.3 x 100.6 cm)
Building Fund, 1939

b. Facade of The Museum of Modern Art's first permanent building,
designed by Philip L. Goodwin and Edward Durell Stone, 1939.
Photograph by Robert Damora
Photographic Archive. MoMA Archives, NY

Ten years after mounting its premier exhibition in rented quarters on Fifth Avenue, The Museum of Modern Art marked the beginning of its second decade with a move into a new flagship building, one that had been expressly designed as both a bold affirmation of the Museum's modernist ideals as well as a functional solution to housing its burgeoning collection and ambitious slate of exhibitions. Several Beaux-Arts town houses had been razed to construct the building, including the town house at 11 West 53rd Street that the Museum had leased as its headquarters for three years from John D. Rockefeller Jr., husband of MoMA cofounder Abby Aldrich Rockefeller. In their place, the sleek International Style building designed by Philip L. Goodwin and Edward Durell Stone rose in striking contrast to the surrounding pre–World War I architecture, signaling the arrival of a new era.

The development of the new building began in 1935 at the behest of the Museum's Board of Trustees. The members of a select Building Committee, including Alfred Barr, Nelson Rockefeller, and A. Conger Goodyear, chose Goodwin to serve as lead architect. A trustee himself, Goodwin clearly had the advantage of knowing his clients well, yet his traditional style tended toward Beaux-Arts design. Barr strongly advocated for the addition of a well-known European modernist such as Mies van der Rohe or Walter Gropius to counter Goodwin's conservative tendencies; Goodwin insisted on working with an American. In the end, the Committee settled on the thirty-three-year-old Stone, an avowed modernist who was just emerging to prominence in the field.

From its glass-walled base, the Goodwin-Stone building rises five more stories, a white marble box topped by parallel rows of windows above a two-story glass wall. This striking element of the facade was constructed using a revolutionary new form of glass called Thermolux, which allowed for even, diffuse light to pour into the galleries while cutting heat loss by two-thirds over conventional glass. Perched above, the Members' Penthouse Lounge opened onto a Le Corbusier-inspired rooftop patio with distinctive "portholes" cut into the overhang open to the sky, while below, a new sculpture garden stretched along West 54th Street.

The interior included three floors of exhibition galleries with triple the space of the previous town house, a basement auditorium for on-site film screenings, a library with sound-absorbing cork flooring, and two floors of office space. In addition to the Thermolux glass walls, the loftlike galleries introduced innovative features now common in modern exhibition spaces, such as movable partitions, plain white walls, and adjustable track lighting.

To commemorate the opening of the building in May 1939, as the rise of totalitarianism overseas was causing increasing alarm, President Franklin Roosevelt in a radio address cast the Museum as an exemplar of cultural freedom, a "citadel of civilization." "In encouraging the creation and enjoyment of beautiful things," Roosevelt said, "we are furthering democracy itself."[1] —Seth Anderson

1. Franklin D. Roosevelt, address on The Museum of Modern Art as printed in the *New York Herald Tribune*, May 11, 1939. Monroe Wheeler Papers, I.146. MoMA Archives, NY.

a.

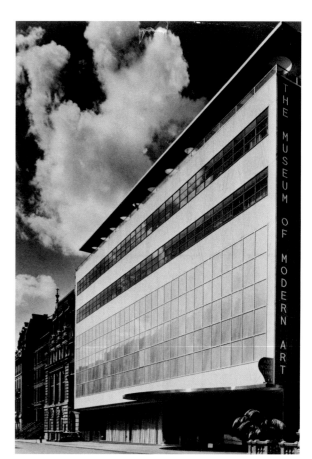

b.

Ernst Ludwig Kirchner (German, 1880–1938)

Street, Berlin. 1913
Oil on canvas, 47½ x 35⅞ in. (120.6 x 91.1 cm)
Purchase, 1939

The Museum of Modern Art caused a sensation in spring 1931 when it dedicated an entire exhibition to German painting and sculpture. As Alfred Barr noted at the time, the most difficult works in the show by far for the American public were the Expressionist paintings by the Brücke group.[1] One of the characteristic examples of this movement was Ernst Ludwig Kirchner's *Street, Berlin*, on loan from the Nationalgalerie in Berlin. Kirchner was the leading member of Die Brücke, a society of artists that formed in Dresden in 1905 and would go on to be at the vanguard of German Expressionism. Shortly after the group disbanded in 1913, Kirchner, feeling isolated and living precariously in Berlin, painted several street scenes of the pulsating metropolis, work now considered his most important series. Here, the artist's use of arbitrary color and distorted forms serve as hallmarks of this Expressionist moment, in addition to the dynamic composition created by his vigorous brushwork and his repeated use of slightly curving verticals. Kirchner chose to represent the energy and intensity of the rapidly modernizing German capital by focusing on a pair of prostitutes, identifiable as such by the feather headdress worn by one as well as the women's excessive makeup and flamboyant walk. Despite its progressive style and content, Kirchner's work was initially appreciated in both Germany and Switzerland, where he later settled. Indeed, when Barr borrowed *Street, Berlin* from the Nationalgalerie in 1931, at least twelve German museums owned paintings by Kirchner.

 The progressive acquisition policy of German museums—much admired by Barr and a role model for the new Museum of Modern Art—was quashed after Hitler was appointed chancellor in January 1933. The Romanticism and Realism of nineteenth-century Germany became the cherished art of the Third Reich, while the Nazis mounted a relentless campaign to attack German Expressionism and other avant-garde movements on both racial and stylistic grounds. This assault on modern art varied from city to city, ranging from the banning of artworks from exhibitions and their removal from public collections to selling and sometimes destroying them. In 1937, many thousands of works deemed "degenerate art" by the Nazis were removed from state-owned museums, including *Street, Berlin* from the Nationalgalerie. Karl Buchholz, one of four art dealers acting on behalf of the German government, and his associate in New York, Curt Valentin, a German-Jewish immigrant who had fled his homeland, sold this painting to MoMA in 1939. The acquisition was widely publicized by Barr, who, echoing the speech given by President Roosevelt in May to commemorate the Museum's new Goodwin-Stone building (p. 86), argued that what he described as "exiled art" banished from Nazi Germany would now enrich the countries where artistic freedom still flourished.[2] —Lynn Rother

1. Alfred H. Barr Jr., quoted in undated MoMA press release [1931]. MoMA Exhs., 11.11. MoMA Archives, NY.
2. Alfred H. Barr Jr., quoted in "Exiled Art Purchased by Museum of Modern Art," MoMA press release, August 7, 1939. MoMA Archives, NY.

T. Hayes Hunter (American, 1884–1944)
Edwin Middleton (American, 1866–1929)

Lime Kiln Club Field Day. 1914/2014
35mm film (black and white, silent), 61 minutes
Gift of the Biograph Studio, 1939

In 1912, the most powerful theater-production organization of the vaudeville era, Klaw and Erlanger, allied with the prestigious Biograph film studio, seeking to exploit "by the means of motion pictures, the biggest dramatic successes of the age."[1] The following year, that would include quietly adding a "race subject" to Biograph's film-production roster, with an eye toward capitalizing on the success of African American stage productions with white audiences. None were more successful than those starring Bert Williams, the veteran comedian who most recently had landed a prominent role in the otherwise all-white Ziegfeld Follies. In the fall of 1913, a pioneering cast of African American performers and an interracial crew, including directors Edwin Middleton and T. Hayes Hunter, gathered around Williams in the Bronx to make a feature-length motion picture. It was a project that appeared potentially historic, yet the movie was never finished. After shooting well over an hour of film on location in New York and New Jersey, the project was abandoned by its white producers, who packed the footage away in unmarked cans, leaving no written record of the film's existence. Twenty-five years later, in 1938, MoMA film curator Iris Barry rescued a cache of nine hundred Biograph negatives taken from the bankrupt studio's vaults. After restoring the readily identifiable films during the next thirty-five years, archivists eventually discovered the seven reels of unedited footage from the Williams film, which included multiple takes for various scenes and nearly a hundred photographic and moving-image fragments documenting the activities of the cast and crew on set.

The earliest surviving feature-length film to feature a black cast, *Lime Kiln Club Field Day* follows Williams's efforts to win the hand of a local beauty. It is centered on his membership in a fictional black social club, which provided archivists with clues to the film's literary and theatrical sources, most notably the widely syndicated *Lime Kiln Club* stories by Charles Bertrand Lewis, previously adapted for the stage by black performers, as well as the Harlem stage musical *Darktown Follies* (1913), a major hit for African American entertainers that featured a transitional blending of minstrel stereotypes and contemporary black representation. The film's highlights include a high-energy example of African American vernacular dance that still feels contemporary, and a cutting-edge display of onscreen affection between its black leads, at a time when such scenes were considered unacceptable for white audiences.

Delays in postproduction were initially responsible for the film's remaining incomplete, then in 1915, the release of the divisive blockbuster *Birth of a Nation* incited race riots and protests nationwide. In this climate, Biograph appears to have judged its progressive black feature film too risky for distribution. A century later, however, its singular imagery is a testament to the achievements of a little-known company of performers, and this long-lost landmark of black film history serves as an example of how interracial collaboration might have developed much sooner in the history of American film.

—Ron Magliozzi

1. "K. & E. in Motion Pictures," *New York Clipper*, March 22, 1913, 5.

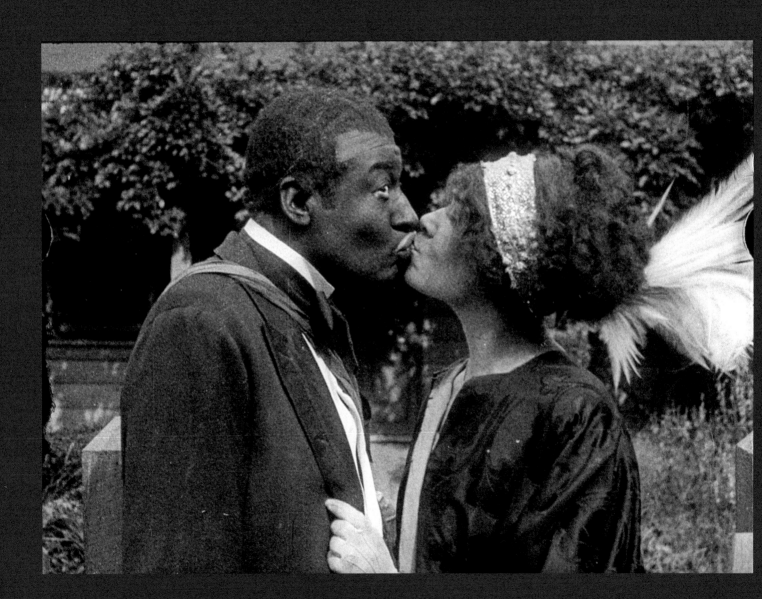

Man Ray (American, 1890–1976)

a. **Rayograph**. 1922
Gelatin silver print, 9 ⅜ x 11 ¾ in. (23.9 x 29.9 cm)

b. **Anatomies**. 1929
Gelatin silver print, 8 ⅞ x 6 ¾ in. (22.6 x 17.2 cm)

Gift of James Thrall Soby, 1941

In January 1941, the artist Man Ray, who had been living in Paris for almost two decades, received a letter from James Thrall Soby, the Hartford, Connecticut-based author, collector, and critic (and MoMA trustee) who, some eight years prior, had acquired a large selection of the artist's most important photographs, many of them unique. "[S]everal months ago, the Museum of Modern Art formed a department of Still Photography," Soby wrote. "It seemed to me that instead of going to [the Wadsworth Atheneum in] Hartford, where there is no collection of photographs nor any plan for showing them, all your prints should be given to the Museum of Modern Art. I'm on the committee of the new department there, so that I know there are active plans for collecting and exhibiting the work of the outstanding photographers of our time."[1] Beaumont Newhall was appointed curator in this newly established Department of Photography, and was a key figure in these "active plans." Newhall organized the department's inaugural exhibition, *Sixty Photographs: A Survey of Camera Esthetics* (1941), which included three of the Man Ray photographs from Soby.

Even before Soby's gift of more than one hundred photographs, the polyvalent Man Ray had been an integral part of the Museum's program. Alfred Barr included Man Ray's photographs, paintings, drawings, sculpture, film, and chess set in his major exhibitions *Cubism and Abstract Art* (1936) and *Fantastic Art, Dada, Surrealism* (1936–37). All three of the Man Ray photographs in *Cubism and Abstract Art* were drawn from the Museum collection, while the majority of the photographs in *Fantastic Art, Dada, Surrealism* were on loan from the artist, including the one featured on the cover of the show's catalogue. Soby himself loaned four Man Ray photographs to Newhall's sweeping historical survey *Photography 1839–1937* (1937), when Newhall was still officially the Museum's librarian, albeit one with a keen interest in photography. In an inventory compiled in June 1940, Newhall could boast that the Museum owned 404 individual photographs (and an additional 273 in albums); the prospect of adding to this Soby's collection of photographs by Man Ray was surely a tantalizing one.

Soby had purchased his expansive group of Man Ray photographs directly from the artist in the summer of 1933, and he published them early the following year as *Man Ray Photographs 1920 Paris 1934*. In the book's introductory text, Man Ray writes, "A certain amount of contempt for the material employed to express an idea is indispensable to the purest realization of this idea."[2] The artist's "contempt" for traditional approaches to the photographic medium led to a dizzying array of experimentation: negative prints, solarized prints, exaggerated grain, isolated detail, and most memorably, cameraless photographs that he dubbed "Rayographs." —Sarah Hermanson Meister

1. James Thrall Soby to Man Ray, January 17, 1941. Man Ray letters and albums, 1922–1976, box 2, folder 15. Getty Research Institute, Los Angeles.
2. Man Ray, "The Age of Light," in *Man Ray Photographs 1920 Paris 1934* (Hartford, CT: James Thrall Soby, 1934), n.p.

a.

b.

Max Beckmann (German, 1884–1950)

Departure. 1932, 1933–35
Oil on canvas, three panels, center panel:
7 ft. ¾ in. x 45⅜ in. (215.3 x 115.2 cm), each side
panel: 7 ft. ¾ in. x 39¼ in. (215.3 x 99.7 cm)
Given anonymously (by exchange), 1942

Max Beckmann's paintings are marked by the historical events of the first half of the twentieth century, when in the span of a generation, one devastating war in Europe gave way to a second, even more brutal one. After painting for more than twenty years, Beckmann began *Departure* in 1932, his first triptych, a format borrowed from medieval and Renaissance altarpieces that enabled him to elaborate a theme more fully than would a single canvas. The left panel presents gruesome depictions of violence and torture, including a bound woman at the mercy of an executioner. Though the action contained in the right panel is more ambiguous, it remains menacing, with its central image of an upside-down figure of a man tied to a woman holding a lantern. By contrast, the center panel shows a boat that, beneath blue skies on a calm sea, carries three figures: a man wearing a crown, a woman holding a child, and a hooded ferryman. Like many of Beckmann's paintings, *Departure* draws on Christian and classical iconography, deployed here as an allegory of freedom. As the artist's friend and patron Lilly von Schnitzler recalled, Beckmann explained to her: "The Queen carries the greatest treasure—Freedom—as her child in her lap. Freedom is the one thing that matters—it is the departure, the new start."[1]

In the context of 1930s Germany, freedom assumed urgency. Three months after Hitler became chancellor in January 1933, Beckmann was dismissed from his professorship at Frankfurt's Städel art school and relocated to Berlin. In 1937, the artist left Germany for Amsterdam, where he would live in exile for the next decade. That same year, *Departure* arrived in New York from Holland, having been purchased by Curt Valentin, a German-Jewish art dealer who left Berlin for New York in 1936 to open a branch of the Buchholz Gallery. Valentin included *Departure* in Beckmann's first exhibition at the gallery, in January 1938. Alfred Barr expressed interest in the work the following year and acquired it for the Museum's collection in 1942, taking the opportunity to forcefully condemn the Nazis' brutal suppression of artistic freedom: "[N]ot only must the artist of Nazi Germany bow to political tyranny," Barr wrote, "he must also conform to the personal taste of that great art connoisseur, Adolf Hitler—the feeble and conventional taste of a mediocre Viennese art student of thirty years ago, frozen by failure into paranoiac bigotry."[2] *Departure*, Barr argued, "can have but one meaning: the triumphant voyage of the human spirit through and beyond the agony of the modern world."[3] In June 1942, MoMA mounted the exhibition *Free German Art* to highlight works that the Nazis had deemed "degenerate," including *Departure*. Beckmann himself traveled to New York for the first time in 1947; four days after his arrival, he was "deeply moved" to find *Departure* on view at the Museum.[4] —Paulina Pobocha

1. Lilly von Schnitzler to Alfred H. Barr Jr., June 1, 1955. Museum Collection Files, Department of Painting and Sculpture, MoMA, NY.
2. Alfred H. Barr Jr., "'Free German Art' Acquisitions Shown by Museum of Modern Art," undated press release [c. 1942]. Museum Collection Files, Department of Painting and Sculpture, MoMA, NY.
3. Ibid.
4. Max Beckmann, quoted in Sabine Reward, "Beckmann in Manhattan," in *Max Beckmann in New York* (New York: The Metropolitan Museum of Art, 2016), 5.

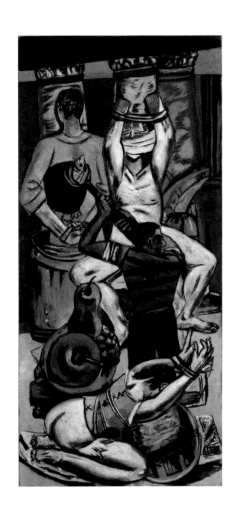 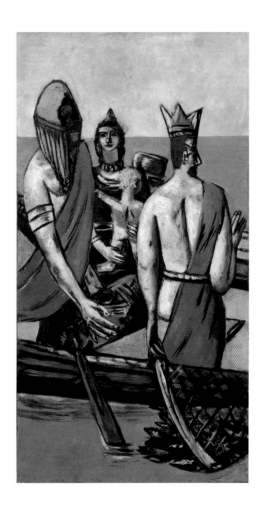

Frida Kahlo (Mexican, 1907–1954)

Self-Portrait with Cropped Hair. 1940
Oil on canvas, 15¾ x 11 in. (40 x 27.9 cm)
Gift of Edgar Kaufmann Jr., 1943

As early as 1929, Alfred Barr singled out Mexico as one of the few countries where MoMA might look for important works of modern art beyond France and the United States, and soon the Museum began to assemble an impressive collection of "the big three in Mexican Art": Diego Rivera, José Clemente Orozco, and David Alfaro Siqueiros.[1] In 1931, Rivera succeeded Henri Matisse as the second artist to be offered a solo exhibition, and he was accompanied to New York by his young wife, Frida Kahlo, who was credited as lender of many of the works in the show. There is no evidence, however, that the Museum considered Kahlo's own work at the time, or even that it acknowledged her as an artist in her own right.

It wasn't until 1938 that Kahlo herself began to draw the attention of the New York art scene. Her solo show at Julien Levy's gallery was a success, which led MoMA's founding president, A. Conger Goodyear, to commission a painting for his private collection. In 1940, two major paintings by Kahlo appeared in MoMA's monumental exhibition *Twenty Centuries of Mexican Art*, whose catalogue described her as a "surrealist . . . with a complex and morbid imagination."[2] Organized in collaboration with the Mexican government, the show boldly affirmed the Museum's commitment to Latin American artists, and if this seemed to echo the Roosevelt administration's "Good Neighbor" policy toward the region, it was hardly an accident: in 1941, Nelson Rockefeller would resign as MoMA president to head Roosevelt's Office of Inter-American Affairs; the following year, he would anonymously endow the Museum with an Inter-American Fund specifically devoted to the purchase of art from Latin America.

It was Edgar Kaufmann Jr., however, an enthusiastic proponent of Mexican art who was familiar with Kahlo and her work, who provided MoMA the funds to buy this painting, the Museum's first acquisition of the artist's work. In 1943, having identified Kahlo as a critical omission from the collection, Barr wrote to Kaufmann: "I have my eye on the small self-portrait of Frida sitting in a chair with close cropped hair, the floor strewn with the hair which she has just cut off . . . Do you think this is a good picture? . . . I like it very much."[3] Ironically for someone who had just spent the past summer in Mexico hunting for paintings, Barr likely encountered this picture only a few blocks from MoMA, in *Exhibition by 31 Women* at Peggy Guggenheim's new gallery, Art of This Century. Kaufmann later called the painting "one of Frida's best, as well as an exceptional document."[4]

Indeed, *Self-Portrait with Cropped Hair* is the only known painting in which Kahlo depicts herself short-haired and wearing men's clothing. Painted immediately after her painful separation from Rivera, it has been seen as epitomizing her attempt to assert herself as an independent artist, free from the shadow of her acclaimed husband. If so, such an enterprise would seem ratified by MoMA's acquisition of the painting, confirming Kahlo's triumph in killing the muse to become the master.[5] —Charlotte Barat

1. "Advisory Committee Report on Museum Collections," April 1941, p. 21. Alfred H. Barr Jr. Papers (AHB), II.C.38. MoMA Archives, NY.
2. Miguel Covarrubias, "Modern Art," in *Twenty Centuries of Mexican Art* (New York: The Museum of Modern Art, 1940), 141.
3. Alfred H. Barr Jr. to Edgar Kaufmann Jr., February 4, 1943. AHB, I.A.103 [mf 2169;970]. MoMA Archives, NY.
4. Edgar Kaufmann Jr. to Alfred H. Barr Jr., undated. AHB, I.A.103 [mf 2169;963]. MoMA Archives, NY.
5. See Robert Storr, "Frida Kahlo: Autoportrait aux cheveux coupés," *Art Press* 113 (April 1987): 84.

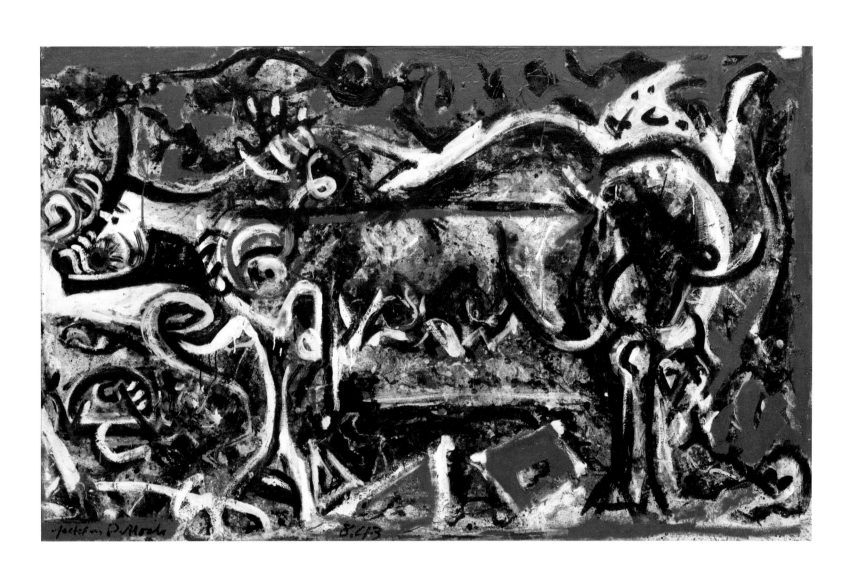

Georgia O'Keeffe (American, 1887–1986)

Farmhouse Window and Door. 1929
Oil on canvas, 40 x 30 in. (101.6 x 76.2 cm)
Acquired through the Richard D. Brixey Bequest, 1945

Depicting a spatially ambiguous view of a building exterior in which window shutters appear to frame a doorway, Georgia O'Keeffe's *Farmhouse Window and Door* belongs to a group of works by the artist that were inspired by architecture. The location is a house in Lake George in upstate New York that was part of the estate owned by the family of O'Keeffe's husband, Alfred Stieglitz, where the couple spent time away from New York each summer and fall between 1918 and 1934. The composition's close framing emphasizes the geometry of its subject at the same time that it flirts with abstraction; the shutters, in particular, appear as elemental rectangular forms. As she did in her paintings of flowers, here O'Keeffe focuses on a small section of a scene, reflecting her conviction, as expressed in 1922, that "it is only by selection, by elimination, by emphasis, that we get at the real meaning of things."[1]

By the time O'Keeffe made this work in 1929, she had become a major figure in American modernist painting. The only woman in the circle of artists who surrounded Stieglitz, she had been the subject of multiple solo exhibitions at Stieglitz's New York galleries, as well as a 1927 retrospective at the Brooklyn Museum. In 1943, MoMA received O'Keeffe's *The Red Hills with Sun* (1927) in a bequest by Richard D. Brixey. Two years later, in an agreement through Stieglitz's An American Place gallery, MoMA exchanged that painting for *Farmhouse Window and Door* on the advice of James Johnson Sweeney, director of the Department of Painting and Sculpture, who argued it was a stronger work. The 1945 exchange allowed the painting to be included in that year's exhibition *The Museum Collection of Painting and Sculpture*, organized by Alfred Barr, which was the largest survey of the Museum's collection to date, displaying a full third of its holdings. That important works by American artists were featured throughout seemed to demonstrate Barr's ongoing concern with ensuring that an appropriate balance was maintained between acquiring and exhibiting the products of American talent and introducing art from European centers of modernist expression. In 1946, this painting was included in O'Keeffe's retrospective at MoMA, the Museum's first exhibition devoted to showcasing the paintings of a woman artist. —Margaret Ewing

1. Georgia O'Keeffe, quoted in "'I Can't Sing, So I Paint!' Says Ultra Realistic Artist; 'Art Is Not Photography—It Is Expression of Inner Life!': Miss Georgia O'Keeffe Explains Subjective Aspect of Her Work," *New York Sun*, December 5, 1922; reprinted in Barbara Buhler Lynes, *O'Keeffe, Stieglitz and the Critics, 1916–1929* (Ann Arbor, MI: U.M.I. Research Press, 1989), 180.

Alfred Stieglitz (American, 1864–1946)

a. **Equivalent**. 1925
Gelatin silver print, 4¹¹⁄₁₆ x 3⅝ in. (11.9 x 9.2 cm)

b. **Equivalent**. 1927
Gelatin silver print, 3⅝ x 4¹¹⁄₁₆ in. (9.2 x 11.9 cm)

c. **Equivalent**. 1927
Gelatin silver print, 3⅝ x 4⅝ in. (9.2 x 11.7 cm)

d. **Equivalent**. 1927
Gelatin silver print, 3⁹⁄₁₆ x 4⅝ in. (9.1 x 11.8 cm)

e. **Equivalent**. 1929
Gelatin silver print, 4¹¹⁄₁₆ x 3⅝ in. (11.9 x 9.2 cm)

Alfred Stieglitz Collection. Gift of Georgia O'Keeffe, 1950

A central figure in introducing the American public to the avant-garde art of Europe during the early part of the twentieth century, Alfred Stieglitz was no less pioneering in his belief that photography should be accepted as equal to painting and sculpture. From its opening in 1905, his Little Galleries of the Photo-Secession (commonly known as 291 for its address on Fifth Avenue) was one of the leading spaces in New York to view cutting-edge art, including Stieglitz's own groundbreaking work in the photographic medium. Three years after Stieglitz's death in 1946, his widow, Georgia O'Keeffe, tactically distributed her late husband's surviving work to leading museums across the United States. By then, Edward Steichen had replaced Beaumont Newhall as head of the Department of Photography at MoMA, and it was in recognition of the long friendship between Stieglitz and Steichen, who had partnered with Stieglitz to open 291, that O'Keeffe donated fifty-five photographs printed by Stieglitz himself to the Museum. Taking into account the Stieglitz images already held by MoMA, as well as those in the collection of The Metropolitan Museum of Art, O'Keeffe carefully selected complementary prints "so that New York may have as broad a representation of Stieglitz's work as possible."[1] Yet O'Keeffe considered MoMA's storage facilities for its photographs inadequate, so she stipulated as a condition of the gift that the Alfred Stieglitz Collection be kept instead with the Museum's collection of prints, to be "stored, handled, and shown in the same manner as your fine etchings and engravings."[2] It wasn't until 1961 that O'Keeffe was persuaded to permit the Photography Department to move the photographs to its newly modernized quarters.

Twenty-three of these images—nearly half the prints in O'Keeffe's gift—are part of Stieglitz's remarkable *Equivalent* series, a landmark in the development of the medium. Beginning in 1922 with a Graflex camera at his family's summer house in Lake George, New York, and continuing through the mid-1930s, Stieglitz produced hundreds of cloud studies, a subject matter that was considered almost technically unfeasible at the time. Ranging from moderately abstract skyscapes to compositions reduced to light-and-shadow patterns with no orienting anchor, the 4-x-5-inch photographs, printed no larger than their negatives, encourage intimate engagement with the images. Early on in his work on the series, Stieglitz explained: "I wanted to photograph clouds to find out what I had learned in 40 years about photography. Through clouds to put down my philosophy of life—to show that my photographs were not due to subject matter—not to special trees, or faces, or interiors, to special privileges—clouds were there for everyone—no tax as yet on them—free."[3] Two months after the Stieglitz prints entered MoMA's collection, they were exhibited in a two-person show of recent acquisitions alongside fifty prints by Stieglitz's French contemporary Eugène Atget, reinforcing the Museum's ongoing commitment to presenting, in Steichen's words, "peak attainments in the art of photography."[4]

—Katerina Stathopoulou

1. Georgia O'Keeffe to Edward Steichen, December 11, 1949. "Georgia O'Keeffe," Correspondence Folders, Department of Photography, MoMA, NY.
2. Ibid.
3. Alfred Stieglitz, "How I Came to Photograph Clouds," *The Amateur Photographer & Photography* 56, no. 1819 (1923): 255.
4. Edward Steichen, quoted in "Photography Recent Acquisitions: Stieglitz, Atget," MoMA press release, March 28, 1950. Department of Photography Exhibition Archives, MoMA, NY.

a.

b.

c.

d.

e.

From the Archives: **The International Program**, 1952

a. Installation view of **The New American Painting**,
The Museum of Modern Art, New York, May 28–September 8, 1959
Photographic Archive. MoMA Archives, NY

b. Cover of the catalogue for the exhibition **The Family of Man**, 1955
Publications Archive. MoMA Archives, NY

c. Visitors in line to view **The Family of Man** at Kalemegdan Pavilion
in Belgrade, 1957
International Council and International Progam Records, I.B.135. MoMA Archves, NY

In 1952, MoMA created the International Program, the first program of its kind in the United States to be primarily focused on the promotion and touring of American modern art overseas. Sponsored by a grant from the Rockefeller Brothers Fund, the program was supported as well by the International Council, an affiliate group of art patrons and community leaders formed in 1953 under the direction of Blanchette Rockefeller. The program's founding director, Porter McCray, proposed an initial slate of twenty-five exhibitions, twenty-two of which circulated abroad.

Among the International Program's important early shows were exhibitions such as *Built in USA: Post-war Architecture* (1953–58) and *The New American Painting* (1958–59), while at the same time, one of the program's primary responsibilities during its initial years was to organize U.S. representation at international biennials and expositions. This included five Venice Biennales, from 1954 through 1962, during which time the Museum owned the pavilion that brought American artists as diverse as Willem de Kooning and Ben Shahn to wider international attention.

Perhaps no exhibition affiliated with the International Program achieved a broader reach than *The Family of Man*, the expansive photography exhibition organized by Edward Steichen, director of the Department of Photography, to reflect the "universal elements" and "oneness of human beings throughout the world" via the photographic medium.[1] Speaking in January 1955 prior to the show's initial opening at the Museum, Nelson Rockefeller, former president of MoMA who was serving as special assistant to President Eisenhower, stated that the show "gives us hope that in all human relationships we can find a common framework of objectives—objectives broad enough to encompass the hopes and aspirations of all mankind."[2] After its run at MoMA, five copies of the exhibition toured worldwide through 1962, under the auspices of the International Program and the United States Information Agency. The 503 images, typically featuring compelling photographic perspectives of ordinary people around the world engaged in everyday tasks, represented photographers from sixty-eight countries, both amateur and professional, including such notable artists as Dorothea Lange, Ansel Adams, and Steichen himself. The exhibition toured in thirty-seven countries across Europe, Latin America, and Asia, as well as Australia, attracting more than nine million visitors at venues in cities as far ranging as Belgrade, Moscow, Cairo, Tehran, Calcutta, and Havana. A copy of the exhibition remains on permanent display in Luxembourg, and the show's catalogue is still in print today.

Even as the International Program administered its last touring exhibition in 1998, it continues to organize workshops and symposia to promote regional art movements and artists around the globe and to facilitate international cultural conversation. In 2009, it established the Contemporary and Modern Art Perspectives in a Global Age Initiative (C-MAP), a cross-departmental research program that supports the study of art histories outside North America and Western Europe, with separate groups focusing on Asia, Central and Eastern Europe, and Latin America, thereby continuing the International Program's original mission of promoting the understanding of modern art throughout the world.

—Tellina Liu

1. Edward Steichen, quoted in "Museum of Modern Art Plans International Photography Exhibition," MoMA press release, January 31, 1954. MoMA Archives, NY.
2. Nelson Rockefeller, quoted in "Nelson Rockefeller Speaks at Preview of Family of Man Exhibition," MoMA press release, January 24, 1955. MoMA Archives, NY.

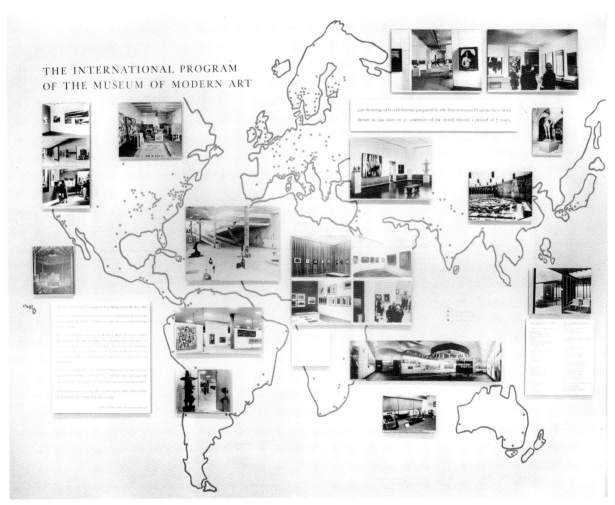

a.

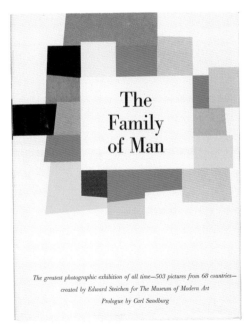

b.

c.

Mark Rothko (American, born Russia [now Latvia], 1903–1970)

No. 10. 1950
Oil on canvas, 7 ft. 6⅜ in. x 57⅛ in. (229.6 x 145.1 cm)
Gift of Philip Johnson, 1952

In June 1943, Mark Rothko and his artist friend Adolph Gottlieb submitted a now-famous letter to *The New York Times* in response to the "befuddlement" expressed by one of the paper's critics concerning the meaning of the artists' biomorphic abstract paintings. "No possible set of notes can explain our paintings," the pair wrote. "Their explanation must come out of a consummated experience between picture and onlooker."[1] These words set the course for Rothko's painting going forward. By the time of his fifth and final exhibition at the Betty Parsons Gallery, in 1951, Rothko had left all vestiges of figuration behind and arrived at his mature style of stacked blocks of translucent fields of color, as epitomized by *No. 10*, which was first exhibited in the show alongside other works that demonstrated the artist's transformation of his canvases into vessels for emotional response. As William Rubin, chief curator of the Department of Painting and Sculpture at MoMA, would later describe, Rothko's colors were unparalleled for "the mysterious and exalted character with which he endowed them."[2]

Alfred Barr selected *No. 10* from the Parsons exhibition and brought it to the Museum's Acquisitions Committee after the show closed in late April. Owing to mixed opinions, a decision was postponed until the following year, when the acquisition was finally approved, prompting founding Museum president and lifetime trustee A. Conger Goodyear to resign from the committee in protest. The controversial painting ultimately became the gift of Philip Johnson, who was in the middle of serving his second stint as head of the Department of Architecture and Design. It entered the collection just in time to be included in the 1952 exhibition *15 Americans*, organized by Dorothy Miller and featuring a total of six paintings by Rothko, in addition to works by contemporaries such as Jackson Pollock and Clyfford Still.

Later in the decade, *No. 10* was included in two traveling exhibitions organized by MoMA's International Program : *Modern Art in the U.S.A.: A Selection from the Collections of The Museum of Modern Art, New York* (1955–56) and *The New American Painting* (1958–59). Between them, the shows traveled to fourteen European cities as part of a program aimed at showcasing advances in American contemporary art for audiences abroad. In the context of the Cold War, Abstract Expressionism in particular was positioned as an ambassador for American democracy, its gestural freedom linked to values of democratic liberty. Rothko was little known in Western Europe prior to these exhibitions, but they, in addition to the artist's 1961 MoMA retrospective, which also traveled to six cities in Europe, substantially increased his attention overseas. —Margaret Ewing

1. Adolph Gottlieb and Marcus (Mark) Rothko, quoted in Edward Alden Jewell, "The Realm of Art: A New Platform and Other Matters: 'Globalism' Pops into View," *The New York Times*, June 13, 1943.
2. William Rubin, "Mark Rothko 1903–70," *The New York Times*, March 8, 1970.

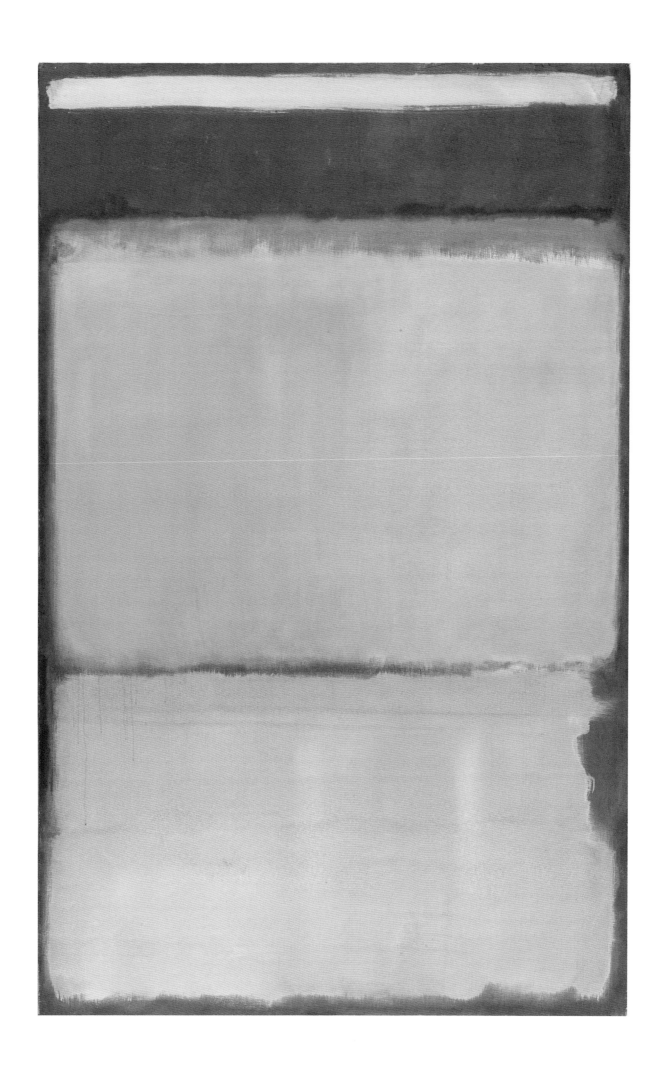

Kurt Schwitters (German, 1887–1948)

a. **Merz 22**. 1920
Cut-and-pasted printed paper and ink on paper
with cardstock border, 15⅛ x 11⅝ in. (38.4 x 29.5 cm)

b. **Merz Drawing 83. Drawing F
(Merzzeichnung 83. Zeichnung F)**. 1920
Cut-and-pasted papers on paper with
cardstock border, 12⅞ x 9½ in. (32.7 x 24.1 cm)

Katherine S. Dreier Bequest, 1953

These five collages by Kurt Schwitters entered the MoMA collection in 1953, through the bequest of Katherine Dreier. An artist as well as a collector, Dreier was the president of the Société Anonyme, which she founded in New York in 1920 with Marcel Duchamp and Man Ray to introduce, support, and present modern art. Dreier amassed works on behalf of the Société and for her own collection. In 1941, after the Société collection had been given to Yale University, Dreier still possessed a substantial private collection comprised primarily of living artists, including those at the very beginning of their careers. She was one of the first American collectors to acquire works by Duchamp, Vasily Kandinsky, Fernand Léger, and Piet Mondrian. Her family origins in Bremen guaranteed a special place for German artists, including Schwitters. After her death in 1952, a few works from her private collection joined the Société collection at Yale, and Duchamp served as executor to distribute the remainder. Understanding the significance of Dreier's collection, Alfred Barr focused on securing 102 works for MoMA. Of these, nineteen were by Schwitters.

Schwitters was an important participant in the activities and exhibitions organized by the Société. Dreier first encountered the artist's work in 1920 at Galerie Der Sturm in Berlin. Five years later, she began to correspond with Schwitters and first visited him in Hannover in 1926. They developed a close friendship, exchanging work as well as news of their respective art communities. In the wake of World War I, Schwitters invented the term *Merz* to describe his art of collaging found materials, an approach that demonstrated how destruction feeds creation. *Merz*, a nonsensical term employed by Schwitters to denote equality among all artistic purposes and materials, stems from the second syllable of the German word for commerce, *Kommerz*. Schwitters created his assemblages from bits of urban detritus and other objects that he scavenged and then carefully composed and affixed to painted boards, producing more than two thousand during his career. Melding drawing, painting, printmaking, and writing, Schwitters disrupted conventional artistic categories to create works *of* paper as much as works *on* paper. Multiple overlapping pieces of printed paper, the edges of which are rough and torn in some places and smooth and straight in others, create a juxtaposition of various lines and textures.

In the five collages shown opposite and on the next spread, Schwitters set aside painterly effects for a bolder kind of planarity that is built outwards from the work's center. The formal stability of the grid format, with carefully plotted diagonal movements, contains an interplay of shapes that enlivens the rectilinear geometry. Though seen on the wall, these works thematize the horizontal, redefining the picture as a receptor surface open to the accumulation of things in the world, as described by critic Leo Steinberg in relation to the art of Robert Rauschenberg.[1] *Merz* became Schwitters's personal philosophy: "My ultimate aspiration is the union of art and non-art in the *Merz* total world view," he wrote in 1920.[2] His late career was devoted to *Merzbau*, an ambitious and unrealized architecture of objects and rubbish, for which MoMA provided a grant. —Heidi Hirschl

1. See Leo Steinberg, "Reflections on the State of Art Criticism," *Artforum* 10, no. 7 (March 1972): 87–97.
2. Kurt Schwitters, quoted in John Elderfield, *Kurt Schwitters* (London: Thames & Hudson Ltd., 1985), 31.

a.

b.

Kurt Schwitters (German, 1887–1948)

c. **Merz 460. Two Underdrawers (Twee onderbroeken).** 1921
Cut-and-pasted colored and printed papers and fabric on
cardstock, 7⅞ x 6⅝ in. (20 x 16.8 cm)

d. **Merz 458.** c. 1922
Cut-and-pasted colored and printed papers on paper
with cardstock border, 15 x 12⅝ in. (38.1 x 32.1 cm)

e. **Mz 704. Bühlau.** 1923
Cut-and-pasted colored and printed papers and cloth
on cardstock, 12¼ x 8¾ in. (31.1 x 22.2 cm)

Katherine S. Dreier Bequest, 1953

c.

d.

e.

Willem de Kooning (American, born the Netherlands, 1904–1997)

Woman, I. 1950–52
Oil on canvas, 6 ft. 3⅞ in. x 58 in. (192.7 x 147.3 cm)
Purchase, 1953

Woman, I gained a reputation in the art world before it had ever been shown. The popular art magazine *Artnews* devoted a lengthy article to chronicling Willem de Kooning's long travails with the painting's execution, which was published in advance of the work going on view at the Sidney Janis Gallery in New York in March 1953.[1] Writer Thomas B. Hess recounted how, in June 1950, the artist began to tackle the canvas, resolving to "concentrate on this single major effort until it was finished to his satisfaction."[2] What followed, in Hess's telling, was a year and a half of ceaseless reworking of the painting and de Kooning's subsequent abandonment of the project for a few months. Only at the urging of art historian Meyer Schapiro, who happened to visit the artist's studio and asked to see the painting, did de Kooning finally resume work on it, ultimately finishing it by June 1952. All told, *Woman, I* was "completed and then painted out literally hundreds of times," according to Hess.[3]

 Paintings on the Theme of Women, de Kooning's solo exhibition at the Janis gallery, was a true *succès de scandale*. Along with five other *Woman* paintings on view, all completed between 1952 and 1953, *Woman, I* shocked the public and critics alike with its perceived aggression and its seemingly retardataire embrace of figuration. Rather than passively accept our gaze, the seated figure, commandeering the approximately six-foot-long canvas, emerges from a maze of frenzied brushstrokes to confront us with bulging eyes, gargantuan breasts, and a toothy grimace. But the painting was also understood to be an artistic breakthrough—a "triumph."[4] This mixed reception was echoed when the painting was presented to MoMA's Acquisitions Committee in June 1953, where committee members were said to have found the work "quite frightening" while still acknowledging its "intense vitality."[5] Alfred Barr, who had the painting hanging in his office at that point, reported to the committee his impression that *Woman, I* "grew stronger" over time.[6] MoMA duly acquired the painting. The timely acquisition of *Woman, I* was central to MoMA's ongoing commitment to developments in Abstract Expressionism, and in carrying out the Museum's founding mission of collecting groundbreaking art in real time.

—Tamar Margalit

1. Thomas B. Hess, "De Kooning Paints a Picture," *Artnews* 52 (March 1953): 30–33; 64–67.
2. Ibid., 30.
3. Thomas B. Hess, *Willem de Kooning* (New York: The Museum of Modern Art, 1969), 75.
4. Ibid., 74.
5. Painting and Sculpture Acquisition Committee minutes, June 22, 1953. Department of Painting and Sculpture, MoMA, NY.
6. Ibid.

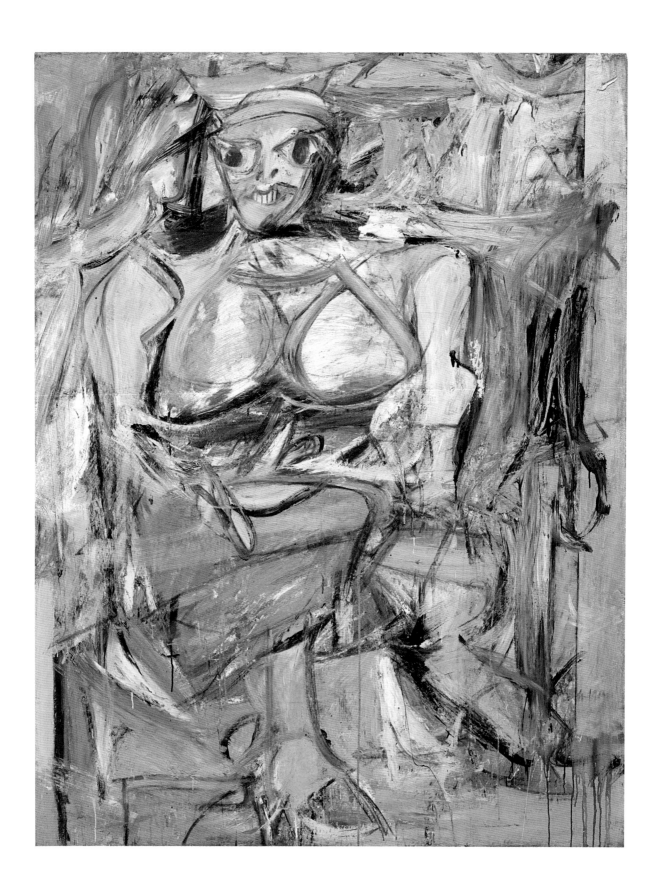

Skidmore, Owings & Merrill (American, founded 1936)
Gordon Bunshaft (American, 1909–1990)

Lever House, New York, New York. 1950–52 (model, 1949/1959)
Paper, wood, plastic, plexiglass, metal, aluminum, and paint,
40¾ x 37⅞ x 40¾ in. (103.5 x 96.2 x 103.5 cm)
Gift of Lever Brothers Company, 1953

The gleaming glass curtain wall of Lever House made the building an instant landmark upon its completion in 1952, two years after this model appeared in the MoMA exhibition *Architectural Work by Skidmore, Owings & Merrill*. The show followed what was by then two decades of tradition at the Museum showcasing the latest building design, beginning in 1932 with *Modern Architecture: International Exhibition*. How best to convey the dramatic vision of an up-and-coming generation of architects was, however, something of a conundrum. Models were often deemed more truthful representations than drawings—Philip Johnson commissioned several for *Modern Architecture*—yet the models themselves were considered educational tools, not artworks, and thus were catalogued separately from the Museum's formal collection.

Even so, the artistry of model-maker Theodore Conrad on display here merits recognition. Modern architects' groundbreaking use of materials required professional model-makers to innovate as well: Conrad's miniature Lever House is one of his first models for a glass skyscraper to represent a curtain wall with large sheets of plexiglass and aluminum inlays. Conrad built it as a presentation model in late 1949, and it was given to Lever Brothers in January 1950. That it ended up in MoMA's model collection was apt: although an independent model-maker, Conrad had long worked closely with the Museum, and until the late 1950s, he was responsible for all the Museum's model work, including his construction in 1939 of the model of the new MoMA building designed by Philip L. Goodwin and Edward Durell Stone.

Not long after Lever Brothers gifted this model to MoMA in August 1953, it embarked on an extensive international tour, courtesy of an era of Cold War diplomacy. Included in the Museum's 1953 exhibition in New York *Built in USA: Postwar Architecture*, the model then traveled throughout Western Europe in similar shows that were facilitated by the U.S. Information Agency to promote American culture abroad, culminating at the 1958 Brussels World's Fair and the Centre Culturel Américain in Paris in 1959. Upon its return to MoMA in March 1959, the model was in complete disrepair; its plexiglass sides had fallen off, and its paint was chipped. Conrad rebuilt it, and in so doing, replaced the original facade with one that more closely replicated the building's final design. Then the model was off again, this time to Moscow as part of the *American National Exhibition*, which opened in July.

Acknowledging the object's promotional significance yet dubious of it as an artwork, Arthur Drexler, director of the Department of Architecture and Design, wrote to Alfred Barr in 1957: "Requests for the use of this model are frequent, and time spent meeting them is perhaps out of proportion to the model's value to the collection . . . I would like to propose that the model be returned to Lever Brothers and that at the same time we try to acquire something more recent and perhaps better."[1] Luckily, Barr disagreed, and the model remains in MoMA's collection to this day.

—Teresa Fankhänel

1. Arthur Drexler to Alfred H. Barr Jr., October 17, 1957. MoMA Study Center Files, MoMA, NY.

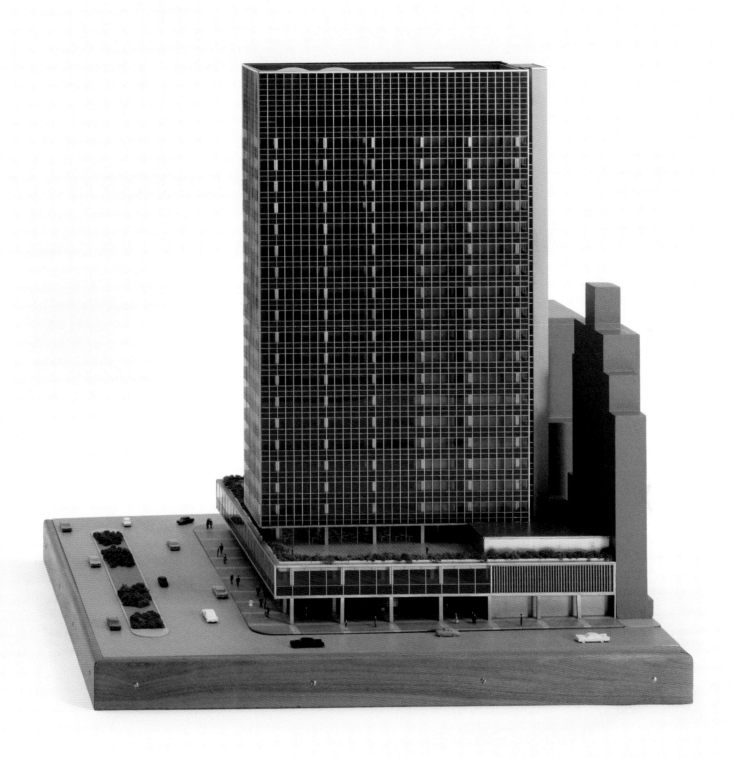

From the Archives: **Pablo Picasso's silk necktie**, 1957

a. Silkscreened silk tie and hand-decorated envelope
 sent by Pablo Picasso to Alfred Barr, 1957
 Alfred H. Barr Jr. Papers, XI.B.6, 7. MoMA Archives, NY

b. Picasso wearing novelty glasses, France, summer 1956,
 with Barr in the background, far left. Photograph by T. Darvas
 Alfred H. Barr Jr. Papers, XI.B.5. MoMA Archives, NY

In the summer of 1956, Alfred Barr and Marga Scolari Barr traveled to Cannes to visit Pablo Picasso at the artist's villa, La Californie. It had been a decade since Alfred had published *Picasso: Fifty Years of His Art*, a revised and expanded version of the catalogue that had accompanied MoMA's first retrospective of the artist's work, and a decade, too, since Harvard University had granted Barr a PhD for his scholarship on Picasso. Now the artist was approaching another milestone, and Alfred and Marga were in Cannes specifically to prepare for the upcoming MoMA retrospective *Picasso: 75th Anniversary*, which would open at the Museum the following spring. The Barrs' relationship with Picasso having now spanned more than two decades, the couple no doubt expected there would be moments of socializing and amusement in addition to work, yet still there was the potential for surprise, as Marga would later recall in an informal account: "P. was showing us pictures one after the other, moving them himself, refusing all help. All of a sudden—who should walk in—but Gary Cooper, his wife and daughter."[1] Marga had bought two pairs of novelty eyeglasses on Sixth Avenue in New York as gifts for Picasso. One pair featured long, dramatic eyelashes and the other shifty, side-glancing eyes. "All visitors bear gifts because this is a *court*, it is difficult & honorable to be received," Marga wrote later. "The gifts pile up tho' the most successful go into circulation."[2] The eyeglasses were apparently a hit, as photographs soon appeared in European newspapers of Cooper and Picasso wearing them. "[W]hy did the glasses seem such fun to him[?] More fun than they would to you & me?" Marga would ask. "Because he has always loved masks & disguises—because of his predilection for putting a twist on reality—for imposing an alteration, for metamorphosis of every kind."[3]

In May 1957, immediately prior to the opening of the retrospective, Picasso mailed Alfred Barr two large hand-addressed envelopes, one containing several crayon-decorated neckties cut from paper and the other containing an off-white silkscreened silk tie, each with a unique eye motif. On the backs of the paper ties, the artist wrote, "*cravate a porter au vernissage*" ("tie to wear at the opening"). Barr wore a tuxedo to the event but clipped one of the paper ties over his bowtie.

By August, more than 200,000 visitors had seen the show, and the Museum extended its hours to accommodate the crowds, almost 20 percent of whom, according to a MoMA press release, were first-time visitors to the Museum.[4] The exhibition set an attendance record for a show devoted to a single artist. —Michelle Harvey

1. Margaret Scolari Barr, "Picasso, A Reminiscence" (unpublished typescript, 1973), p. 15. Margaret Scolari Barr (MSB) Papers, III.A.41. MoMA Archives, NY.
2. Margaret Scolari Barr, unpublished handwritten notes for a lecture (n.d.), p. 11. MSB Papers, III.A.42. MoMA Archives, NY.
3. Ibid., 13–14.
4. "Picasso Show Breaks Attendance Records," MoMA press release, August 7, 1957. MoMA Archives, NY.

a.

b.

Frank Stella (American, born 1936)

The Marriage of Reason and Squalor, II. 1959
Enamel on canvas, 7 ft. 6¾ in. x 11 ft. ¾ in. (230.5 x 337.2 cm)
Larry Aldrich Foundation Fund, 1959

Frank Stella was just twenty-three years old when MoMA curator Dorothy Miller selected him for inclusion in the 1959 exhibition *16 Americans*, in which *The Marriage of Reason and Squalor, II* was first exhibited. Miller and Alfred Barr had recently visited the studio of the yet unknown artist in downtown New York, where Stella had shown them his large canvases in cramped quarters. As Miller would later recall: "In order to show them to us he'd grab one and go out into the hall and turn it like this . . . and come back in with it face out . . . It was like a ballet."[1] *The Marriage of Reason and Squalor, II* was among four works from Stella's series *Black Paintings* (1958–60) included in the exhibition, which Miller organized as a group of small solo displays for each of the exhibited artists, several of whom would also go on to garner recognition as among the period's most significant talents, including Jay DeFeo, Jasper Johns, Ellsworth Kelly, and Robert Rauschenberg. This painting and two others in the exhibition were second versions of earlier works that Stella painted after having concluded the original compositions were slightly crooked.

Stella made his *Black Paintings* with commercial black enamel paint, which he applied with a house-painter's brush to unprimed canvas. The width of the brush determined the width of the black lines, made freehand so that imprecisions in execution remain discernable. Stella's statement in the exhibition catalogue was penned by fellow artist Carl Andre, who pithily distilled his friends's concerns: "Art excludes the unnecessary. Frank Stella has found it necessary to paint stripes. There is nothing else in his painting . . . Frank Stella's painting is not symbolic. His stripes are the paths of brush on canvas. These paths lead only into painting."[2] The work's title also came from Andre, who had previously conceived it for a drawing of his own (later destroyed). The two artists found the phrase an apt description for the experience of being a young artist in New York. A decade later, William Rubin, chief curator of the Department of Painting and Sculpture at MoMA, who organized two exhibitions of Stella's work, in 1970 and 1987, explained Stella's search for "a directly given experience—an immediacy, simplicity, frankness, even bluntness."[3] In reducing a painting to only black paint and simple compositions based on parallel lines, Stella found a new approach to abstraction in the wake of Abstract Expressionism.

Shortly before Miller visited Stella's studio with Barr, she had made a visit accompanied by art dealer Leo Castelli, who, by the time *16 Americans* opened, had added Stella to his roster of artists. *The Marriage of Reason and Squalor, II* was thus purchased from the Castelli gallery in 1959, with funds from the Larry Aldrich Foundation Fund, which Aldrich had established that year to support acquisitions of works by emerging American artists. —Margaret Ewing

1. Dorothy C. Miller, quoted in transcript of Paul Cummings, oral history interview with Dorothy C. Miller, May 26, 1970–September 28, 1971, p. 138. Archives of American Art, Smithsonian Institution.
2. Carl Andre, "Frank Stella," in *Sixteen Americans*, ed. Dorothy C. Miller (New York: The Museum of Modern Art, 1959), 76.
3. William S. Rubin, *Frank Stella* (New York: The Museum of Modern Art, 1970), 13.

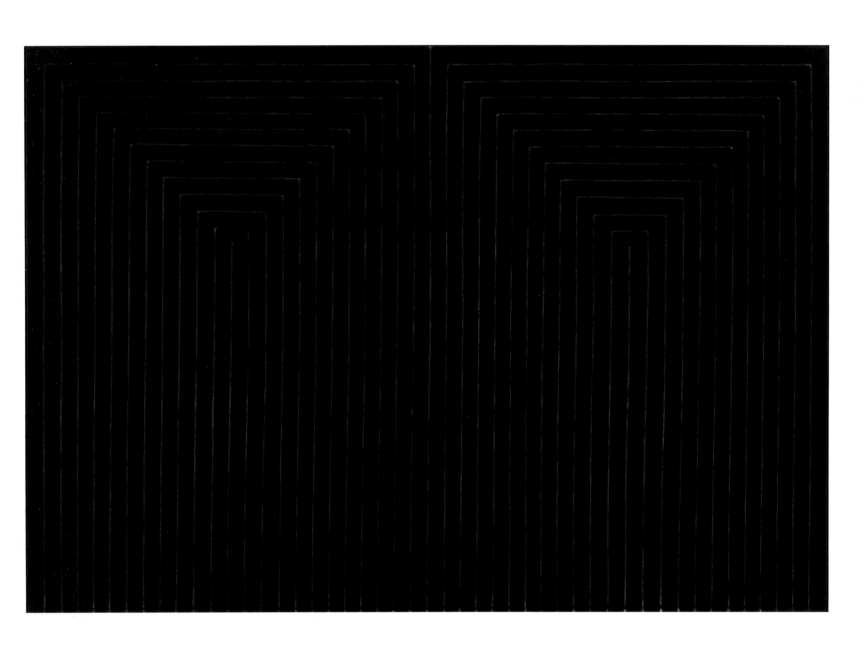

Jasper Johns (American, born 1930)

Map. 1961
Oil on canvas, 6 ft. 6 in. x 10 ft. 3⅛ in. (198.2 x 314.7 cm)
Gift of Mr. and Mrs. Robert C. Scull, 1963

Map was among the first paintings made by Jasper Johns at his Edisto Beach home in South Carolina during the summer of 1961. The artist took a small mimeographed map of the United States, traced a grid over it, and then expanded the grid over a large canvas. "This done, freehand he copied the printed map, carefully preserving its proportions," recounted John Cage, a close friend of Johns, a few years later. "Then with a change of tempo he began painting quickly, all at once as it were, here and there with the same brush, changing brushes and colors, and working everywhere at the same time rather than starting at one point, finishing it and going on to another."[1]

Johns transformed the boundaries of each state into erratic successions of vigorous, multidirectional, gestural brushstrokes in bright colors. From a distance, the geographical outlines are still largely identifiable, yet closeup, they dissolve into an active field of drips, brush marks, and stenciled letters. Johns's application of oil paint simultaneously accentuates and conceals the map image. He undoubtedly went to great lengths to ensure that abstraction would not prevail over figuration, or vice versa.

In *Map* there is a carefully calibrated balance between painting as visual field and painting as object. Instead of conventionally depicting a map within a painting, Johns presents a map occupying the full length of the canvas, thereby dovetailing subject and matter. Rather than resorting to illusionistic figure-ground conventions, the artist dispenses with the background entirely so that the figure becomes the painting and the wall behind it becomes the background.[2] It is as if the representation of an object were supplanted by the object itself, a paradox the thirty-one-year-old Johns took enormous pleasure in creating.

In the little more than a year between the creation of *Map* and its acquisition by MoMA, the painting attained a significant reputation, having been shown across the country. A group show at Leo Castelli Gallery in New York was followed by presentations at the Art Institute of Chicago, the Seattle World's Fair, and Brandeis University. The painting finally returned to New York for Johns's fourth one-person show at the Castelli gallery in January 1963.

As a work that heralded an important new motif, *Map* was particularly significant to Johns. MoMA curator Dorothy Miller had seen the painting at the Castelli gallery in autumn 1961 and set her sights on acquiring it for the Museum. (The first institution to collect his work, MoMA had acquired three paintings from Johns's first show at Castelli, in 1958.) Johns decided to sell *Map* only to a buyer who would give it to MoMA, preventing several eager collectors from purchasing it. Numerous offers to pay more than the asking price were refused by Johns. Ultimately, Robert and Ethel Scull—the flamboyant enthusiasts of Pop art and Minimalism and avid collectors of Johns's work—stepped in and purchased the painting for the Museum. —Lilian Tone

1. John Cage, "Jasper Johns: Stories and Ideas," in *Jasper Johns* (New York: The Jewish Museum, 1964), 73. This painting marks the first time that Johns blew up the map into a large painting. He had previously painted a map measuring 8-x-11 inches, the same dimensions as the original mimeographed map.
2. See Robert Morris's remarks in Kirk Varnedoe, "Fire: Johns's Work as Seen and Used by American Artists," in *Jasper Johns: A Retrospective* (New York: The Museum of Modern Art, 1997), 17.

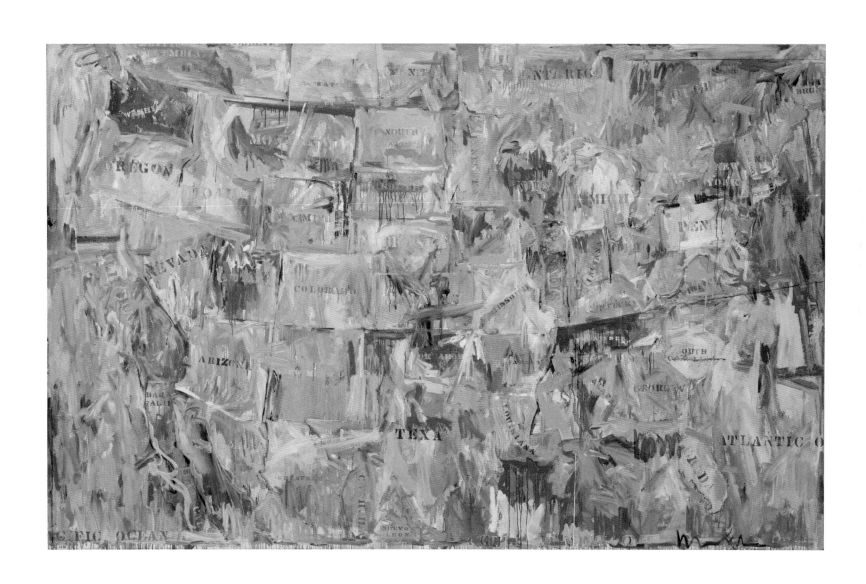

Henri Matisse (French, 1869–1954)

Goldfish and Palette. 1914
Oil on canvas, 57¾ x 44¼ in. (146.5 x 112.4 cm)
Gift and bequest of Florene M. Schoenborn and Samuel A. Marx, 1964

In a postcard to the painter Charles Camoin, Henri Matisse explained that at the right side of *Goldfish and Palette* he had depicted "a person who has a palette in his hand and who is observing."[1] It is widely held that this person is the artist himself. *Goldfish and Palette* is the final work in a series of six compositions by Matisse that represent goldfish in an interior setting, and it is the most abstract. Compared to its immediate predecessor, *Interior with Goldfish* (1914), which features a similar color spectrum and composition, the objects in *Goldfish and Palette* have barely any volume, and the space they occupy has no depth, appearing almost flat against the picture plane. These qualities, and the array of angular planes and shifting perspectives within the composition, show the impact of Cubism on Matisse at this time, particularly as it was practiced by Juan Gris, with whom Matisse had developed a close friendship the year before.

Throughout Matisse's career, which spanned the first half of the twentieth century, the artist was ceaselessly inventive across mediums that include painting, sculpture, drawing, prints, and paper cutouts. Early on, he was associated with Fauvism, the French art movement whose practitioners shocked audiences by prioritizing bold, raw color on their canvases. Matisse would later describe his artistic process as "construction by colored surfaces," which is evident in his career-long pursuit to reinvent the relationship between color and line.[2]

Alfred Barr held Matisse's art in particularly high regard: "In a world grown dark with fear and muddy with lies," Barr wrote in 1951, "Matisse has sought truth and serenity by transforming his delight in the visible world into works vigorous in form, joyous in color."[3] The occasion was MoMA's second major retrospective for Matisse; the first, twenty years prior, had also been the Museum's first exhibition devoted to a single artist (p. 48). MoMA acquired its first painting by Matisse, *Interior with a Violin Case* (1918–19), in 1934. *Goldfish and Palette* debuted at the Museum five years later, when it was lent by Jeanne Doucet, the widow of famed French couturier and collector Jacques Doucet, for inclusion in the Museum's tenth-anniversary exhibition, *Art in Our Time*, which inaugurated MoMA's new flagship building on West 53rd Street (p. 84). *Goldfish and Palette* would return to the Museum for numerous exhibitions before it was ultimately acquired in 1964 through a gift and bequest from Florene M. Schoenborn and Samuel A. Marx. —Emily Liebert

1. Henri Matisse to Charles Camoin, autumn 1914; cited in Danièle Giraudy, "Correspondance Henri Matisse/Charles Camoin," *Revue de l'art* 12 (1971): 19.
2. Henri Matisse, "Statement to Tériade: On Fauvism and Color" [1929]; reprinted in Jack Flam, ed., *Matisse on Art* (Berkeley: University of California Press, 1995), 84.
3. Alfred H. Barr Jr., quoted in "Advance Notice of Henri Matisse Exhibition and Book by Alfred H. Barr, Jr.," undated MoMA press release [1951]. MoMA Archives, NY.

Pablo Picasso (Spanish, 1881–1973)

Boy Leading a Horse. 1905–06
Oil on canvas, 7 ft. 2⅞ in. x 51⅝ in. (220.6 x 131.2 cm)
The William S. Paley Collection, 1964

Although intended as a study for his unrealized large-scale painting *The Watering Place* (known only through a gouache study in The Metropolitan Museum of Art), Pablo Picasso's *Boy Leading a Horse* does not appear preparatory. Neither does the looming, life-size painting, with its neutral color scheme of browns and grays, appear to belong to Picasso's so-called Rose Period during which it was painted, in 1905–06, abandoning as well overt references to circus people, the artist's dominant subject matter during those two years. Rather, it evinces the classical, more sculptural turn that Picasso's art took in that winter. By looking at Greek art in the Louvre, Picasso developed a fascination with the stiff, regal poses of classical sculpture, echoed here in the boy's stillness, his solemn facial expression, and his noble gesture of authority—the horse follows his command without reins. But Picasso was also profoundly influenced by Paul Cézanne, whose work he had seen in visits to their mutual dealer, Ambroise Vollard, and at the Salon d'Automne in 1904. The recurring brown and gray in the figures and background, the exploratory brushwork, and the broken contours of *Boy Leading a Horse* are all in the spirit of Cézanne. Indeed, the monumentality and frontality of the boy can scarcely be understood without reference to Cézanne's *The Bather* (p. 51)—created ten years earlier, once sold and exhibited by Vollard, and in MoMA's collection since 1934.

In 1939, these two related masterpieces were shown together for the first time, at the Museum's tenth-anniversary exhibition, *Art in Our Time*. Three years earlier, the American broadcast pioneer and founder of CBS, William S. Paley, had bought *Boy Leading a Horse* through his European agent Albert Skira after it had left the famous collection of Paul and Elsa von Mendelssohn-Bartholdy in Berlin. It immediately became a prized possession for the young collector. Following the painting's appearance in *Art in Our Time*, Alfred Barr convinced Paley to extend the lending agreement so that MoMA was able to exhibit and publish the work numerous times over the next twenty-five years—before Paley made this most generous gift to the Museum in 1964. The collector was an active supporter of MoMA throughout his life, serving as both president and chairman and contributing to the purchase of many important works before he bequeathed his entire collection to the Museum in 1990.

—Lynn Rother

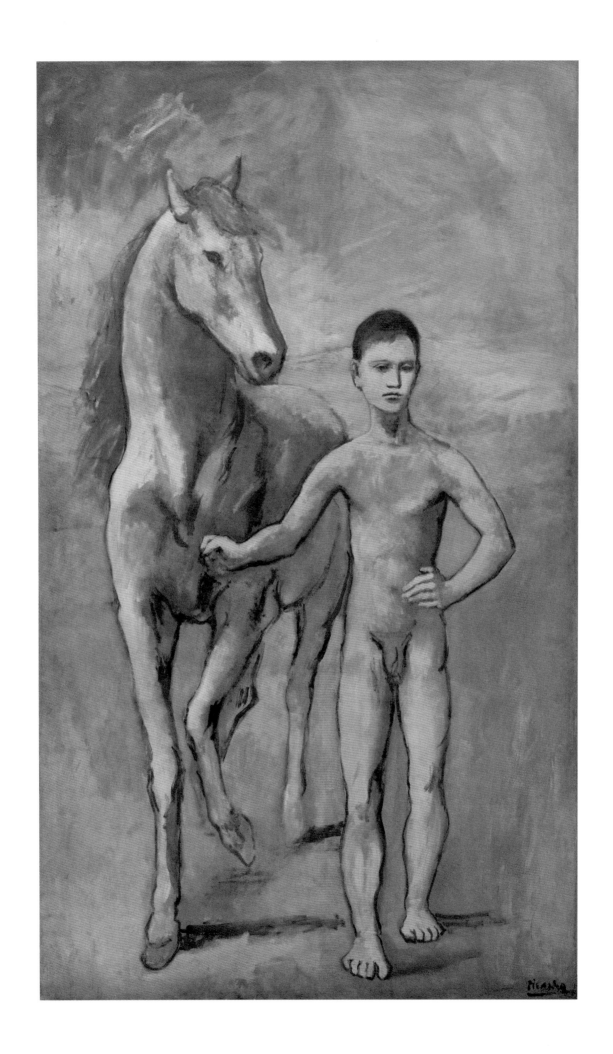

Marcel Duchamp (American, born France, 1887–1968)

Bicycle Wheel. 1951 (third version, after lost original of 1913)
Metal wheel mounted on painted wood stool,
51 x 25 x 16½ in. (129.5 x 63.5 x 41.9 cm)
The Sidney and Harriet Janis Collection, 1967

Around 1913, Marcel Duchamp began bringing found objects into his studio in Paris and combining them in various ways, an experiment in art-making that, he would recall a half century later, was about "letting things go by themselves and having a sort of created atmosphere in a studio, an apartment where you lived. Probably to help your ideas come out of your head."[1] It wasn't until January 1916 that the artist, in a letter written from New York to his sister, Suzanne, in Paris, first used the term "readymade" for these objects: "Now, if you have been up to my place, you will have seen, in the studio, a bicycle wheel and a bottle rack. I bought this as a ready-made sculpture."[2] *Bicycle Wheel* is one of Duchamp's earliest readymades. Works like these were revolutionary within the history of modernism because they foregrounded an essential question: What is art?

Like many of the first versions of Duchamp's readymades, the initial version of *Bicycle Wheel*, which he made in Paris in 1913, did not survive. A second version, made three years later in New York, was also lost to posterity. The *Bicycle Wheel* in MoMA's collection is the third version of this readymade, and thus the earliest extant one. The American collector and gallery owner Sidney Janis collaborated with Duchamp on the creation of this particular work, which Janis wanted to include in the exhibition *Climax in 20th Century Art, 1913* at his New York gallery in early 1951. Janis purchased the bicycle wheel in Paris in 1950 and sourced the stool in Brooklyn; Duchamp then put the two parts together for the show. Unlike other versions of this readymade, this particular *Bicycle Wheel* has a distinctive curved fork that extends far below the seat of the stool. The proportional relationships between the individual parts of the work are also different from those in other versions of the sculpture.

In 1967, Sidney and Harriet Janis donated their collection of more than a hundred paintings and sculptures to MoMA, including the *Bicycle Wheel* here. The gift greatly enhanced the Museum's holdings of historical modernism while also introducing important new works by younger American artists into the collection. "That the Janis collection should find a home at a great museum has long been my hope," Sidney Janis commented, "and happily the museum of my first love, The Museum of Modern Art, has graciously accepted it."[3] —Talia Kwartler

1. Marcel Duchamp, quoted in Arturo Schwarz, *The Complete Works of Marcel Duchamp* (New York: Harry N. Abrams Inc., 1969), 442.
2. Marcel Duchamp to Suzanne Duchamp, January 16, 1916; reprinted in *Affectionately Marcel: The Selected Correspondence of Marcel Duchamp*, ed. Francis Naumann and Hector Obalk (Ghent and Amsterdam: Ludion Press, 2000), 43.
3. Sidney Janis, quoted in Alfred H. Barr Jr., *The Sidney and Harriet Janis Collection: A Gift to The Museum of Modern Art* (New York: The Museum of Modern Art, 1968), 1.

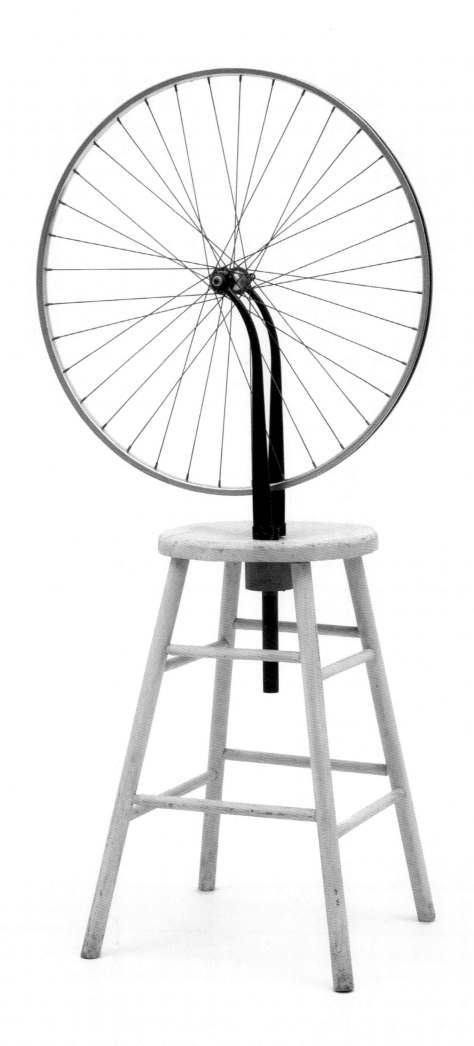

Diane Arbus (American, 1923–1971)

Identical Twins, Roselle, New Jersey. 1967
Gelatin silver print, 15⅛ x 14⁹⁄₁₆ in. (38.4 x 37 cm)
Richard Avedon Fund, 1967

In November 1965, photographer Richard Avedon made an unsolicited gift of $250 to MoMA to support the purchase of work by young photographers. The fund was untouched for nearly two years, until it was used to acquire two prints by Diane Arbus, including this one. Hers were not the first works by a "young photographer" to enter the Museum collection during that time, which suggests that John Szarkowski, who had succeeded Edward Steichen as director of the Department of Photography in 1962, may have been waiting for an opportunity to fund a purchase with special significance for Avedon. Avedon first met Arbus sometime in the 1950s, either through a professional connection with her then-husband, Allan Arbus, or at *Harper's Bazaar*, where Avedon had been the staff photographer for twenty years, and their friendship continued until her death in 1971.

The only significant museum exhibition in Arbus's career took place at MoMA in 1967. Titled *New Documents*, it included thirty-two photographs by Arbus along with thirty by Lee Friedlander and thirty-two by Garry Winogrand. Avedon attended the opening and, according to Szarkowski, brought a bouquet of yellow roses for Arbus.[1] In the exhibition's wall text, Szarkowski observed that these three photographers were "direct[ing] the documentary approach toward more personal ends" and clarified, "What they hold in common is the belief that the commonplace is really worth looking at, and the courage to look at it with a minimum of theorizing."[2] About Arbus he wrote: "The portraits of Diane Arbus show that all of us—the most ordinary and the most exotic of us—are on closer scrutiny remarkable. The honesty of her vision is of an order belonging only to those of truly generous spirit."[3] This photograph is one of only four images printed by Arbus for the exhibition on 16-x-20-inch paper. It was the most recent work on view, made only two months prior at a gathering of the Suburban Mothers of Twins and Triplets Club of Roselle, New Jersey. A few months after the exhibition closed, Szarkowski proposed it for acquisition.

The print is striking in scale, printed from a 2¼-inch square negative that allows for a finely detailed rendering—which in this instance offers the viewer the beguiling experience of scrutinizing the subtle differences between two ostensibly identical subjects. Arbus made the transition away from the rectangular 35mm Nikon to a medium-format camera in 1962, a change that also facilitated a new means of encountering her subjects. Whereas a 35mm camera is held against the photographer's eye, a twin-lens reflex camera is held against her torso, making it possible for Arbus to maintain eye contact with her subjects and thus amplify the sense of recognition that characterizes so much of her work. —Sarah Hermanson Meister

1. Doon Arbus, Sandra S. Phillips, Elisabeth Sussman, et al., eds., *Diane Arbus: Revelations* (New York: Random House, 2003), 183–85, 337.
2. John Szarkowski, wall text for the exhibition *New Documents* (1967). MoMA Exhs., 821.3. MoMA Archives, NY.
3. Ibid.

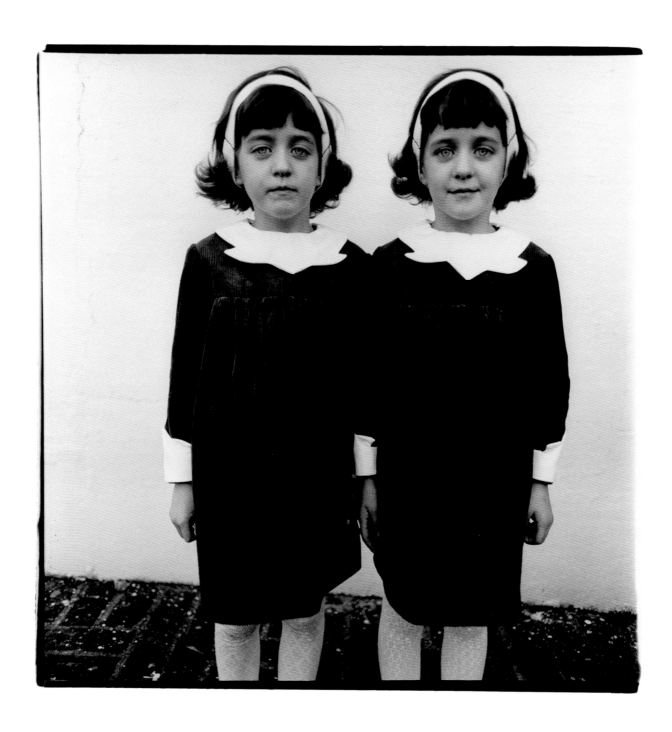

Ludwig Mies van der Rohe (American, born Germany, 1886–1969)

Concrete Office Building Project, Berlin, Germany. 1923
Charcoal and crayon on paper, 54½ in. x 9 ft. 5¾ in. (138.4 x 288.9 cm)
Mies van der Rohe Archive, gift of the architect, 1968

The close relationship between Mies van der Rohe and The Museum of Modern Art began with his inclusion in the Museum's first architecture exhibition, *Modern Architecture: International Exhibition*, in 1932. This landmark show introduced Mies to a broader American public largely unfamiliar with his work. It also marked the beginning of his long association with Philip Johnson, who, in his multiple roles as curator, patron, and later, architect, ceaselessly advocated for the acceptance of Mies's architectural vision in the United States. This close relationship resulted in the inclusion of Mies in numerous exhibitions and projects at MoMA, and in the collaboration of Johnson and Mies on the Seagram Building, the only building by Mies in New York.

The large drawing here was among the many hundreds of works Mies left behind in the haste of his emigration from Germany in 1938. Several years later, during the chaotic period near the end of World War II, the contents of his Berlin office were packed into crates and shipped to the East German home of the parents of Eduard Ludwig, an employee of Mies. There the crates remained, inaccessible due to the partition of Germany, until 1963, when they were delivered to an elderly Mies in Chicago. Twenty-five years' separation from his drawings did not render him especially nostalgic or possessive; shortly after their arrival, Mies began donating select drawings to MoMA, with large groups accessioned in 1963 and 1965. Continued discussions throughout the 1960s with Johnson, Alfred Barr, and chief curator of Architecture and Design Arthur Drexler later bore fruit with Mies's decision to donate his entire archive in 1969. The Mies van der Rohe Archive was the first architectural archive at MoMA; in 2012, the Museum joined with Columbia University to establish the Frank Lloyd Wright Foundation Archives, bringing together two of the titans of modern architecture.

The dramatic charcoal rendering of the Concrete Office Building project is the largest drawing in the Mies Archive, an appropriate distinction for a vision of what, had the project been constructed, would have been among the largest structures ever designed by the architect. Reproduced in the first issue of the avant-garde Berlin magazine *G*, the project represents Mies's concept of a "skin-and-bones building." The edifice is stripped to its most essential structural elements: long, horizontal concrete beams alternate with ribbons of glass windows to create a rhythmic arrangement of planes. A monumental abstraction, the Concrete Office Building contrasts dramatically with the historical buildings surrounding it and recalls Mies's earlier explorations of urban interventions: the Friedrichstrasse (1921) and Glass Skyscraper (1922) projects. Along with his designs for a Concrete Country House (1923) and a Brick Country House (1924), these five experimental projects of the early 1920s cemented Mies's place at the vanguard of the modernist movement. —Paul Galloway

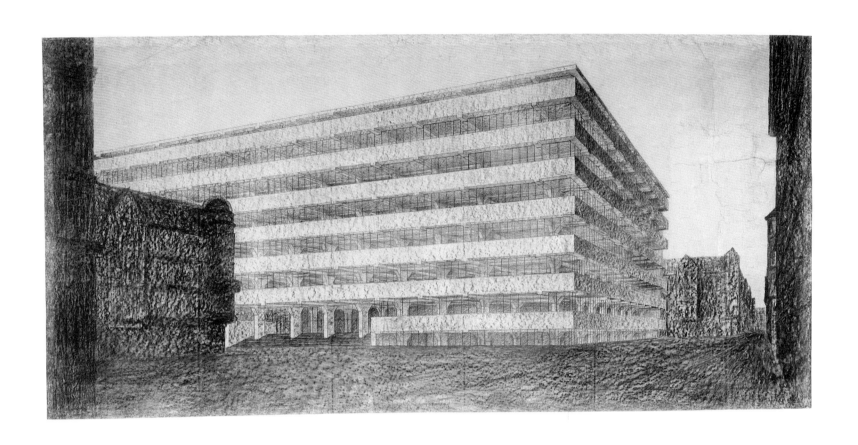

Francis Picabia (French, 1879–1953)

M'Amenez-y. 1919–20
Oil and enamel paint on cardboard,
50 ¾ x 35 ⅜ in. (129.2 x 89.8 cm)
Helena Rubinstein Fund, 1968

M'Amenez-y belongs to a group of artworks that Francis Picabia made during his Dada years, between approximately 1915 and 1921, that have been classified as "mechanomorphic," a term used in reference to their mechanical subject matter. Like many of Picabia's mechanomorphic works, *M'Amenez-y* is based on a scientific illustration: the circular central form derives from a photograph published in the popular French scientific magazine *La Science et la Vie* in the fall of 1919.[1] Picabia transformed the printed image by enlarging the machine and translating the black-and-white reproduction into vivid shades of paint. He also presents his mechanical subject with enigmatic inscriptions, including "PORTRAIT A L'HUILE DE RICIN" ("Portrait with ricin oil"), "PEINTURE CROCODILE" ("Crocodile painting," or "false painting"), "RATELIER D'ARTISTE" ("The artist's false teeth"), and the titular "M'AMENEZ-Y" ("Take me there").

 M'Amenez-y was shown at MoMA for the first time in William Rubin's exhibition *Dada, Surrealism, and Their Heritage* (1968). While the exhibition was on view, Rubin pursued the acquisition of several important artworks in the show, including *M'Amenez-y*. Picabia's friend and fellow artist Jean (Hans) Arp had acquired the painting in the 1930s from Gabrielle Buffet-Picabia, the artist's first wife. In 1968, *M'Amenez-y* was in the collection of Arp's widow, Marguerite Hagenbach Arp, who had promised the painting to the Kunstmuseum Basel. In a letter to Franz Meyer, director of the Kunstmuseum, written with the collaboration and support of Hagenbach Arp, Rubin expressed his keen desire to acquire the painting for MoMA. Meyer graciously ceded the painting to the Museum, writing to Rubin that the "marvelous picture . . . is in the right place precisely in the Museum of Modern Art."[2]

 In 1921, Picabia wrote, "If you want to have clean ideas, change them like shirts."[3] During the course of his long career, he certainly did that, swapping ideas and styles with speed and irreverence. The Museum has slowly but steadily acquired his works in their many different forms. The first, *I See Again in Memory My Dear Udnie* (1914), entered the collection in 1954. Of particular importance are a group of monumental abstractions—*The Spring* (1912), *Dances at the Spring* [*II*] (1912), *Comic Wedlock* (1914), and *This Has to Do with Me* (1914)—which were given to the Museum in 1974 by the children of Eugene and Agnes Ernst Meyer, the works' former owners. These paintings, along with *Udnie*, comprise Picabia's most significant group of early monumental abstractions in a public collection. In 2016, *M'Amenez-y* was reunited with its mechanomorphic counterparts in the retrospective *Francis Picabia: Our Heads Are Round so Our Thoughts Can Change Direction*, organized by MoMA and the Kunsthaus Zürich. The exhibition presented Picabia's career in toto for the first time in the United States. —Talia Kwartler

1. Arnauld Pierre, "Sources inédites pour l'oeuvre machiniste de Francis Picabia, 1918–1922" [1992]; cited in Lilian Tone, entry on *M'Amenez-y* in *Dada in the Collection of The Museum of Modern Art*, ed. Anne Umland and Adrian Sudhalter (New York: The Museum of Modern Art, 2008), 243.
2. Franz Meyer to William S. Rubin, May 21, 1968. Master Collection Files, Department of Painting and Sculpture, MoMA, NY.
3. This aphorism appears on *Funny-Guy*, a handbill that Picabia distributed on the steps of the Salon d'Automne in 1921. Translation by Natalie Dupêcher. See Anne Umland and Cathérine Hug, eds., *Francis Picabia: Our Heads Are Round so Our Thoughts Can Change Direction* (New York: The Museum of Modern Art, 2016), 109.

Eugène Atget (French, 1857–1927)

a. **Untitled**. 1910–11
Albumen silver print, 8¹¹⁄₁₆ x 7¹⁄₁₆ in. (22 x 18 cm)

b. **Boutique, rue de Sèvres**. 1910–11
Gelatin silver printing-out-paper print,
8⅞ x 6⅞ in. (22.5 x 17.5 cm)

c. **Place Maubert**. 1910–11
Gelatin silver printing-out-paper print,
8¹¹⁄₁₆ x 7¹⁄₁₆ in. (22 x 18 cm)

d. **Journaux. Coin rue Mouffetard**. 1912
Albumen silver print, 8¹¹⁄₁₆ x 7¹⁄₁₆ in. (22 x 18 cm)

Abbott-Levy Collection. Partial gift of Shirley C. Burden, 1969

The Museum of Modern Art's purchase of Eugène Atget's archive in the spring of 1968 was the largest acquisition ever made by the Museum of work by a single photographer. The archive was offered for sale by the American photographer Berenice Abbott, and it included, as she stated in her proposal letter, "all prints, negatives and other materials from Atget's hand which are currently owned by me": approximately 5,000 vintage prints, 2,500 duplicate prints, more than 1,000 glass-plate negatives, and a few personal papers (diaries, albums, notebooks).[1] Abbott had become familiar with Atget's work while apprenticing in Paris with his neighbor, the American artist Man Ray. Fascinated by Atget and his work, she bought the contents of his studio in 1928, a few months after his death, thanks to a loan from the New York gallerist Julien Levy—hence the Abbott-Levy Collection in the works' credit line here—and brought the archive to New York soon after.

Beginning in the late 1920s, members of the artistic avant-garde on both sides of the Atlantic considered Atget a father figure in modern photography. In France, his images were read in Surrealist circles as enigmas, whereas in Germany and the United States, they were praised for their clarity and straightforwardness. When MoMA mounted its first major exhibition of photography, a group show in 1937, Atget was represented prominently through works loaned by Abbott. Between 1938 and 1950, nearly seventy works by Atget entered the collection, both vintage prints and modern versions printed by Abbott from the original negatives. From a selection of these, the Museum's first Atget-focused installation was organized in 1950.

In light of this history, it is clear that the 1968 acquisition and the exhibition that followed, in 1969, were the final steps in an ongoing, decades-long dialogue with Abbott. The collection had been available for sale for a number of years, and MoMA's Department of Photography had made several tentative and unsuccessful attempts to secure it for the Museum. For John Szarkowski, the director of the department, the acquisition of the entire archive definitively positioned Atget's work as a cornerstone of the Museum's collection and recognized the artist as a benchmark in the development of modern photography: as the most gifted early representative of the "unmanipulated, literal, clear, complete and easy" photographic approach Szarkowski championed at MoMA during those years but also as someone whose documentary vision had been highly influential to two generations of American photographers, from Walker Evans to Diane Arbus.[2] The study of the collection culminated in a series of four exhibitions and a four-volume publication, *The Work of Atget* (1981–85), coedited by Szarkowski and Maria Morris Hambourg, which reconstructed for the first time the photographer's complex record system and displayed the full range of his production. —Quentin Bajac

1. Berenice Abbott to John Szarkowski, March 1, 1968. Department of Photography Object Files, MoMA, NY.
2. John Szarkowski, quoted in "Atget at the Museum of Modern Art," MoMA press release, December 1, 1969. Department of Photography Exhibition Archives, MoMA, NY.

a.

b.

c.

d.

Eugène Atget (French, 1857–1927)

e. **Coiffeur, boulevard de Strasbourg**. 1912
Gelatin silver printing-out-paper print,
8¹³⁄₁₆ x 6⅞ in. (22.4 x 17.5 cm)

f. **Boulevard de Strasbourg**. 1912
Gelatin silver printing-out-paper print,
8¹¹⁄₁₆ x 7¹⁄₁₆ in. (22 x 18 cm)

g. **Magasin, avenue des Gobelins**. 1925
Gelatin silver printing-out-paper print,
8⁹⁄₁₆ x 6¾ in. (21.8 x 17.1 cm)

h. **Magasin, avenue des Gobelins**. 1925
Gelatin silver printing-out-paper print,
8¼ x 6½ in. (21 x 16.7 cm)

Abbott-Levy Collection. Partial gift of Shirley C. Burden, 1969

e.

f.

g.

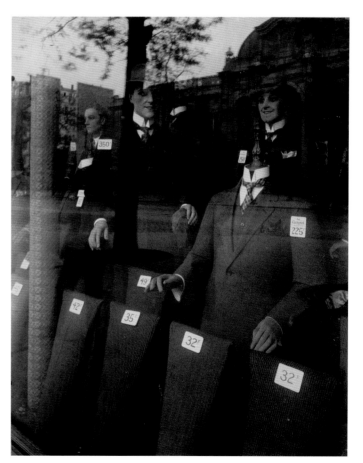

h.

Jackson Pollock (American, 1912–1956)

Echo: Number 25, 1951. 1951
Enamel paint on canvas, 7 ft. 7⅞ in. x 7 ft. 2 in. (233.4 x 218.4 cm)
Acquired through the Lillie P. Bliss Bequest (by exchange)
and the Mr. and Mrs. David Rockefeller Fund, 1969
Conservation was made possible by the Bank of
America Art Conservation Project

"I've had a period of drawing on canvas in black," Jackson Pollock wrote in 1951, "with some of my early images coming through."[1] *Echo: Number 25, 1951*, a roughly 7-x-7-foot unprimed canvas populated by linear marks of black enamel paint of varying lengths, thicknesses, and densities, is one of this series of works. Though abstract, the composition hints at figuration: bold calligraphic strokes of paint evoke bodily contours. And yet pictorial space is dramatically compressed, both materially and compositionally: the black enamel has seeped into the unprepared canvas and become united with the ground, while the unpainted areas of canvas themselves appear to shape, or compose, Pollock's lines into figure-like forms. The work marks a radical departure from Pollock's earlier "drip paintings," the dynamic allover abstract compositions that he made by laying canvas down on the floor and pouring, flinging, and spattering paint straight from the can, or with sticks or stiffened brushes. The comparatively controlled composition of *Echo* reveals an equally measured process of creation. During this time, Pollock began to apply his paint with turkey basters, among other instruments, measuring out pulses of paint by squeezing the bulb with varying force and dragging it across the canvas, as evidenced by lines visible on the back of the canvas inside the broader marks of black that indicate points of contact between the kitchen tool and the canvas.[2] This unique mark-making strategy invested the medium of painting with the technique of drawing to create a "new category," as Pollock's wife, Lee Krasner, described it.[3] It was a move that permitted the possibility of a return to representation within the artist's signature art-making approach, claiming a paradoxically forward-thinking ambition in his intuition to look back at his earlier images.

Echo found its way to MoMA in 1968, nearly two decades after its making, as part of a group of major Abstract Expressionist works purchased from the private collector Ben Heller, an early champion of the movement and a friend of many of its artists at a time when the Museum itself had not yet committed to building its own collection of such work. One of few collectors to hang monumentally scaled paintings in his home, Heller covered the walls of his apartment on Central Park West floor to ceiling with the works he owned. Along with *Echo*, Heller agreed to sell MoMA a group of exceptional works by Arshile Gorky, Franz Kline, and Pollock, and offered Barnett Newman's *Vir Heroicus Sublimis* (1950–51) as a gift. These significant acquisitions greatly enhanced the Museum's holdings of Abstract Expressionism. —Cara Manes

1. Jackson Pollock to Alfonso Ossorio and Edward Dragon, 1951; quoted in David Anfam, *Abstract Expressionism* (London: Thames & Hudson Ltd., 1990), 175.
2. James Coddington and Jennifer Hickey, "MoMA's Jackson Pollock Conservation Project; Insight into the Artist's Process," *Inside/Out* blog post, April 17, 2013, https://www.moma.org/explore/inside_out/2013/04/17/momas-jackson-pollock-conservation-project-insight-into-the-artists-process/.
3. Lee Krasner, quoted in B. H. Friedman, "An Interview with Lee Krasner Pollock," in *Jackson Pollock: Black and White*, exh. cat. (New York: Marlborough Gallery, 1969), 7.

Carl Andre (American, born 1935)

144 Lead Square. 1969
Lead, 144 units, overall: ⅜ in. x 12 ft. x 12 ft. (1 x 367.8 x 367.8 cm)
Advisory Committee Fund, 1969

"Art excludes the unnecessary," Carl Andre wrote in 1959 on behalf of his friend Frank Stella (p. 120), for the catalogue that accompanied the MoMA exhibition *16 Americans*, in which Stella had been included.[1] Examples of Andre's own explorations of Minimal art would first be featured at the Museum almost a decade later, in 1968, in the pivotal exhibition *The Art of the Real: USA, 1948–1968*, organized by guest curator E. C. Goossen. Among the work of artists who similarly had been experimenting with pared-down modes of abstraction distinct from Abstract Expressionism, such as Stella, Donald Judd, Barnett Newman (p. 153), and Ellsworth Kelly (p. 145), Goossen included two sculptures by Andre: *Cedar Piece* (1959/64), consisting of interlocking blocks of wood stacked in the shape of a double pyramid, and *Fall* (1968), a forty-nine-foot-long sculpture made with hot-rolled-steel plates that extended along the base of a wall in the Museum's sculpture garden. Andre's turn to metal, and in particular the sort of standardized plates typically used for construction and industrial applications, had occurred the year before, when he produced three "squares" in aluminum, hot-rolled steel, and zinc for a solo exhibition at Dwan Gallery in New York, each work consisting of a twelve-by-twelve grid of plates. The resulting number of plates—144—is the twelfth number in the Fibonacci sequence in mathematics, often associated with rhythm and harmony. Three more such works followed in 1969, in copper, magnesium, and lead, the latter shown here, its factually descriptive title indicative of Andre's straightforward, elemental approach to sculpture.

It is hard to believe that *144 Lead Square* is composed of nearly three tons of lead, yet with its sheets less than a half-inch thick, discreet almost to the point of imperceptibility, it pointedly eschews the sense of monumentality often inherent to sculpture in favor of a more direct experience of materiality and space. In addition to its five square siblings, the sculpture belongs to a much larger body of more than a hundred similar works Andre produced between 1967 and 1969 that include rectangles and lines as well, described by early critics as "rugs" for their direct placement on the floor and the artist's intention that they be walked upon by viewers and experienced from within. MoMA's acquisition of *144 Lead Square* in 1969, the year the work was made, marked the first Andre sculpture to enter the collection and came upon the recommendation of assistant curator Jennifer Licht, who considered the artist "one of the most radical sculptors of our time."[2] —Yasmil Raymond

1. Carl Andre, "Frank Stella," in *16 Americans*, ed. Dorothy C. Miller (New York: The Museum of Modern Art, 1959), 76.
2. Jennifer Licht, quoted in "Minutes of Meeting of the Committee on Painting and Sculpture, May 20, 1969," p. 2. Department of Painting and Sculpture, MoMA, NY.

Ellsworth Kelly (American, 1923–2015)

Colors for a Large Wall. 1951
Oil on canvas, sixty-four panels,
7 ft. 10½ in. x 7 ft. 10½ in. (240 x 240 cm)
Gift of the artist, 1969

When Ellsworth Kelly finished *Colors for a Large Wall* in 1951, he was convinced that it belonged in the MoMA collection.[1] At the time, Kelly was twenty-eight, virtually unknown, and midway through a nearly six-year stay in France on the GI Bill. There, he began to develop the abstract vocabulary of line, form, and color that would come to define his singular contribution to the history of American art in the postwar era.

Colors for a Large Wall is composed of sixty-four individual one-square-foot monochrome canvases arranged in an eight-by-eight-panel grid. Apart from this structural decision, Kelly left the work's compositional organization largely to chance. Like other paintings he made at the time, this one is derived from a collage made from cut squares of bright, glossy, colored paper sheets backed with adhesive gum that were typically used in French art classrooms. Kelly made the study using scraps left over from a series of eight collages he had recently completed titled *Spectrum Colors Arranged by Chance*. In these colored papers, he found a means of capturing what he described as the "quality" of light flickering across the surface of the Seine that he observed from his lodgings on the Île Saint-Louis in Paris, in a way that both resisted a recapitulation of earlier color-theory-reliant pointillism and invited the crucial element of chance to come into play, a strategy Kelly began to explore in different mediums (p. 191) after encountering the work of Jean (Hans) Arp.[2]

A breakthrough painting in terms of scale and approach, its completion signaled to Kelly that he was onto something. Lacking many of the signature traits of contemporaneous works made in New York—gestural dynamism or contemplative color deployment, hallmarks of Abstract Expressionism—Kelly's work from this moment signaled a new interest in anonymity, in making resolutely abstract work that foregrounded pure color and form while minimizing the presence of the artist's hand. He dismantled the panels, boxed them up, and returned with them to New York in 1954. Back on American soil, and in dialogue with other artists such as Agnes Martin, Robert Indiana, and Jack Youngerman, Kelly continued to explore the idea of joining monochrome panels together in various compositions.

In 1968, critic and professor E. C. Goossen included *Colors for a Large Wall* in the landmark exhibition he organized at MoMA, *The Art of the Real*, which brought together work that did not, in Goossen's words, "strive to be realistic—i.e., *like* the real—but to be as real in itself as the things we experience everyday: the things we see, feel, knock against, and apprehend in normal physical ways."[3] By this time, Kelly was well respected, with two paintings, a sculpture, and many works on paper already in MoMA's collection. After the exhibition debut of *Colors for a Large Wall* at the Museum, Kelly finally realized his dream of making the institution its permanent home, by arranging with chief curator William Rubin to make the work a gift of the artist. —Cara Manes

1. Ann Temkin, unpublished oral history interview with Ellsworth Kelly, 2012. Department of Painting and Sculpture, MoMA, NY.
2. Ellsworth Kelly, quoted in ibid.
3. E. C. Goossen, quoted in untitled MoMA press release, July 3, 1968. MoMA Archives, NY.

Giorgio de Chirico (Italian, born Greece, 1888–1978)

Gare Montparnasse (The Melancholy of Departure). 1914
Oil on canvas, 55⅛ in. x 6 ft. ⅝ in. (140 x 184.5 cm)
Gift of James Thrall Soby, 1969

In 1969, Giorgio de Chirico's *Gare Montparnasse* was given to MoMA by the art critic and scholar James Thrall Soby, who showed his generosity and devotion to the Museum by donating many artworks over the years—including eight paintings by de Chirico. Soby was appointed a MoMA trustee in 1942, a role (and an institution) to which he remained dedicated for almost forty years. As one of the pioneering collectors of modern art in America, he began to assemble work by contemporary artists, many of whom he knew personally, in the 1930s. While working on his first book, *After Picasso*, Soby became convinced that in de Chirico's youth, the artist had provided the central starting point both for the reveries of the Neo-Romantics and for the affronts to logic of the Surrealist painters. It is therefore hardly surprising that when Soby's friend the art dealer Pierre Matisse held an exhibition of de Chirico's early work in December 1935 in his New York gallery, the enthusiastic scholar bought four paintings directly from the show. One might have thought that with this extravagant purchase, Soby had acquired enough paintings by the Italian artist to last a lifetime, as Soby himself admitted.[1] Yet in 1940, on the occasion of Matisse's next de Chirico exhibition, Soby acquired three more paintings, including *Gare Montparnasse*. The artist remained the dominant figure in Soby's collection as well as in his writing.

De Chirico is best known for his "metaphysical" style, which he began developing around 1910 and later formalized as *scuola metafisica*. As opposed to Futurism, the Italian art movement that wanted to eradicate the past and emphasized speed, technology, and the urban industrialization of the early twentieth century, de Chirico's metaphysical paintings are melancholic and silent. In *Gare Montparnasse*, sometimes also called *The Melancholy of Departure*, it seems the train will never arrive—its thick white exhaust rises without any horizontal movement—while the two tiny passengers who cast eerily long shadows seem frozen. The painting stops time at the exact moment shown on the station clock, even though the light seems too dark for the afternoon and too bright for night. The presence of the out-of-scale bananas in the foreground is inexplicable; indeed, the whole scene is enveloped in mystery. De Chirico's paintings evoke their atmosphere of uncertainty not by inventing new forms but by assembling objects and architecture with their geometries altered and skewed so as to enhance their poetic suggestiveness. The architecture of the railway station combines references to medieval, Renaissance, and Neoclassical forms in a way that is typical of the settings of de Chirico's metaphysical art. But at the same time, *Gare Montparnasse* reflects the modern, commercial structure of the actual station (the nearest to the artist's studio during his years in Paris). In this respect, it is unique in de Chirico's early oeuvre. —Lynn Rother

1. James Thrall Soby, "The Changing System," in *Studies in Modern Art 5: The Museum of Modern Art at Mid-Century–Continuity and Change* (New York: The Museum of Modern Art, 1996), 192–93.

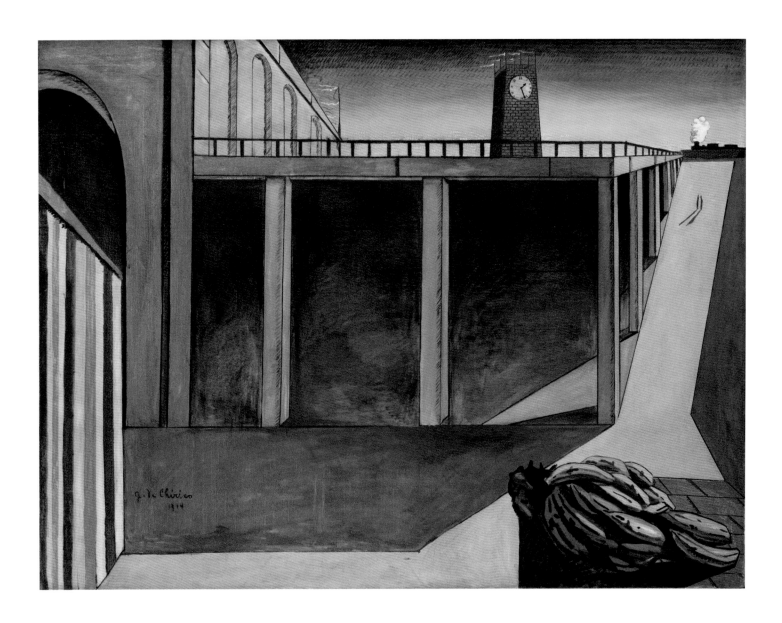

From the Archives: **Information**, 1970

a. Cover of the catalogue for the exhibition **Information**, 1970
Publications Archive. MoMA Archives, NY

b. Four ballots used for Hans Haacke's **Poll of MoMA Visitors** in the exhibition **Information**, 1970
Kynaston McShine **Information** Exhibition Research, IV.37. MoMA Archives, NY

c. Installation view of **Information**, The Museum of Modern Art, New York, July 2–September 20, 1970
Photographic Archive. MoMA Archives, NY

1. Untitled MoMA press release (no. 69), July 2, 1970. MoMA Archives, NY.
2. Bruce Altshuler, *Biennials and Beyond: Exhibitions That Made Art History, 1962–2002* (New York: Phaidon Press, 2013), 127.

Often cited as among the most influential exhibitions of the second half of the twentieth century, *Information* opened at MoMA in July 1970, organized by Kynaston McShine, associate curator in the Department of Painting and Sculpture. In response to the social, political, and economic upheavals that had convulsed countries around the world since the mid-1960s, many artists had sought new forms of expression in ways that often upended conventional, typically material-based ideas about art, sometimes engaging new forms of mass media and information sharing or inviting—even demanding—viewer interaction. Such work would increasingly come to be categorized as Conceptual art, although in announcing the show, the Museum did not attempt to brand the diverse production of more than 150 artists from fifteen countries with any one label: "The only common denominator is that all are trying to extend the idea of art beyond traditional categories."[1]

McShine's curatorial approach of inviting artists' submissions yielded a wide range of conceptual strategies, from language-based propositions and photographic series as documentation to electronic means of communication. As suggested by the show's title, a central theme was the politics of access to and control of information. Iain Baxter of the Canadian art collective N. E. Thing Co. Ltd., for example, sent messages from Vancouver to telex machines in the galleries, while Vito Acconci had his personal mail delivered to the Museum. Artists grappled with information overload (Ettore Sottsass's "visual jukebox" simultaneously projected multiple films on forty screens), the potential irrationality of numerical systems (as in the number-based contributions of Hanne Darboven, Mel Bochner, and Siah Armajani), and the absence of information (e.g., Christine Kozlov's telegram submission: "PARTICULARS RELATED TO THE INFORMATION NOT CONTAINED HEREIN CONSTITUTE THE FORM OF THIS ACTION").

No less notable was the explicit sociopolitical engagement of many of the works and their implication of the viewer. The Art Workers' Coalition produced a poster that featured a photograph of Vietnamese civilians killed during the My Lai massacre overlaid with the text, "Q. And babies? A. And babies" (p. 161). The Board of Trustees deemed the poster too controversial to distribute, but McShine nevertheless included it in both the exhibition and catalogue. Hans Haacke's *Poll of MoMA Visitors* asked whether the fact that Nelson Rockefeller, a former president of the Museum, had not denounced the Vietnam War would be reason to vote against him in the upcoming New York gubernatorial election; two transparent ballot boxes revealed that nearly 70 percent of visitors voted yes. Today Haacke's poll is considered an early example of "institutional critique." Meanwhile, Brazilian artist Hélio Oiticica's "leisure proposition," *Barracao Experiment 2*, was an installation of wooden bunks with mattresses and burlap curtains into which visitors could climb to rest. "The international roster of artists was a critical aspect of the exhibition," explains critic and art historian Bruce Altshuler, "not only demonstrating the global use of conceptual strategies but also the existence of a McLuhanesque 'global village' created by electronic systems of communication."[2] —Sofia Kofodimos

a.

b.

c.

Romare Bearden (American, 1911–1988)

Patchwork Quilt. 1970
Cut-and-pasted cloth and paper with synthetic polymer
paint on composition board, 35¾ x 47⅞ in. (90.9 x 121.6 cm)
Blanchette Hooker Rockefeller Fund, 1970

Along with Jacob Lawrence, Romare Bearden was one of the few African American artists to attract the attention of MoMA relatively early on. In 1944, James Thrall Soby, director of the Department of Painting and Sculpture, wrote a long letter to Bearden's army major in an attempt to prevent the artist's transfer from Fort Dix, New Jersey, to a labor battalion in Louisiana, calling Bearden "one of the most capable and talented young soldier artists I have come across."[1] A year later, MoMA purchased the drawing *He Is Arisen* (1945), the first Bearden work to enter a public collection. The Museum acquired its second work by Bearden, the large abstract painting *The Silent Valley of Sunrise* (1959), in 1960.

Successively experimenting with the major artistic trends of the time, from Social Realism to Abstract Expressionism, Bearden found his signature style around 1964, when he started developing his own collage technique and unfolded an iconography inspired by the black experience— "the life of my people as I know it."[2] Made of many different pieces of cloth and paper cut and pasted onto board, *Patchwork Quilt* is exemplary of the artist's distinctive method, while epitomizing his interest in black history and culture. "Here a woman on a patchwork quilt, in possibly a southern cabin, is given overtones that relate her to ancient Benin and Egypt," Bearden explained.[3]

The timing of the work's acquisition by MoMA in late 1970 was anything but accidental. The Museum was about to open a solo exhibition focusing on Bearden's recent collage practice (*Patchwork Quilt* would ultimately appear on the catalogue's cover), and the show had been conceived in direct response to the vigorous protest campaign that artists and activists had been waging since 1969, charging MoMA with racism for its exclusion of artists of color and at times picketing the Museum, some with signs demanding "Retrospective for Romare Bearden Now." An internal investigation surrounding the protesters' allegations concluded that "whereas MoMA's acquisitions policy was not consciously ethnocentric, selection decisions for the collection were based primarily on the 'White' experience," which in turn "may have unconsciously contributed" to a "legacy of neglect."[4] In the years that immediately followed, the Museum actively worked to counter its historical bias, both by devoting more resources to acquiring works by nonwhite artists as well as incorporating such works more prominently in its exhibition program. Funds given by Blanchette Hooker Rockefeller were, at her request, specifically allocated toward this purpose, allowing the Museum to purchase not only *Patchwork Quilt* and two smaller collages by Bearden but also major works by such important figures as Benny Andrews, Bob Thompson, and Howardena Pindell.

Initially made for *She* (1970), a group exhibition at the Cordier & Ekstrom gallery devoted to artistic depictions of women over the centuries, *Patchwork Quilt* became MoMA's first picture of a dark-skinned reclining nude, quietly disrupting her many white counterparts painted by artists such as Henri Rousseau, Amedeo Modigliani, and Tom Wesselmann. —Charlotte Barat

1. James Thrall Soby to Major Leo Friedman, November 16, 1944. Romare Bearden Artist File, Department of Painting and Sculpture, MoMA, NY.
2. Romare Bearden, "Rectangular Structure in My Montage Paintings," *Leonardo* 2, no. 1 (January 1969): 18.
3. Romare Bearden, Artist Questionnaire in Object File, Department of Painting and Sculpture, MoMA, NY.
4. "Byers Committee Report to Trustees," February 1971, p. 18. John B. Hightower Papers, I.9.70. MoMA Archives, NY.

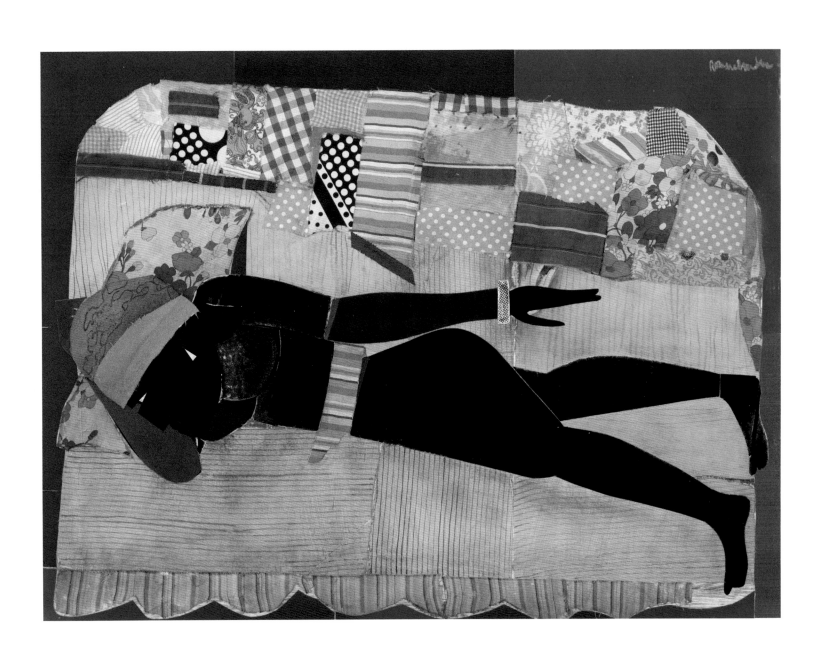

Barnett Newman (American, 1905–1970)

Onement III. 1949
Oil on canvas, 71⅞ x 33½ in. (182.5 x 84.9 cm)
Gift of Mr. and Mrs. Joseph Slifka, 1971

In 1948, Barnett Newman began to make the works that he would later title the *Onement* paintings. The six paintings in this landmark group, made over the course of five years, all share Newman's signature gesture: the "zip," a vertical swath of oil paint, which at once cleaves and unites an otherwise unmodulated field of color. Newman had employed the vertical band before, but as one of several elements within more variously populated compositions. With *Onement I*, the zip became the work's defining feature, and remained so for the rest of the artist's career. The six *Onement* paintings all differ considerably from one another in palette, format, and scale. For example, *Onement III* is nearly three times as tall and twice as wide as *Onement I*, even as the two works share similar colors.

In keeping with the commitment to abstraction that was dominant among New York artists in the immediate postwar years, the *Onement* paintings do not depict a particular subject. However, we know from Newman's own notes that he associated "onement" with, or derived it from, the word "atonement."[1] In the Jewish tradition in which Newman was raised, an annual ritual of atonement takes place on the holiday of Yom Kippur; following atonement, one begins the coming year afresh. "Atonement" can also be understood as "at-onement," implying an inner sense of unity and peace.

Because Newman had worked as an art critic and curator during the early-to-mid-1940s, his turn to painting in the second half of the decade was greeted with a good deal of skepticism in the art world. He was known more as an intellectual than a painter, and what's more, his paintings operated distinct from the modes of Abstract Expressionism being explored by other rising talents, sharing neither the virtuosic gestural markings of Jackson Pollock (p. 141) or Willem de Kooning (p. 115), for example, nor the flowing fields of color of Mark Rothko (p. 109). The odd-person-out quality of Newman's work long prevented his paintings from gaining serious attention outside a very small circle of admirers. When MoMA purchased Newman's painting *Abraham* (1949) in 1959, it became the first museum in America to own a work by the artist. A decade later, in June 1969, *Onement III* was announced as a promised gift from Sylvia and Joseph Slifka, generous patrons of the MoMA collection. The announcement was made upon the occasion of the work's appearance in the exhibition *The New American Painting and Sculpture: The First Generation*, organized by William Rubin.

Onement III fully entered the Museum collection in 1971, a year after Newman's death. *Onement I* would join the collection in 1992, as a donation from Annalee Newman, the artist's widow. Together with five other paintings and sculptures, as well as a significant group of drawings and prints, they comprise one of the most important collections of Newman's work. —Kayla Dalle Molle

1. Ann Temkin, *Barnett Newman* (Philadelphia: Philadelphia Museum of Art, 2002), 158.

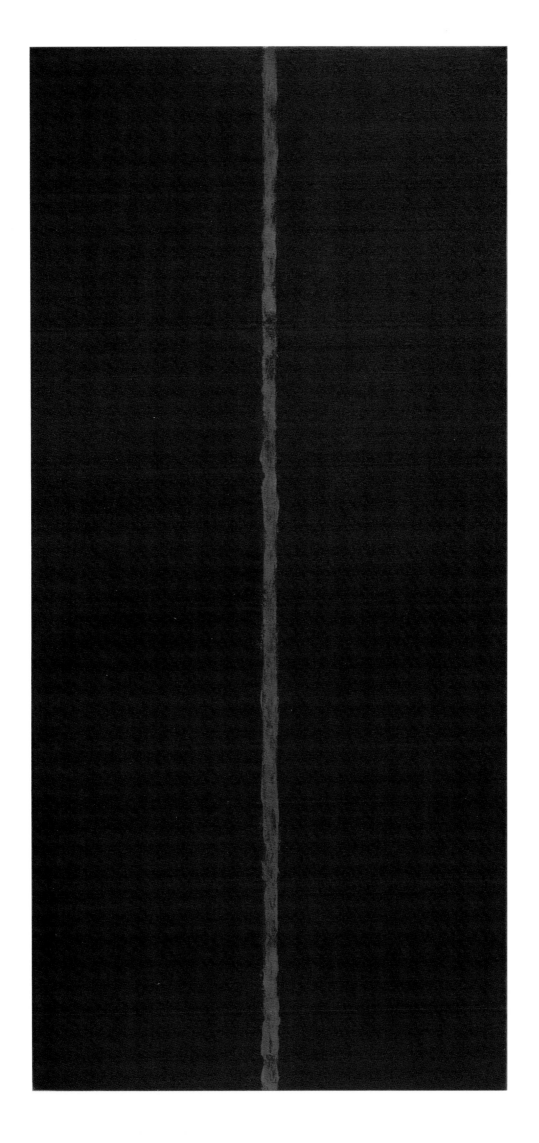

Roy Lichtenstein (American, 1923–1997)

Drowning Girl. 1963
Oil and synthetic polymer paint on canvas,
67⅝ x 66¾ in. (171.6 x 169.5 cm)
Philip Johnson Fund (by exchange) and
gift of Mr. and Mrs. Bagley Wright, 1971

In a report to MoMA trustees in 1933, Alfred Barr put forward his theory of an ideal collection for a museum devoted to modern art, which he conceived as resembling "a torpedo moving through time, its broad end in the ever-advancing present, its narrow tail in the ever-receding past."[1] This forward-moving vision necessitated, since the early days of the Museum's operation, the judicious use of deaccession, or the process of offering less essential works for sale so as to purchase others that might advance and refine the institution's holdings, an approach indefatigably supported by Barr. Roy Lichtenstein's *Drowning Girl* is one of hundreds of works in MoMA's collection that was funded, at least in part, by this practice.

In early 1963, Lichtenstein began his most iconic series: graphic paintings of lovelorn women appropriated from DC Comics and dramatically scaled. *Drowning Girl* was first presented to the public that spring at the Ferus Gallery in Los Angeles, where it went unsold. Later that year, at Lichtenstein's second solo exhibition at the Leo Castelli Gallery in New York, the painting was purchased by Virginia and Bagley Wright, Seattle-based members of MoMA's International Council. Bagley was the real-estate developer behind the city's landmark Space Needle, and together the couple was assembling the most extensive collection of modern and contemporary art in the Pacific Northwest.

In 1971, chief curator of the Department of Painting and Sculpture William S. Rubin enlisted Irving Blum, the director of Ferus Gallery, to make contact with the Wrights. Rubin explained his high opinion of *Drowning Girl* and his conviction that it was a particularly strong example of Lichtenstein's comic-strip style essential to MoMA's representation of the artist's work. The Wrights consented to part with their masterpiece, as a partial gift and partial purchase. In order to make this acquisition possible without creating debt for the acquisitions funds, the Committee on Painting and Sculpture proposed that *Flatten—Sand Fleas!* (1962), another work from the same moment in Lichtenstein's career, be deaccessioned to help cover the Museum's commitment toward the new purchase. Based on a wartime comic, *Flatten—Sand Fleas!* had been acquired in 1966 using monies from a purchase fund endowed by Philip Johnson, the longtime MoMA trustee who was founding chairman of the Museum's Department of Architecture.

Drowning Girl entered the collection in December 1971, and nearly half a century later, MoMA's holdings of Lichtenstein's work have grown to include ten paintings, two sculptures, twenty-three drawings, eighty-one prints, seventeen illustrated books, and four graphic designs. Because the Museum wishes to recognize the formative contributions of donors who have supported the collection, names from deaccessioned gifts are carried forward to new acquisitions: as such, the credit line for *Drowning Girl* acknowledges the generosity of the painting's preowners while also renewing the legacy of Johnson's initial gift. —Kayla Dalle Molle

1. Alfred H. Barr Jr., "Report on the Permanent Collection," November 1933, p. 13. Alfred H. Barr Jr. Papers, II.C.16. MoMA Archives, NY.

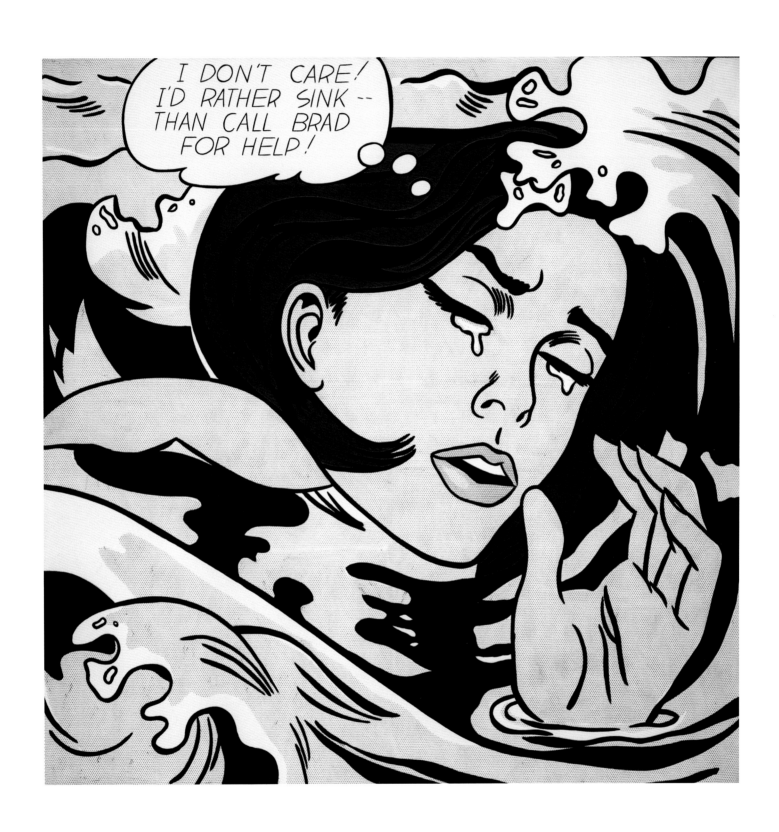

From the Archives: **Projects**, 1971

a. Installation view of **Projects: 100 Boots by Eleanor Antin**,
The Museum of Modern Art, New York, May 30–July 8, 1973.
Photograph by Katherine Keller
Photographic Archive. MoMA Archives, NY

b. Eleanor Antin installing **100 Boots**, 1973.
Photograph by Leonardo Le Grand
Photographic Archive. MoMA Archives, NY

c. Postcard titled **100 Boots on the Ferry, Upper Harbor, New York City,
May 16, 1973, 11:20 a.m.**, mailed by Eleanor Antin to William Lieberman
at MoMA for the exhibition **100 Boots**, 1973
MoMA Exhibition Records, 1035.3. MoMA Archives, NY

In May 1971, less than a year after MoMA opened *Information* (p. 148), its pioneering international survey of Conceptual art, the Museum inaugurated its Projects series, conceived as a way to more regularly showcase a new generation of avant-garde performance, installation, and Conceptual artworks that challenged conventional exhibition methods by circumventing the "spatial and temporal limits" of traditional gallery spaces.[1] In announcing the first such show, a sound-and-light installation by Keith Sonnier, MoMA defined Projects as "a series of small exhibitions presented to inform the public about current researches and explorations in the visual arts."[2] By specifically making room in its programming for new artists working in dynamic new media, the Museum created space for experimentation and growth even within its structured art-historical narrative.

100 Boots by Eleanor Antin, which opened in May 1973, was among the earlier exhibitions in the Projects series. For the artwork, Antin spent two and a half years staging photographs that documented the travels of a hundred pairs of black rubber boots, photographs that she then turned into postcards and mailed to hundreds of various people and institutions around the world. These dramatic, enigmatic postcards, fifty in all, chronicle the boots' picaresque adventures in both California and New York to create a narrative at once specific and strange, weighted with mysterious allegory, from the boots' surreal march beneath Western oil derricks to their seemingly attentive surveying of the Manhattan skyline. *100 Boots* at MoMA displayed the full collection of postcards, photographic blowups of the boots' journey, and a gallery transformed into the boots' New York "crash pad": a tenement room with sink, mattress, sleeping bags, blankets, kitchen chair, and radio.[3] The room could only be seen through a crack in a door secured by a chain lock.

The first exhibition series of its kind in the United States, Projects has played an essential role in MoMA's contemporary art programming for more than forty years while at the same time serving as a springboard for numerous young artists just starting their careers, many of whom have gone on to international acclaim, such as Chuck Close (1973), Laurie Anderson (1978), Louise Lawler (1987), Rosemarie Trockel (1988), Lorna Simpson (1990), Kiki Smith (1990), and Steve McQueen (1998). And Projects continues to this day, consistently challenging our definitions of art, art-making, and the relationship between ourselves and our worlds. In 2006, the series was renamed the Elaine Dannheisser Projects Series, in honor of longtime contemporary art collector Elaine Dannheisser, who bequeathed most of her collection to MoMA upon her death in 2001. —Elisabeth Thomas

1. "Projects: Keith Sonnier," MoMA press release, May 24, 1971. MoMA Archives, NY.
2. Ibid.
3. Eleanor Antin to Jane Necol, May 8, 1972. MoMA Exhs., 1035.5. MoMA Archives, NY.

a.

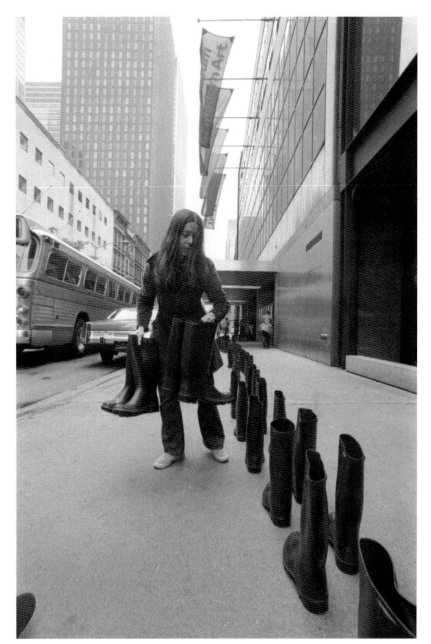

b.

c.

Gustav Klimt (Austrian, 1862–1918)

Hope, II. 1907–08
Oil, gold, and platinum on canvas,
43½ x 43½ in. (110.5 x 110.5 cm)
Jo Carole and Ronald S. Lauder and
Helen Acheson Funds, and Serge Sabarsky, 1978

Gustav Klimt was one of the foremost painters of the group of artists who, in 1897, broke away from the Vienna Academy to form the Secession, under the banner of which Klimt mounted exhibitions and elaborated a style free from the prevailing conservative historicism.

Hope, II is one of several paintings executed in Klimt's signature manner *Jugendstil*, or Art Nouveau, that feature stylized allegorical figures within decorative fields. These paintings' alternately matte and reflective surfaces—including precious metals that evoke otherworldly realms—flicker between flatness and dimensionality. In *Hope, II*, a pale, bare-chested, pregnant woman, cloaked in brilliantly patterned garb with polychromatic and gilded concentric circles, bows her head in contemplation. Symbols of love, birth, and death coexist in a delicate balance. A skull floats precariously above her womb, and at her feet, ensconced within her massive robe, a cluster of three bowing female figures raise their hands in gestures of supplication.

Called *Vision* during Klimt's lifetime, the work was later retitled because of its association with an earlier painting, *Hope, I* (1903), which features a fully nude pregnant protagonist surrounded by looming figures and a suspended skull. In German, within the context of pregnancy, *Hoffnung*, which is translated as "hope," also means "expecting." In addition to these two paintings, Klimt executed several drawing studies of pregnant nudes.

In 1978, *Hope, II* became the first *Jugendstil*/Art Nouveau painting by Klimt to enter any collection in the United States, public or private. As William Rubin described it: "For many years The Museum of Modern Art—and many other museums around the world—have tried to obtain a major Art Nouveau (or *Jugendstil*) Klimt. Klimt's reputation as a crucial figure in the art of the fin de siècle rests on such ornamental Symbolist paintings."[1] In the spring of 1977, the Museum became aware that *Hope, II*, then in a private collection in Vienna, was available for purchase. It was exceedingly rare to find an iconic Klimt still in private hands, and the acquisition would require the approval of the Austrian Bundesdenkmalamt, or Federal Monuments Office, to grant an exceptional permanent export license. Once the license was granted, the Museum still needed to secure the funds to purchase the work. Rubin, in consultation with MoMA's Committee on Painting and Sculpture, decided that an earlier painting by Klimt (and the first to enter the collection), *The Park* (1910 or before), should be sold to art dealer Serge Sabarsky to facilitate the purchase of *Hope, II*, a proposition with which Gertrud Mellon, who had originally given the funds to purchase *The Park*, enthusiastically agreed. The proceeds from the sale, along with a contribution from the Jo Carole and Ronald S. Lauder and Helen Acheson Funds, allowed the Museum to welcome *Hope, II* into the collection on June 26, 1978. But the loss of *The Park* was temporary: happily, the Museum was able to repurchase the painting from Sabarsky, and today both works remain icons of the collection. —Akili Tommasino

1. William Rubin, "To: File," October 12, 1978. Object Files, Department of Painting and Sculpture, MoMA, NY.

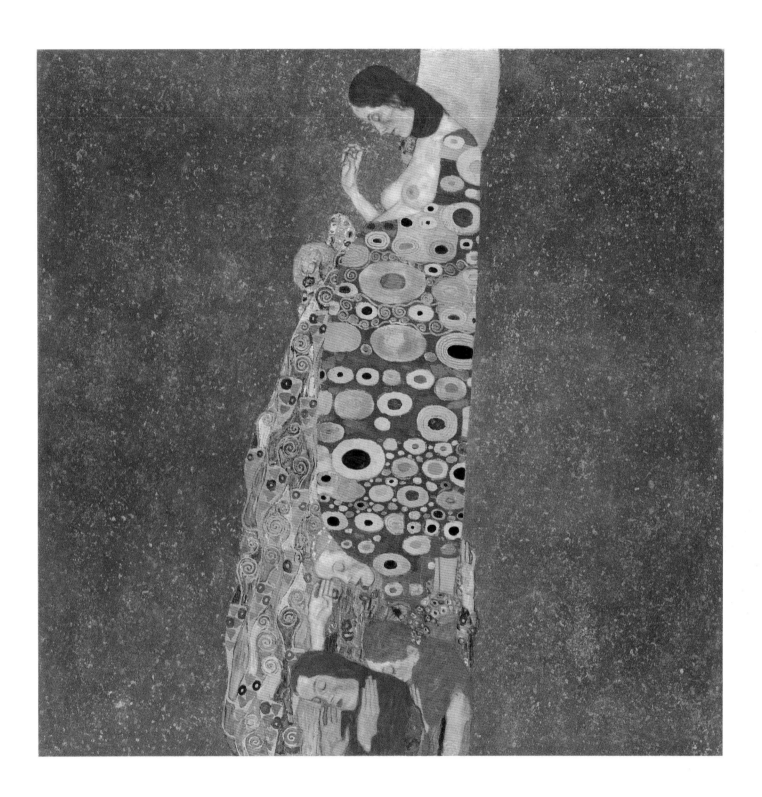

Irving Petlin (American, born 1934)
Jon Hendricks (American, born 1939)
Frazer Dougherty (American, born 1922)

Photograph by Ronald L. Haeberle (American, born 1941)

Q. And babies? A. And babies. 1970
Publisher: Artists' Poster Committee of
the Art Workers' Coalition, New York, NY
Offset lithograph, 25 x 38 in. (63.5 x 96.5 cm)
Gift of the Benefit for Attica Defense Fund, 1978

This powerful poster employs Ronald L. Haeberle's photograph of the 1968 My Lai massacre, overlaid with quotes from a television interview with a soldier who participated in the attack. One of the most heinous acts of carnage documented during the Vietnam War, as many as five hundred unarmed civilians—men, women, children, and infants—were beaten, sexually assaulted, and summarily executed by American soldiers. Though documentation was censored by the U.S. military, other photographs, like this one taken by Haeberle with his personal camera, were later released to the media to draw attention to the atrocity.

In 1969, the Art Workers' Coalition formed in New York to challenge social injustices within the collections, programs, and operations of MoMA and other local cultural institutions. In addition to demanding the display of art by women and artists of color, the coalition also pushed the Museum to take a political stand and oppose the Vietnam War. At a meeting in November 1969 between Museum representatives, the coalition, and other artists, artist Irving Petlin suggested making a poster decrying the My Lai massacre, which the Museum and the artists agreed to co-publish. Petlin, along with Jon Hendricks and Frazer Dougherty of the coalition, elected to serve on a committee with two members of MoMA's staff. By December, this Artists' Poster Committee had obtained permission to use Haeberle's photograph and approval for a final design, and secured in-kind donations for the poster's production. But at the last minute, MoMA president William Paley expressed reservations about the institution's becoming politically entangled in "any matter not directly related to a specific function of the Museum," and MoMA withdrew its support.[1]

The Artists' Poster Committee immediately printed fifty thousand copies of the poster for free distribution, with MoMA's name removed from the credits. An Art Workers' Coalition statement castigated the Museum's decision as a "bitter confirmation of this institution's decadence and/or impotence" in the face of global outrage.[2] In early 1970, Hendricks and other members of the coalition staged an action in which they held copies of the poster in front of *Guernica* (1937), the mural painted by Pablo Picasso in response to the bombing of civilians during the Spanish Civil War, which was on extended loan to the Museum. By comparing one painter's masterly reprobation of the horrors of war with a contemporary antiwar poster the Museum had effectively rejected, the artists sought to highlight the ambivalence of the Museum and to question the underpinnings of its selective political engagement.

Despite its close connection with MoMA, the poster was not formally acquired into the collection until 1978. It has been displayed in a number of significant Museum exhibitions on the subjects of protest art, communication design, and design for and about children, including *Information* (1970, p. 148), *The Artist as Adversary* (1971), *MoMA2000* (2000), and *Century of the Child* (2012). —Luke Baker

1. William Paley, quoted in "The Museum and the Protest Poster," MoMA statement, January 8, 1970. John B. Hightower Papers, III.1.11.a. MoMA Archives, NY.
2. Art Workers' Coalition, untitled statement, undated. Ibid.

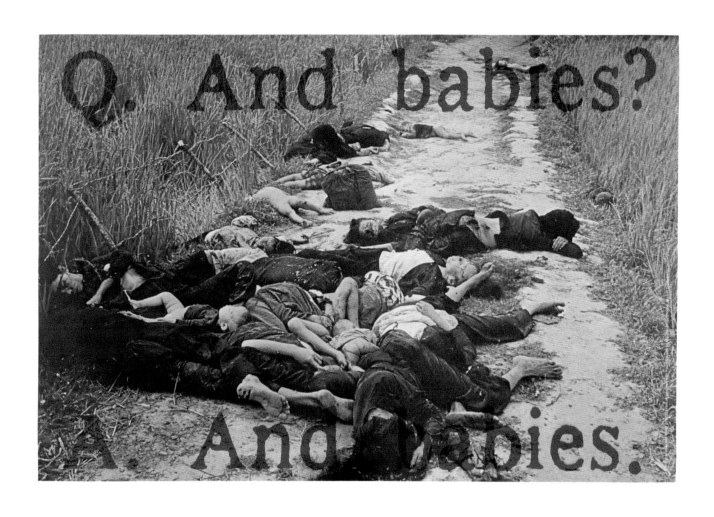

Philip Guston (American, born Canada, 1913–1980)

Tomb. 1978
Oil on canvas, 6 ft. 6⅛ in. x 6 ft. 1¾ in. (198.4 x 187.6 cm)
Acquired through the A. Conger Goodyear and
Elizabeth Bliss Parkinson Funds and gift of the artist, 1981

"I just did a painting which I shall call *The Tomb* or *The Artist's Tomb*," Philip Guston wrote soon after completing this work in 1978. "So it is truly a bitter comedy that is being played out. Painting, which duplicates and is a kind of substitute for your life, as lived from hour to hour, day to day."[1] Completed a year after his wife, Musa McKim Guston, suffered a stroke, and two years before Guston's own fatal heart attack, *Tomb* is one of the darkest examples among a series of the artist's last works that display a growing preoccupation with illness, infirmity, and mortality.

The 6-x-6-foot canvas is dominated by a monumental accumulation of slabs or bricks on top of which rests an assortment of everyday objects rendered in ominous shades of black, gray, and red. Guston had begun depicting the items lying around his studio in Woodstock, New York, in the late 1960s, when, in a move that shocked artists and critics alike, he abandoned the Abstract Expressionist style for which he had become well-known during the course of the previous two decades. In *Tomb*, he employs the vocabulary of rounded representational forms typical of his late paintings to render a series of portentous memento mori: in the center, a smoking cigarette; above it, a lifeless paintbrush plunged into a can of black paint; at the top right, a ball perched on the mound's edge as if captured in the moment before its final fall; and throughout, the repeated image of a horseshoe form—likely that of a pressing iron found in Guston's studio—often interpreted as an omega, the last letter of the Greek alphabet.[2]

Before his death in June 1980, Guston had expressed his desire to make a gift to MoMA, and as a reflection of that wish, *Tomb* entered the collection the following year. The acquisition was a partial gift of the artist and partial purchase with the funds of two loyal MoMA stewards: A. Conger Goodyear, the Museum's first president, and Elizabeth Bliss Parkinson, a longtime trustee, founder of the Museum's International Council, and niece of Museum cofounder Lillie P. Bliss. Following this acquisition, MoMA would go on to become the single largest repository of Guston's late work, a collection that now numbers sixteen paintings made between 1969 and 1979, due in large part to the extraordinary gifts and bequest of the artist's widow in 1991 and 1992 and collector Edward R. Broida in 2005. —Jenny Harris

1. Philip Guston, quoted in Musa Mayer, *Night Studio: A Memoir of Philip Guston* [1986] (Munich: Sieveking Verlag; Berlin: Hauser & Wirth Publishers, 2016), 299.

2. Robert Storr, "Guston's Trace," in *Philip Guston in the Collection of The Museum of Modern Art* (New York: The Museum of Modern Art, 1992), 20–23.

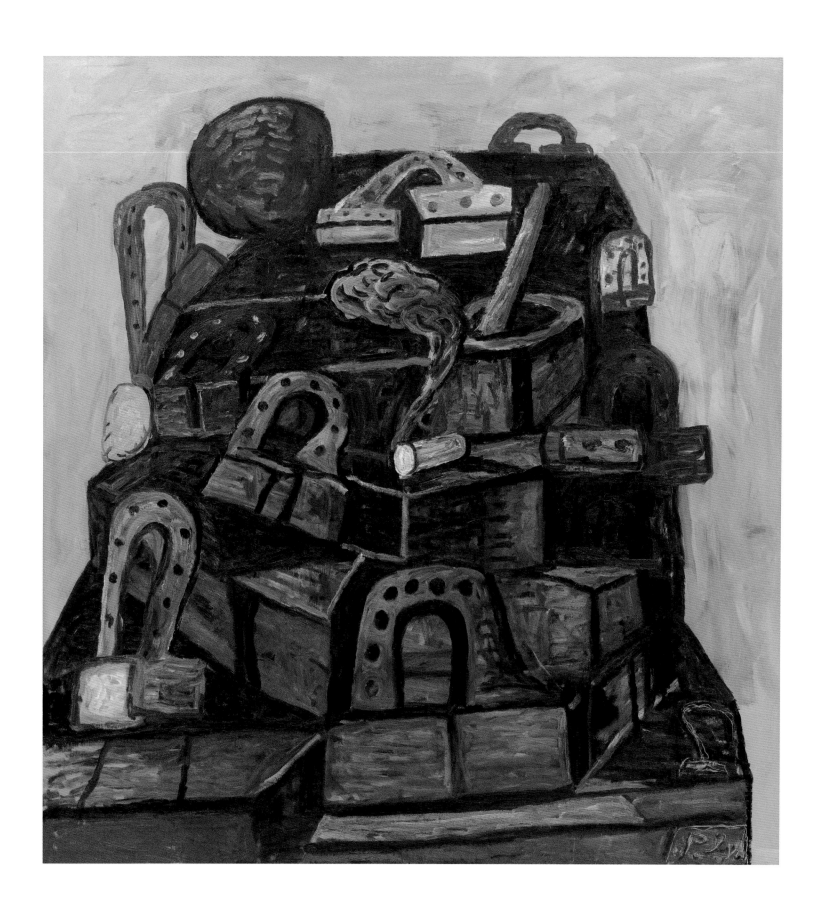

Barbara Kruger (American, born 1945)

Untitled (You Invest in the Divinity of the Masterpiece). 1982
Gelatin silver print, 71¾ x 45⅝ in. (182.2 x 115.8 cm)
Acquired through an anonymous fund, 1983

Working in the magazine industry as a designer, photography editor, and art director in the 1960s and '70s, Barbara Kruger saw firsthand the manipulation of images by the mass media and the persuasive power of advertising. These experiences proved formative for the art Kruger began making in 1970 and circulating via such mass-distribution platforms as posters, postcards, billboards, magazine covers, *New York Times* op-ed pages, and merchandise, extending and amplifying the reach of her images. As she would later recall, "My 'job' as a designer became, with a few adjustments, my 'work' as an artist."[1] By 1979, Kruger had abandoned taking her own photographs and begun to appropriate found images from magazines, books, how-to manuals, and other published sources, overlaying blocks of text on black-and-white photographs, often with attention-grabbing red borders. She has described her use of the aesthetic of advertising design as a "device to get people to look at the picture, and then to displace the conventional meaning that image usually carried with perhaps a number of different readings."[2] Her work frequently deals with issues of feminism ("Your body is a battleground"), consumerism ("I shop therefore I am"), religion ("God said it. I believe it. And that settles it."), and power ("Your money talks").

Kruger came into artistic maturity during the 1980s and the politically conservative Reagan era in the United States. MoMA was among the first cultural institutions to support her work, acquiring *Untitled (You Invest in the Divinity of the Masterpiece)* in 1983, after it had been exhibited in the Whitney Biennial earlier that year. In this work, Kruger employed specially formulated gelatin silver paper made for use with a Photostat recorder, a large-format, camera-like copier commonly used in the industrial design trades. This system was ideal for graphic work, as demonstrated here with the title phrase superimposed over the iconic scene from Michelangelo's Sistine Chapel depicting God's creation of man via his touch of Adam's finger. The work draws a parallel between the biblical creation story and the glorified masterpiece of Western painting—an indictment of art's commodity status.

Kruger's use of appropriation hindered the photographic community, including MoMA's Department of Photography, from embracing her practice in the 1980s. In fact, *Untitled (You Invest in the Divinity of the Masterpiece)* was purchased by the Department of Painting and Sculpture, which had extensive experience collecting artworks that incorporate preexisting objects and imagery, from Marcel Duchamp's readymades (p. 129) to Robert Rauschenberg's mixed-media paintings and Andy Warhol's silkscreens (p. 197). —Katerina Stathopoulou

1. Barbara Kruger, quoted in *Barbara Kruger*, exh. brochure (New York: Whitney Museum of American Art, 2000).
2. Barbara Kruger, quoted in Jeanne Siegel, "Barbara Kruger: Pictures and Words," in *Art Talk: The Early 1980s* (New York: Da Capo, 1988), 303.

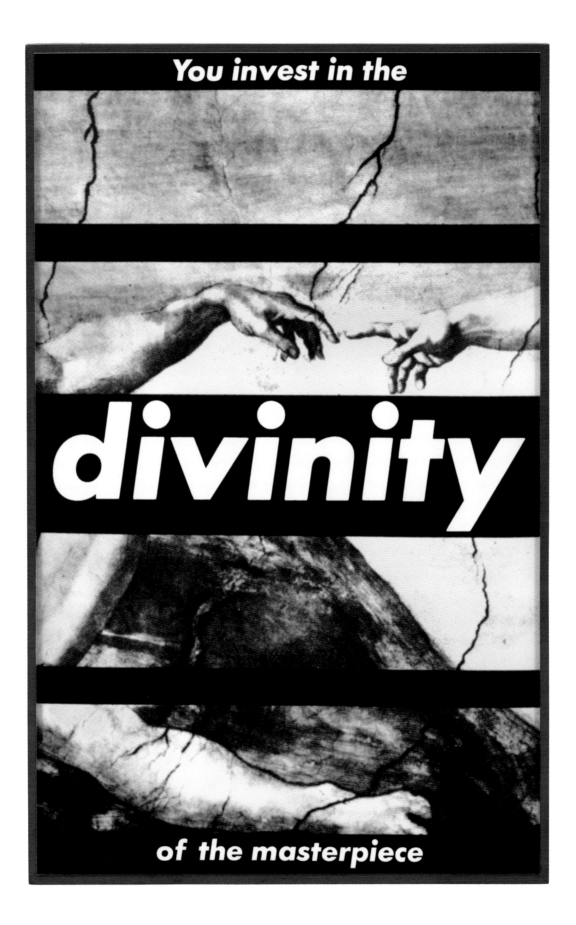

Andy Warhol (American, 1928–1987)

a. **Screen Test: Jane Holzer** [ST142], 1964

b. **Screen Test: Dennis Hopper** [ST154], 1964

c. **Screen Test: Susan Sontag** [ST321], 1964

d. **Screen Test: Edie Sedgwick** [ST308], 1965

e. **Screen Test: Lou Reed** [ST263], 1966

f. **Screen Test: Salvador Dalí** [ST67], 1966

16mm film (black and white, silent),
approximately 4 minutes at 16 frames per second, each
Original film elements preserved by The Museum of Modern Art, New York.
Gift of The Andy Warhol Foundation for the Visual Arts, Inc., 1983

From 1964 to 1966, Andy Warhol made 472 film portraits of friends, acquaintances, and assorted visitors to The Factory, his studio in New York. Not called *Screen Tests* until Warhol and his associate Gerard Malanga began marking the boxes of reels as such in early 1966, these short, silent moving-picture portraits in black and white were initially referred to as "filmed portraits" or "stillies" by their maker. All the *Screen Tests* were shot using the commercially available 16mm Bolex camera that Warhol acquired in 1963, and they generally share the same strikingly simple technical setup: the Bolex was affixed to a tripod, and lighting was adjusted to create shadows or flat expanses of light on the subject, who was supplied with a chair. A pulldown screen provided a backdrop that could be light, dark, or perhaps a faux-brick wall. After starting the camera, Warhol would often walk away for the duration of the four-minute reel. Some subjects appear visibly anxious or self-conscious, while others sit quietly and smile or even mug for the camera. On occasion, the subject would be given a prop or activity, such as poet George Millaway applying lip balm, Jane Holzer brushing her teeth, or Warhol's one-time boyfriend Philip Fagan munching on an apple. Art-world rapscallion Salvador Dalí sat for two *Screen Tests* in 1966 and cheekily disappears from the screen in one of them.

The *Screen Tests* provide a fascinating glimpse into the culture of 1960s New York, and specifically, the diverse levels of the city's social order that Warhol moved fluidly between. Pop-culture superstars, high-society doyennes, fashion icons, downtown drag queens, revolutionaries, and art-world celebrities all mingled at The Factory, where they were frequently asked to sit for a *Screen Test*, a project that in turn underscores Warhol's personal attraction to the conflation of photographic portraiture and the moving image.

In the early 1970s, Warhol removed from public circulation the films he made between 1963 and 1968.[1] The disappearance of these works created a mythology concerning their creation and content. It was not until the late 1980s that the Film and Video Department at the Whitney Museum of American Art and the Department of Film and Media at MoMA approached the Andy Warhol Foundation for the Visual Arts with a novel idea: the Whitney would conduct scholarly research on Warhol's films and produce a catalogue raisonné, and MoMA would preserve the original film materials and make new copies available for access. By 1995, the first group of *Screen Tests* had been preserved and was available for scholarly study and exhibition. To date, nearly three hundred *Screen Tests* have been preserved and are in circulation as 16mm prints via MoMA's Circulating Film Library. —Anne Morra

1. Mary Lea Bandy, foreword to *Andy Warhol Screen Tests: The Films of Andy Warhol, Catalogue Raisonné*, vol. 1, ed. Callie Angel (New York: Abrams, in association with the Whitney Museum of American Art, 2006), 7.

a.

b.

c.

d.

e.

f.

Laurie Anderson (American, born 1947)

What You Mean We? 1986
Video (color, sound), 19:51 minutes
Purchase, 1986

Laurie Anderson's hybrid practice has spanned music, performance, sculpture, and video, among other art forms, during a four-decade career that originated in the downtown art scene of New York's SoHo in the 1970s. There, artists often sought to challenge the status quo by circumventing institutional politics and the commercial gallery system; by the 1980s, this resistance extended to the adoption of television as a medium and form of activism. Many artists employed narrative tropes or editing techniques borrowed from television, and incorporated television-appropriated content into their work. Others broadcast their work itself on television or collectively organized their own television programming on local public-access stations. In these ways, artists wielded television against itself to deconstruct the mass media, aiming to reach wider audiences and critique the corporate forces behind major television networks.

MoMA's collecting of video art began in 1977, thanks in large part to the pioneering commitment of curator Barbara London, an early champion of Anderson's work. The Museum acquired its first work by Anderson in 1982; four years later, it purchased *What You Mean We?* from the Contemporary Art Television Fund, a joint initiative between the Institute of Contemporary Art, Boston, and the New Television Workshop, a division of Boston public television station WGBH. Created as a platform for artist projects, the fund commissioned more than twenty works between 1984 and 1991, including *What You Mean We?*, which Anderson wrote, directed, and starred in. Made for broadcast on the PBS arts series *Alive from Off Center* and hailed as one of the show's best-known episodes, this work is both an exercise in self-fragmentation and a caricature of celebrity, in which Anderson portrays herself and two "clones" of herself. The video begins with Anderson being interviewed on a fictitious talk show and explaining to the off-screen interviewer (Spalding Gray) how, overwhelmed by the demands of fame and with little time to write, she decided to clone herself. Due to complications in the cloning process, however, the clone is half her size and has physically masculine traits, including a deep voice (rendered through electronic distortion). As the clone works furiously, Anderson relaxes with a newspaper. "We have to get a show put together for a fast-approaching opening," she says. "*What You Mean We?*," the clone retorts. Eventually some of the clone's ideas for movies—Rambo Meets Rocky, for example—make him so successful that he, too, procures a clone to write for him while he's busy with TV appearances. The clone's clone emerges as an oversize version of Anderson in clownlike makeup, bringing to a close the absurd feedback loop of this surreal affair. *What You Mean We?* is a key example of the ways in which early video art was intertwined with underground and popular culture, a phenomenon that intensified during the MTV era. The work also epitomizes Anderson's inimitable storytelling combining poetry, music, and satire, as well as her hallmark use of doubling, which she has employed in iconic performances throughout her career. —Erica Papernik-Shimizu

Paul Signac (French, 1863–1935)

Opus 217. Against the Enamel of a Background Rhythmic with Beats and Angles, Tones, and Tints, Portrait of M. Félix Fénéon in 1890. 1890
Oil on canvas, 29 x 36½ in. (73.5 x 92.5 cm)
Gift of Mr. and Mrs. David Rockefeller, 1991

Paul Signac's oil portrait of his friend the art critic and political activist Félix Fénéon, is a formally expansive and whimsical celebration of a well-known progressive cultural figure in fin-de-siècle Paris. Presented in profile and gazing beyond the picture plane, Fénéon wears a three-piece suit and his hallmark goatee, and holds a top hat, glove, and walking stick in his left hand. With his right hand, he gingerly extends a lily to an unseen recipient. The subject's pose implies motion, yet his body is incongruously still, especially in comparison to the background against which he appears, a kaleidoscopic swarm of patterns and colorways emanating from a central point. Fénéon is at once contrasted and continuous with, detached from and "enameled" to this dynamic environment.

The background's constituent patterns, symbols, and colors likely reference richly varied sources, including Japanese textiles (seen in the purple-and-yellow motif at left) and mystic occultism (evidenced by the astral globes orbiting Fénéon's body).[1] The pinwheel design evokes the recently published color wheel of optical theorist Charles Henry. Signac and Fénéon shared Henry's eccentric interest in charting correspondences between the elemental properties of form and color and emotional expression. Through the dots that fill it, as well as its titular beats, angles, tones, and tints, *Opus 217* both deploys and depicts Henry's empirical model. In an 1889 letter to Vincent van Gogh, Signac praised the "great social bearing" of Henry's theories, which he found powerful tools for teaching "the art of seeing correctly and beautifully to apprentice workmen etc."[2] In *Opus 217*, Signac celebrates the ability of art, through its mass appeal, to give new scientific findings a widespread audience. A testament to these raised stakes for art, the painting is at once a portrait of Fénéon and of vision itself—both a portrayal of its subject using his faculty of sight and a symbolic depiction of the newly expanded modes of conceiving the modern world.

Opus 217 was a hard-won painting. Fénéon evaded Signac's initial entreaties to sit for him, finally accepting on the condition that the artist would depict him in "effigy absolutely full-face."[3] Displeased that Signac ignored his wishes, Fénéon nonetheless hung this profiled portrait in his home until his death, in 1944. After his wife's death three years later, it was sold to the first of what would be a sequence of private collectors, until it was purchased at auction in 1968 by longtime Museum trustee David Rockefeller. Feeling it was a picture destined for MoMA, Rockefeller and his wife, Peggy, generously promised the work to the Museum in 1970 and officially offered MoMA a fractional ownership of it in 1991, as part of a historic gift that also included masterworks by Paul Cézanne, Henri Matisse, and Pablo Picasso, among others. With David Rockefeller's death in March 2017, these gifts fully entered the Museum's collection. —Cara Manes

1. Robert Herbert, *Neo-Impressionism* (New York: Solomon R. Guggenheim Foundation, 1968), 140–41.
2. Paul Signac to Vincent van Gogh, April 12, 1889. Van Gogh Museum, http://vangoghletters.org/vg/letters/let757/letter.html.
3. Joan U. Halperin, *Félix Fénéon: Aesthete and Anarchist in Fin-de-siècle Paris* (New Haven, CT: Yale University Press, 1988), 144.

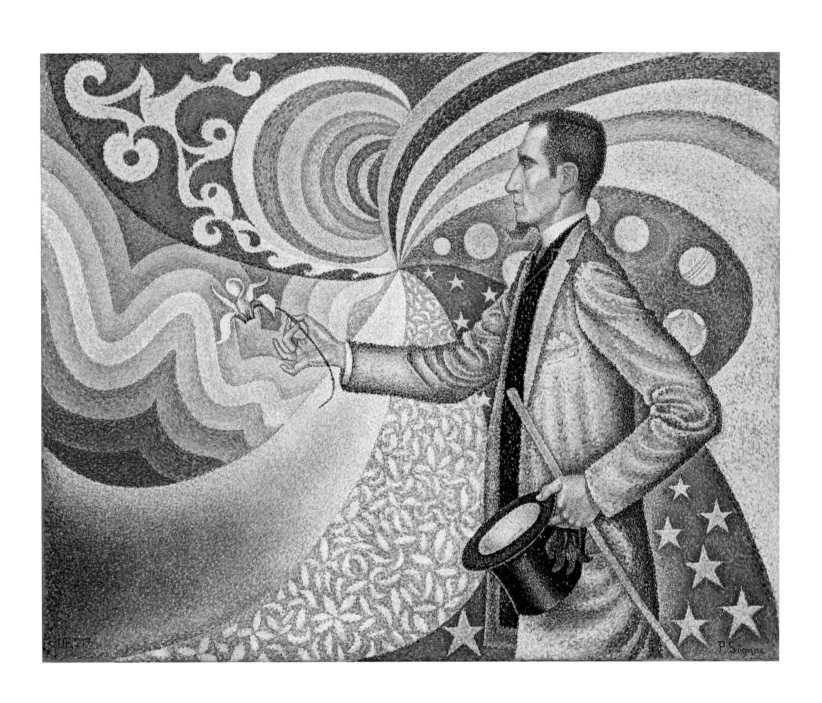

Bruce Nauman (American, born 1941)

Human/Need/Desire. 1983
Neon tubing and wire with glass tubing suspension frames,
7 ft. 10⅜ in. x 70½ in. x 25¾ in. (239.8 x 179 x 65.4 cm)
Gift of Emily and Jerry Spiegel, 1991

Bruce Nauman's six-spoked neon sculpture shown here features the words "HUMAN," "HOPE," "NEED," "DREAM," and "DESIRE." The words are composed of glass tubing, with each word illuminated in two different colors of neon. Nauman first began experimenting with the use of neon tubing in his sculptures in 1965 while he was a graduate student at the University of California, Davis. After he completed his studies, he took a studio in San Francisco that had previously been a grocery store. The former tenants had left a beer sign in the window; Nauman later recalled that seeing the sign from both sides led him to begin making neon signs as artworks.[1] It was during this period that he made *Window or Wall Sign* (1967), which reads: "The true artist helps the world by revealing mystic truths." This early neon presents language as both form and subject in a bright, eye-catching medium that Nauman has repeatedly returned to throughout his career, while continuing to make innovative work in a diverse range of other mediums, from sculptures and drawings to sound and video.

In 1982, the Baltimore Museum of Art presented a comprehensive exhibition of Nauman's neon signs to date, which prompted the artist to take a renewed look at the medium. As Nauman later explained: "What I tend to do is see something, then remake it and remake it and remake it and try every possible way of remaking it. If I'm persistent enough, I get back to where I started."[2] *Human/Need/Desire* was the fourth neon sign that Nauman made the year following the Baltimore exhibition, a series of works that reference human nature, carnal urges, and bodily desires, foregrounding longstanding elements within the artist's oeuvre.

Nauman's neon signs, including *Human/Need/Desire*, often begin as large and elaborate word drawings. The drawing for this particular sign iterates the words with detailed notes about the colors to use and how the words should be illuminated, such as flashing, in changing combinations, or a specific pattern. The instructions on the drawing specify: "HUMAN NEED DESIRE/red+yellow/pink light (cool green)/Desire can be pale purple+pale yel/for pale desire-/(November) pale yellow/blue+orange/HOPE/DREAM/simultaneous/1A Flash clockwise/flash counterclockwise/4 times and/all flash together 1 sec+/repeat/total cycle 5 sec."[3] When lit, the words in *Human/Need/Desire* function as flickering, elusive mantras for the human experience.

This work was gifted to MoMA in 1991 by Emily and Jerry Spiegel, longtime benefactors of the Museum who built an important private collection of modern and contemporary art. MoMA had, by that point, been collecting Nauman's work for twenty years, starting with the print *Studies for Holograms* (1970) followed by sculptures, drawings, additional prints, and a video, but *Human/Need/Desire* was the first neon work by the artist to enter the collection. In 1996, an earlier neon work by Nauman, *Perfect Door/Perfect Odor/Perfect Rodo* (1972), came into the collection as a gift of Werner and Elaine Dannheisser, and the Museum has continued to acquire many artworks by Nauman in the subsequent two decades, including key installations, sculptures, videos, and works on paper. —Talia Kwartler

1. Joan Simon, "Breaking the Silence," in *Bruce Nauman*, ed. Robert C. Morgan (Baltimore: John Hopkins University Press, 2002), 273–74.
2. Ibid., 270–71.
3. *Bruce Nauman: Drawings 1965–1986* (Basel: Museum für Gegenwartskunst, 1986), no. 423.

Christopher Wool (American, born 1955)

Untitled. 1990
Enamel on aluminum, 9 x 6 ft. (274.3 x 182.9 cm)
Gift of the Louis and Bessie Adler Foundation, Inc., 1991

Christopher Wool's paintings consolidate competing urges. Always visually seductive, they often contain markings best described as unremarkable—imperfectly rolled patterns of foliage or arabesques, meandering lines of spray paint, smears signaling erasure, and black stains obscuring what lies beneath—delivered large scale and typically in black and white. During the late 1980s and into the '90s, written language became the central visual motif of Wool's work. His blocky stenciled letters form individual words, phrases, and sentences capable of communicating with the directness of graffiti and the deliberation of poetry. The most straightforward of these language-based works feature single words painted on 9-x-6-foot aluminum panels, a standard format for Wool, with letters that measure four feet high. At that scale, "FOOL," "RIOT," or "RUN" scream with unparalleled intensity. Elsewhere, Wool's syntax is more complex, and the image follows suit. He typically ignores conventional punctuation and word or line breaks when positioning text onto a panel for a desired visual effect. Sometimes the passages are authored by the artist; most times they are appropriated from elsewhere. Wool borrowed the phrase that appears in *Untitled*, shown here, from the 1957 film noir classic *Sweet Smell of Success*, where the character played by Tony Curtis says, "The cat's in the bag, and the bag's in the river" to indicate that a dirty job, likely a "hit," will be taken care of. By giving spoken language visual form, Wool further amplifies the sinister qualities of the phrase, which sits on the panel with a blustering authority that calls to mind urban signage of the sort that admonishes "NO TRESPASSING." Leaning on the heady text-based Conceptual art of the 1970s, Wool revitalizes its legacy with paintings that unmistakably look and sound like the street.

MoMA purchased this work, a signature example of Wool's "word paintings," in 1991 from the Luhring Augustine Gallery in New York. It was the first painting by Wool to enter the collection, although the Museum already owned one print and one illustrated book by the artist. The acquisition was made possible by funds from the Louis and Bessie Adler Foundation, established in 1975 for "the purpose of purchasing paintings by living American artists (by birth or by adoption)."[1] Twenty-three works in the Museum's collection were acquired with Adler Foundation funds. Since entering the collection, this painting has become a touchstone of the Museum's presentations of art from the 1980s on, where it is often shown in close proximity to work by American artists of Wool's generation such as Jeff Koons, Cady Noland, and Robert Gober. —Paulina Pobocha

1. Seymour M. Klein, president of the Louis and Bessie Adler Foundation, Inc., to The Museum of Modern Art, December 26, 1975. Donor Files, Department of Painting and Sculpture, MoMA, NY.

CATS
INBAG
BAGS
IN
RIVER

Joseph Beuys (German, 1921–1986)

Felt Suit. 1970
Multiple of felt, overall (irregular): 69⅞ x 28⅛ x 5⁵⁄₁₆ in.
(177.5 x 71.5 x 13.5 cm)
Publisher: Galerie René Block, Berlin
Edition of 100
The Associates Fund, 1993

As its matter-of-fact title indicates, Joseph Beuys's *Felt Suit* (*Filzanzug*) is made of thick gray felt cut and assembled into a rough version of a man's two-piece suit. Felt was a signature material for Beuys, and he famously used it in sculptures, installations, and performances. He explained its significance with an apocryphal story about his experience as a German pilot shot down during World War II whose life was saved by nomadic Tatars who covered him with fat and felt to keep him warm. In Beuys's art, felt came to symbolize the fundamental theme of energy flow (*hauptstrom*) and the healing salvation of warmth and insulation. For Beuys, who became the preeminent artist, teacher, and activist of a postwar generation in Germany that was coming to grips with the country's recent past, this concept of an enveloping, sustaining energy went beyond the physical to a "spiritual warmth or the beginning of an evolution."[1]

Modeled on one of his own garments, *Felt Suit* was published in an edition of 100 by Beuys's Berlin gallerist, René Block. Evoking the presence of the artist himself as a healer and catalyst for social revolution, it is the most iconic of the hundreds of multiples, or editioned artworks, that Beuys made during the course of his career. He first embraced the format of the artist's multiple in the mid-1960s, along with artists such as Dieter Roth and Claes Oldenburg who were similarly inspired by the legacy of Marcel Duchamp's readymades (p. 129) and sought to subvert traditional notions of an artwork's originality. "I'm interested in the distribution of physical vehicles in the form of editions," Beuys said, "because I'm interested in spreading ideas."[2] He believed his multiples were imbued with a psychic energy and that as they circulated they would enable others to activate their own creative powers, the generative force underlying his famous statement that "everybody is an artist."[3] Acknowledging the fundamental significance he attached to his editioned artworks, Beuys once reportedly said, "If you have all my multiples, you have all of me."[4]

MoMA began acquiring Beuys's art in 1970, a few years after the artist first gained broad exposure in Germany via a number of exhibitions and his highly sensational performances, or Actions, in the mid-1960s. Although the Museum's first acquisition of Beuys's work, *The Sled* (1969), was itself a sculptural multiple, the artist's practice of creating such editioned works challenged MoMA's departmental collecting patterns. This is among the notable reasons why *Felt Suit* was not acquired until more than two decades after it was made. The Department of Prints and Illustrated Books (now Drawings and Prints) was mainly concerned with editioned works on paper, while the Department of Painting and Sculpture was mainly concerned with unique works of art. In recent years, however, such boundaries have become more porous, and multiples have been acquired in greater depth, including many more by Beuys that are part of an increasingly important collection of the artist's work. —Starr Figura

1. Joseph Beuys, quoted in Jörg Schellmann and Bernd Klüser, *Joseph Beuys: Multiples* (Munich: Edition Schellmann, 1985), n.p.
2. Ibid.
3. Ibid.
4. Joseph Beuys, quoted by Günther Ulbricht [1987] and cited in Katharina Schmidt, "Zur Beuys Stiftung Ulbricht im Kunstmuseum Bonn," in *Joseph Beuys: Die Multiples* (Bonn: Kunstmuseum, 1992), iii.

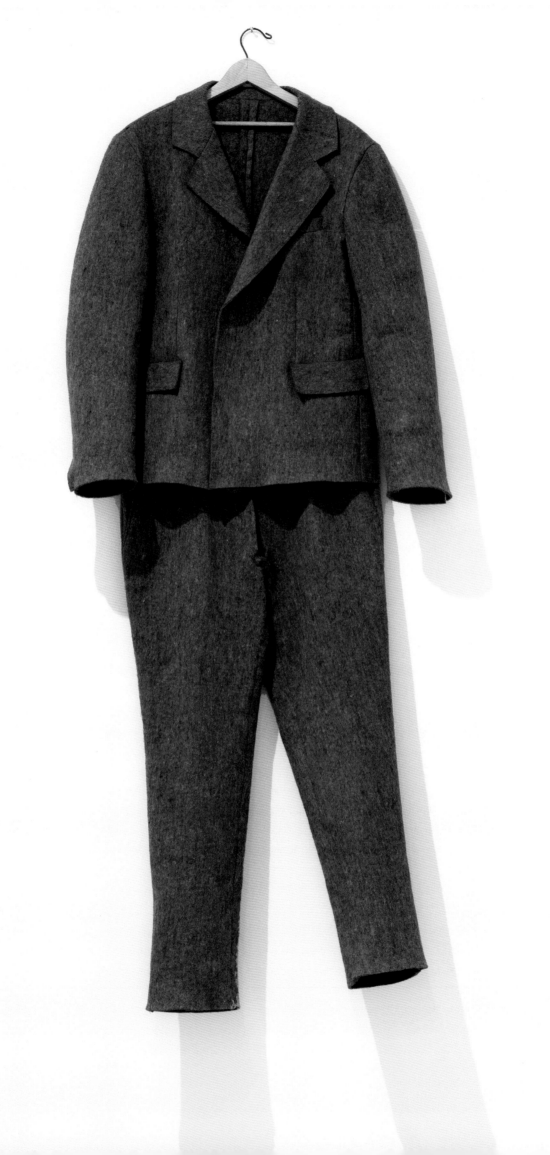

Cindy Sherman (American, born 1954)

a. **Untitled Film Still #7**. 1978
Gelatin silver print, 9½ x 7 9⁄16 in. (24.1 x 19.2 cm)
Acquired through the generosity of Sid R. Bass, 1995

b. **Untitled Film Still #15**. 1978
Gelatin silver print, 9 7⁄16 x 7½ in. (24 x 19.1 cm)
Acquired through the generosity of Barbara and Eugene Schwartz
in honor of Jo Carole and Ronald S. Lauder, 1995

c. **Untitled Film Still #21**. 1978
Gelatin silver print, 7½ x 9½ in. (19.1 x 24.1 cm)
Horace W. Goldsmith Fund through Robert B. Menschel, 1995

d. **Untitled Film Still #56**. 1980
Gelatin silver print, 6⅜ x 9 7⁄16 in. (16.2 x 24 cm)
Acquired through the generosity of Jo Carole and
Ronald S. Lauder in memory of Mrs. John D. Rockefeller 3rd, 1995

e. **Untitled Film Still #16**. 1978
Gelatin silver print, 9 7⁄16 x 7 9⁄16 in. (24 x 19.2 cm)
Acquired through the generosity of Jo Carole and
Ronald S. Lauder in memory of Eugene M. Schwartz, 1995

f. **Untitled Film Still #2**. 1977
Gelatin silver print, 9½ x 7 9⁄16 in. (24.1 x 19.2 cm)
Horace W. Goldsmith Fund through Robert B. Menschel, 1995

Cindy Sherman's *Untitled Film Stills* take the form of once-ubiquitous images: the 8-x-10-inch black-and-white publicity shots that accompanied the distribution of Hollywood movies. Although Sherman's work did not appear in the landmark 1977 exhibition organized by Douglas Crimp at Artists Space in New York, she is nevertheless associated with the cohort of artists who came to be known as the Pictures generation, after the title of the show, a group whose work often revolved around the surplus of images and media from popular culture. Sherman's *Stills*, however, are not found images, nor do they attempt to copy particular actresses or films. Rather, the women embody a range of Hollywood types, from ingenue to vamp to working girl, imaginary characters all played by the artist herself, typically in vaguely familiar but nonspecific settings. Of the photographs' technically poor execution—grainy, slightly out of focus, and sometimes abruptly cropped—Sherman has said: "I wanted them to seem cheap and trashy, something you'd find in a novelty store and buy for a quarter. I didn't want them to look like art."[1]

Sherman began making the *Stills* while in college in Buffalo, New York, and continued after she moved to New York City. The initial six in the series, each featuring the same actress with a short blond bob, were first shown in 1977 in a group exhibition at Hallwalls, an artist-run studio and exhibition space in Buffalo, after which Sherman decided to expand the scope of the project. For a time she sold the prints out of a three-ring binder from the front desk of Artists Space, where she was working as a secretary. A selection of *Stills* made their official New York debut in 1978 as large-scale prints in a four-person exhibition at Artists Space, with Louise Lawler, Christopher D'Arcangelo, and Adrian Piper. Sherman concluded work on the series in 1980 when she felt like she had run out of new characters; over the course of the next decade, her serial exploration of feminine roles and the nuances of cultural

1. Cindy Sherman, quoted in Calvin Tompkins, "Her Secret Identities," *The New Yorker*, May 15, 2000: 78.

a.

b.

c.

d.

e.

f.

Cindy Sherman (American, born 1954)

g. **Untitled Film Still #62**. 1977
Gelatin silver print, 6¼ x 9⁵⁄₁₆ (15.9 x 23.6 cm)
Gift of the photographer, 2003

h. **Untitled Film Still #27**. 1979
Gelatin silver print, 9⁷⁄₁₆ x 6¹¹⁄₁₆ in. (24 x 17 cm)
Acquired through the generosity of Peter Norton, 1995

i. **Untitled Film Still #13**. 1978
Gelatin silver print, 9⁷⁄₁₆ x 7½ in. (24 x 19.1 cm)
Acquired through the generosity of Jo Carole and
Ronald S. Lauder in memory of Eugene M. Schwartz, 1995

j. **Untitled Film Still #48**. 1979
Gelatin silver print, 7⁷⁄₁₆ x 9⁷⁄₁₆ in. (18.9 x 24 cm)
Acquired through the generosity of Jo Carole and
Ronald S. Lauder in memory of Eugene M. Schwartz, 1995

shifting would inspire reams of commentary, from feminist and psychoanalytic critical discourse to parsing in the popular press.

In 1995, MoMA acquired the complete set of *Stills*, ensuring that this groundbreaking body of work would be preserved intact in a single public institution. The series was exhibited in 1997 and published as a book by the Museum in 2003. Preparing for the publication, Sherman rediscovered an image at once characteristic of the series (the artist poses as an archetypical Hollywood starlet, here in smoky makeup and stiletto heels) and unique for the *Stills* (she looks straight into the camera lens), a photograph that then joined the series as its seventieth image, shown here as *Untitled Film Still #62*.[2] In 2012, MoMA presented the complete *Stills* again, this time in the context of a major retrospective that brought together the full sweep of Sherman's multifaceted photographic investigations of representation and the construction of identity. —Lucy Gallun

2. Like the other *Stills*, this one is untitled but known by the inventory number originally assigned by the artist's gallery, a system that does not reflect an order in which the works should be presented. In the years after the *Stills* were shot, Sherman occasionally added and subtracted images, resulting in "titles" in which the numbering system does not follow the order in which the images were made and exceeds the seventy extant images.

g.

h.

i.

j.

Felix Gonzalez-Torres (American, born Cuba, 1957–1996)

"Untitled" (USA Today). 1990
Candies individually wrapped in red, silver, and blue cellophane,
endless supply, overall dimensions vary with installation,
ideal weight: 300 lbs. (136 kg)
Gift of the Dannheisser Foundation, 1996

Elaine Dannheisser's 1996 gift of a substantial portion of her collection was among the largest in MoMA's history. Dannheisser and her late husband, Werner, had amassed one of the greatest private collections of art of the 1980s and '90s, and the eighty-five artworks in the gift represent many of the most important artists of the late twentieth century, such as Bruce Nauman, Sigmar Polke, Richard Serra, and Cindy Sherman, working in mediums that span a number of Museum departments, ranging from painting and sculpture to installations, prints, and video. Felix Gonzalez-Torres in particular was strongly represented, with six works that demonstrate the breadth of his wide-ranging practice.

"Untitled" (USA Today) is one of Gonzalez-Torres's candy spills, a flowing heap of cellophane-wrapped candies—in this case, red, white, or blue—whose parenthetical title references a nationally distributed mass-market newspaper. The political situation in the United States from the mid-1980s to mid-'90s is central to Gonzalez-Torres's work, which probes questions of presence and absence, and visibility and camouflage. In the context of the "culture wars" of this period, when images of gay desire were under attack by conservative politicians, Gonzalez-Torres chose forms and images through which his subject matter is implied rather than depicted, in order to counter political attempts to use him "as a rallying point" in conservatives' "battle to erase meaning."[1] Gonzalez-Torres's work for a 1992 exhibition as part of MoMA's Projects series, for example, saw the image of his empty, unmade bed (also in the 1996 gift) installed on twenty-four billboards across New York.

Central to Gonzalez-Torres's candy spills, as well as his signature paper stacks of identical prints piled on the floor, is the implicit invitation for viewers to take either a piece of candy or a sheet of paper, meaning the works gradually disappear as they are "used." Allowing viewers to remove parts of his work, Gonzalez-Torres explained, was motivated by his own experience of loss during the AIDS epidemic and his process of learning to let go. In January 1996, three months before the announcement of the Dannheisser gift, Gonzalez-Torres died from an HIV-related illness. His works are among the most affecting memorials to the early years of the AIDS crisis and the related movement for LGBT rights, and are key examples of the ways in which artists persisted in a period marked by bigotry, severe political pressure, and profound personal loss. —Margaret Ewing

1. Felix Gonzalez-Torres, quoted in Nancy Spector, *Felix Gonzalez-Torres* (New York: Guggenheim Museum, 1995), 73.

Andy Warhol (American, 1928–1987)

Campbell's Soup Cans. 1962
Synthetic polymer paint on thirty-two canvases,
each canvas: 20 x 16 in. (50.8 x 40.6 cm)
Partial gift of Irving Blum
Additional funding provided by Nelson A. Rockefeller Bequest,
gift of Mr. and Mrs. William A. M. Burden, Abby Aldrich Rockefeller Fund,
gift of Nina and Gordon Bunshaft in honor of Henry Moore, acquired
through the Lillie P. Bliss Bequest, Philip Johnson Fund, Frances R. Keech
Bequest, gift of Mrs. Bliss Parkinson, and Florence B. Wesley Bequest
(all by exchange), 1996

Perhaps the first public mention of Andy Warhol's *Campbell's Soup Cans* at MoMA was on December 13, 1962, during a symposium on the then-nascent phenomenon of Pop art. The majority of the panelists expressed some degree of skepticism in regards to the movement's commercial subject matter and apparent repudiation of originality, though the same week, MoMA had acquired its first work by Warhol, *Gold Marilyn Monroe* (1962). The panelists included art historians Dore Ashton and Leo Steinberg, critic Hilton Kramer, poet and critic Stanley Kunitz, and curators Peter Selz of MoMA and The Metropolitan Museum of Art's Henry Geldzahler—the only wholehearted Pop enthusiast among them. Reflecting the conventional wisdom in the room, Kunitz argued that it was difficult to consider Warhol's "celebrated rows of Campbell's soup labels" as paintings at all "since apparently, the serial image has been mechanically reproduced with the aid of a stencil."[1]

The debut of *Campbell's Soup Cans* had taken place less than six months prior, in July 1962, at the Ferus Gallery in Los Angeles, Warhol's first solo exhibition and the premiere of Pop art on the West Coast. Ferus's director, Irving Blum, had seen some of the canvases a few months earlier in Warhol's New York studio and offered him the show on the spot. With the artist's blessing, Blum mounted all thirty-two *Soup Can* canvases in a single line flush to the gallery wall, with a narrow shelf running beneath them, wryly heightening the connection between Warhol's depictions and the real thing—assembly line soup, available on supermarket shelves across America. Blum sold five canvases, but then, having an urge to keep the entire group together, managed to buy them back.[2] The canvases remained with him for the next three decades—a period during which Warhol's star rose dramatically, Pop largely left behind its early detractors, and the *Soup Cans* became icons, their deadpan aesthetic having captivated the art world as something inexorably new, even as they would go on to be both celebrated and scorned in popular culture. Blum occasionally loaned them for exhibitions, including to MoMA's 1989 show *High and Low: Modern Art and Popular Culture*, until 1996, when they entered the Museum collection. This watershed acquisition, of a singular work that epitomizes the revolutionary embrace by American Pop art of mass culture and strategies of repetition, dramatically enhanced the Museum's Warhol holdings.

Despite the apparent uniformity of the canvases, there are meaningful discrepancies among them. Drips, blurs, varying reds—these are the result of Warhol's arduous step-by-step process that combined tracing, stamping, and painting. The *Soup Cans* were the last paintings he would produce in this way; soon after completing them, he discovered screenprinting, which allowed him to more precisely and expediently create the same image over and over. Hand-painted and serial, the *Soup Cans* oscillate between a seemingly banal materiality and evanescent conceptual implications. Upending conventions related to authorship, originality, skill, and taste, they triggered a fundamental rethink about what an artwork could be. —Hillary Reder

1. Stanley Kunitz, quoted in "A Symposium on Pop Art," *Arts Magazine* 37, no. 7 (April 1963): 41.
2. Paul Cummings, oral history interview with Irving Blum, May 31–June 23, 1977. Archives of American Art, Smithsonian Institution, Washington, D.C.

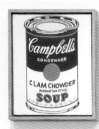 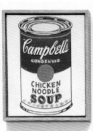 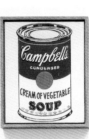 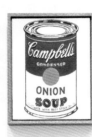 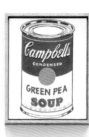
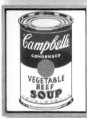 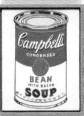 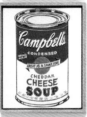 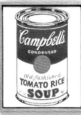 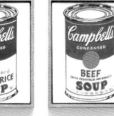 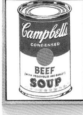 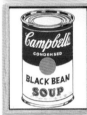
 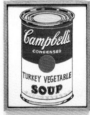 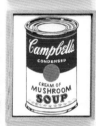
 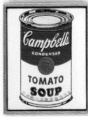 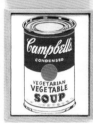

Ellsworth Kelly (American, 1923–2015)

Brushstrokes Cut into Forty-Nine Squares and Arranged by Chance. 1951
Cut-and-pasted paper and ink on paper, 13¾ x 14 in. (34.9 x 35.6 cm)
Purchased with funds provided by Agnes Gund, 1997

In *Brushstrokes Cut into Forty-Nine Squares and Arranged by Chance*, Ellsworth Kelly employs the ordered grid only to obliterate its logical structure. The work's title alerts us to this deployment and obliteration—specifically, to the role of arrangement in the work's making and the disruption of that arrangement by chance. Kelly brushed ink strokes across a sheet of paper, cut the resulting drawing into forty-nine squares, and recomposed the work by randomly shuffling the squares before pasting them in a grid pattern, complicating the orientation of the brushstrokes. By taking something whole and then breaking it down into bits that can be easily reordered according to a simple chance-based strategy, Kelly produced a drawing that is a series of equalized units, each matrix containing as few as one, as many as five, but mostly two or four lines with occasional dots or dashes. The nonaligned fragments intersect, an intriguing arrangement that can be studied horizontally and vertically or in aggregate rows and columns. In each case, the varying rhythmic patterns appear to dance across the paper and animate the collage.

Made in France, where Kelly lived from 1948 to 1954, the artist's early works on paper are the foundation of the ensuing decades of his practice, establishing motifs that would form the basis of his pictorial language throughout his career. In Paris, artists such as John Cage and Jean (Hans) Arp encouraged Kelly to experiment with the idea of chance in his artwork, which would come to define his later series of paintings, scuptures, and works on paper. With the gesture of rearranging a previously complete drawing and randomly collaging pieces together in a gridded reorganization, Kelly addressed the creative potential of accidental aesthetic forms. The modular grid served as the ultimate unifier, the ideal arena to play out the tensions that would drive much of his mature work: between order and randomness, the already made and the created.

Even as Kelly's reputation grew and he became a central figure in postwar modernism, these formative experiments remained in the artist's personal collection and little known, beyond the inclusion of some of the drawings in the 1992 exhibition *Ellsworth Kelly: The Years in France, 1948–1954* at the National Gallery of Art in Washington, D.C. In 1997, MoMA acquired a significant selection of these groundbreaking early works on paper, including the drawing shown here, some as gifts of the artist and others through purchase. Together these were presented in a special exhibition that opened in September, *Ellsworth Kelly: 15 Works on Paper, 1949–1958*. Highlighting the works' keystone connection to Kelly's oeuvre, chief curator Margit Rowell in the Department of Drawings commented in an accompanying text, "[T]he uniquely stylized motifs seen during this period would establish the basis for his highly individualized language."[1] —Heidi Hirschl

1. Margit Rowell, "Ellsworth Kelly: 15 Works on Paper, 1949–1958," exh. brochure (New York: The Museum of Modern Art, 1997), n.p.

From the Archives: **P.S. 1**, 2000

a. Poster for the exhibition **Greater New York**, P.S. 1 Contemporary Art
Center, Long Island City, New York, February 27–May 30, 2000.
Artwork by Piotr Uklanski

MoMA PS 1 Archives, II.D.47*. MoMA Archives, NY

b. View of the courtyard at the P.S. 1 Contemporary Art Center
upon the opening of Philip Johnson's Dance Pavilion, June 1999.
Photograph by Eileen Costa

MoMA PS 1 Archives, II.A.1066. MoMA Archives, NY

In 2000, MoMA merged with P.S. 1 Contemporary Art Center, the resolutely nontraditional arts space located directly across the East River from Midtown Manhattan. It had been twenty-four years since pioneering curator Alanna Heiss and the Institute for Art and Urban Resources had taken over the derelict P.S. 1 school building in Long Island City, Queens, and transformed it into a freewheeling center for performances, installations, and exhibitions that prioritized artists' intentions over curatorial fiat and devoted as much space to art forms such as video, dance, and multimedia installations as to painting and sculpture. By 1997, P.S. 1 had housed more than four hundred exhibitions involving nearly three thousand artists. That year, after a major renovation, the arts center reopened to wide acclaim, assuming a newly elevated position among New York's cultural institutions. Meanwhile, The Museum of Modern Art, under the leadership of Glenn Lowry, who had become the Museum's director two years before, was seeking a way to expand its support of contemporary art, even as the MoMA building in Midtown Manhattan was stretched to its limit exhibiting works of historical modernism. The Museum looked to P.S. 1 as a solution that was nearby (only two subway stops away) and capacious (with 125,000 square feet of exhibition space, P.S. 1 was larger than MoMA at the time), and that possessed a lively exhibition program already in place. Discussions for a merger between the two institutions began in early 1999.

The most immediate visible sign of the new alliance was a dance pavilion designed by famed architect and MoMA trustee Philip Johnson, erected for P.S. 1's second annual summer outdoor music series, Warm Up. Johnson's structure planted the seed for what would, in the next year, grow into the Young Architects Program (YAP), a juried contest now staged at art institutions around the world where emerging architects vie to design outdoor structures that provide a setting for summer programming. In 2000, a more sweeping collaborative project was unveiled. A team of eight curators from MoMA and P.S. 1, led by Heiss, Lowry, and Tom Finkelpearl, combed through slides received from an open call for submissions and scoured studios and galleries across the New York metropolitan area to assemble *Greater New York*, a survey of work by 147 contemporary artists. The exhibition took over the entire P.S. 1 building and courtyard, and further solidified the ties between the institutions.

Greater New York's success led it to become a recurring survey every five years. Likewise, the partnership between MoMA and P.S. 1 has thrived, as demonstrated in the 2009 exhibition *1969*, the first MoMA collection show at P.S. 1, and 2014's *James Lee Byars: 1/2 an Autobiography*, for which the artist's physical works were displayed in Queens while his performances were reenacted in Manhattan. In 2010, P.S. 1 was rechristened MoMA PS1, heralding a new era for both institutions.

—Jonathan Lill

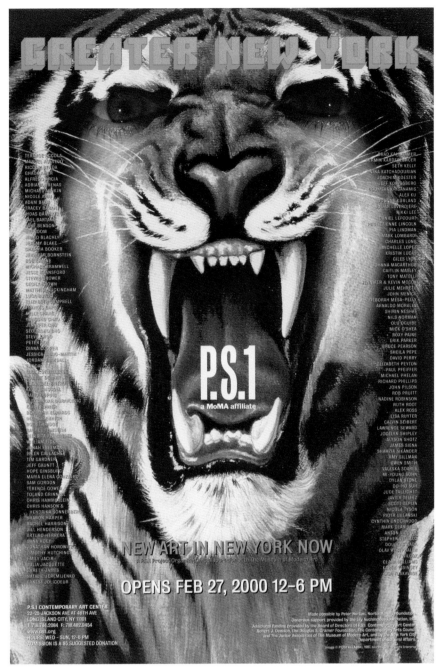

a.

b.

Rem Koolhaas (Dutch, born 1944)
Zoe Zenghelis (British, born Greece, 1937)

a. **New Welfare Island Project, Roosevelt Island, New York City, New York**. c. 1975–76
Gouache on paper, 58 x 40 in. (147.3 x 101.6 cm)

Rem Koolhaas
Madelon Vriesendorp (Dutch, born 1945)

b. **Welfare Palace Hotel Project, Roosevelt Island, New York City, New York**. 1976
Gouache on paper, 51 x 40½ in. (129.5 x 102.9 cm)

Gift of The Howard Gilman Foundation, 2000

That the Office for Metropolitan Architecture (OMA), helmed by Dutch architect Rem Koolhaas, emerged as one of the most influential practices of the late twentieth century is reflected in its inclusion among the collection of some two hundred visionary architectural drawings amassed by the Howard Gilman Foundation and gifted in its entirety to MoMA in November 2000. Assembled between 1976 and 1980 by Gilman and his curator, Pierre Apraxine, the collection documents the genesis of postmodernism through an efflorescence of fantastical paper architecture produced during the 1960s and into the 1970s. Notably, the period would mark the last significant creative development in hand-drawn architectural representation before the advent of digital rendering technologies displaced freehand illustration. In addition to work by OMA, the Gilman collection contains drawings from the leading protagonists of early architectural postmodernism, such as Cedric Price, Superstudio, and Aldo Rossi.

Koolhaas established OMA in 1975 with Madelon Vriesendorp and Elia and Zoe Zenghelis. Three years later, he published *Delirious New York*, a "retroactive manifesto," he called it. The book celebrates Manhattan's architectural and urban character—a culture of congestion that Koolhaas posits as scenography for the "terminal stage of Western civilization"—with a sardonic historical narrative of the city's development since its establishment as a Dutch colony in the seventeenth century.[1] Published as part of the book were illustrations by Vriesendorp and both Zenghelises that depict speculative histories and wildly hypothetical futures for the city's architecture: the Welfare Palace Hotel drawing, for example, shows an imagined six-skyscraper hotel in the East River designed to a Freudian theme, while the drawing for the Roosevelt Island Redevelopment Project shows urbanization proposals inspired by the island's history as an insane asylum. These readily contributed to the enduring fame of *Delirious New York*, which would become one of the most cited and celebrated documents of twentieth-century architectural discourse.

The Gilman acquisition was a seminal contribution to the Department of Architecture and Design, expanding MoMA's historical purview beyond the scope of modern architecture to encompass the postwar reaction against the International Style and modernist orthodoxy. The majority of the Gilman collection's contents—173 of the 200 drawings—was shown in the 2002 exhibition *The Changing of the Avant-Garde: Visionary Architectural Drawings from the Howard Gilman Collection*.

The surrealist iconography of OMA's early drawings and paintings appears prescient today, at a moment when the urban landscape of contemporary New York becomes ever taller, more expensive, more crowded, and closer to the caricature in *Delirious New York*. Ultimately, the congestion simultaneously parodied and celebrated by Koolhaas and his kith through the conjectural means of exaggeration and irony in the mid-1970s—so skillfully rendered in these drawings by Vriesendorp and Zoe Zenghelis—is altogether less hypothetical and more perverse now. —Anna Kats

1. Rem Koolhaas, introduction to *Delirious New York: A Retroactive Manifesto for Manhattan* [1978] (New York: Monacelli Press, 1994).

a.

b.

Andy Warhol (American, 1928–1987)

Double Elvis. 1963
Silkscreen ink on synthetic polymer paint on canvas,
6 ft. 11 in. x 53 in. (210.8 x 134.6 cm)
Gift of the Jerry and Emily Spiegel Family Foundation
in honor of Kirk Varnedoe, 2001

In 1963, Andy Warhol made more than thirty paintings featuring Elvis Presley as a gunslinger, an image that originated as a publicity still for the Hollywood Western *Flaming Star* (1960). Using what would quickly become his signature silkscreen technique, Warhol printed images of Elvis on canvases that had been painted silver, a visual evocation of the "silver screen." Sometimes, as in *Double Elvis*, the figures overlap to create a "jump effect" similar to the stagger or jitter sometimes seen during film projection. *Double Elvis* was first exhibited at the Ferus Gallery in Los Angeles, little more than a year after Warhol's solo debut there that featured his *Campbell's Soup Cans* (p. 189). For the 1963 exhibition, Warhol sent gallery director Irving Blum an uncut roll of canvas painted and printed with the images of Elvis, along with stretcher bars of various sizes. As Blum would later recall, the artist instructed him to "cut them any way that you think you should," and asked only that "they should be hung edge to edge, densely— around the gallery."[1] In some works Elvis appears once; more frequently, he appears two or three times, though one work exhibited at Ferus features eight Elvis images. At the gallery, gun-toting Elvises would have surrounded the visitor from nearly all sides, creating an immersive and intense environment.

Warhol deployed the motifs and mechanisms of mass media and popular culture both in subject and in form. Elvis joined Warhol's celebrity pantheon of the 1960s, which included Marilyn Monroe, Liz Taylor, Marlon Brando, and Jackie Kennedy, among others. Warhol would silkscreen their likenesses hundreds of times on roll after roll of canvas, signaling the ubiquity and infinite reproducibility of the printed image and the fetishization of its content. He applied this picture-making strategy to images of car crashes, criminals, and electric chairs as easily as he did to movie stars, provocatively linking glamour with darker elements of the public's fascination. Together, Warhol's silkscreened paintings capture the zeitgeist of 1960s American culture and provide visual analog to theorist Marshall McLuhan's 1964 proclamation that "the medium is the message."[2]

The first owner of *Double Elvis* was singer Bob Dylan, who received it as a gift from Warhol. Dylan purportedly gave the painting to his manager, Albert Grossman, in exchange for a sofa.[3] Years later, in 2001, the work entered the MoMA collection as a gift of the Jerry and Emily Spiegel Family Foundation. Collectors of modern and contemporary art, the Spiegels funded or gave nineteen works to the Museum, including paintings, sculptures, drawings, and photographs. They gifted *Double Elvis* in honor of Kirk Varnedoe, chief curator of the Department of Painting and Sculpture from 1988 to 2002, on the eve of his retirement. In addition to *Double Elvis*, the department acquired ten paintings and four sculptures by Warhol during Varnedoe's tenure, including the iconic *Campbell's Soup Cans*. The Spiegels' gift of *Double Elvis* celebrated the curator's commitment to Warhol's work. —Paulina Pobocha

1. Irving Blum quoting Andy Warhol, in *The Andy Warhol Catalogue Raisonné, Paintings and Sculpture 1961–1963*, vol. 1, ed. Georg Frei and Neil Printz (New York and London: Phaidon Press, 2002), 355.
2. Marshall McLuhan, *Understanding Media: Extensions of Man* (New York: Mentor, 1964), 7.
3. *The Andy Warhol Catalogue Raisonné*, entry 407.

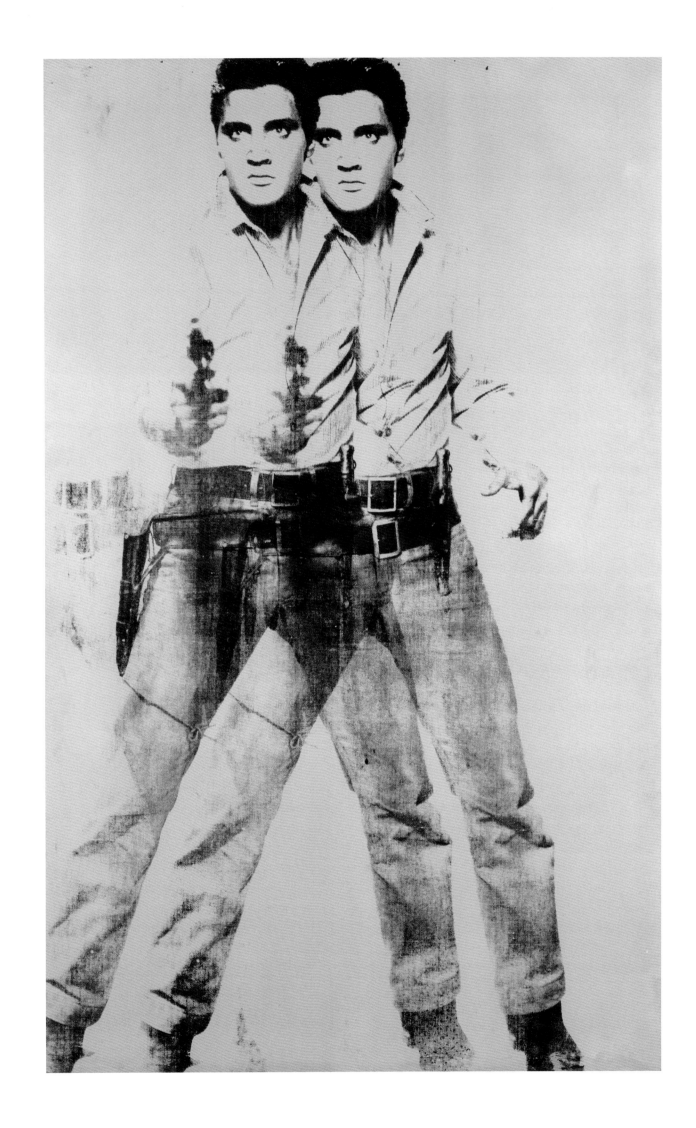

Yvonne Rainer (American, born 1934)

Trio A. 1978
16mm film (black and white, silent), 10 minutes
Purchase, 2002

Dancer and choreographer Yvonne Rainer emerged as a key figure in the Minimalist dance movement of the 1960s. What distinguished Rainer and others who founded the Judson Dance Theater in New York in 1962 was a break with the rigid and contrived movements that were conventional in dance and the integration of a more natural physical fluidity in their choreography. In "No Manifesto" in 1965, Rainer further declared her split with artifice in dance by declaring: "No to spectacle. No to virtuosity. No to glamour and the transcendency of the star image," among other radical pronouncements.[1] In the early 1970s, the artist expanded her practice to include filmmaking, producing works that are often extremely personal and that incorporate dance movement, memory, narration, political commentary, and themes of gender inequality.

Trio A features Rainer as the solitary dancer on a barren set, the film devoid of sound. Dressed in an austere yet casual outfit of dark flowing pants and a loose-fitting tank top, with her hair pulled back with a simple barrette, she engages in movements that are reminiscent of calisthenics yet infused with the free body movements of Anna Halprin. By eschewing explicit beauty, artifice, and spectacle, Rainer commands the viewer to focus on her movements that embrace both grace and physical vigor, which she performs within an economy of space. The choreography is controlled, as are the dancer's movements; there is a minimum of physical expansiveness, as illustrated by the way in which she hugs her body, bends from the waist to the ground, and curls up on the floor. Flourishes such as ballet-like leaps and capacious arm gestures are absent. Nearing the end of the film, a simple title card is inserted that reads "details," which gently commands the viewer to focus on the dancer's feet and their varied movements that include sliding, tapping, and stomping. The use of the card also breaks the flow of the performance, reminding viewers that they are watching a filmed record of the *Trio A* dance, thereby allowing the artist to shrewdly assert herself as a filmmaker in addition to choreographer and dancer.

Rainer's artistic presence is evidenced across a number of curatorial departments at MoMA. The film version of *Trio A* was first acquired by the Department of Film in 2002; ten years later, another copy was acquired via the Department of Media and Performance Art, in addition to Rainer's series *Five Easy Pieces* (1966–69) and *After Many a Summer Dies the Swan: Hybrid* (2002). Rainer's films are also part of an ongoing preservation project in the Film Department. To date, the photochemical preservation of the artist's feature films *Lives of Performers* (1972) and *A Film about a Woman Who . . .* (1976) have been completed. The conservation of films *Kristina Talking Pictures* (1976), *Journeys from Berlin* (1980), *Privilege* (1990), and *Murder and Murder* (1996) are currently in progress. —Anne Morra

1. Yvonne Rainer, "No Manifesto," published as part of "Some retrospective notes on a dance for 10 people and 12 mattresses called 'Parts of Some Sextets,' performed at the Wadsworth Atheneum, Hartford, Conn. and Judson Memorial Church, NY in March 1965," *Tulane Drama Review* 10, no. 2 (Winter 1965).

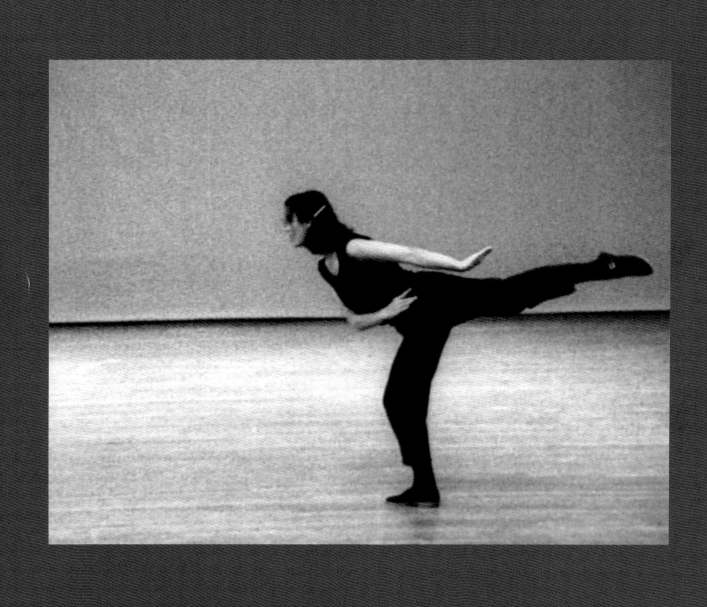

Janet Cardiff (Canadian, born 1957)

The Forty-Part Motet (A reworking of "Spem in Alium" by Thomas Tallis, 1556). 2001
Forty-track sound recording, forty speakers, 14 minutes
Gift of Jo Carole and Ronald S. Lauder in memory of Rolf Hoffmann, 2002

Janet Cardiff's *The Forty-Part Motet* is a forty-channel sound installation that reworks Renaissance composer Thomas Tallis's motet "Spem in Alium Nunquam Habui" in three-dimensional space. Tallis's sixteenth-century composition is known for its complex polyphonic harmonies, with vocal lines moving continuously from consonance to dissonance and back again; in Cardiff's installation, each audio speaker on its stand serves as a virtual body, representing one of the forty voices for which the original composition was written. Cardiff worked with the Salisbury Cathedral Choir, whose sopranos are children of both genders, to achieve a pure, angelic sonic quality. During the recording process, each performer was recorded with individual microphones using sonically crisp, precise, and localized binaural audio equipment. The resulting installation allows the gallery visitor to walk among the speakers, experiencing both the individual subtleties of each voice and the polyphonic complexities of the whole in a way not possible through either a standard recording or live performance. As the artist herself has explained, "I wanted to be able to 'climb inside' the music, connecting with the separate voices."[1]

In this sense, Cardiff both highlights the sculptural properties of sound while at the same time blurring the distinctions between technologically mediated and "real" experiences, as she has throughout her career, from her audio walks to multimedia installations. Sharing the part-human/part-machine duality of a cyborg, the disembodied spectral vocalists in *Motet* feel present in the space, almost physically palpable. Before any singing begins, we hear the murmuring chatter of the choir—they cough, clear their throats, talk among themselves. Their chatter emphatically proclaims their humanity. The installation, then, is a collection of individuals—or rather, their sonic ghosts—and walking through this forest of sound allows one to experience the idiosyncrasies of each singer within the whole, creating a remarkably intimate experience for a motet so grandiose and virtuosic.

Having been installed in numerous locations, from conventional white-cube galleries to cathedral sanctuaries, *The Forty-Part Motet* takes on varying associations based on its context. Its display in the exhibition *September 11* at MoMA PS1, which marked a decade after the 9/11 terrorist attacks, emphasized the work's relationship to elegy. Although *The Forty-Part Motet* was created in 2001 prior to the attacks, its reception in this context exemplifies the power of art and music to harness collective mourning and memory, particularly when presented in a building situated across the river from the Manhattan skyline, the Twin Towers conspicuously absent. The work entered the Museum collection in 2002 as a gift of Jo Carole and Ronald S. Lauder in memory of the art collector Rolf Hoffmann, a member of the International Council at MoMA who died the same year *Motet* was created.

—Martha Joseph

1. Janet Cardiff, untitled statement, in *Elusive Statement: The Millennium Prize at the National Gallery of Canada* (Ottawa: National Gallery of Canada, 2001), 5.

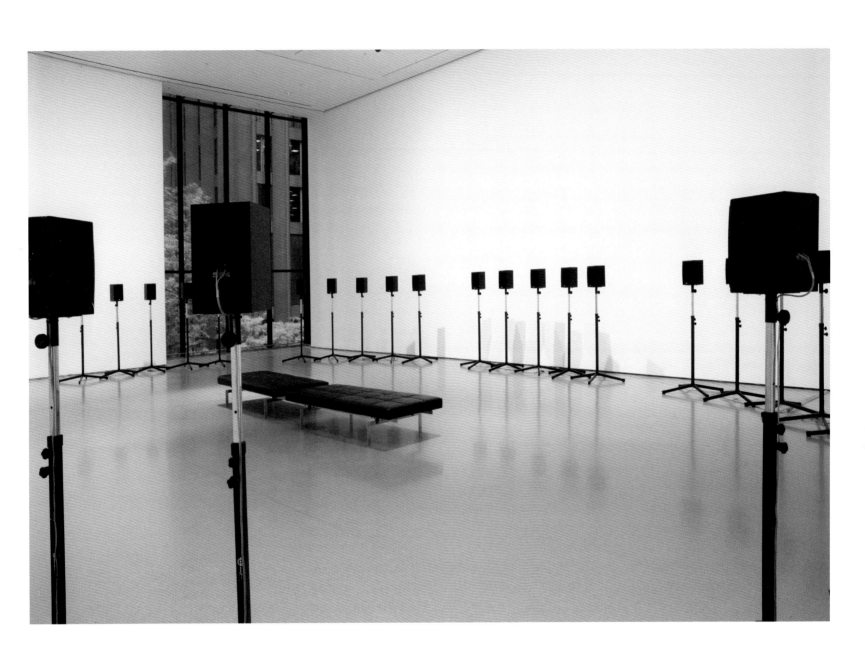

Jeff Wall (Canadian, born 1946)

After "Invisible Man" by Ralph Ellison, the Prologue. 1999–2000
Silver dye bleach transparency and aluminum light box,
5 ft. 8½ in. x 8 ft. 2¾ in. (174 x 250.8 cm)
The Photography Council Fund, Horace W. Goldsmith Fund
through Robert B. Menschel, and acquired through the generosity
of Jo Carole and Ronald S. Lauder and Carol and David Appel, 2003

"Light confirms my reality, gives birth to my form," says the title character of Ralph Ellison's 1952 novel *Invisible Man*.[1] When he is out in the city, Ellison's nameless protagonist is made invisible by virtue of being a black man in a society in which "people simply refuse to see me."[2] Yet when he is alone at home, his physicality—indeed, his selfhood—is maintained and nourished by the radiant environment he has crafted for himself: a basement apartment lit by 1,369 lightbulbs covering every inch of the ceiling and parts of the walls, powered with electricity he has illicitly siphoned from Monopolated Light & Power. Nearly fifty years after Ellison conjured this man and his extraordinary subterranean dwelling in words, Jeff Wall gave them visual form in an image that is literally illuminated from within. In his portrayal, presented in the form of a glowing light box, Wall executed certain precise details based on Ellison's text, such as the number of lightbulbs, together with myriad imagined elements (dishes piled in the sink, cardboard layering the walls) in an elaborate construction built through a labor-intensive process in his Vancouver studio, manifesting what curator Peter Galassi has described as an "aesthetic of accumulation."[3]

At the time it was acquired for the MoMA collection, in 2003, *After "Invisible Man"* had been widely celebrated in the critical press, garnering significant acclaim upon its public debut in 2002 in the major international exhibition Documenta 11, organized by Okwui Enwezor, as well as its presentation later that year at Marian Goodman Gallery in New York. A 2003 solo exhibition at the Hammer Museum in Los Angeles was organized around this critical work, and it would be chosen for the cover of the catalogue for Wall's retrospective at MoMA in 2007. By then it had been almost forty years since Wall's work had first been exhibited at the Museum, in 1970 as part of the landmark show *Information* (p. 148), and the artist's work would be loaned for other MoMA exhibitions over the years as well. So it may come as a surprise that *After "Invisible Man"* was the first work by Wall to enter the Museum's collection, to be followed the next year by two of the artist's earlier light-box works, *Milk* (1984) and *Restoration* (1993). Wall produces very few works each year, and their edition sizes are also quite limited. By the early 2000s, his work was highly sought after and priced accordingly. Funding from multiple sources and longtime supporters of the Museum made possible the acquisition of this landmark work by one of contemporary photography's most esteemed and influential practitioners. —Lucy Gallun

1. Ralph Ellison, *Invisible Man* [1952] (New York: Vintage Books, 1995), 6.
2. Ibid., 3.
3. Peter Galassi, "Unorthodox," in *Jeff Wall*, exh. cat. (New York: The Museum of Modern Art, 2007), 55.

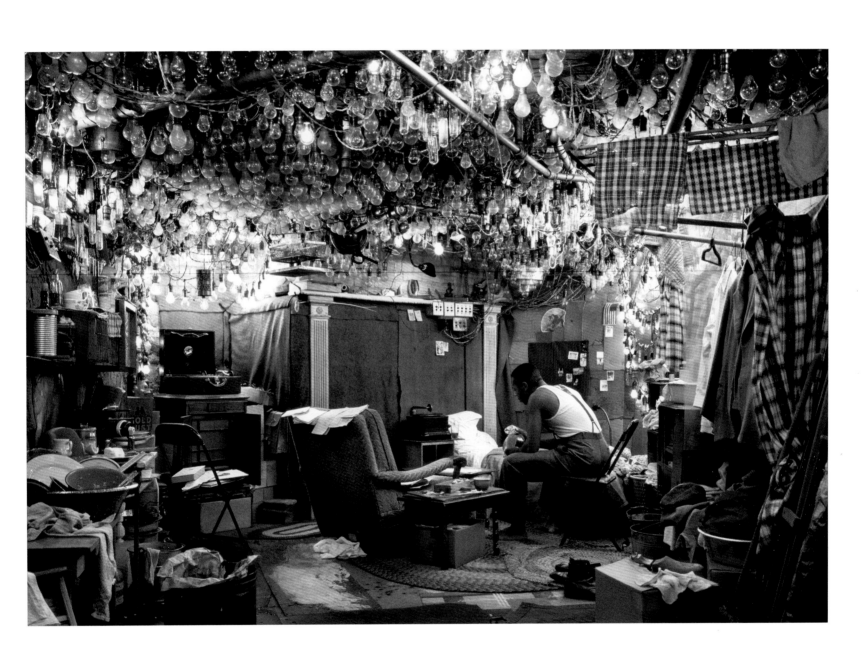

Sherrie Levine (American, born 1947)

Black Newborn. 1994
Cast and sandblasted glass, 5 x 8 in. (12.7 x 20.3 cm)
Committee on Painting and Sculpture Fund and gift of
Susan G. Jacoby in honor of her mother, Marjorie Goldberger, 2004

Eight inches long with a spherical opening at its center, Sherrie Levine's *Black Newborn* resembles the abstracted head of a gaped-mouth infant. The smooth, egg-shaped artifact made from black glass is emblematic of Levine's career-long practice of creating works of art that masquerade as existing modernist masterpieces. Yet the backdrop for Levine's creation is broader than a single "original" object in relation to which her work might be understood as mere replica. Rather, her work is rooted in an awareness of the parallel histories of fabrication, display, and circulation that her objects of choice partake in—histories that she finds to be mostly suppressed—and which she reveals in subtle and canny ways.

Levine's sculpture is modeled after Constantin Brancusi's celebrated *Newborn*, which belongs to a suite of ovoid sculptures Brancusi began in 1908 that represent infants, birth, and rejuvenation. Levine draws on Brancusi's own allegories for the themes of origin and creation, while also calling attention to his proclivity for repetition. Following the first *Newborn* in marble, dated 1915, Brancusi created two additional bronze versions in 1920, and subsequently cast further versions in marble, stainless steel, and bronze.

A similar proliferation is consciously at play in the evolution of Levine's work. Her first remake of *Newborn* consisted of six identical versions cast in frosted white glass, which were made for a 1993 exhibition at the Philadelphia Museum of Art, home to Brancusi's original marble *Newborn*. In lieu of Brancusi's use of an intricately crafted pedestal, Levine placed each of her objects on a sleek, black baby grand piano, inspired by a photograph she had seen in a magazine of another of Brancusi's oval sculptures decorating a piano in Kettle's Yard, the home of British art connoisseur H. S. Ede, which has been converted into a museum in Cambridge. By recalling Brancusi's strategies of variation and how such works, in turn, might be lived with, Levine situates her art not only in the time-honored realm of "the physical and the sensory," as she has stated, but also, crucially, in the domain of "the contingent and the unstable."[1]

Levine subsequently rendered the sculpture in black glass in 1994, renaming her creation *Black Newborn*. Acquired by MoMA in 2004, it is directly linked to the Museum's collection, which houses a bronze version of Brancusi's *Newborn* from 1920. As part of the Museum's holdings, Levine's sculpture continues to serve as a peculiar double: both a sensuous homage and a sly agitator. —Tamar Margalit

1. Sherrie Levine, "After Brancusi," in Ann Temkin, *Sherrie Levine: Newborn* (Philadelphia: Philadelphia Museum of Art, 1993), 7.

Cady Noland (American, born 1956)

THE AMERICAN TRIP. 1988
Wire racks, steel pipes, chrome cuffs, American flag,
pirate flag, leather straps, cane, and metal parts,
45 in. x 8 ft. 8 in. x 57 in. (114.3 x 264.2 x 144.8 cm)
Purchase, 2005

With her sculpture THE AMERICAN TRIP., Cady Noland responded to a tumultuous 1980s context in the United States, a period of growing economic disparity, culture wars, and debates surrounding American hegemony and the country's role on the world stage. MoMA's acquisition of this work in 2005, nearly two decades after it was made, illuminates the question that has been inherent to the Museum since its founding and one that is no less perennial for any institution devoted to contemporary art—namely, which art of the present moment to collect? MoMA's collecting strategy includes balancing both immediate of-the-moment purchases and longer-term consideration of an artist's oeuvre. With two decades of hindsight, the addition of Noland's art to the collection significantly enriched MoMA's holdings of contemporary art from the 1980s and '90s.

The first sculpture by Noland to enter the collection, THE AMERICAN TRIP. peers into celebrity, the traumas embedded within everyday objects, and questions of empire, drawing a queasy parallel between statehood and terror. The piece consists of three unevenly placed steel stanchions supporting various items. Hanging from steel bars are leather straps formerly attached to police batons, a blind person's cane, and a wire rack. Noland directly links the United States to piracy, choreographing a climactic collision between the skull-and-crossbones emblem of the Jolly Roger, taut here, and the oft-venerated stars and stripes of the American flag, limp and softly grazing the gallery floor. To Noland, violence is inseparable from the history of America: "There was a kind of righteousness about violence—the break with England, fighting for our rights, the Boston Tea Party," the artist has said. "Now, in our culture as it is, there is one official social norm—and acts of violence, expressions of dissatisfaction are framed in an atomized view as being 'abnormal.'"[1]

At the time when MoMA purchased THE AMERICAN TRIP. from D'Amelio Terras Gallery in New York, Noland's critical eye toward America's contradictory ethos had proven to be enduringly relevant. New York was recovering from the catastrophic devastation of 9/11 even as it was becoming a flashpoint of income inequality; American military forces were on the ground in Iraq and Afghanistan; and a rightward political shift had reignited the culture wars. THE AMERICAN TRIP. took its place in the collection alongside the work of artists such as Christopher Wool and Robert Gober, who similarly cast a skeptical eye on art's relationship to power and politics. At MoMA, the piece was first shown publicly in *Out of Time: A Contemporary View* (2006), a presentation drawn from the Museum's collection of art from the 1960s to the present. —Jessica Bell Brown

1. Cady Noland, quoted in untitled interview with Michèle Cone, *Journal of Contemporary Art*, n.d.: http://www.jca-online.com/noland.html.

Gerhard Richter (German, born 1932)

September. 2005
Oil on canvas, 20½ x 28¼ in. (52.1 x 71.8 cm)
Gift of the artist and Joe Hage, 2008

Painted four years after the 9/11 terrorist attack on New York, Gerhard Richter's *September* depicts the iconic silvery towers of the World Trade Center in the immediate aftermath of their impact by two commercial jetliners. Regarding the interval between the event and the painting, the artist has explained, "I often need a long time to understand things, to imagine a painting I might make."[1] Richter himself had been en route to New York that day from Cologne for the opening of an exhibition that was to take place two days later; his flight was diverted to Halifax, and he returned to Germany on September 13. He describes looking for a way to represent the event by "concentrating on its incomprehensible cruelty, and its awful fascination."[2] As he has done in many of his paintings since the early 1960s, Richter used a photograph, in this case from the German news magazine *Der Spiegel*, as the starting point for the composition. While he often uses a squeegee or scraper to pull paint across the canvas, here he chose a knife to achieve a similar effect, transforming the towers and smoke into a blurred mass of gray hues against the clear blue sky that is also a hallmark of that day. As former MoMA curator Robert Storr has observed, the painting's small scale reflects the size of a television screen, which was the format through which so many in the United States and around the world experienced the day's catastrophic events.[3]

Although *September* is the only painting Richter has made on the subject of 9/11, it is thematically related to other works by him that investigate the representation of traumatic histories. His subjects have included events and people—notably his own family members—from the Nazi period of his childhood as well as the postwar years in Germany. In one of his best-known works, the fifteen-canvas series *October 18, 1977* (1988), also in the MoMA collection, Richter explores the subject of terrorism in West Germany by representing members of the radical left-wing Baader-Meinhof group, who were active in the 1970s. Based on newspaper and police photographs, as well as television images, Richter's soft-focus gray-scale compositions also reflect his interest in media images and the relationship they bear to representations of truth. In *September*, the artist's technique of blurring the image again reasserts the problem of representing traumatic history in clearly defined terms.

The MoMA collection includes a large body of work by Richter, including paintings, prints, and drawings. Richter and collector Joe Hage presented *September* to the Museum as a gift in 2008, believing that it belonged in the collection for its basis on a subject so indelibly linked to New York.

—Margaret Ewing

1. Gerhard Richter, quoted in Nicholas Serota, "I Have Nothing to Say and I'm Saying It," in *Gerhard Richter/Panorama: A Retrospective*, exh. cat. (London: Tate Publishing, 2011), 25.
2. Ibid., 26.
3. Robert Storr, *September: A History Painting by Gerhard Richter* (London: Tate Publishing, 2010), 47.

Nam June Paik (American, born Korea, 1932–2006)

Zen for Film. 1965
16mm film leader (silent), approximately 20 minutes
The Gilbert and Lila Silverman Fluxus Collection Gift, 2008

A radical reduction of the material and technological conditions of film, Nam June Paik's *Zen for Film* consists of a strip of blank 16mm film leader projected onto a screen or gallery wall to create a rectangle of pure light. The work provocatively poses as an anti-film, stripping the medium to its base materiality (light, projector, blank film stock) and allowing for the nuances of its ambience (the sound of the projector, dust and accumulating scratches on the stock surface, the viewers' shadows) to become generative at the moment the work is actualized, similar to John Cage's idea of silence as music. The film is part of a series Paik made during the early 1960s inspired by Zen philosophy in which the artist interprets La Monte Young's instruction *Composition 1960 #10 (to Bob Morris)* (1960): "Draw a straight line and follow it."

The film's alternative title, *Fluxfilm No. 1*, reflects its connection to Fluxus. Initiated by artist and impresario George Maciunas, Fluxus was as much a state of mind as an art movement, an attitude shared among an international roster of artists centered around Maciunas who aimed to flatten the boundary between art and life. Rather than focus on making unique and precious objects, these artists instead staged iconoclastic, often humorous "Happenings" or created modest editioned objects that took up notions of circulation and ephemerality, such as instructions for events and films that were packaged and distributed by Maciunas as so-called Fluxkits. Indeed, *Zen for Film* was included in Maciunas's *Flux-Kit (A copy)* and *Flux-Kit (B copy)* (both 1965), in which it appears as a short strip of blank film leader contained inside a plastic box and accompanied by an index card with the artist's name and the work's title.

Zen for Film was shown in April 1964 during the festival Twelve Fully Guaranteed Fluxus Concerts in New York, yet it may have been screened as early as December 1962, during Festum Fluxorum in Paris. Its inclusion in various Fluxkit editions and later anthologies complicates its status further. Curator and artist Jon Hendricks gives three relevant dates for the work: the date Paik created the prototype (likely 1962), the year the Fluxkit edition was conceived (1964), and the year the actual copy of the edition was released (1965). In addition to the Fluxkit edition, there exists a longer single-reel version intended for theatrical presentation, which is the version presented here, dated 1965 and approximately twenty minutes in length. In 2008, *Zen for Film* entered MoMA as part of a much larger acquisition: the gift of Detroit collectors Gilbert and Lila Silverman, who built one of the world's most comprehensive collections of Fluxus art. Adding several thousand objects to the Museum's collection, the Silvermans' gift contains drawings and ephemera, sculptures and multiples, films and event scores, and includes artists from the United States, France, the Czech Republic, Japan, and, in the case of Paik, Korea. Its scale and international scope are of unparalleled significance in chronicling this influential yet often ephemeral art movement. —Christian Rattemeyer

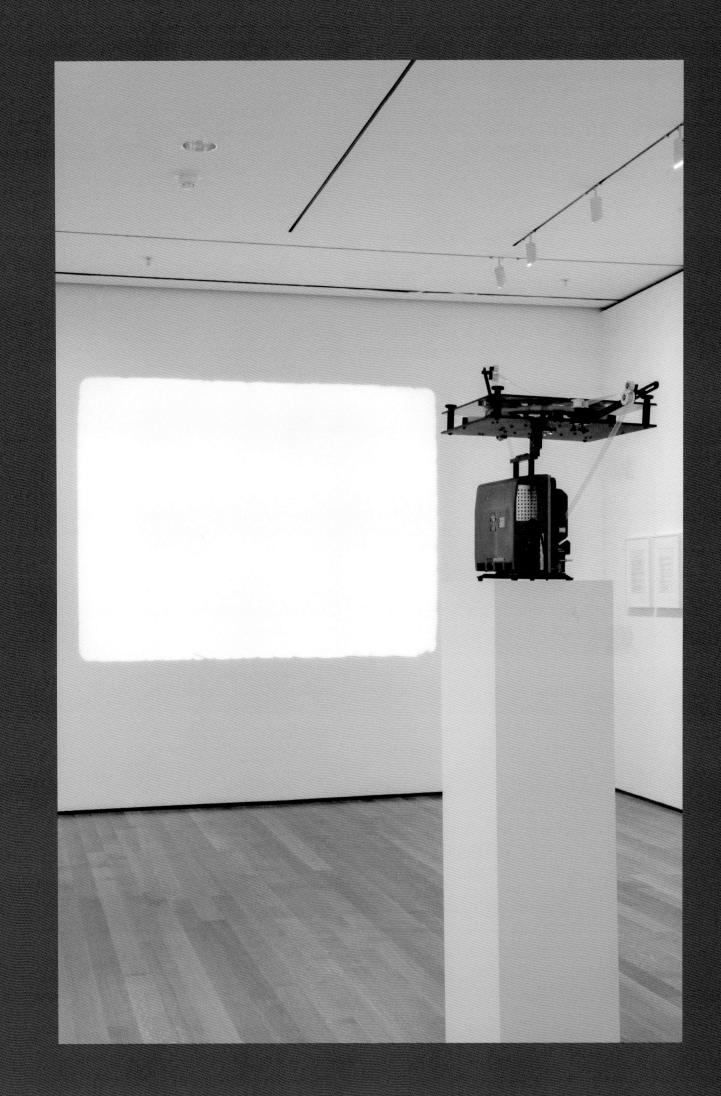

George Brecht (American, 1926–2008)

a. **Start**. c. 1966
Sewn fabric with metal grommets, overall (flag, irregular):
27^{15}/$_{16}$ x 27^{15}/$_{16}$ in. (71 x 71 cm)

b. **Middle**. c. 1966
Sewn fabric with metal grommets, overall (flag, irregular):
28 ¾ x 28 ¾ in. (73 x 73 cm)

c. **Arrow**. c. 1966
Sewn fabric with metal grommets, overall (flag, irregular):
28 ⅜ x 28 ⅜ in. (72 x 72 cm)

d. **End**. c. 1966
Sewn fabric with metal grommets, overall (flag, irregular):
27 ¾ x 28 9/$_{16}$ in. (70.5 x 72.5 cm)

Publisher: Fluxus, New York
Edition: unknown
The Gilbert and Lila Silverman Fluxus Collection Gift, 2008

As with Nam June Paik's *Zen for Film* (p. 211), the four flags here by artist George Brecht came into the MoMA collection as part of the Gilbert and Lila Silverman Fluxus Collection. Over the course of thirty years, the Silvermans maintained a boundless enthusiasm for Fluxus and collected with a keen eye toward how members of this diverse international collective of artists developed a unique framework for inspired creation that subverted the norms of its time. Encompassing nearly ten thousand drawings, sculptures, photographs, prints, multiples, films, audio works, editions, printed matter, archival materials, and books, the Silverman Fluxus Collection is the largest, most diverse, and most important of its kind, and its acquisition by MoMA in 2008 immediately made the Museum the world's foremost center for Fluxus scholarship. From its inception in the early 1960s, the movement held fast to an ethos that spawned interactive, performative, and socially engaged artistic practices. Fluxus's gleeful undercutting of the traditional hierarchies of fine art—including the veneration of painting, sculpture, and other precious art objects upon which MoMA built its reputation—played a central role in the production of Fluxus artists, which was joyful and often raucous while also often barbed with political and social critique.

Fluxus's ambition to break down the boundaries between artist, artwork, and viewer was exemplified in the editions that were conceived by artists and published in collaboration with artist and designer George Maciunas, the movement's chief impresario. Indeed, the four flags here originated as an outgrowth of Brecht's 1963 Fluxus edition, *Water Yam*, which consisted of a box designed by Maciunas that contained individual cards printed with open-ended pithy text statements that were intended for others to read and activate. It was from these instructions that Brecht and Maciunas chose the individual words or symbols to be emblazoned on each flag, early versions of which were originally offered for sale in March 1964 for $25 apiece in the periodical *cc Valise e TRanglE* (*Fluxus Newspaper, No. 3*). More closely resembling signal flags deployed in lieu of radio communication, as in the military or at sea, rather than traditional emblems of a sovereign state, the flags could have been acquired individually or in any combination and hung in any order, their meaning subject to seemingly endless variation despite their straightforward appearance, from puzzling non sequitur to radical pronouncement. As such, the flags might be said to reflect two of Fluxus's best tendencies: multiplicity and participatory performative interaction involving the artist, the owner of a Fluxus object, and the viewer.

—David Platzker

a.

b.

c.

d.

Roman Ondák (Slovak, born 1966)

Measuring the Universe. 2007
Performance
Fund for the Twenty-First Century, 2009

After debuting at Munich's Pinakothek der Moderne in 2007, Roman Ondák's interactive performance piece *Measuring the Universe* received its U.S. premier in 2009, when it was presented as part of MoMA's performance program in one of the Museum's second-floor contemporary galleries. The work consists of museum attendants equipped with black pens marking the height of visitors as they come through the gallery, throughout the duration of the exhibition. By inscribing horizontal lines on the gallery walls, accompanied by each visitor's first name and the date the measurement was taken, a collective, changing portrait comes into being. During the twelve-week period that marked the work's MoMA debut, the process incorporated a multitude of participants; the walls of the gallery, initially blank, were filled with the cumulative traces of thousands of people, and the resulting constellation playfully revealed the average height of the Museum's public.

Ondák is one of the most prominent representatives of a younger generation of artists working with performance. Emerging from a long and rich tradition of site-specific and Conceptual art in Eastern Europe, *Measuring the Universe* is a work that conjoins Ondák's ongoing concerns with ephemerality, the convergence of time and space, merging art with common social rituals, and the active engagement of viewers through simple but metaphorically poignant actions. The performance's script echoes the domestic tradition of recording children's heights on doorframes; however, by making this action public, visible, collective, and ongoing, the artist reminds us of the primal human desire to gauge the scale of the world. *Measuring the Universe* suggests both universal and personal notions of space, while challenging conventional definitions of museums, spectatorship, and display. The title of the piece also reveals a subtle humor commonly found in Ondák's work: it refers to the futility of finding an adequate measure either for the expansiveness of the universe or for any one person's individuality.

With the support of the Museum's Fund for the Twenty-First Century, MoMA's acquisition of *Measuring the Universe* was a crucial step in the Museum's history of acquiring contemporary performance-based art—namely, the acquisition consists of a series of instructions of how to realize the performance. That same year, the Department of Media was renamed the Department of Media and Performance Art, further underscoring the Museum's commitment to including live-action performance art in the collection in its different forms. —Ana Janevski

Ray Tomlinson (American, 1941–2016)

@. 1971
ITC American Typewriter Medium
Acquired, 2010

In 2010, MoMA began adding digital symbols and icons to its collection, selecting as the first a symbol that has become emblematic of the internet age: the @ symbol, which in the digital era serves as the connector between user and domain names in email protocol. Because the symbol, of course, belongs to anyone who wishes to claim it, its incorporation into the collection is technically described as an "anointment," even though it is commonly still referred to as an acquisition.

Some scholars believe the @ symbol dates to the sixth century, when scribes simplified the Latin word *ad* ("at") by exaggerating the upstroke of the letter *d* and curving it over the *a*. Others suggest that the symbol had its genesis in sixteenth-century Venetian trade as an abbreviation for *amphora*, a standard-size terra-cotta vessel used by merchants that became a unit of measure. The word *à* in Norman French might be another source for @, which was adopted in northern Europe to mean "each at," indicating price, its accent eventually becoming @'s curl. Since the nineteenth century, @ has appeared on standard typewriter and computer keyboards, but until fairly recently it was used almost exclusively by accountants as the "commercial *a*," a shorthand symbol to mean "at the rate of."

Working for the technology company Bolt Beranek and Newman in Cambridge, Massachusetts, in 1971, computer programmer Ray Tomlinson created the world's first e-mail system, for the U.S. government's Advanced Research Projects Agency Network. He adopted @ as a stand-in for the long and convoluted programming language used to indicate a message's destination. This was a design decision of extraordinary elegance and economy—taking an underutilized symbol already available on a standard keyboard and repurposing it to suit a revolutionary new technology. The sign's new function is in keeping with its origins: in computer language, as in financial transactions, @ establishes a relationship between two separate elements. It is now part of everyday life all over the world, as demonstrated by the affectionate names it has been given in different cultures. Germans, Poles, and South Africans call it "monkey's tail," Chinese see a little mouse, and Italians, a snail. Finns know it as the *miukumauku*, the "sign of the meow," because it resembles a curled-up sleeping cat.

This fundamental acquisition paved the way for similarly ingenious masterpieces of digital graphic design to enter MoMA's collection during the last few years, including other universal symbols such as the Creative Commons logo (2005), IEC power symbol (p. 233), Susan Kare's Graphic User Interface symbols for Apple (1984), and the original set of 176 emoji (p. 267). Each of these graphics have become ubiquitous in daily life yet harbor a rich design history, and as such, they are in keeping with MoMA's foundational idea that its collection of the art and design "of our time" include such elegantly conceived, humble masterpieces. From the self-aligning ball bearing (p. 62) to the recycling symbol (1970), these items populate quotidian life and propel it toward a progressive future—in other words, they express a quintessential idea of modernity. —Paola Antonelli

Unknown photographers

a. **Untitled**. c. 1935
Gelatin silver print, 4⅝ x 2¹³⁄₁₆ in. (11.8 x 7.1 cm)

b. **Untitled**. c. 1935
Gelatin silver print, 5½ x 3⅛ in. (14 x 8 cm)

c. **Untitled**. c. 1940
Gelatin silver print, 3⅝ x 4¾ in. (9.2 x 12 cm)

d. **Untitled**. c. 1940
Gelatin silver print, 4⅛ x 2⅜ in. (10.5 x 6 cm)

e. **Untitled**. c. 1945
Gelatin silver print, 3 x 4½ in. (7.6 x 11.5 cm)

f. **Untitled**. c. 1949
Gelatin silver print, 4¹³⁄₁₆ x 3 in. (12.2 x 7.6 cm)

Gift of Peter J. Cohen, 2010

When Beaumont Newhall organized the first exhibition for MoMA's newly formed Department of Photography in 1940, *Sixty Photographs: A Survey of Camera Esthetics*, he made sure to include alongside the work of Berenice Abbott, László Moholy-Nagy, Alfred Stieglitz, and other leading figures in the field two news photographs by unknown or unidentified photographers. Thus, from the start, the official history of photography at the Museum included photographs that were never intended to be works of art, and these were soon joined by others made by untrained amateurs, seasoned professionals, journalists, scientists, and commercial studios.

There is a neat name for this messy diversity of images created without explicit artistic ambition: vernacular photography. And ever since the introduction of George Eastman's Kodak No. 1 camera in 1888 (with its now-legendary advertising slogan, "You Press the Button—We Do the Rest"), the snapshot has been vernacular photography's most popular subcategory—particularly if one considers the millions of images on Snapchat, Flickr, Instagram, and Facebook as descendants of the film-based variety. MoMA's collection is as diverse as photography itself, revealing the ways in which the medium's history as a fine art is inextricably linked to its vernacular traditions, a connection made explicit by John Szarkowski, director of the Department of Photography, in the mid-1960s: "[P]hotography—the great undifferentiated, homogeneous whole of it—has been teacher, library, and laboratory for those who have consciously used the camera as artists."[1] The ubiquity of photography, the near impossibility of finding a person who has not held in his or her hand a snapshot similar to the ones reproduced here, has been a source of both irritation and inspiration for those seeking to secure photography's status among the fine arts. In no other medium are the boundaries between artist, amateur, and professional for hire so blurred, making it foolish to attempt to understand one without the others.

Still, to acknowledge these intertwined histories is not to suggest that the methods of acquiring works from each category are identical. Pursuing the work of a fine art photographer can be as straightforward as contacting the artist directly, or the artist's estate or gallery. Snapshots, on the other hand, are more likely to be found in someone's attic or under a bed, and though many might find their way to a local flea market, it takes special persistence to accumulate examples that

1. John Szarkowski, *The Photographer's Eye* (New York: The Museum of Modern Art, 1966), 11.

a.

b.

c.

d.

e.

f.

Unknown photographers

g. **Untitled.** c. 1950
Gelatin silver print, 4⁵⁄₁₆ x 3¹⁄₁₆ in. (11 x 7.8 cm)

h. **Untitled.** c. 1950
Gelatin silver print, 5¾ x 3⁹⁄₁₆ in. (14.6 x 9 cm)

i. **Untitled.** c. 1950
Gelatin silver print, 4³⁄₁₆ x 2⁵⁄₁₆ in. (10.6 x 5.8 cm)

j. **Untitled.** c. 1950
Chromogenic color print, 3⁹⁄₁₆ x 3⁷⁄₁₆ in. (9 x 8.8 cm)

k. **Nilda, Ann, Kathryn, Florence.** c. 1955
Gelatin silver print, 3¹⁄₁₆ x 5¼ in. (7.7 x 13.4 cm)

l. **Untitled.** 1969
Gelatin silver print, 3⁹⁄₁₆ x 3⁹⁄₁₆ in. (9 x 9 cm)

Gift of Peter J. Cohen, 2010

transcend the often-mundane circumstances of their creation. Peter J. Cohen did just this for more than twenty years, scouring flea markets and eBay to amass a personal collection of tens of thousands of photographs, dating from the late nineteenth century to the waning decades of the analogue era. Ultimately, he invited curators from MoMA to comb through his remarkable collection and to select snapshots that both suggest the richness of photography's vernacular tradition and resonate with works in the Museum collection made for myriad other purposes, a process that resulted in Cohen's gift of more than three hundred photographs, from which this selection is drawn.

—Sarah Hermanson Meister

g.

h.

i.

j.

k.

l.

Steve Reich (American, born 1936)

Drumming. 1971
33⅓ rpm LP, lithographs, and typewritten text on paper,
record sleeve: 12⅜ x 12⁵⁄₁₆ in. (31.5 x 31.2 cm)
Partial gift of the Daled Collection and partial purchase through
the generosity of Maja Oeri and Hans Bodenmann, Sue and
Edgar Wachenheim III, Agnes Gund, Marlene Hess and James D.
Zirin, Marie-Josée and Henry R. Kravis, and Jerry I. Speyer and
Katherine G. Farley, 2011

On December 3, 1971, what would soon become an iconic work of Minimalist music premiered at MoMA, performed by the ensemble Steve Reich and Musicians. A composition for eight tuned drums, three marimbas, three glockenspiels, voice, and piccolo, *Drumming* reflects Reich's study of Balinese and African drumming and consists of four sections that flow seamlessly together, its composition emphasizing polyrhythms that build and go out of phase with each other over time. This technique of phasing, popularized by Reich through his experiments with tape music, occurs when one performer's tempo remains constant while another's slightly speeds up or lags so that they play the same phrase simultaneously yet out of sync.

For a number of reasons, *Drumming* was a landmark work for Reich, first as an example of "construction and reduction," a new musical process developed by the composer in which beats are gradually substituted for rests (and vice versa) within the repeating rhythmic cycle. It is also an early example of a work in which Reich combines instruments of different timbres playing the same line, and it is revolutionary for its treatment of the human voice as merely another instrument in the ensemble. Rather than singing words, the vocalists imitate the sounds of instruments, intoning "tuk," "tok," or "duk" for drums, "boo" or "doo" for marimbas, and whistling to approximate the register of the glockenspiel. The combination of these effects enhances the uncanny doppelgänger nature of the phasing effect. Reich intended for these compositional strategies to be evident to the listener: "I am interested in perceptible processes," he said. "I want to be able to hear the process happening throughout the sounding music."[1]

MoMA's commitment to music and sound practices began with avant-garde music programming in the 1940s and continued to grow with the establishment of the annual series Jazz in the Garden in 1964 and then Summergarden in 1971. Music continues to have a prominent place in the Museum's programming and exhibitions, particularly highlighted in the 2013 show *Soundings: A Contemporary Score*, and in the collection, which includes work by numerous composers and artists working in sound, including John Cage, David Tudor, Alvin Lucier, and a younger generation of artists, such as Stephen Vitiello and Kevin Beasley.

Only weeks after MoMA's premiere of *Drumming*, the recording on the LP was made in New York at Town Hall and was published by John Gibson and Multiples in 1972. The record in MoMA's collection is edition 1 of 500. In 2011, it was partially gifted to the Museum by Herman and Nicole Daled along with the composition's score. The Daleds donated more than two hundred works that they acquired between 1966 and 1978, primarily Conceptual and process-based art. While MoMA's collection does include live performances by artists such as Simone Forti and Tino Sehgal, the certificate for *Drumming* indicates that the musical score cannot be used to perform the work without the permission of the composer, exemplifying the myriad possibilities for performance's representation in a museum collection. —Martha Joseph

1. Steve Reich, "Music as a Gradual Process," in *Steve Reich: Writings about Music* (Halifax: Press of Nova Scotia College of Art and Design; New York: New York University Press, 1974), 9.

The performance begins with two three or four drummers playing in unison at measure ①. When one drummer moves to the second measure and adds the second drum beat the other drummer(s) may or may join him immediately or remain at bar ① for several repeats. This process of gradually substituting beats for rests within the pattern is continued with at least 6 or 8 repeats for each measure until all drummers have reached the fully constructed pattern at measure ⑧. At ⑨ only drummers one and two continue, and after several seconds of getting comfortable in close unison, drummer two begins to slightly increase his tempo so that after 20 or 30 seconds he has finally moved one quarter note ahead of drummer one, as shown at ⑩. The dotted lines indicate this gradual shift in phase relation between the two drummers. Throughout the piece the alternation of stems up and stems down indicate the alternation of right + left hands. The choice as to which hand is indicated by stems up or down is left to the performers.

Lynn Hershman Leeson (American, born 1941)

a. **Roberta Breitmore Blank Check**. 1974
Offset lithography and letterpress with
black marker on paper, 2¾ x 6 in. (7 x 15.2 cm)
The Modern Women's Fund, 2011

b. **Dental X Ray**. 1975
Chromogenic color print, 7⅜ x 9⁷⁄₁₆ in. (18.7 x 24 cm)
Gift of Gallery Paule Anglim, 2011

c. **Lynn Turning Herself into Roberta**. 1975
Video (color, sound), 5:20 minutes
Gift of Gallery Paule Anglim, 2011

d. **Roberta's Construction Chart #2**. 1976
Chromogenic color print, 2003,
22¹⁵⁄₁₆ x 29⅝ in. (58.3 x 75.3 cm)
The Modern Women's Fund, 2011

In 1974, artist and filmmaker Lynn Hershman Leeson founded the Floating Museum, a pioneering association that, for the next four years, commissioned hundreds of art projects for non-art spaces, ranging from city streets to prison courtyards. Breaking free from institutional settings, Leeson assumed at this time the fictional alter ego "Roberta Breitmore," a thirtysomething divorcée living in the San Francisco Bay Area during the tumultuous years of the women's liberation movement. Asked more than two decades later about her construction of this character, Leeson replied: "*Roberta* was a fictional person: she was virtual, but she interfaced with reality all the time. Documents were part of her life, and they allowed you to witness a process of not just her life, but a culture and a society, and the law that were part of that, giving you a contextual portrait of that particular place in time."[1]

Leeson's physical self-transformation through makeup, a blond wig, and a specific style of clothing, as well as her construction of Breitmore's personality, which Leeson composited from stereotyped psychological data, added up to a fully fledged character. As Breitmore, Leeson maintained a small apartment, had a checking account, credit cards, and a driver's license, saw a psychiatrist, participated in the Weight Watchers diet program, and placed personal ads looking for dates. Leeson thus converted her own life into a platform for social commentary and for critique of accepted typologies of the self. In the third year of the project, the artist engaged three other people to don Roberta-like clothing and perform as Breitmore. The project concluded in November 1978 with the exorcism of Breitmore on the grave of Lucrezia Borgia at the Palazzo dei Diamanti in Ferrara, Italy. What comprises the work today is a wide cache of documentation, including photographs, drawings, surveillance reports, films, letters, and legal and medical papers, as well as portraits heavily manipulated by Leeson to highlight the processes of gender construction.

Roberta Breitmore was featured in *WACK! Art and the Feminist Revolution*, an exhibition organized by the Museum of Contemporary Art, Los Angeles, that traveled to MoMA PS1 in 2008. In 2011, MoMA acquired forty works for its collection that personify the multifaceted persona and life of Breitmore. The acquisition was the result of a museum-wide initiative to expand the representation of women artists and was generously supported by the Modern Women's Fund. Given the work's significance in redefining perceptions of femininity through innovative, performance-based photographic practice, the project was presented in *XL: 19 New Acquisitions in Photography* at MoMA in 2013. Leeson's *Roberta Breitmore* expanded the definitions of art and artist, making a critical contribution to the relationship between gender, performance, and politics in the post-1970s period. —Roxana Marcoci

1. Lynn Hershman Leeson, quoted in "Lynn Hershman Leeson in Conversation with Gabriella Giannachi," *Leonardo* 43, no. 3 (June 2010): 232.

a.

b.

c.

d.

Yayoi Kusama (Japanese, born 1929)

Accumulation No. 1. 1962
Sewn stuffed fabric, paint, and chair fringe,
37 x 39 x 43 in. (94 x 99.1 x 109.2 cm)
Gift of William B. Jaffe and Evelyn A. J. Hall
(by exchange), 2012

In the summer of 1962, collector and gallery owner Beatrice Perry purchased an early sculpture by artist Yayoi Kusama made that same year: an armchair onto which the artist had boldly stitched across its surface hundreds of hand-sewn phallic shapes stuffed with fabric and painted all white. Perry was an early patron and dealer of Kusama's art; she kept this work, *Accumulation No. 1*, in her collection for nearly fifty years, until her death in 2011.

Kusama once said that she "shed [her] skin" as a painter to become a sculptor of environments.[1] First she painted and drew "infinity nets," dizzying fields of dots on paper. In her work as a sculptor, Kusama continued building up dense surfaces when she began to attach phallic protuberances she called "accumulations" to tables, sofas, and baby carriages. Occasionally, her studio neighbor Donald Judd helped her salvage materials and affix the phalluses, a process the artist described as one that offered a kind of therapeutic healing from her fear of sex, which she developed as a child. "I make them and make them and then keep on making them, until I bury myself in the process," Kusama wrote years later, explaining her compulsive repetition in making the infinity nets and accumulations. "I call this 'obliteration.'"[2]

Accumulation No. 1 was first exhibited publicly in June 1962 in a group show at Richard Bellamy's Green Gallery, which championed New York artists such as Claes Oldenburg, Mark di Suvero, and Robert Morris. Kusama's handmade, sexually charged objects provocatively challenged the male-dominated Pop and Minimalist art scenes in New York, but for many decades, her contributions to twentieth-century art were marginalized. MoMA purchased its first work by Kusama, a drawing, in 1970, a year after the artist staged an unauthorized happening at the Museum, *Grand Orgy to Awaken the Dead*, which featured nude performers painted in dots dancing in the sculpture garden. In 1996, MoMA acquired its first Kusama accumulation sculpture, *Violet Obsession* (1994), followed by the purchase of a second, *Suitcase* (2004), in 2005. By then, the Museum had further examined Kusama's importance to art of the 1960s. *Accumulation No. 1* was shown in MoMA's 1998 Kusama survey, *Love Forever: 1958–1968*. At the time, Perry did not wish to part with *Accumulation No. 1*, but when she died, she bequeathed the work to her son, who sold it in 2012 to the Museum, where it has been frequently placed on view ever since. —Jessica Bell Brown

1. Yayoi Kusama, quoted in Jo Applin, *Yayoi Kusama: Infinity Mirror Room–Phalli's Field* (London: Afterall Books, 2012), 33.
2. Yayoi Kusama, *Infinity Net: The Autobiography of Yayoi Kusama* (Chicago: University of Chicago Press, 2011), 47.

Juan Downey (Chilean, 1940–1993)

Map of America. 1975
Colored pencil, pencil, and acrylic on map on board,
34⅛ x 20¼ in. (86.7 x 51.4 cm)
Purchased with funds provided by the Latin American
and Caribbean Fund and Donald B. Marron, 2013

After training as an architect in his native Santiago de Chile, Juan Downey left for Europe at the age of twenty-one, where he lived in Madrid, Barcelona, and Paris before relocating to the United States in the mid-1960s, settling definitively in New York in 1967. As a Chilean expatriate, he was shaken by the news in 1973 that Chilean president Salvador Allende had been deposed by a military coup, widely seen as having been supported by the Nixon administration. "I realized that the cultural shock I suffered could possibly be the seed of a work of art," Downey later recalled, "and I understood it was important to return to my roots, to what was strictly Latin American."[1] So began Downey's most ambitious project, for which he was determined to travel the continent of South America, using newly available portable video technology to record local communities and then screen the resulting footage for others in neighboring areas, in order to undermine their mutual isolation.

Between 1973 and 1979, Downey embarked on several road trips and a yearlong residency in the Amazon rainforest, where he lived with the Yanomami indigenous communities in Venezuela along the Orinoco River. Later on, Downey would recall, "The map of the American continents was a metaphor of my confused mind; as I began to take on sections, an introspective process began."[2] It was during this time that Downey created *Map of America*, using a preexisting map to construct a mesmerizing image of South America painted in a swirl of bright colors and contour lines. The drawing's support is cut into five rectangular sections, and the navel point of the winding spirals corresponds geographically to the area of the Amazon basin in northwestern Brazil. Significantly, the drawing conceals political borders, emphasizing instead the veinlike cartographic lines that identify some of the continent's largest rivers—the Orinoco, Amazon, Tocantins, Paraná, and Xingu—suggesting channels of energy and communication that transcend geopolitical divisions.

Map of America was acquired by MoMA in 2013, thanks to the generosity of President Emeritus Donald B. Marron and the Latin American and Caribbean Fund. The latter, a funding committee that has been active since 2006, is devoted to supporting and promoting acquisitions of art from the region—a mission that resonates profoundly in the image of transnational integration that is central to Downey's *Map of America*. Immediately following its acquisition, the work was first shown at MoMA as part of the exhibition *A Trip from Here to There*, a survey of works by peripatetic artists from the Museum's drawings collection. Exhibited again in 2015, it became the hallmark image of *Transmissions: Art in Eastern Europe and Latin America, 1960–1980*, a show that traced parallels in artistic practices during a period of political turmoil in both regions. Part emblem, part travel journal, *Map of America* continues to engage contemporary audiences through its beautifully transfixing appeal to upend traditional notions of territory. —Karen Grimson

1. Juan Downey, quoted in René Naranjo and Víctor Briceño, "Entrevista a Juan Downey," in *Sexto Festival Franco-Chileno de Video Arte* (Santiago: Servicio Cultural de la Embajada de Francia, 1986), n.p.
2. Juan Downey, quoted in Raúl Zurita, "Conversación entre Raúl Zurita y Juan Downey," *Pluma y pincel* (Santiago) 14 (April–May 1984): 37.

Downey 75

Tomohiro Nishikado (Japanese, born 1944)

a. **Space Invaders**. 1978
 Video game software
 Publisher: Taito, Japan
 Gift of the Taito Corporation, 2013

Dave Theurer (American)

b. **Tempest**. 1981
 Video game software
 Publisher: Atari, Inc., U.S.A.
 Gift of Atari Interactive, Inc., 2013

In 2012, MoMA began acquiring video games for its collection, reflecting the Museum's ongoing commitment to celebrating major achievements in design. Video games are expressions of interaction design, a field in which designers address the new circumstances that arise as humans communicate with increasingly complex machines—primarily, and most consequentially since the postwar era, in the digital universe. With touch screens and voice-activated devices ubiquitous in our daily lives today, it is easy to forget that computers were once enormously complicated—and enormous *tout court*—used almost exclusively by highly trained technicians and scientists. The profound shift from their early technical exclusivity to omnipresence and easy accessibility was in many ways facilitated by the work of video game designers. Before the graphical user interface, before the mouse, before internet and email, computer programmers and engineers used gaming as a way to help bridge the divide between human and machine. Good interaction design as expressed in video games is not only about visual quality and aesthetic experience but also—and especially—about behavior. The major tool of the interaction designer is code, the software composition that depicts the space of the interaction and the rules of communication; well-designed code shapes the behavior of both user and machine to form an elegant feedback loop that optimizes the user experience.

Early video games were severely limited in spatial quality and definition, but they transfixed the public nevertheless. *Pong*, the first arcade game, established a company (Atari), an industry, and a culture that profoundly altered the world. Video arcades were already a craze in Japan when, in 1978, Taito released *Space Invaders*. Tomohiro Nishikado's powerfully affecting game had players frantically piloting a gun turret to shoot down a never-ending rain of gyrating aliens in outer space. Tense and bizarre, it was completely unlike the sports and driving games more common at the time, and it proved a runaway hit: so captivated was the Japanese public that the frenzy caused a temporary national shortage of the hundred-yen coins used to start each game. Three years later, American designer Dave Theurer, who worked for Atari, conceived *Tempest*, a first-person *Space Invaders*. Displayed on the new and striking vector graphics monitor, Theurer's game features a series of tunnels rendered three-dimensionally out of which threatening aliens climb. Using a spinning knob, players must rapidly move their gun turret around the outer circumference of the tunnel, shooting the aliens before they can reach the surface. Both games speak to an anxiety of violence, of the frantic defense from advancing hordes of monsters, whether from the sky or from unknown depths. And both radically advanced how humans interact with and inhabit digital space, marking significant milestones on a technological path that continues to blur the distinctions between the digital realm and what is now called RL, or real life. —Paola Antonelli and Paul Galloway

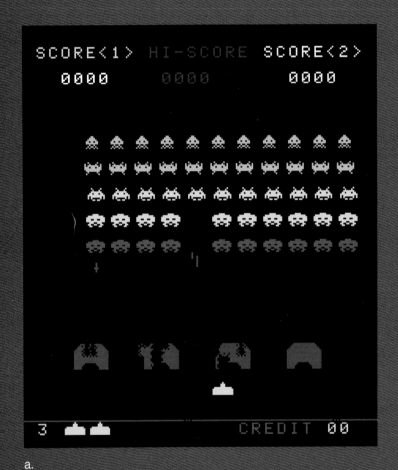

a.

b.

Jens Eilstrup Rasmussen (Danish, born 1966)

a. **Google Maps Pin**. 2005
Digital image file
Gift of Google Inc., 2013

International Electrotechnical Commission (IEC) (Switzerland, established 1906)

b. **Power Symbol**. 1973/2002
Digital image file
Acquired, 2015

Google was developing its own mapping system in 2004 when it acquired the digital mapping company Expedition and brought the company's founders, brothers Jens and Lars Rasmussen, onto its own team. It was there that Jens Rasmussen, a designer and software developer, created the *Google Maps Pin*, a graphic icon that was both distinctive and functional, precisely indicating a location without obscuring the area nearby: the unique upside-down teardrop shape means that only the very tip of the pin touches the map. The success of Rasmussen's design is reflected not only in the icon's ubiquity in the digital realm but also in its leap into real life as an immediately recognizable symbol, such as in the work of artist Aram Bartholl, who creates physical map pins—often several meters high—to mark sites in the material world and call attention to the ways in which we negotiate space in the real and virtual realms.

The *Power Symbol* also bridges the analog and digital worlds, conceived of in the former and recently reimagined in the latter. The earliest binary switches on consumer electronic products were marked with an *I* and an *O* to denote, respectively, a closed electrical circuit (device on) and an open circuit (device off). In 1973, these two symbols were combined by the International Electrotechnical Commission (IEC) into one now-familiar icon—an almost-complete circle cut at the top by a solid, straight vertical line. The official definition for this symbol was initially "standby setting." Almost thirty years later, an international committee of scientists and engineers led by Bruce Nordman and Alan K. Meier of the Lawrence Berkeley National Laboratory in Northern California undertook a three-year research project to reconsider power-control user interface standards, ultimately recommending in 2002 that this combined symbol should henceforth denote its more commonly accepted understanding: "power." This standard was adopted by Unicode, the international body that oversees the computing industry text standard.

Although both the *Google Maps Pin* and *Power Symbol* may at first seem inextricably of their moment, they can be connected to a lineage of modern design in which clarity and grace of form have served to direct and orient a diverse public on the go, such as Massimo Vignelli's subway signage for the New York City Transit Authority (1966–70) and Margaret Calvert and Jock Kinneir's signage for British Rail (1964) and U.K. roadways (1957–67). Indeed, MoMA has shaped this history not only through collecting graphic design related to information and way finding but through public dialogue, not least via the seminal *Signs in the Street* exhibition in 1954 organized by curator Mildred Constantine, and her 1967 public symposium "Transportation Graphics: Where Am I Going? How Do I Get There?," at which Calvert, Kinneir, Vignelli, and others discussed how information graphics can and should shape human experiences of space. —Michelle Millar Fisher

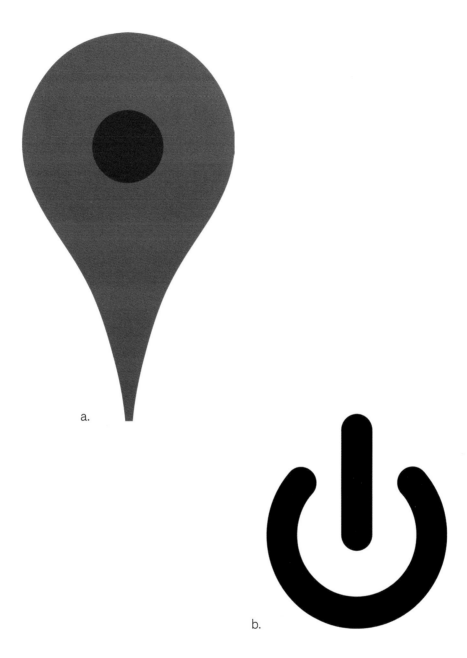

a.

b.

Trisha Donnelly (American, born 1974)

To Be Titled. 2013
Rose quartz, 10 ft. 2 in. x 6 ft. 7⅛ in. x 1⅛ in. (309.9 x 201 x 2.9 cm)
Gift of G. David Thompson and Countess Felicia Gizycka
(both by exchange), 2013

Weighing more than a thousand pounds and designed to lean against a wall, *To Be Titled* belongs to a series of large sculptures Trisha Donnelly made between 2011 and 2013 at a quarry in Bolzano, Italy, that were, at the time, her largest works to date. Like many of Donnelly's artworks, *To Be Titled* is hard to place: evoking forms in postwar sculpture and modern architecture, it also alludes to ancient ruins or relics, while the abstract drawing carved into its surface reads as a sign waiting to be deciphered.

Since she began her career in the early 2000s, Donnelly's work has spanned a range of mediums, including drawing, sculpture, assemblage, sound, video, photography, and live actions. She arrived at the opening for her first solo exhibition at Casey Kaplan gallery in New York, in 2002, riding a white horse and gave a short speech that concluded, "I am electric." Since then, her projects have continued to elude traditional strategies of interpretation that strive to fix art's meaning. Heir to Conceptual art and its legacies, Donnelly does not seek to relay a predetermined message but rather to set the coordinates between which questions about the very nature of spectatorship can be raised and considered. The obstacles to legibility in Donnelly's work—and even the frustration that they may elicit—serve as invitations for viewers to examine the expectations and desires they bring to their encounters with art. Central to what one critic has described as Donnelly's "sphinx-like air of inscrutability" is the artist's frequent withholding of explanatory information surrounding presentations of her work.[1] The language found in Donnelly's exhibition press releases, often penned by the artist herself, typically behaves like the works of art that they accompany, for example: "I incline towards the minds of others / and all it is / all it is - is / the vert panic / the mind mass / of cantled freaks / the triple knock of / 3 parallel pains // I am the all star epileptic truth— / x4 x4 x4 / africa take me in your form.[2]

MoMA has been committed to acquiring and displaying Donnelly's work since early in her career, and in 2012, she was the tenth artist to participate in the Museum's Artist's Choice series, for which artists organize an exhibition drawn from the collection. Donnelly's widely celebrated iteration, described in the press as "eccentric, joyful, and finely wrought," featured works from across curatorial departments, and her groupings offered alternatives to the chronological and movement-classified installations for which MoMA's presentations have historically been known.[3] Donnelly filled her show with what she characterized as "striking voices I couldn't let go of . . . images that go beyond the images themselves"[4] The next year, in recognition of Donnelly's own striking voice, MoMA acquired *To Be Titled* soon after it was made, thereby deepening what is one of the largest institutional collections of the artist's work to date. —Emily Liebert

1. Andrea K. Scott, "Sorcerer's Stone," *The New Yorker*, May 31, 2010, 16.
2. "Trisha Donnelly," Casey Kaplan gallery press release, undated (May 2007), http://caseykaplangallery.com/wp/wp-content/uploads/2012/08/Press-Release.pdf
3. Roberta Smith, "Ambushed by Sundry Treasures," *The New York Times*, January 2, 2013.
4. Trisha Donnelly, quoted in Jerry Saltz, "The Best of the Basement," *New York*, December 9, 2012.

Andrea Geyer (German and American, born 1971)

Insistence. 2013
Video (color, sound), 15:21 minutes
The Modern Women's Fund, 2014

Since the 1990s, the work of Andrea Geyer has systematically asserted that notions of history are always in flux, vulnerable to ever-changing subjective forces, social contexts, and constructs of power. Her moving-image and text-based installations are rooted in meticulous investigations of historical and political phenomena, creating opportunities for reexamination that offer profound implications.

During Geyer's 2012–13 research fellowship at MoMA, made possible by the Museum's Wallis Annenberg Fund for Innovation in Contemporary Art, the artist embarked on a project focused on MoMA cofounders Lillie P. Bliss, Abby Aldrich Rockefeller, and Mary Quinn Sullivan, conducted with the support of the Museum Archives. During the past five years, that inquiry has expanded into a continually evolving body of work charting the vast network of women involved in shaping the modernist movement in New York and beyond, an investigation spurred by Geyer's discovery of how little recognition the essential contributions of these women had received and the cursory nature of what information was available: women were often only casually mentioned, or their stories were encapsulated in short descriptions that barely scratched the surface.

Insistence confronts the fundamental omissions and shortcomings of historical representation that Geyer encountered through her research. As the artist narrates a short history of women's involvement in modernism that begins in the late nineteenth century, she methodically stacks postcard depictions of these women and their peers interspersed with artistic representations of women. The postcard format evokes the pervasive visibility of male artists and thinkers through its almost inevitable association with the ubiquitous commercial reproductions for sale in museum gift shops worldwide, thus laying bare the unrecognizability of many of these women to contemporary viewers. It is a point reinforced by the photographs' small scale, demonstrating how the roles these women played in the shaping of modernism and their indelible impact on today's cultural landscape have historically been diminished. The titular "insistence" inherent in the artist's stacking gesture drives this point home, and the accumulation of portraits serves as both a tribute and a critical comment on how easily these women have been overlooked, suggesting that the convictions that compelled them to create far-reaching networks across art, politics, education, and social reform remain at work today.

One year after its completion, *Insistence* was purchased for the Museum collection with funds provided by MoMA's Modern Women's Fund. The video was exhibited at the Museum in 2015 in conjunction with the related work *Revolt, They Said*, a wall-size diagram based on a drawing begun by Geyer in 2012 and ongoing that delineates a network of more than eight hundred women who were instrumental in effecting social and cultural change in the first part of the twentieth century. *Revolt, They Said* was also acquired by MoMA with support from the Modern Women's Fund.

—Erica Papernik-Shimizu

Rirkrit Tiravanija (Thai, born Argentina, 1961)

untitled (the days of this society is numbered / December 7, 2012). 2014
Acrylic and newspaper on linen, 7 ft. 4 in. x 7 ft. ½ in. (221 x 214.6 cm)
Committee on Drawings and Prints Fund, 2014

The work of Rirkrit Tiravanija takes many forms, from drawings and editioned multiples to sculpture and performance, but at its core, it often revolves around participation and shared experience. Tiravanija has quite literally encouraged the involvement of his audience through the creation of social spaces, collaborative activities, and communal meals, as in his breakthrough work, *untitled 1992 (free)* (1992), in which the artist transformed an exhibition space into a sprawling kitchen for the ongoing cooking and consumption of Thai green curry by Tiravanija, his friends, and gallery visitors.

A similar yet distinct sense of the shared and the ephemeral is present in the series of newspaper drawings that Tiravanija began in 2010, in which daily broadsheets from the United States, France, the United Kingdom, Spain, and elsewhere become the carriers of provocative slogans such as "All you need is dynamite" and "Freedom can not be stimulated." In MoMA's example, *untitled (the days of this society is numbered / December 7, 2012)*, Tiravanija collaged together spreads from a Thai newspaper published the week of the eighty-fifth birthday of King Bhumibol Adulyadej, who had been on the throne for more than sixty years. A massive public celebration with parades and throngs of admirers took place, in seeming obliviousness to the history of political turmoil and military coups that had punctuated the king's long reign. Among the pages in the work shown here are advertisements for cars, luxury real estate, and credit cards, overpainted with Tiravanija's text, "The days of this society is numbered," a grammatically questionable tweak of Situationist thinker Guy Debord's statement, "The days of this society are numbered; its reasons and its merits have been weighed in the balance and have been found wanting; its inhabitants are divided into two sides, one of which wants this society to disappear." Indeed, two years after the date of the newspapers in Tiravanija's drawing, and the year in which the work was made, a coup launched by the Thai military overthrew the country's democratic government, a move that was ultimately endorsed by the king. In the context of the work itself, the phrase appears both prescient and ominous, and at the same time, its forecast of societal breakdown seems as relevant today—and on a global scale—as it did when Tiravanija painted it a decade ago, or indeed when Debord first used it in 1967.

MoMA has been collecting Tiravanija's work since the mid-1990s, and the acquisition of *untitled (the days of this society is numbered / December 7, 2012)* in 2014 evidences the Museum's efforts to keep the collection current with his practice. The Committee on Drawings and Prints Fund is earmarked specifically for the acquisition of works on paper, and it is often relied upon to support the work of artists such as Tiravanija who already hold a place in the collection and whose work is considered central to contemporary practice. —Sarah Suzuki

Leo Fender (American, 1909–1991)
George Fullerton (American, 1923–2009)
Freddie Tavares (American, 1913–1990)

Fender Stratocaster Electric Guitar. Designed 1954, this example 1957
Wood, metal, and plastic, 38 x 12¾ x 1¾ in. (96.5 x 32.4 x 4.4 cm)
Committee on Architecture and Design Funds, 2014

One of the most influential instrument designs of the twentieth century, the iconic Stratocaster electric guitar was designed in 1954 by Leo Fender, with engineering assistance from George Fullerton. Fender, a musician and tinkerer, had already pioneered the development of the solid-body electric guitar with his commercially successful Telecaster from 1950. The Stratocaster diverged from the form of its predecessors in its bold profile, which heralded the electric guitar as a wholly new type of instrument. Its space-age form, designed by Fender draftsman Freddie Tavares and unchanged after sixty years of production, was ergonomically sculpted to meld with the player's body. The guitar also boasted a recessed jack to keep amplifier cables out of the way, volume and tone knobs positioned for easy adjustment while playing, and deeper double cutouts for better neck access. Its technical features included three pickups for a bright, glassy sound and a Fender-patented, built-in tremolo arm ("whammy bar"). While originally marketed to country musicians, the Stratocaster's distinct sound and player-friendly design quickly found favor with pop and rock musicians. The model set a new standard for electric-guitar design and performance, and eventually it came to dominate the market.

Before MoMA acquired the Stratocaster in 2014, instruments in the Museum's collection skewed toward the high tech: a digital MIDI-controlled flute; an electric violin; and the Tenori-on, a handheld electronic instrument with a visual interface. These objects suggested the myriad ways design and technology had pushed the musical envelope, but none is an archetype of design in its own right. It was in preparation for a 2015 music-related exhibition of the design collection that prompted the Museum's search for a Stratocaster. The curators sought a vintage model from the golden era of production, at the optimal and most influential state of its design. As the guitar was destined for museum display as an exemplar of its form, it needed to be in excellent cosmetic condition. Finding an instrument with all its original components also posed a challenge, as the modular electronics and bolt-on construction of the Stratocaster made it ripe for custom modification. The Museum located an all-original 1957 Stratocaster, miraculously in near-perfect condition after fifty-eight years. What's more, 1957 was a significant year for the Stratocaster, and for rock and roll: Buddy Holly appeared on television performing his hits "That'll Be the Day" and "Peggy Sue" with his '57 Strat, canonizing this rollicking new genre and introducing its flagship instrument to a national audience.

Once acquired, the Stratocaster was immediately put on display in the exhibition *Making Music Modern: Design for Ear and Eye*. Because the instrument's good design was also due to its supreme playability and unique sound, it was important that visitors be able to experience the object in action: during the course of the show, MoMA staff was invited to demonstrate the Stratocaster by playing the guitar live in the galleries, plugged into its companion 1959 Fender Bassman amplifier. —Luke Baker

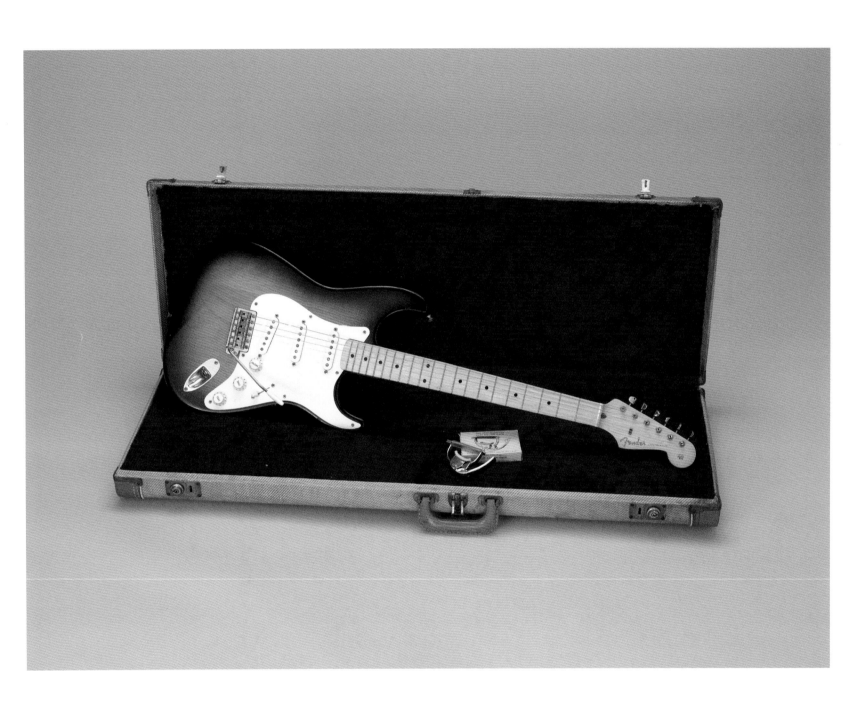

LaToya Ruby Frazier (American, born 1982)

a. **Mom and Me in the Phase**. 2007
Gelatin silver print, 18 ⅜ x 23 ⁵⁄₁₆ in. (46.7 x 59.2 cm)

b. **Grandma Ruby and Me**. 2005
Gelatin silver print, 18 ⅜ x 23 ⁵⁄₁₆ in. (46.7 x 59.2 cm)

The Photography Council Fund, 2015

c. **Fifth Street Tavern and U.P.M.C.
Braddock Hospital on Braddock Avenue**. 2011
Gelatin silver print, 17 ½ x 23 ⁵⁄₁₆ in. (44.5 x 59.2 cm)
Acquired through the generosity of Bernard I. Lumpkin and
Carmine D. Bocuzzi in honor of Cerrie Bamford and the
Friends of Education of The Museum of Modern Art, 2015

A self-proclaimed conceptual documentary artist, LaToya Ruby Frazier was a teenager when she started photographing her family in her hometown of Braddock, Pennsylvania, a once-thriving steel-mill town where poverty, drug use, and health problems related to industrial pollution have crippled the community in recent decades.[1] As an artist and activist, Frazier is committed to making visible the lives of underrepresented individuals and highlighting the devastating impact of the decline of industrial American manufacturing.

In her acclaimed photographic series *The Notion of Family*, initiated in 2001, Frazier follows the rich tradition of American social documentary photographers, turning the camera upon herself and her family to document from within while weaving this personal narrative into the larger history of Braddock. She began taking these photographs by asking herself: If Florence Owens Thompson—the woman in Dorothea Lange's iconic *Migrant Mother* (1936)—made portraits of herself and her family's condition, what would they look like?[2] The resulting images comprise an unabashed photo album of a working-class African American family, a body of work for which Frazier credits the women who raised her, her mother and grandmother, as collaborators.

In the double portrait *Mom and Me in the Phase*, the artist's mother sits on a barstool intensely confronting her daughter's gaze, whose reflection is visible in the mirror. Frazier has dryly captioned the image: "We are not in Manet's A Bar at the Folies Bergère," nodding to both women's place in society and the artist's own relationship to art history. In *Grandma Ruby and Me*, the artist sits with her Grandma Ruby on the floor in front of a television, both women turned to face the camera and surrounded by a doll collection belonging to the grandmother. Frazier's hair is braided in a childlike manner and her athletic shorts reveal traces of a school sports uniform, further signaling the artist's own coming-of-age and the tensions inherent therein. *Fifth Street Tavern and U.P.M.C Braddock Hospital on Braddock Avenue* depicts the remnants of what was the town's only hospital, demolished after a controversial decision and leaving residents, including the artist and her family, without a local hospital.

In 2015, MoMA acquired a diverse group of six works from Frazier's *Notion of Family* series that portray the various characters and storylines of this multifaceted body of work but that also each stand alone as powerful individual images. Five of the works were acquired through the generosity of the Photography Council, an association of collectors and others seriously interested in the medium that supports the acquisition of photographs for the collection. The sixth image, *Fifth Street Tavern*, was offered to the Museum as a gift from collectors Bernard I. Lumpkin and Carmine D. Bocuzzi, strong advocates for diversity in museums. The work was given in honor of MoMA's Friends of Education affiliate group, as well as the group's coordinator, Cerrie Bamford, whose mission is to foster greater representation of the work African American artists. —Katerina Stathopoulou

1. Drew Sawyer, "Documentary Practices: Quentin Bajac & LaToya Ruby Frazier," *Document* 8 (May 25, 2016): http://www.documentjournal.com/article/documentary-practices.
2. LaToya Ruby Frazier and Dawoud Bey, "A Conversation," in *The Notion of Family* (New York: Aperture, 2014), 149–53.

a.

b.

c.

Kerry James Marshall (American, born 1955)

Untitled (Club Scene). 2013
Synthetic polymer paint and glitter on unstretched canvas,
9 ft. 15⁄16 in. x 18 ft. (302.3 x 548.6 cm)
Gift of Mr. and Mrs. Martin Segal in honor of Agnes Gund, 2015

In *Untitled (Club Scene)*, Kerry James Marshall presents a view into a dark gathering place, a space intended to hold performances yet, despite the prominent diagonal glare of three spotlights, absent any actual entertainers onstage. At the painting's periphery, two figures stand backlit in a doorway beneath an exit sign, while throughout the composition, empty chairs surround tables topped with balloons, hats, and other party favors, all seemingly bereft of their revelers. A few blue-black bodies move throughout the nearly vacant scene, whether in anticipation of the event or lingering afterward. Discussing this painting, Marshall has explained: "If you think about the presence of black people in the world, the dominant presence is in the world of entertainment. They are great athletes, great singers, or great dancers. Most people encounter black people in those domains, in the sports world or the musical entertainment world; there is a tendency to always represent those figures in the act of performing. I decide to avoid the obvious—the performance—but to create a space in which the idea of, or the history of, performance is embedded within the space of performance."[1]

Through a series of commemorative banners hanging above the stage, Marshall suggests black creativity as the historical wellspring for the musical genres of jazz, soul, gospel, rap, the blues, and ska. If the viewer experiences any semblance of a performance spectacle, it is in the shimmering, glitter-accentuated surface of this sprawling unstretched canvas. "I am trying to establish a phenomenal presence that is unequivocally black and beautiful," Marshall has written of his life's work as a painter, which has garnered him widespread recognition for his large-scale history paintings that insert black figures into the European master tradition.[2] *Untitled (Club Scene)* is one of many works by the artist that open up the history of Western art to quotidian scenes of black life.

Marshall's work initially entered the MoMA collection in 2000, by way of the Department of Drawings and Prints, with *Rythm Mastr* (1999–2000), a comic series featuring African sculptures turned superheroes. *Untitled (Club Scene)* was the first painting of Marshall's to enter the collection, selected by curators in continuance of the Museum's broader goal of enhancing its holdings of artists who, like Marshall, had emerged in the 1980s and '90s. The painting was acquired in May 2015 as a gift of Martin and Edith Segal in honor of Agnes Gund, president emerita of the Museum and longtime patron and champion of artists of color. —Jessica Bell Brown

1. "Kerryjamesmarshall Clubhouse," video interview with Kerry James Marshall, M HKA Museum of Contemporary Art, October 3, 2013, https://www.youtube.com /watch?v=nnTbmdwgMcE.
2. Kerry James Marshall, "Shall I Compare Thee . . . ?" in *Kerry James Marshall: Mastry*, ed. Kerry James Marshall, Helen Molesworth, et al. (Chicago: Museum of Contemporary Art, Chicago, 2016), 79.

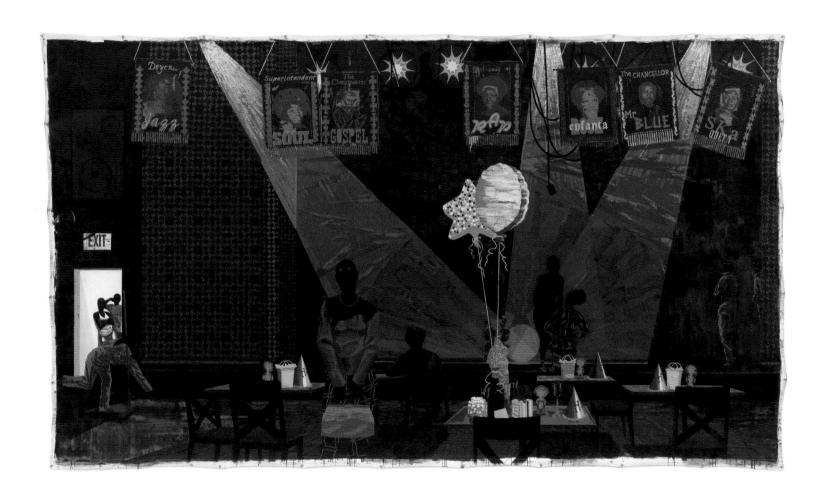

Edward Krasiński (Polish, 1925–2004)

Miroir. 1972
Mirror, synthetic polymer paint, wood, fiberboard, steel, and tape,
21¾ x 34⅜ x 1⁹⁄₁₆ in. (55.2 x 87.3 x 4 cm)
Promised gift of James Keith Brown and Eric Diefenbach, 2015

Intervention with a Phone. 1972
Telephone, synthetic polymer paint, wood, fiberboard, steel,
and tape, 29½ x 21⅜ x 11 in. (74.9 x 54.3 x 28.1 cm)

Permis de la fille. 1972
Pencil, synthetic polymer paint, wood, fiberboard, steel,
and tape, 29⅝ x 21¾ x 1½ in. (75.2 x 55.2 x 3.8 cm)

Beton gris. 1972
Concrete, wood, fiberboard, steel, and tape,
29½ x 21⁷⁄₁₆ x 1⁹⁄₁₆ in. (74.9 x 54.5 x 4 cm)

Committee on Painting and Sculpture Funds, 2015

A chief protagonist in the history of Central European art in the postwar era, Edward Krasiński synthesized abstraction, performance, and Conceptual art in an idiosyncratic practice that remains highly influential today. During the period immediately following World War II, Krasiński studied painting at the Academy of Fine Arts in Krakow. He moved to Warsaw in 1954 and, there, confronted the legacy of Polish Constructivism, particularly through the examples of Władysław Strzemiński and Katarzyna Kobro, participants in the first wave of the 1920s Polish avant-garde. Krasiński was intrigued by the theoretical underpinnings of Strzemiński's and Kobro's geometric abstraction, especially their contention that sculpture has no natural borders and thus connects to infinite space. Krasiński followed this line of inquiry throughout his career.

In the late 1960s, after several years spent making sculptures in the shape of arrows and spears that hung in the air in single, seemingly weightless lines, Krasiński came across a standard roll of blue tape. He stuck the tape to a variety of surfaces, including the walls of the buildings in which he lived and even onto his friends and family. The blue tape, hung at a consistent height of 130 centimeters from the floor, transformed the world around him into art. "It was an evolutionary process," Krasiński later explained. "I framed parts of reality . . . and made a picture out of it. These pieces of wall were for sale. They became paintings."[1] The group of nine works acquired by MoMA in 2015 articulates this logic. Each represents either a room in an apartment or the world beyond. The line of blue tape enters each picture and continues onto the wall, connecting the works in a progression from interior to exterior, or vice versa. The panels featuring wallpaper, a mirror, bathroom tiles, a child's drawing, and a telephone conjure the domestic space of communist-era housing *bloks*. A single panel covered in a thin layer of concrete signals the exterior shell of the ubiquitous buildings, while the tram number and the map of Warsaw attached to two separate additional panels evoke the larger urban landscape. This group is among the earliest examples of what would evolve into a lifelong project of "Interventions," as the artist would later call his endeavors.

Seven of the nine panels MoMA acquired in 2015 were purchased from the Starmach Gallery in Krakow; *Miroir* and *No. 124* had been sold by the gallery to private collections. *Miroir* is now a promised gift of James Keith Brown and Eric Diefenbach to the Museum, and *No. 124* entered the collection as a gift of the Grażyna Kulczyk Collection. When these works were acquired, they joined three early sculptures by the artist already in the collection. Very few of Krasiński's foundational works remain extant; the acquisition of this group enabled MoMA to become a unique resource for access in the United States to Krasiński's work. —Paulina Pobocha

1. Edward Krasiński, quoted in "Drôle d'interview: Edward Krasiński in conversation with Eulalia Domanowska, Stanisław Cichowicz, and Andrzej Mitan," in *Edward Krasiński: Les mises en scène* (Vienna: Generali Foundation, 2006), 33.

Gilbert Baker (American, 1951–2017)

Rainbow Flag. 1978
Nylon, 60 x 36 in. (152.4 x 91.4 cm)
Gift of the designer, 2015

The *Rainbow Flag*—also known as the LGBT flag—is a symbol of pride and activism for the lesbian, gay, bisexual, and transgender community. The original flag was first unfurled on June 25, 1978, at the San Francisco Gay and Lesbian Freedom Day Parade. The design was conceived by Gilbert Baker, and in the days prior to the event, he led thirty volunteers in hand-dying and stitching two large flags at the city's Gay Community Center. As Baker would recall in an interview at MoMA in 2016: "[W]e had huge trashcans full of water and mixed natural dye with salt and used thousands of yards of cotton. . . . I wanted to make [the flag] at the center, with my friends—it needed to have a real connection to nature and community."[1] During the parade, the flags were hung in United Nations Plaza to highlight the global struggle for LGBT civil rights.

Baker admired the universality of the rainbow as a "natural flag . . . from the sky."[2] The proliferation of American flags during the recent U.S. Bicentennial celebrations of 1976 had also served as inspiration, reiterating the potential of flags as powerful symbols of unity, commemoration, and festivity. Since its inception, the *Rainbow Flag* has undergone numerous revisions; all variations maintain the rainbow scheme. Today the flag is most widely seen with six colored stripes, each imbued with meaning: red for life, orange for healing, yellow for sunlight, green for nature, blue for serenity, and violet for spirit.

A gift of the designer, MoMA's acquisition of a contemporary, mass-produced version of the flag in celebration of its accessibility and worldwide adoption occurred following months of careful research and preparation, yet the acquisition's timing in mid-June 2015 could not have been more serendipitous: on the same day that the U.S. Supreme Court handed down its historic decision that legalized same-sex marriage across the country—and thirty-eight years to the day after the flag's San Francisco debut—the *Rainbow Flag* was raised at MoMA as part of the design collection exhibition *This Is for Everyone: Design Experiments for the Common Good*. As a Museum preparator finished installing the flag on a pole overlooking the sculpture garden, an impromptu crowd of visitors and staff gathered to watch and burst into spontaneous applause when the rainbow finally unfurled. Later that month, Baker reflected: "I can go to another country, and if I see a rainbow flag, I feel like that's someone who is a kindred spirit. . . . It's sort of a language, and it's also proclaiming power. . . . I hoped it would be a great symbol, but it has transcended all of that. . . . Now it's made all over the world. The beauty of it is the way that it has connected us."[3] —Michelle Millar Fisher

1. Gilbert Baker, quoted in Michelle Millar Fisher, "MoMA Acquires the Rainbow Flag," Inside/Out [MoMA] blog post, June 17, 2016: https://www.moma.org/explore/inside_out/2015/06/17/moma-acquires-the-rainbow-flag/
2. Ibid.
3. Ibid.

United Nations Headquarters Board of Design
Wallace K. Harrison (American, 1895–1981)
Max Abramovitz (American, 1908–2004)
Oscar Niemeyer (Brazilian, 1907–2012)
Le Corbusier (Charles-Édouard Jeanneret) (French, born Switzerland, 1887–1965)

Facade from the United Nations Secretariat Building, New York, NY. 1952
Aluminum and glass, each panel approximately
12 ft. 1 in. x 48 in. x 8 in. (368.3 x 121.9 x 20.3 cm)
Gift of the United Nations, 2015
Restoration by Heintges & Associates, New York
Conservation was made possible by the Fondation Louis Vuitton, Paris

Prominently situated along the East River, the monolithic United Nations Secretariat Building is among the most visible and important skyscrapers in Manhattan, and was the first International Style building to be constructed in New York. Nelson Rockefeller purchased the site in 1946, a year after the United Nations officially formed, and donated the land to build a permanent headquarters for the new organization; a contentious design process involving architects from around the world soon began. The U.N. Board of Design eventually settled on a striking modernist proposal designed jointly by Oscar Niemeyer and Le Corbusier that featured four buildings: an assembly hall, library, conference building, and office tower, the form of each dictated by its specific function. The thirty-nine-story Secretariat was built to efficiently house the bureaucracy of this fledgling international organization. The lack of setbacks, which were a ubiquitous feature of New York skyscrapers at the time, gave the tower a dramatic geometry that stood in stark contrast to the rest of midtown Manhattan. Enormous vertical planes of white marble on the windowless north and south facades contrast with blue-green glass on the east and west facades, further accentuating the jewel-like quality of the design. The Secretariat was the first large building to employ a unitized glass curtain wall, a long-theorized system in which the facade, freed of all structural restraints, wraps around the tower's concrete-and-steel core like a curtain. One of the great achievements in midcentury architecture, the U.N. Secretariat heralded a new era in urban office tower construction.

As was the case with many modernist structures that pioneered new construction techniques, the buildings of the U.N. complex began to show signs of major structural wear and damage within a few decades. In 2008, the United Nations embarked on a major reconstruction and rehabilitation effort. Among the many tasks for this project was the complete replacement of the curtain wall for the Secretariat, which was deemed beyond repair. The entire curtain wall was removed, and components in good condition were salvaged for potential reuse. A section of the original dismounted facade was gifted to MoMA in 2015.

The installation of the Secretariat curtain wall as part of the current exhibition at Fondation Louis Vuitton is the first display of these fragments since they were acquired by the Museum. This installation allows visitors an unprecedented chance to experience up close the subtle material qualities of this modernist landmark—qualities such as transparency and reflection that are observable precisely because the fragments are removed from their built context. As both a physical record of a structure and a fascinating sculptural form in its own right, the Secretariat fragments stand as a powerful symbol for the synthesis of art, architecture, and engineering. —Paul Galloway

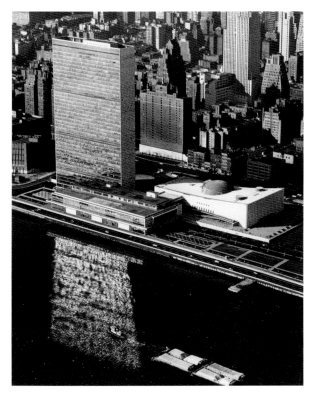

Mark Bradford (American, born 1961)

Let's Walk to the Middle of the Ocean. 2015
Paper, acrylic paint, and acrylic varnish on canvas,
8 ft. 5 in. x 12 ft. (259.1 x 365.8 cm)
Anonymous gift, 2016

Mark Bradford describes his art as "social abstraction": the work's concerns and the artist's choice of materials have always been inspired by life outside his studio.[1] While Bradford was working as a stylist at his mother's hair salon in South Central Los Angeles in the late 1990s, he noticed the color and reflective qualities of end papers—thin, translucent strips of paper made for hairdressers to wrap curls. He took these back to his studio and began incorporating them into his art. From this initial inspiration, Bradford developed his distinctive technique of painting. He begins by layering assorted papers (billboard paper and carbon paper, for example), fixing each layer to the canvas with shellac and paint and building their surfaces by embedding additional materials between the layers, such as string. He then rips, gouges, and sands the work's surface to create dynamic compositions that seem to pulse within their frames. Bradford continues to be devoted to repurposing non-art materials, frequently shopping at the home-improvement chain store Home Depot to stock his studio.

The visual impact of Bradford's multilayered process is evident in *Let's Walk to the Middle of the Ocean*, which MoMA acquired through an anonymous gift shortly after the work's debut in fall 2015 as part of the artist's exhibition *Be Strong Boquan* at Hauser & Wirth gallery in New York. As this painting also demonstrates, it is not only the physical stuff of the everyday world that comprises Bradford's art but also contemporary politics. Whereas Bradford's early work engages socioeconomic issues of race in urban life, *Let's Walk to the Middle of the Ocean* alludes to the emergence of the AIDS epidemic in the 1980s, which shaped the artist's young adulthood as a gay man who was part of the nightclub community in Los Angeles. "It's my using a particular moment and abstracting it," Bradford has said of this painting and the related body of work that explores this history.[2] Between sweeping gestures and swaths of color, the imagery in *Let's Walk to the Middle of the Ocean* summons bodily associations such as veins, cells, molecules, clots, and lesions. When this work debuted at Hauser & Wirth, it was installed in proximity to *Deimos* (2015), Bradford's video installation evoking the disco scene of the 1970s and early '80s, setting a wider cultural frame for the issues that this painting and the artist's related works address.

A native and lifelong resident of Los Angeles, Bradford cofounded Art + Practice in 2014, an arts and education foundation in South Los Angeles that provides support services for foster youth. Art + Practice can be understood as an extension of the political commitments that drive Bradford's artwork. For the innovative ways he has integrated the traditions of abstract painting with contemporary American sociopolitical issues throughout his career, Bradford represented the United States in the 57th Venice Biennale in 2017. —Emily Liebert

1. Mark Bradford, quoted in Calvin Tomkins, "What Else Can Art Do?," *The New Yorker*, June 22, 2015, 28.
2. Ibid.

Iman Issa (Egyptian, born 1979)

Heritage Studies #5. 2015
Aluminum and vinyl text,
overall: 17 ⁵⁄₁₆ in. x 7 ft. 6 ³⁄₁₆ in. x 17 ⁵⁄₁₆ in. (44 x 229 x 44 cm)
Fund for the Twenty-First Century, 2016

The work of Iman Issa is predicated on combining discrete elements from different mediums, such as sculpture, photography, text, and sound. Through her work and the interaction between its various parts, which seemingly fail to cohere, Issa explores the slippages that exist between official historical narratives and lived experience. Taking as a point of departure specific cultural markers that span architecture, public monuments, historical artifacts, and literary sources, she charges these references with a sense of ambiguity. The objects she presents, often on white plinths, tend to be abstract and unadorned, while the accompanying texts that might ostensibly be expected to elucidate the works instead only serve to obfuscate their meaning.

In her body of work *Heritage Studies* of 2015, Issa directly engages with the language of museum holdings and display. Each of the sixteen sculptures that comprise the series is precisely crafted by specialized fabricators in the vein of Minimalist sculpture. A wall label provides what at first glance appears to be typical information about the work, including title, medium, year, and inventory number. Yet it quickly becomes apparent that the information on the label does not reference the artwork on display but instead belongs to a different object entirely, one not seen. Seemingly alluding to the source of inspiration for the sculpture on view, each label specifically conjures an ancient relic that has been uprooted and preserved. Through Issa's reinterpretation, these artifacts undergo a material and formal transformation that leaves them further abstracted, suggesting both the reverberations of displacement and the fluidity of memory, a fact that Issa highlights in her choice of title. "Unlike history, whose study might appear self-evidently constructive, heritage studies seemed to be framed with a practical relevance to the present," she has explained.[1]

Heritage Studies #5 consists of a cylindrical aluminum cast that is placed directly on the floor and tapers into a nose cone on both ends: one end smooth, resembling a missile head or bullet; the other end scalloped, evoking an adornment motif prevalent in Islamic architecture. Keeping with Issa's practice for this series, the accompanying label describes an artifact severed from a thirteenth-century stone minaret overlooking the sea. The label further lists the generic-sounding "International Museum of Ancient Arts and Culture" as the object's holding institution, while declining to give a precise geographic location for the fictive museum. Through the layered evocation of cultural patrimony, wartime weaponry, and religious worship, Issa repositions the ancient monument as a contemporary creation that resonates deeply with our time.

Heritage Studies #5 is one of three works from the series acquired by MoMA a year after their creation. Its acquisition was facilitated by the Fund for the Twenty-First Century, a purchase fund dedicated to acquiring works made in the last five years by artists not yet represented in the Museum collection. —Tamar Margalit

1. Iman Issa, quoted in Lauren O'Neill-Butler, "500 Words: Iman Issa," *Artforum.com*, March 4, 2015: https://www.artforum.com /words/id=50485.

Ian Cheng (American, born 1984)

Emissary in the Squat of Gods. 2015
Simulation (color, sound), infinite duration
Fund for the Twenty-First Century, 2016

Since 2013, Ian Cheng has used video-game engines to develop computer-generated animations that move beyond the conventional narrative and temporal structures of cinema, effectively producing live, virtual ecosystems that unfold in real time. These works draw on predictive simulations that are used, for instance, to forecast consumer behavior, test possible electoral outcomes, or simulate the effects of weather patterns on new aerospace designs. Eschewing the fidelity to photorealistic imagery often prioritized in digital image production, Cheng's simulations are digital sketches that map behavioral movements, suggesting the possibilities of characters and communities in formation, rather than fixed scenarios. Film and video in the context of art galleries and museums have largely been defined by the loop, enabling each work to cycle recorded images repeatedly, but in Cheng's simulations, there is no scheduled conclusion; rather, the system continues to change irreversibly as it gradually generates, regenerates, and erodes. The work can never be witnessed in its entirety.

Cheng's authorship lies partly in setting the parameters for these emergent digital biospheres. Although he instigates open-ended systems for which he cannot control the outcome, conversely he also introduces narrative agents within these systems; the intersection of the two forms threaten to destabilize one another, provoking new behavioral patterns and forming habitats for narratives to unfold according to their own rules.

Emissary in the Squat of Gods forms the first chapter of a trilogy of works that seeks to comprehend human cognitive evolution and the ecological and social conditions through which it has been formed. Each episode features an "emissary" who is forced to negotiate rapidly shifting circumstances as the realities of the past quickly give way to emerging possibilities. Set in a distant past, the situation first plays out within an ancient community of humans living within the ecologically fertile conditions of a volcanic crater. The second chapter, *Emissary Forks at Perfection* (2015–16), and third chapter, *Emissary Sunsets the Self* (2017), are each set several millennia into a post-human future, charting the evolution of the initial crater first into a lake—a Darwinian laboratory managed by artificial intelligence—and then subsequently into an atoll, navigated by a new sentient substance evolved from the AI, which seeks to impart its agency to a radical successor.

The *Emissary* trilogy marks Cheng's most ambitious project to date. MoMA's acquisition of the trilogy in 2016 builds upon the Museum's decades-long commitment to artists working with the latest moving-image technologies. Highlighting the nimble and responsive approach to contemporary art offered by the Museum's merger with P.S.1 Contemporary Art Center in 2000 (p. 192), the trilogy premiered at MoMA PS1 in April 2017, the artist's first solo museum exhibition in the United States and a presentation that occurred within months of the trilogy's completion. In addition to exhibiting the *Emissary* trilogy in the galleries at MoMA PS1, an online platform featuring the three works was hosted on the streaming site Twitch.tv during the run of the show, returning the trilogy to its roots in the digital sphere. —Stuart Comer

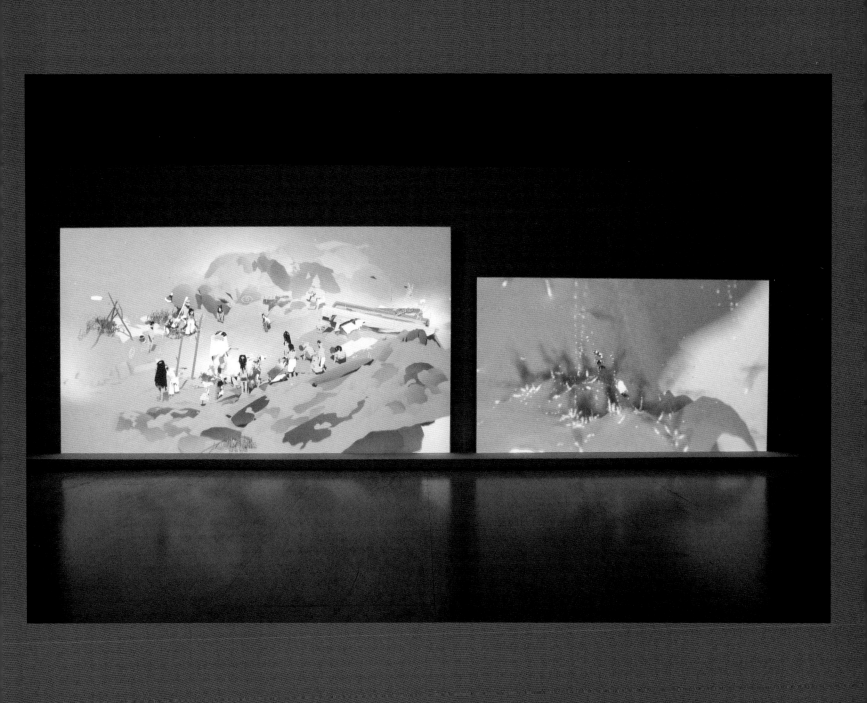

Lele Saveri (Italian, born 1980)

The Newsstand. 2013–14
Produced in collaboration with Alldayeveryday
Mixed-medium installation, dimensions variable
Acquired with support from the Fund for the
Twenty-First Century and gift of the artist, 2016

From June 2013 to the following January, *The Newsstand* was presented at the Lorimer Street/
Metropolitan Avenue subway station in Brooklyn, organized by Lele Saveri—photographer, curator,
cultural organizer, and founder of the independent publisher 8 Ball Zines—and produced in collabo-
ration with the creative agency Alldayeveryday. Given its setup in a standard retail stall like those that
exist across New York's transit system, a hurried glance might have suggested that this newsstand was
no different than any of the other hundreds in the city, but instead of selling tabloid newspapers and
magazines, bottled water, candy, and cigarettes, *The Newsstand* sold a variety of zines (self-published
books and magazines, often printed via a photocopier), records, and artworks, including hundreds of
individual photographs. Artists dropped off their work at the stand, where commuters could browse
and buy. Part pop-up store, part collaborative forum, *The Newsstand* was a place of distributive author-
ship, involving the community through art-making events, the trade and circulation of images, and dis-
cussion. As one reviewer noted, "In a digitalized world, it is a small haven for printed media."[1]

A year after it closed, *The Newsstand* was restaged at MoMA as part of *Ocean of Images: New
Photography 2015*, one in a series of exhibitions devoted to contemporary photography. The physical
reconstruction of the stand was faithful to the original, including a subway-tiled exterior and display
shelves built to mimic those used in Brooklyn, among many other details. Saveri had kept one copy
of each of the zines, photographs, and other items that were included in the original presentation,
and these were displayed at the Museum. At set times during the exhibition, volunteer clerks, many
of whom had also participated in Brooklyn, were present to assist visitors in perusing the contents
of the stand, as passersby had done in the subway station, even as the objects were no longer for
sale. *The Newsstand* at MoMA also periodically hosted one-day events, including zine launches, per-
formances (in which the Museum audience was invited to participate), and a display of Saveri's own
Commuters series of photographs, more than six hundred portraits of passersby made during *The
Newsstand*'s tenure in Brooklyn.

Thanks to the support of the Museum's Fund for the Twenty-First Century and Saveri's gift of
his own collection of more than six hundred zines, *The Newsstand* entered MoMA's collection just a few
weeks after the exhibition closed. As an installation and as a complete archive of all the items presented
at MoMA, it is an extraordinary representation of New York zine culture at the beginning of the twenty-
first century. —Lucy Gallun

1. Erika Allen, "No Porn, Just Books and Zines,"
The New York Times, July 2, 2013.

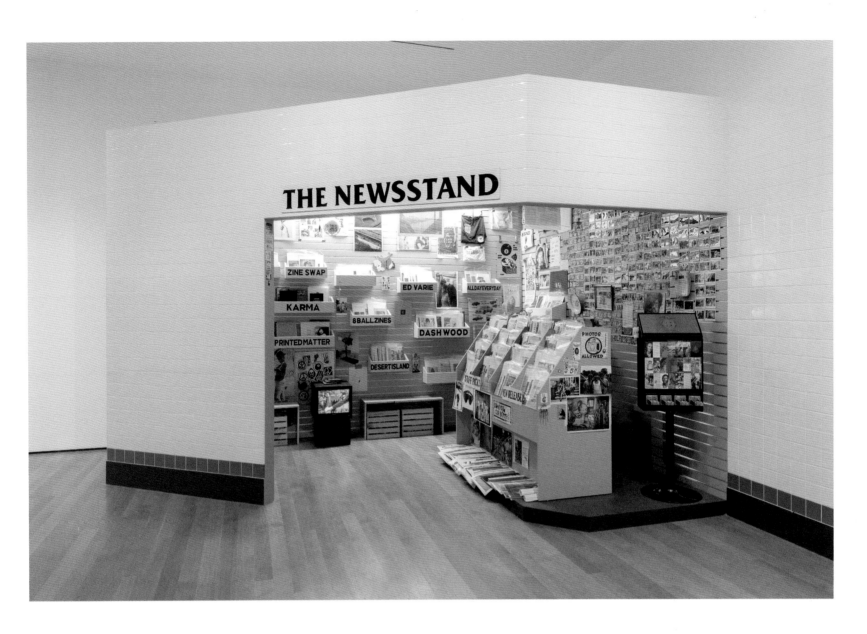

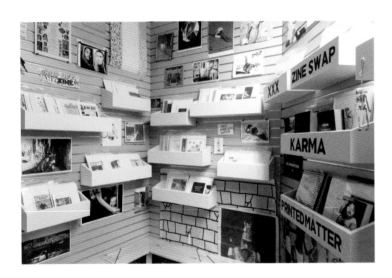

Park McArthur (American, born 1984)

Posey Restraint. 2014
Posey restraint net, 48 x 35¼ in. (121.9 x 89.5 cm)
Fund for the Twenty First Century, 2016

In the sculptures and installations she has made since beginning her career in the early 2010s, Park McArthur has activated and reimagined found objects through deliberate architectural interventions that address the viewer's bodily experience. *Posey Restraint* consists primarily of a nylon-mesh net manufactured by the Posey medical supply company that is used to restrain patients in hospital beds. "I don't know that I make work 'about the conditions' of a specific place or organization," the artist has said. "But I do make work *with* the conditions, or *through* the conditions present."[1] In the case of this work, McArthur asks in part, "Why and in what circumstances do institutions resort to restraint?"[2]

McArthur first exhibited *Posey Restraint* in her 2014 solo exhibition at Yale Union, an industrial building converted into an artist-run space in Portland, Oregon, where she hung the work from the skylight of one of the building's bathrooms. The following year, *Posey Restraint* was one of two works by McArthur included in the fourth iteration of MoMA PS1's *Greater New York*, a quinquennial exhibition of works by emerging artists who live and work in the New York metropolitan area. At MoMA PS1, a former public school building, *Posey Restraint* was hung in the doorway between two galleries so that viewers encountered the work as a barrier that hindered their passage. In this context, McArthur not only transforms the restraint itself from utilitarian device to art object but also its implied restriction, from being imposed on a singular reclining body to being redirected to the upright, mobile bodies of many.

As with a significant number of McArthur's works, *Posey Restraint* engages questions surrounding the politics of accessibility: What happens when a normative idea of the body and how it operates is challenged by bodies with differing needs? What does it mean to live in a society that often doesn't account for these conditions? When encountering *Posey Restraint* as an obstacle, visitors are invited to confront forms of structural discrimination against those with disabilities, a topic rarely addressed in the space of art museums. McArthur's engagement with these issues and her inquiry into medical materials and discourse are informed by her firsthand experience of living with muscular dystrophy from a young age and navigating life from a wheelchair. Acquired through the support of the Fund for the Twenty-First Century just months after the closing of *Greater New York* in March 2016, McArthur's work joins the Museum's deep holdings in the traditions of both Marcel Duchamp's readymades (p. 129) and Minimalism, further expanding the investigations posed by these sculptural legacies. —Jenny Harris

1. Park McArthur, quoted in Daniel S. Palmer, "Against Accommodation," *Mousse* 47 (February 2015): 174.
2. Park McArthur, email correspondence with MoMA, July 25, 2017.

Aslı Çavuşoğlu (Turkish, born 1982)

a. **Red / Red (Untitled) Diptych 1**. 2015
 Armenian cochineal ink and Turkish red on two pieces
 of painted paper, each sheet: 39 x 27⅜ in. (99.1 x 69.5 cm)

b. **Red / Red (Untitled) Diptych 2**. 2015
 Armenian cochineal ink and Turkish red on two pieces
 of painted paper, each sheet: 39 x 27⅜ in. (99.1 x 69.5 cm)

Fund for the Twenty-First Century, 2016

Turkish artist Aslı Çavuşoğlu's series *Red / Red* consists of drawings made in books and on artificially aged sheets of large drawing paper, four of which were acquired by MoMA in 2016, following their exhibition the previous year in the Istanbul Biennial. The title describes both the subject and the material of the works, and the investigation into which it leads is no less charged, both geopolitically and historically, for the disarming subtlety and quiet beauty of the artist's renderings of flowers and carpets. One red in the title is Armenian red, derived from *Porphyrophora hamelii*, an insect commonly known as the Armenian cochineal that lives in the roots of the plant *Aeluropus littoralis* on the banks of the Aras River, which marks the natural border between Turkey and Armenia. The other red is the brighter, stronger red of the Turkish flag, a Turkish red, which has traditionally been derived from plants in the genus *Rubia* through a laborious process and was one of the first synthetic dyes to be developed in the late nineteenth century.

It is through her use of these two pigments that Çavuşoğlu probes the violent recent past of both countries, to graceful yet devastating effect. The carminic acid found in the Armenian cochineal enables the production of a special red that dates to the seventh century BCE, made mostly by Armenians for use in textiles, frescoes, and manuscripts. The industrialization in the 1970s of Armenia when it was a republic of the Soviet Union decimated the *Aeluropus littoralis* plant and the Armenian cochineal, and today both are categorized as endangered species. On the Turkish side, the plant and insect continue to thrive, but the historical knowledge of how to produce Armenian red has been gone since the early part of the twentieth century, as a result of the systematic extermination of Armenian citizens by the Ottoman Empire and its successor state, Turkey, between 1915 and 1923.

To extract the twelve grams of Armenian red pigment she uses to create her series, Çavuşoğlu worked with Armen Sahakyan, a phytotherapist and senior researcher at the Mesrop Mashtots Institute of Ancient Manuscripts in Yerevan, Armenia, who is probably the only person still able to extract this red based on recipes from fourteenth-century Armenian manuscripts. One gram was held in reserve to donate to the pigment library at Harvard University.

Çavuşoğlu's drawn motifs reflect a shared tradition in both countries of ornamental design, such as in carpets, and of the natural sources used to produce each color red. By using the lighter, fainter Armenian red to render elements that seem to fade and disappear and the bolder Turkish red as dominant visual blocks that seem to want to expand in the drawings' compositions, the artist finds a poetic visual correspondence between the colors and their respective countries' role in a shared, conflicted history. —Christian Rattemeyer

a.

b.

Shigetaka Kurita (Japanese, born 1972)
NTT DOCOMO, Inc., Tokyo (Japanese, established 1992)

Emoji. 1998–99
Digital image, dimensions variable
Gift of NTT DOCOMO, Inc., 2016

From its inception, the MoMA design collection has celebrated works that, at first glance, may seem astonishingly simple. Starting with the 1934 exhibition *Machine Art* (p. 60), in which industrial ball bearings and springs were shown on pedestals in the manner of sculpture, MoMA has placed the work of designers at the center of the modernist narrative. The rapidly changing state of technology is intricately intertwined with this story, and nowhere is this rapid change more apparent than in the field of design. Like the ball bearing and many of the other "humble masterpieces" in MoMA's collection, the original emoji embody the best qualities of design: simplicity, functionality, and beauty.

Designed by Shigetaka Kurita for Japanese telecommunications company NTT DOCOMO, the emoji were a clever solution to the vexing problem of how to create a visually engaging interface for what was the first mobile internet service on cellular telephones, DOCOMO's i-Mode software platform. Working within the limitations of both the software and hardware of the late 1990s, Kurita created his emoji on a small grid of 12 by 12 pixels. Drawing on sources as varied as manga, Zapf Dingbats, and commonly used emoticons, Kurita designed a set of 176 picture characters (*emoji* in Japanese) that included illustrations of weather phenomena, pictograms like the ♥, and a range of expressive faces. Released in 1999, DOCOMO's emoji were an instant success and were immediately copied by rival companies in Japan. Eleven years later, when a far larger set of emoji was released as part of Apple's update of iOS, its mobile operating system, their use exploded into a new form of global visual communication.

The acquisition of the DOCOMO emoji reflects MoMA's commitment to collecting the greatest achievements of design in the digital realm. Adding ephemeral, digital-born works to the collection of an art museum challenges long-established conventions around the concepts of ownership and exclusivity. The ability of design to enter our lives and to be used on a daily basis separates it from the rest of the fine arts, making it among the expressions of human creativity that affects us most powerfully, shaping both our behavior and how we communicate. Emoji, along with other works of interaction design such as apps and video games (p. 231), facilitate the use of the increasingly complex and ubiquitous technology that surrounds us today and lend distinctly human nuance to the otherwise cold, impersonal digital realm. Today's emoji (the current set numbers nearly 1,800) have evolved far beyond those Kurita created for DOCOMO. However, the DNA for the emoji we use today is clearly present in Kurita's humble, pixelated, seminal designs. —Paul Galloway

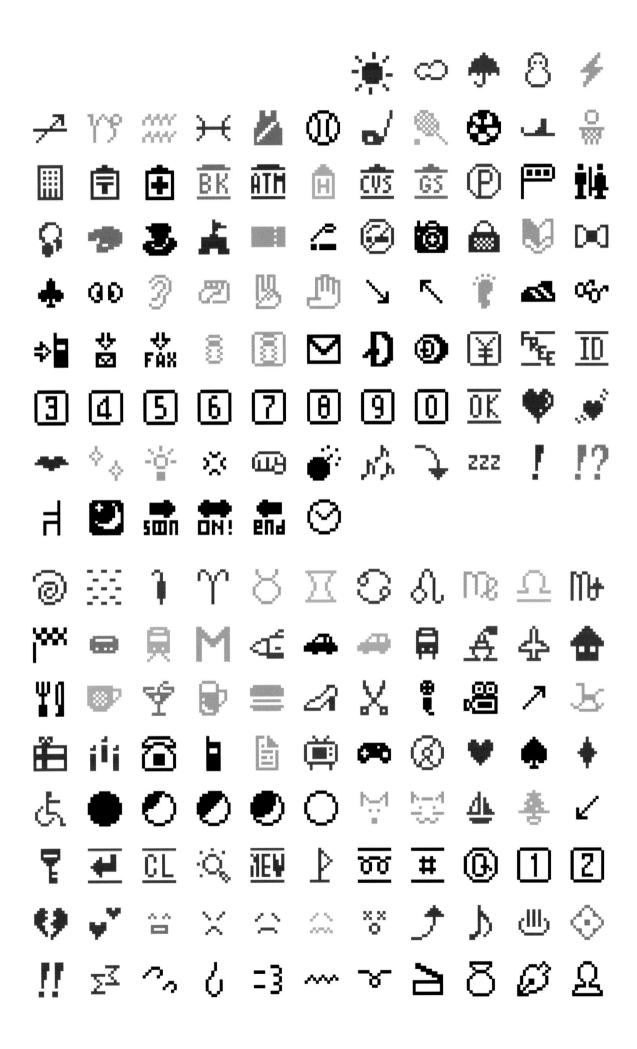

Cameron Rowland (American, born 1988)

Insurance. 2016
Container lashing bars and Lloyd's Register certificates,
overall: 8 ft. 6 in. x 8 ft. x 11½ in. (259.1 x 243.8 x 29.2 cm) or
4½ in. x 12 ft. 5 in. x 18 in. (11.4 x 378.5 x 45.7 cm)
Fund for the Twenty-First Century, 2016

Lloyd's of London monopolized the marine insurance of the slave trade by the early eighteenth century. Lloyd's Register was established in 1760 as the first classification society in order to provide insurance underwriters information on the quality of vessels. The classification of the ship allows for a more accurate assessment of its risk. Lloyd's Register and other classification societies continue to survey and certify shipping vessels and their equipment. Lashing equipment physically secures goods to the deck of the ship, while its certification is established to insure the value of the goods regardless of their potential loss.

Lygia Clark (Brazilian, 1920–1988)

Counter Relief no. 1. 1958
Synthetic polymer paint on wood,
55½ x 55½ x 1⁵⁄₁₆ in. (141 x 141 x 3.3 cm)
Promised gift of Patricia Phelps de Cisneros
through the Latin American and Caribbean Fund, 2016

By the time Lygia Clark added her signature to the Neo-Concrete manifesto, written in 1959 by the poet and art critic Ferreira Gullar, the thirty-eight-year-old artist had already come to terms with the idea that art—and painting, in particular—needed to be liberated from the constraints imposed by the tradition of representation. Looking to upend conventions, Clark did away with the metaphorical quality of pictorial space, first by abandoning figuration and then by obliterating the picture's frame. The issue of space was at the core of Clark's artistic concerns, and it was through the discovery of what she termed "organic line" that she systematized her approach to the subject.[1] These hinging lines that "function as doors, as connections among materials, as tissues, etc., in order to articulate an entire surface" allowed her to pursue a unique exploration of the pictorial space and its possibilities for expansion.[2]

Counter Relief no. 1 is the first in a series of works in which Clark utilized the organic line to transform the work's surface into a field of reliefs, suggesting an augmented relationship with the surrounding space. Devoid of a frame, the work is comprised of four superimposed plaques of wood in square or *V* shapes, alternately oriented and painted, respectively, white or black. Its planes appear physically distinct from one another and suggest ambiguous spaces, depending on the viewer's position. Observed from a certain vantage point, a separation between the wooden slabs creates an opening on the work's surface: a crack, a threshold, an organic line through which pictorial and exterior space converge. Classically Neo-Concrete in its assumption of a dynamic viewer, *Counter Relief no. 1* synthesizes the volumetric quality of a sculptural object and the mural restraint of traditional painting, a hybridity that inspired Gullar's category of the "non-object," spatial constructions that are "no longer a canvas but wood, [in which] the painter no longer uses oil paint but liquid industrial paint, and no longer uses a brush but spray pistol."[3] Gullar traced the genealogy of the non-object back to the Russian avant-garde, echoing Clark's own titling of her series *Counter Reliefs* after Vladimir Tatlin's experimental constructions from the 1910s.[4]

Clark has long been a focus of the acquisition strategies and exhibition programs at MoMA, where a large monographic retrospective, *Lygia Clark: The Abandonment of Art, 1948–1988*, was organized in 2014. Two years later, the Museum received a transformative gift of more than a hundred works of Latin American modern art, generously offered by trustee Patricia Phelps de Cisneros. The acquisition of this landmark gift, which included *Counter Relief no. 1* and four other works by Clark, not only strengthened the representation of Brazilian Neo-Concrete artists in the Museum's holdings but also reinforced MoMA's position as one of the world's leading repositories of Latin American art, a field to which the Museum has been committed since its earliest beginnings (p. 96).

—Karen Grimson

1. Lygia Clark, "Maquete para interior," *Diario de Minas* (Belo Horizonte), January 27, 1957; reprinted in English as "Lecture at the Escola Nacional de Arquitetura, Belo Horizonte, Fall 1956," in *Lygia Clark: The Abandonment of Art, 1948–1988* (New York: The Museum of Modern Art, 2014), 54.
2. Ibid.
3. Ferreira Gullar, "Lygia Clark's Trajectory," in *Lygia Clark* (Barcelona: Fundació Antoni Tàpies, 1998), 60.
4. Ferreira Gullar, "Teoria do não-objeto," *Jornal do Brasil* (Rio de Janeiro), December 19–20, 1959, Suplemento Dominical, 1.

David Hammons (American, born 1943)

African American Flag. 1990
Cotton canvas and grommets,
7 ft. 10½ in. x 59 in. (240 x 149.9 cm)
Promised gift to The Museum of Modern Art
and The Studio Museum in Harlem by the
Hudgins Family in memory of Jack Tilton, 2017

David Hammons is an elusive presence in the art world who has consciously steered away from its institutional conventions, yet he is nevertheless among the most influential artists working in the United States today. Since the late 1960s, his work has engaged with a vernacular that touches on African American identity, urban culture, and racial stereotyping through the use of evocative, often discarded materials (such as hair clippings, paper bags, grease, and basketballs) and the construction of pointed visual puns.

African American Flag is one of Hammons's most iconic works. A deft reflection on the turbulence that has long surrounded the issue of race in the United States, the banner conflates the schema of the American flag ("Old Glory") with the colors of the Pan-African flag, designed by Marcus Garvey in 1920 for the Universal Negro Improvement Association (U.N.I.A.). Through its material double entendre—literally denoting both an African *and* an American flag—Hammons's flag calls attention to the ways in which patriotism and black activism have historically been perceived by certain sectors in American society to lie in conflict. In merging the two icons, the work declares each cause to be congruent with the other.

Hammons has often submitted his artworks to new readings. He has deployed *African American Flag* both as a solitary icon—in various materials, meant for display indoors or out—and as a component of multipart installations. A different version of the banner, from an edition of five, was first shown in April 1990 as part of the group exhibition *Black U.S.A* at the Museum Overholland in Amsterdam, where it was mounted on a pole across the square from the American consulate that was flying its own flag. The flag shown here is part of an edition of ten slightly larger flags, each composed of individually sewn bands of color and stars. One of these appeared in the artist's solo exhibition in autumn 1990 at Jack Tilton Gallery in New York, *Who's Ice Is Colder*, an overarching installation that featured *African American Flag* alongside the flags of South Korea and Yemen, each suspended above an oil drum containing a block of ice that gradually melted, a sly send-up on the rivalries that existed among the three communities over the proprietorships of neighborhood corner stores and bodegas in New York.

In 1997, one of the five Amsterdam variants of *African American Flag* was gifted to MoMA by the Over Holland Foundation. The version here, from the Tilton edition, was initially acquired by the Hudgins family, longtime friends and supporters of the artist. In 2017, it was donated as a joint promised gift to MoMA and to the Studio Museum in Harlem in memory of Jack Tilton. At MoMA, it joins several other major works by Hammons gifted by the Hudgins family to the Museum. —Tamar Margalit

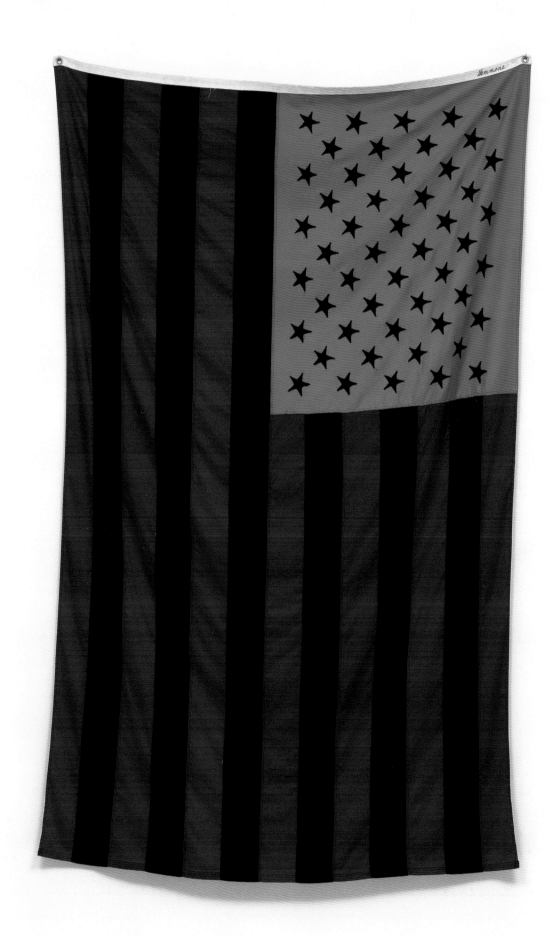

Becoming Modern: A Selected Chronology

Michelle Elligott

Fig. 1. Alfred H. Barr Jr., founding director of The Museum of Modern Art, 1929. Margaret Scolari Barr Papers, V.19. MoMA Archives, NY

Fig. 2. Installation view of *Machine Art*, The Museum of Modern Art, New York, March 5–April 29, 1934. Photographic Archive. MoMA Archives, NY

This chronology presents an overview of some of the many facets of MoMA's illustrious history. In addition to noting landmark and iconic exhibitions, an effort has been made to highlight the depth and diversity of the Museum's exhibition program, as well as other innovative efforts to promote and engage the public with the art of our time.

1929

The Museum of Modern Art opens in rented quarters in an office building at 730 Fifth Avenue, less than a year after three women—Lillie P. Bliss, Abby Aldrich Rockefeller, and Mary Quinn Sullivan—first began exploring their idea for an institution devoted to exhibiting and collecting modern art. Alfred H. Barr Jr. leads the Museum as its founding director (fig. 1); A. Conger Goodyear is appointed president. Josephine Boardman Crane, Frank Crowninshield, and Paul Sachs complete the board. The Museum is chartered as an educational institution "for the purpose of encouraging and developing the study of modern arts and the application of such arts to manufacture and practical life, and furnishing popular instruction . . ."

Cézanne, Gauguin, Seurat, van Gogh is the inaugural exhibition.

The first acquisition is a group of eight prints and a drawing, donated by Sachs.

1930

Edward Hopper's *House by the Railroad* (p. 47) is the first major painting acquired.

The Junior Advisory Committee is founded to engage young collectors in supporting the Museum.

1931

Bliss dies and bequeaths her collection to the Museum. While her bequest allows MoMA to deaccession some of the donated works over time, it also stipulates that the Museum raise a sufficient endowment to care for its own collection (p. 50).

Henri Matisse (p. 48) is the first solo exhibition.

1932

First architecture exhibition, *Modern Architecture: International Exhibition*, precedes the founding of the Department of Architecture, with Philip Johnson as chairman.

The Museum Library is created, with Iris Barry as librarian.

Seeking more space, the Museum moves to a five-story townhouse at 11 West 53rd Street, owned by John D. Rockefeller Jr. and Abby Aldrich Rockefeller.

American Folk Art: The Art of the Common Man in America, 1750–1900 is the first complete survey of American folk art of the eighteenth and nineteenth centuries in the United States.

1933

In a report to trustees, Barr creates his "'Torpedo' Diagram of Ideal Permanent Collection" (p. 15).

The Department of Circulating Exhibitions is founded, with Elodie Courter as director, to organize tours of MoMA exhibitions throughout the United States.

1934

Machine Art (fig. 2; pp. 60–63) is the first exhibition devoted to industrial design.

The Lillie P. Bliss Bequest is officially deeded to the Museum.

Housing Exhibition of the City of New York and its accompanying publication, *America Can't Have Housing*, advocates for modern, affordable housing solutions to replace tenement slums.

1935

The Film Library is established, with John E. Abbott as director and Iris Barry as curator. It will be renamed the Department of Film in 1966, and the Department of Film and Video in 1994.

African Negro Art exhibition highlights parallels in form, materials, and free expression between indigenous art of Africa and modern art.

1936

Barr organizes the landmark exhibition *Cubism and Abstract Art* (p. 75), followed nine months later by his equally influential survey, *Fantastic Art, Dada, Surrealism*.

1937

Photography 1839–1937 is the first survey exhibition of photography.

The Museum temporarily relocates to the Rockefeller Center concourse at 14 West 49th Street so that the townhouse it has occupied can be demolished in preparation for construction of a new flagship building designed by Philip L. Goodwin and Edward Durrell Stone (fig. 3).

Fig. 3. The staff of the Museum in front of the townhouse at 11 West 53rd Street before the move to temporary quarters, 1937. Photographic Archive. MoMA Archives, NY

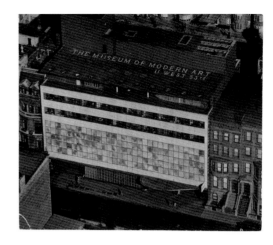

Fig. 4. Aerial view of the Museum's first permanent building, designed by Philip L. Goodwin and Edward Durell Stone, 1939. Photograph by Andreas Feininger. Photographic Archive. MoMA Archives, NY

The Young People's Gallery opens, MoMA's first space devoted specifically to education. Victor D'Amico is named first education director.

1938

Bauhaus 1919–1928 exhibition presents work of the influential German school of art and design whose cross-disciplinary approach served as a model for the organization of the Museum.

Useful Objects inaugurates a series of annual exhibitions devoted to the design of everyday items that will continue through 1947.

Walker Evans: American Photographs is the first solo photography exhibition and is accompanied by a landmark publication that helps to establish the genre of the photographer's book.

Trois siecles d'art aux États-Unis (*Three Centuries of American Art*), the first MoMA exhibition sent abroad, opens at the Jeu de Paume Museum in Paris.

1939

The Goodwin-Stone building opens (fig. 4; p. 86), with a sculpture garden designed by curator John McAndrew.

Dance Archives for the study of contemporary dance is founded by Lincoln Kirstein, with Paul Magriel as librarian.

Art in Our Time exhibition celebrates the Museum's tenth anniversary and is the first showcase of its collection.

Pablo Picasso's *Les Demoiselles d'Avignon* (1907) is acquired, followed six months later by the retrospective *Picasso: Forty Years of His Art*, which is the first MoMA exhibition devoted to the artist and the first showing at the Museum of *Guernica* (1937), Picasso's monumental anti-war canvas.

Stephen C. Clark becomes chairman of the board; he will serve through 1946.

Nelson A. Rockefeller is appointed president; he will serve through 1941, and again, 1946–53.

1940

The Department of Photography is founded, with Beaumont Newhall as curator.

The Circulating Film Library is established, with Margareta Akermark as director, to facilitate loans of films in the collection.

The Department of Industrial Design is formed, with Eliot Noyes as director. It will merge with the Department of Architecture in 1949.

Working on behalf of the Museum in collaboration with the Emergency Rescue Committee, a group aiding war refugees, Barr and his wife, Margaret Scolari Barr, assist artists, art historians, gallery owners, and their families fleeing Europe by sponsoring visas, writing letters of reference, and securing funds for passage.

Abby Aldrich Rockefeller donates her collection of 1,600 prints.

The exhibition *Twenty Centuries of Mexican Art* features contemporary artist José Clemente Orozco creating a fresco painting on site.

Frank Lloyd Wright, American Architect and *D. W. Griffith, American Film Master* are presented as separate exhibitions but combined under the title *Two Great Americans*.

Stephen C. Clark is appointed acting president until the appointment of John Hay Whitney in 1941. Whitney will serve as president until 1946, and then as chairman of the board until 1956.

1941

Indian Art of the United States exhibition showcases Native American art while simultaneously seeking to improve the economic self-sufficiency of Native tribes.

Organic Design in Home Furnishings exhibition features the winning entries to the MoMA-sponsored Organic Design competition. The designers also receive manufacturing and distribution contracts, and upon the show's opening, the exhibited items are made available for sale at major department stores nationwide.

1942

Children's Festival of Modern Art opens, with games designed by D'Amico and a studio area for art-making. The festival, later renamed the Children's Art Carnival, will be held annually at the Museum until 1952.

MoMA establishes the Inter-American Fund to support acquisitions of Latin American art.

Under the directorship of James Thrall Soby, the Armed Services Program is established to facilitate war-themed exhibitions, provide art books and reproductions to military bases, and organize social activities for service members.

Fig. 5. Cover of Alfred Barr's *What Is Modern Painting?*, 1943. Publications Archive. MoMA Archives, NY

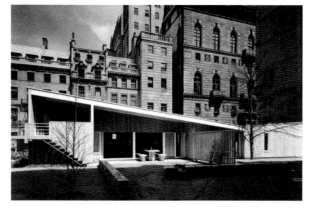

Fig. 6. Installation view of Marcel Breuer's *House in the Museum Garden*, The Museum of Modern Art, New York, April 12–October 30, 1949. Photograph by Ezra Stoller. Photographic Archive. Exhibition Albums, 405.6. MoMA Archives, NY

Road to Victory photography exhibition is a dramatic propagandistic effort to celebrate the contributions of individual citizens to the war effort.

Self-taught artist Joe Milone's *Shoeshine Stand* is exhibited in the Museum lobby, displeasing chairman Stephen C. Clark, whose tastes in art are more conservative. This incident will lead in part to Barr's dismissal.

1943

What Is Modern Painting?, Barr's foundational primer on modern art, is published (fig. 5).

The Museum board, citing concerns that too much of Barr's time is being spent on "administrative routine" rather than organizing exhibitions and writing, forces him to resign as director and to assume the position of advisory director.

1944

The Department of Dance and Theater Design is founded, with George Amberg as curator. The department will be dissolved in 1948. Until the creation of the Department of Media and Performance Art in 2009, the Museum's engagement with dance and performance is less formalized and undertaken by the Junior Council and the Summergarden program.

The War Veterans' Art Center, headed by D'Amico, is created with the aim of using art to aid in the rehabilitation of service members returning from war, and will be credited as a pioneer in the field of art therapy.

1946

Fourteen Americans is the second of six "Americans" exhibitions organized by curator Dorothy C. Miller between 1942 and 1963 to introduce the work of contemporary American artists, with a gallery dedicated to each artist.

Arts of the South Seas exhibition presents a comprehensive overview of Oceanic art and suggests parallels to Expressionism and Surrealism.

1947

Inter-Museum Agreement calls for MoMA and the Whitney Museum of American Art to transfer "older" works of art to The Metropolitan Museum of Art in exchange for funds to purchase contemporary works. Only a few such transfers are made, and the agreement is terminated in 1953.

1948

The War Veterans' Art Center becomes the People's Art Center. In 1960, this will become part of the Museum's independent Institute of Modern Art, headed by D'Amico.

1949

René d'Harnoncourt is named Museum director.

The Junior Council, an affiliate group for younger Museum patrons, is founded.

Master Prints from the Museum Collection exhibition marks the opening of The Abby Aldrich Rockefeller Print Room.

The House in the Museum Garden features full-scale "expandable house" designed by Marcel Breuer (fig. 6).

1950

Good Design series of annual exhibitions showcasing contemporary design in furniture and housewares begins, co-sponsored with The Merchandise Mart in Chicago. The series ends in 1955.

1951

The Museum expands with an addition at 21 West 53rd Street designed by Philip Johnson.

The Art Lending Service, managed by the Junior Council, is established to allow Museum members to borrow artworks for personal display for a modest fee.

Barr organizes the retrospective *Henri Matisse*, which is accompanied by his widely acclaimed monograph, *Matisse: His Art and His Public*.

Eight Automobiles is the first exhibition devoted to automotive design.

1952

Led by Porter McCray as director, the International Program is founded to promote modern art abroad, largely through traveling exhibitions (p. 106). Under the program's auspices, the Museum organizes the American representation at the Venice Biennale as well from 1954 to 1962, during which time MoMA owns the U.S. Pavilion.

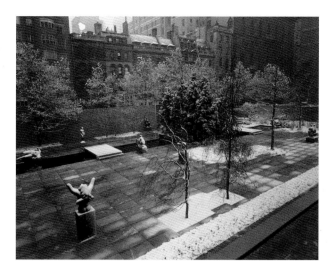

Fig. 7. The Abby Aldrich Rockefeller Sculpture Garden, designed by Philip Johnson, 1953. Photographic Archive. MoMA Archives, NY

The Television Project is created to engage with the new medium and to develop television programs, including the children's educational program *Through the Enchanted Gate*, by D'Amico. The project continues until 1955.

15 Americans exhibition showcases Abstract Expressionism and the New York School, featuring emerging talent such as Jackson Pollock and Mark Rothko.

1953

The International Council affiliate group is founded to support the mission and activities of the International Program.

The Museum garden is redesigned by Philip Johnson and christened The Abby Aldrich Rockefeller Sculpture Garden (fig. 7).

William A. M. Burden is appointed president; he will serve through 1959.

1954

Full-scale Japanese house, built in Japan and shipped to New York, is reassembled in the sculpture garden, drawing parallels between traditional Japanese and modern architecture.

1955

Large *Family of Man* photography exhibition, organized by Edward Steichen, director of the Department of Photography, underscores universal aspects shared by humanity (p. 106). Five copies of the show will tour thirty-seven countries through 1962.

1956

Nelson A. Rockefeller becomes chairman of the board; he will serve through 1958.

1957

Picasso: 75th Anniversary retrospective, organized by Barr, surveys the artist's entire career to date (p. 118).

1958

A fire on the second floor of the Goodwin-Stone building results in one fatality and damages several artworks.

The Department of Conservation is founded, with Jean Volkmer as director.

David Rockefeller becomes chairman of the board; he will serve through 1959, followed by two more terms, 1962–72 and 1987–93.

1959

16 Americans exhibition features the recent radical aesthetic innovations of Robert Rauschenberg, Jasper Johns, and Frank Stella, heralding a break in modern American art from Abstract Expressionism.

Blanchette Hooker Rockefeller becomes chairman of the board, and later this year she is appointed president. She will serve as president until 1962, and again, 1972–85. She will serve as chairman, 1985–87.

Dr. Henry Allen Moe becomes chairman of the board; he will serve through 1961.

1960

The International Program and Council institute the Art in Embassies program, which assembles collections of artworks for placement in U.S. embassies. The federal government will assume responsibility for the program in 1970.

Jazz in the Garden summer concert series begins.

Jean Tinguely's *Homage to New York*, a towering "self-constructing and self-destructing work of art," is exhibited in the sculpture garden.

1961

The Art of Assemblage exhibition features the work of artists such as Rauschenberg, John Chamberlain, and Joseph Cornell, introducing what curator William C. Seitz describes as the "new medium" of assemblage.

William A. M. Burden becomes chairman of the board; he will serve through 1962.

1962

Copy of the Children's Art Carnival is donated to the people of India, presented to Indira Gandhi by honorary International Council member Jacqueline Bouvier Kennedy.

1963

Americans 1963 exhibition introduces Pop artists such as Robert Indiana, Claes Oldenburg, and James Rosenquist, as well as the pure abstractions of Ad Reinhardt.

William A. M. Burden is appointed president; he will serve through 1965.

Fig. 8. Robert Indiana's *LOVE* holiday card commissioned by MoMA's Junior Council, 1965. Junior Council Records. MoMA Archives, NY

Fig. 9. Installation view of *Information*, The Museum of Modern Art, New York, July 2–September 20, 1970. Photographic Archive. MoMA Archives, NY

Fig. 10. Richard E. Oldenburg, director of the Museum, and Blanchette Hooker Rockefeller, president of the board of trustees, accepting an honorary Oscar from actor Gregory Peck for MoMA's Department of Film, April 1979. Photographic Archive. MoMA Archives, NY

1964

The Museum expands with a new East Wing (formerly 5 and 7 West 53rd Street), Garden Wing (on West 54th Street), and renovated lobby, all designed by Philip Johnson.

1965

Robert Indiana designs *LOVE* as a commission by the Junior Council for a Museum holiday card (fig. 8).

The Responsive Eye, organized by Seitz, draws international attention to optical, or "Op," art.

Architecture Without Architects exhibition showcases communal, "non-pedigreed" architecture.

Elizabeth Bliss Parkinson is appointed president; she will serve through 1968.

1966

The Department of Drawings and Prints is established as an independent department, with William S. Lieberman as director.

Alexander Calder donates nineteen works, in appreciation of the Museum having mounted his first retrospective, in 1943.

1967

Barr retires as Director of Museum Collections.

New Documents exhibition, organized by John Szarkowski, director of the Department of Photography, features Diane Arbus (p. 130), Lee Friedlander, and Garry Winogrand.

1968

Cineprobe series begins, devoted to recent films by young filmmakers.

René d'Harnoncourt retires.

Bates Lowry is named Museum director.

Mies van der Rohe Archive is acquired (p. 132).

The Museum acquires a collection of more than five thousand original prints and negatives by Eugène Atget (p. 136).

The Machine as Seen at the End of the Mechanical Age exhibition explores artists' changing attitudes toward technology.

In Honor of Dr. Martin Luther King exhibition is held seven months after King's assassination. Prominent American artists donate works to be sold for the benefit of the Southern Christian Leadership Conference, the first time a MoMA exhibition benefits another organization.

Word and Image: Posters and Typography from the Graphic Design Collection of The Museum of Modern Art, 1879–1967 exhibition is the first historical survey of this material.

William S. Paley is appointed president; he will serve through 1972.

1969

The Children's Art Carnival opens in Harlem.

The Department of Prints and Illustrated Books is founded, with Riva Castleman as curator. Responsibility for drawings reverts to the Department of Painting and Sculpture.

The Art Workers' Coalition stages several protests at the Museum and issues "13 Demands," calling for greater representation of artists of color in the Museum's administration and exhibition program, greater outreach to minority communities, and free admission.

Yayoi Kusama stages *Grand Orgy to Awaken the Dead at MoMA*, an unsanctioned event in the sculpture garden described in the press as an "impromptu nude-in."

Spaces exhibition marks the Museum's first foray into installation art, featuring installations by artists such as Michael Asher, Larry Bell, Dan Flavin, and Robert Morris.

1970

John B. Hightower is named Museum director.

What's Happening series showcases films relevant to current social and political issues.

Information, organized by associate curator Kynaston McShine, is a landmark international survey of Conceptual and performance practices (fig. 9; p. 148).

1971

The Department of Drawings is created as a separate division, with William S. Lieberman as director.

The Museum computerizes its catalogue of its collections, becoming the first museum in the world to do so.

Projects series of exhibitions begins, with a focus on Conceptual, installation, and performance-based works (p. 156).

278

Fig. 14. Installation view of *Marina Abramović: The Artist Is Present*, The Museum of Modern Art, New York, March 14–May 31, 2010. Photographic Archive. MoMA Archives, NY

2004
MoMA marks its 75th anniversary with the opening of its new Taniguchi-designed building and renovated spaces (fig. 13).

2005
The Modern Women's Fund is established through the support of Sarah Peter to promote scholarship on women in the arts.

David Rockefeller pledges extraordinary bequest of $100 million, and in addition commits to donating $5 million annually until his death.

Marie-Josée Kravis is appointed president.

2006
The Department of Media is founded, with Klaus Biesenbach as director, and its first project is *Doug Aitken: Sleepwalkers* (2007). The department will be renamed Media and Performance Art in 2009.

Latin American and Caribbean Fund is established to support acquisitions of modern and contemporary art from the region.

2007
The position of Associate Director is created to strengthen and support contemporary programs at MoMA and P.S. 1 and to partner with the Museum director on global initiatives and advocacy.

"The Feminist Future: Theory and Practice in the Visual Arts," a two-day international symposium, is the first project sponsored by the Modern Women's Fund.

Modern Mondays series begins, featuring work by artists in the fields of film, video, performance, and sound.

Jerry I. Speyer becomes chairman of the board.

2008
The Gilbert and Lila Silverman Fluxus Collection and Archives is acquired (pp. 210–214), encompassing several thousand artworks and two hundred linear feet of archival items.

2009
Contemporary and Modern Art Perspectives in a Global Age (C-MAP) is founded, a cross-departmental internal research program that fosters in-depth study of art histories outside North America and Western Europe.

Performance 1: Tehching Hsieh inaugurates ongoing performance series showcasing both original performance pieces and reenactments of historical performances.

2010
Marina Abramović: The Artist Is Present is the first large-scale American museum retrospective of the artist's groundbreaking performance work (fig. 14).

2011
The Herman and Nicole Daled Collection and Archives is acquired (p. 222), a key collection of American and European Conceptual art from the 1960s and '70s that comprises more than two hundred works, with a concentration of sixty works by Marcel Broodthaers.

The Seth Siegelaub Collection and Archives is acquired, including twenty major works of Conceptual art.

2012
The Frank Lloyd Wright Archive is jointly acquired with Columbia University, encompassing forty large-scale architectural models, more than 65,000 photographs and architectural drawings, and 300,000 documents.

2015
Transmissions: Art in Eastern Europe and Latin America, 1960–1980 is the most substantial product of C-MAP research to date, and explores the parallels and networks between artists in Eastern Europe and Latin America in the 1960s and '70s.

2016
The Colección Patricia Phelps de Cisneros Gift is acquired, including more than a hundred works by major artists from Latin America, and the Cisneros Research Institute for the Study of Art from Latin America is established.

2017
The Museum completes the renovation of the eastern end of its campus to mark the first phase of its expansion project designed by Diller Scofidio + Renfro. The expansion is projected to be completed in 2019.

Artist Index

Acknowledgments

The exhibition *Being Modern: MoMA in Paris* was commissioned by Bernard Arnault and has benefited greatly from his interest and commitment. The exhibition has received the consistent support of Jean-Paul Claverie. We extend our gratitude to Marie-Josée Kravis, President of the Board of Trustees of The Museum of Modern Art, who played a crucial role in the completion of this project. Our special thanks go to the teams at the Fondation Louis Vuitton and MoMA, to their respective partners, and especially to those who participated directly in the endeavor.

At the Fondation Louis Vuitton: Anne-Louise Amanieu, Benjamin Baudet, Sébastien Bizet, Élise Blanc, Patricia Brunerie, Patricia Buffa, Marie-Monique Couvègnes, Coralie Coyard, Isabella Capece Galeota, Candice Chenu, Leslie Compan, Benoit Dagron, Clélia Dehon, Pauline Dujardin, Laurent Escaffre, Sébastien Gokalp, Pascale Hérivaux, Olivia Jacquinot, Claire Jousselme, Maude Le Guennec, Prune Lepape, Caroline Levai, Bérengère Lévêque, Joachim Monégier du Sorbier, Roya Nasser, Jean-François Quemin, Renaud Sabari, Jean-Christian Seguret, Charlotte Sorel, Yan Stive, and especially Tadeo Kohan.

At The Museum of Modern Art: Nancy Adelson, Bill Ashley, Anny Aviram, Giampaolo Bianconi, Klaus Biesenbach, Eva Bochem-Shur, Karlos Carcamo, Christophe Cherix, Ingrid Chou, Madeleine Compagnon, Ellen Conti, Matthew Cox, Lee Ann Daffner, Ellen Davis, Marina Dumont-Gauthier, Emily Edison, Megan Feingold, Derek Flynn, Cerise Fontaine, David Frankel, Roger Griffith, Lily Goldberg, Danielle Hall, Susan Homer, Kathy Hill, Athena Holbrook, Rob Jung, Nicole Kaack, Amy Kao, Robert Kastler, Rachel Kim, Tom Kruger, Kate Lewis, Prin Limphongpand, Tasha Lutek, Maggie Lyko, Ryan Magyar, John Martin, Laura McGuiness, Kim Mitchell, Meg Montgoris, Ellen Moody, Erika Mosier, Laura Neufeld, Peter Oleksik, Matt Osiol, Erik Patton, Peter Perez, Jan Postma, Diana Pulling, Megan Randal, Sylvia Renner, Roberto Rivera, Rajendra Roy, Stefanii Ruta-Atkins, Jennifer Sellar, Blair Shoemaker, Martino Stierli, Rebecca Stokes, Marion Tandé, Ann Temkin, Steven Wheeler, Sarah Wood, and Lynda Zycherman. —S.P.

Being Modern: MoMA in Paris

An exhibition organized by the Fondation Louis Vuitton, Paris, and The Museum of Modern Art, New York

Fondation Louis Vuitton, October 11, 2017, to March 5, 2018

Fondation Louis Vuitton

Bernard Arnault, President
Jean-Paul Claverie, Advisor to the President, Administrator
Suzanne Pagé, Artistic Director
Sophie Durrleman, Executive Director

The Museum of Modern Art

Glenn D. Lowry, Director
Kathy Halbreich, Associate Director
Ramona Bronkar Bannayan, Senior Deputy Director,
 Exhibitions and Collections
Todd Bishop, Senior Deputy Director, External Affairs
James Gara, Chief Operating Officer
Patty Lipshutz, General Counsel and Secretary to the Board
Peter Reed, Senior Deputy Director, Curatorial Affairs

Exhibition

Under the direction of
Suzanne Pagé, Artistic Director, Fondation Louis Vuitton
Glenn D. Lowry, Director, The Museum of Modern Art,
New York

Curators
Quentin Bajac, The Joel and Anne Ehrenkranz Chief Curator of
Photography, MoMA, assisted by Katerina Stathopoulou, Assistant
Curator, MoMA

Archival section organized by Michelle Elligott, Chief of Archives,
Library, and Research Collections, MoMA

Curator in Paris
Olivier Michelon, Curator, Fondation Louis Vuitton

Production
Elodie Berthelot, Fondation Louis Vuitton
Lisa Delmas, Arter

Exhibition Design
Jean-François Bodin, assisted by Hélène Roncerel, Paris
Lana Hum, Director, Exhibition Design and Production, MoMA

Catalogue

Published by The Museum of Modern Art, New York,
the Fondation Louis Vuitton, Paris, and Thames & Hudson, London
Produced by the Department of Publications, MoMA

The Museum of Modern Art
Christopher Hudson, Publisher
Chul R. Kim, Associate Publisher
Don McMahon, Editorial Director
Marc Sapir, Production Director

Jason Best, editor of the English-language catalogue
Amanda Washburn, Senior Designer
Rebecca Roberts, Editor

Translations from the French by Jeanine Herman

Fondation Louis Vuitton
Raphaël Chamak, Head of Publishing, Fondation Louis Vuitton
Annie Pérez, editorial coordinator, Paris

Translations of foreword and preface from the French by
Ian Peisch and Charles Penwarden

Authors
Foreword by Bernard Arnault

Preamble by Glenn D. Lowry

Preface by Suzanne Pagé

Essays by Quentin Bajac, Glenn D. Lowry, and Olivier Michelon

Plate essays by Seth Anderson, Paola Antonelli, Quentin Bajac,
Luke Baker, Charlotte Barat, Jessica Bell Brown, Stuart Comer,
Kayla Dalle Molle, Christina Eliopoulos, Michelle Elligott, Margaret
Ewing, Teresa Fankhänel, Starr Figura, Michelle Millar Fisher,
Samantha Friedman, Paul Galloway, Lucy Gallun, Kristen Gaylord,
Karen Grimson, Jenny Harris, Michelle Harvey, Heidi Hirschl,
Ana Janevski, Martha Joseph, Anna Kats, Juliet Kinchin, Sofia
Kofodimos, Talia Kwartler, Emily Liebert, Jonathan Lill, Tellina Liu,
Ron Magliozzi, Cara Manes, Roxana Marcoci, Tamar Margalit,
Sarah Hermanson Meister, Anne Morra, Annie Ochmanek, Erica
Papernik-Shimizu, David Platzker, Paulina Pobocha, Christian
Rattemeyer, Yasmil Raymond, Hillary Reder, Lynn Rother, Katharine
Rovanpera, Kelly Sidley, Katerina Stathopoulou, Sarah Suzuki,
Elisabeth Thomas, Akili Tommasino, and Lilian Tone

Chronology by Michelle Elligott

Photograph Credits

© 2017 Laurie Anderson. Photo: John Wronn, The Museum of Modern Art, Department of Imaging and Visual Resources: p. 171. © Carl Andre/Licensed by VAGA, New York, NY. Photo: Kate Keller, MoMA, Imaging and Visual Resources: p. 143. © 2017 Eleanor Antin. Photo: Robert Gerhardt, MoMA, Imaging and Visual Resources: p. 157. ©The Estate of Diane Arbus, LLC. Photo: MoMA, Imaging and Visual Resources: p. 131. © 2017 Artists Rights Society (ARS), New York/ADAGP, Paris. Photo: MoMA, Imaging and Visual Resources: p. 55. © 2017 Artists Rights Society (ARS), New York/ADAGP, Paris/Estate of Marcel Duchamp. Photo: MoMA, Imaging and Visual Resources: p. 129. © 2017 Artists Rights Society (ARS), New York/ADAGP, Paris. Photo: John Wronn, MoMA, Imaging and Visual Resources: p. 135. © 2017 Artists Rights Society (ARS), New York/SIAE, Rome. Photo: Paige Knight, MoMA, Imaging and Visual Resources: p. 111, b; 147. © 2017 Artists Rights Society (ARS), New York/ VG Bild-Kunst, Bonn. Photo: Robert Gerhardt, MoMA, Imaging and Visual Resources: p. 113 , c, e. Photo: Thomas Griesel, MoMA, Imaging and Visual Resources: p. 95. Photo: MoMA, Imaging and Visual Resources: p. 149. Photo: Jonathan Muzikar, MoMA, Imaging and Visual Resources: p. 133. Photo: John Wronn, MoMA, Imaging and Visual Resources: p. 111, a; 113, d;

181. © 2017 Artists Rights Society (ARS), New York/VG Bild-Kunst, Germany. Photo: Peter Butler, MoMA, Imaging and Visual Resources: p. 213. © 2017 Atari, Inc.: p. 231. © 2017 Estate of Gilbert Baker. Photo: Peter Butler, MoMA, Imaging and Visual Resources: p. 249. © 2017 Banco de México Diego Rivera Frida Kahlo Museums Trust, Mexico, D.F./Artists Rights Society. Photo: Kate Keller, MoMA, Imaging and Visual Resources: p. 97. © Romare Bearden Foundation/Licensed by VAGA, New York, NY. Photo: John Wronn, MoMA, Imaging and Visual Resources: p. 151. © 2017 Mark Bradford. Photo: Thomas Griesel, MoMA, Imaging and Visual Resources: p. 255. © 2017 Calder Foundation, New York/Artists Rights Society (ARS), New York. Photo: Peter Butler, MoMA, Imaging and Visual Resources: p. 59. © 2017 Janet Cardiff. Courtesy of the artist and Luhring Augustine, New York and Galerie Barbara Weiss, Berlin. Photo: Thomas Griesel, MoMA, Imaging and Visual Resources: p. 201. The Forty-Part Motet by Janet Cardiff was originally produced by Field Art Projects with the Arts Council of England, the Salisbury Festival, BALTIC Gateshead, The New Art Gallery Walsall, and the NOW Festival Nottingham; sung by Salisbury Cathedral Choir; recording and postproduction by SoundMoves; edited by George Bures Miller; produced by Field Art Projects. © 2017 Aslı Çavuşoğlu. Photo: Jonathan Muzikar, MoMA, Imaging and Visual Resources: p. 265. © 1981 Center for Creative Photography, Arizona Board of Regents. Photo: MoMA, Imaging and Visual Resources: p. 67. © Ian Cheng. Photo: Peter Butler, MoMA, Imaging and Visual Resources: p. 259. © O Mundo de Lygia Clark–Associação Cultural, Rio de Janeiro: p. 271. © Eileen Costa. Photo: Eileen Costa: p. 193, b. © 2017 Salvador Dalí, Gala-Salvador Dalí Foundation/Artists Rights Society (ARS), New York. Photo: Jonathan Muzikar, MoMA, Imaging and Visual Resources: p. 57. © Robert Damora: p. 87. © T. Darvas.

Photo: MoMA, Imaging and Visual Resources: p. 119. © 1928 Disney Enterprises, Inc.: p. 73. © 2017 Trisha Donnelly. Photo: Jonathan Muzikar, MoMA, Imaging and Visual Resources: p. 235. © 2017 Juan Downey/Artists Rights Society (ARS), New York. Photo: Jonathan Muzikar, MoMA, Imaging and Visual Resources: p. 229. © 2017 Walker Evans Archive, The Metropolitan Museum of Art. Photo: MoMA, Imaging and Visual Resources: p. 83. © 2017 Estate of Andreas Feininger. Photo: MoMA, Imaging and Visual Resources: p. 275. © 2017 LaToya Ruby Frazier, courtesy of LaToya Ruby Frazier and Michel Rein, Paris/Brussels. Photo: John Wronn, MoMA, Imaging and Visual Resources: p. 243. © 2017 Andrea Geyer. Courtesy Galerie Thomas Zander, Cologne. Photo: MoMA, Imaging and Visual Resources, p. 237. © The Felix Gonzalez-Torres Foundation, Courtesy of Andrea Rosen Gallery, New York. Photo: John Wronn, MoMA, Imaging and Visual Resources: pp. 4, 187. © 2005 Google Inc.: p. 233. © 2017 The Estate of Philip Guston. Photo: Jonathan Muzikar, MoMA, Imaging and Visual Resources: p. 165. © 2017 David Hammons. Photo: Jonathan Muzikar, MoMA, Imaging and Visual Resources: p. 273. © Copyright 1971 by Hendon Music Inc., Revised, © Copyright 2011 by Hendon Music Inc., a Boosey & Hawkes company. Photo: Jonathan Muzikar, MoMA, Imaging and Visual Resources: p. 223. © 2017 C. Herscovici, Brussels/Artists Rights Society (ARS), New York. Photo: John Wronn, MoMA, Imaging and Visual Resources: p. 71. © Holt-Smithson Foundation/Licensed by VAGA, New York, NY. Photo: John Wronn, MoMA, Imaging and Visual Resources: p. 253 © Timothy Hursley. Photo: MoMA, Imaging and Visual Resources: p. 280. © Iman Issa. Photo: Chris Ceravolo, MoMA, Imaging and Visual Resources: p. 257. © 2017 Jasper Johns/Licensed by VAGA, New York. Photo: Paige Knight, MoMA, Imaging and Visual Resources: p. 123. © Ellsworth

Published in conjunction with the exhibition *Being Modern: MoMA in Paris*, at the Fondation Louis Vuitton, Paris, October 11, 2017, to March 5, 2018

Produced by the Department of Publications, The Museum of Modern Art, New York
Christopher Hudson, Publisher
Chul R. Kim, Associate Publisher
Don McMahon, Editorial Director
Marc Sapir, Production Director

Edited by Jason Best
Designed by Amanda Washburn with Tina Henderson
Production by Marc Sapir
Printed and bound by Graphius–New Goff
Color separations by t'ink, Belgium
Duotone separations by Thomas Palmer

The essay by Quentin Bajac was edited by David Frankel.
The essay by Glenn D. Lowry was edited by Maria Marchenkova.
The essay by Olivier Michelon was edited by Don McMahon.

The essays by Olivier Michelon and Quentin Bajac and the plate essay by Bajac were translated from the French by Jeanine Herman. The foreword by Bernard Arnault and the preface by Suzanne Pagé were translated from the French by Ian Peisch and Charles Penwarden.

This book is typeset in Visuelt and Freight Text Pro. The paper is 150 gsm Magno Satin.

First published in the United Kingdom in 2017 by
Thames & Hudson Ltd, 181A High Holborn,
London, WC1V 7QX

British Library Cataloguing-in-Publication Data
A catalogue record for this book is available from the British Library

ISBN 978-0-500-23979-7

P. 2: Andy Warhol. *Campbell's Soup Cans*. 1962 (detail, see p. 189); p. 4: Felix Gonzalez-Torres. *"Untitled" (USA Today)*. 1990 (detail, see p. 187); p. 10: Ellsworth Kelly. *Colors for a Large Wall*. 1951 (detail, see p. 145); p. 15: Albert H. Barr Jr.'s "'Torpedo' Diagram of Ideal Permanent Collection," included in his "Report on the Permanent Collection," November 1933. Alfred H. Barr Jr. Papers, II.C.16. MoMA Archives, NY; p. 18: Eugène Atget. *Magasin, avenue des Gobelins*. 1925 (detail, see p. 139, g.); p. 23: Jeff Wall. *After "Invisible Man" by Ralph Ellison, the Prologue*. 1999–2000 (detail, see p. 203); p. 26: Gustav Klimt. *Hope, II*. 1907–08 (detail, see p. 159); p. 39: Lynn Hershman Leeson. *Roberta's Construction Chart #2*. 1976 (detail, see p. 225, d.)

Printed and bound in Belgium

To find out about all our publications, please visit **www.thamesandhudson.com**. There you can subscribe to our e-newsletter, browse or download our current catalogue, and buy any titles that are in print.